WHO SHOT SPORTS

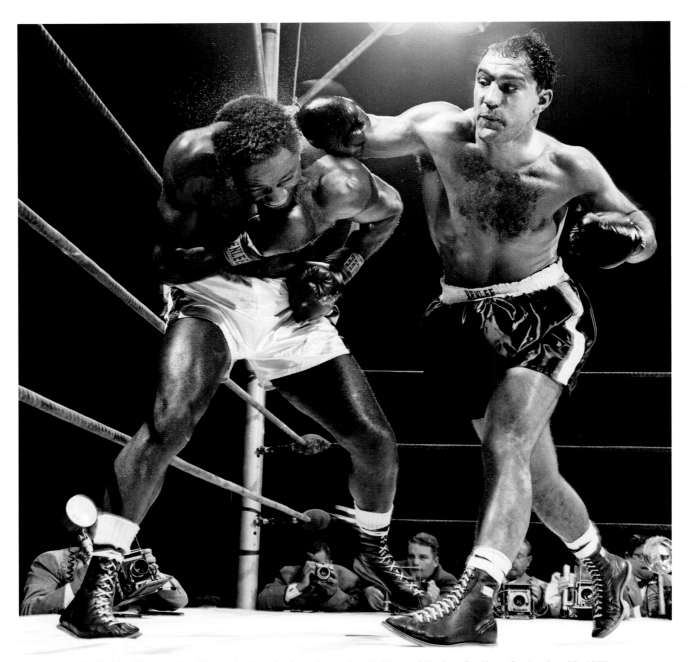

Hy Peskin, "Carmen Basilio lands right hook on Sugar Ray Robinson," Yankee Stadium, September 23, 1957.

WHO SHOT SPORTS

A PHOTOGRAPHIC HISTORY, 1843 TO THE PRESENT

GAIL BUCKLAND

ALFRED A. KNOPF · NEW YORK · 2016

This Is a Borzoi Book Published by Alfred A. Knopf

Copyright © 2016 by Gail Buckland

Technology Timeline copyright © 2016 by Nigel Russell

All rights reserved. Published in the United States by Alfred A. Knopf, a division of Penguin Random House LLC, New York, and distributed in Canada by Random House of Canada, a division of Penguin Random House Canada Limited, Toronto.

www.aaknopf.com

Knopf, Borzoi Books, and the colophon are registered trademarks of Penguin Random House LLC.

Library of Congress Cataloging-in-Publication Data
Names: Buckland, Gail, author.
Title: Who shot sports : a photographic history, 1843 to the present / Gail Buckland.
Description: First edition. | New York : Alfred A. Knopf, [2016] | Includes bibliographical references and index.
Identifiers: LCCN 2015038089 | ISBN 9780385352239 (hardcover : alk. paper)
Subjects: LCSH: Photography of sports—History.
Classification: LCC TR821 .B83 2016 | DDC 779/.9796—dc23 LC record available at
http://lccn.loc.gov/2015038089

Front-of-jacket photograph: Bill Russell (6) of the Boston Celtics guarding Elgin Baylor (22) of the Los Angeles Lakers, NBA Finals, 4/20/1966. © Walter Iooss Jr./*Sports Illustrated*/Getty Images
Back-of-jacket photograph: Nigerian women's 4 × 100m relay team, Olympic Games, Barcelona, Spain, 1992, by Ken Geiger/*The Dallas Morning News*
Jacket design by Carol Devine Carson

Printed in Germany

2 4 6 8 10 9 7 5 3 1

First Edition

TO MY GRANDCHILDREN,

IVY DORSET TAYLOR

AND

MILES ACADIA TAYLOR,

AND

MY SON-IN-LAW

STEPHEN JACKSON TAYLOR,

WHO IS TEACHING THEM THE JOY, HEARTBREAK, AND LOVE OF SPORTS

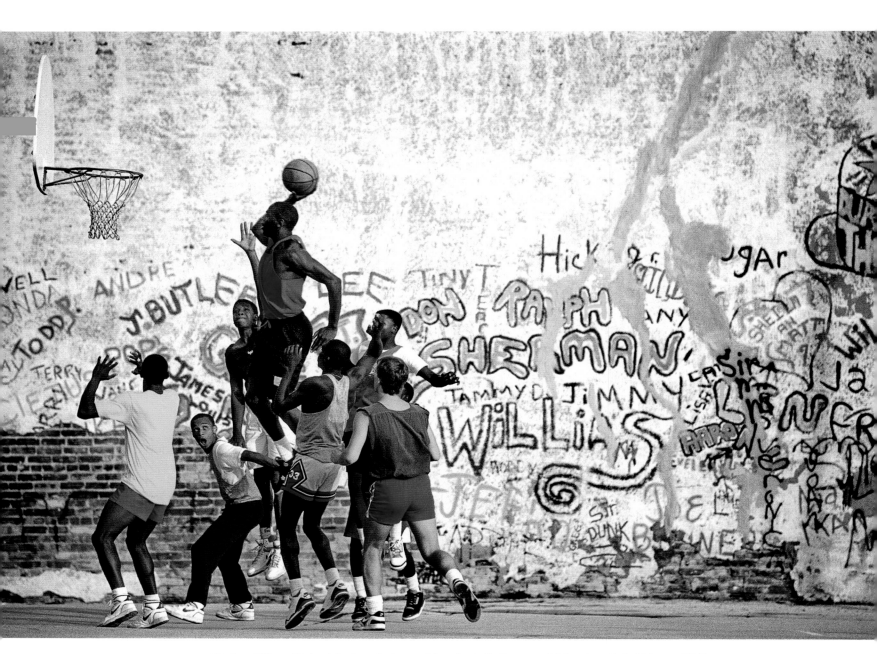

Stephen Wilkes, Michael Jordan playing a pickup basketball game with local youth in Chicago, 1987

CONTENTS

INTRODUCTION ix

ONE • THE DECISIVE MOMENT 3

TWO • FANS AND FOLLOWERS 37

THREE • PORTRAITS 73

FOUR • OFF THE FIELD 107

FIVE • VANTAGE POINT 125

SIX • IN AND OUT OF THE RING 171

SEVEN • FOR THE LOVE OF SPORT 195

EIGHT • THE OLYMPICS 223

APPENDIX ONE
THE BEGINNINGS OF SPORTS PHOTOGRAPHY 259

APPENDIX TWO
TECHNOLOGY TIMELINE 293

BIBLIOGRAPHY 305

ACKNOWLEDGMENTS 311

INDEX 315

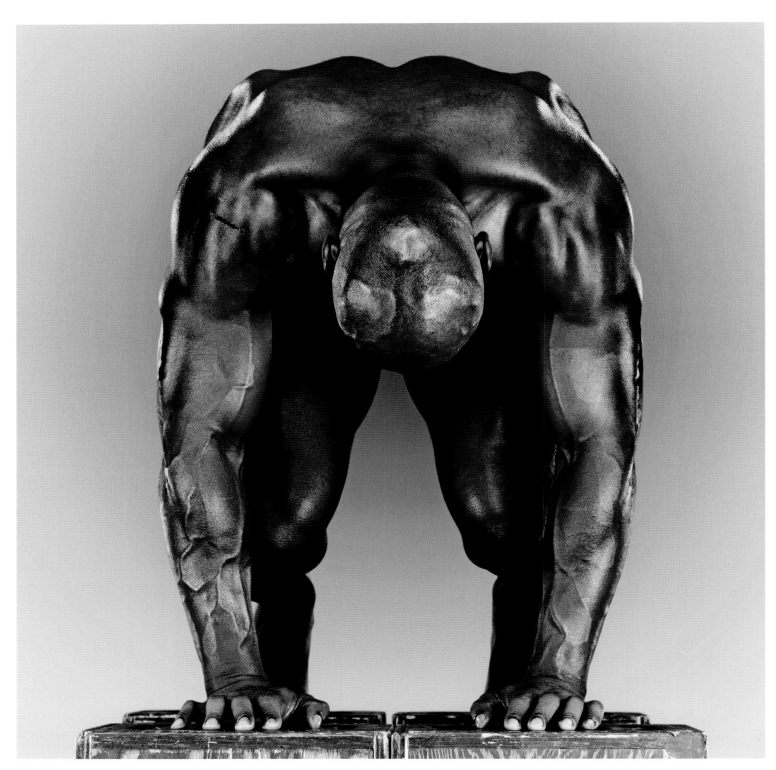

Howard Schatz, *Human Body Study #1255, Bryan Scott,* October 2011

INTRODUCTION

There is no need to go back to Pindar or Greek and Roman statuary to become aware of the harmony found among the cinder tracks, stadiums and swimming pools. . . . It is therefore natural that the greatest photographers should have explored the world of sport to find that each athlete is the sculptor of his own body, that all movement is rhythm, and that a stadium may be the most beautiful setting for ballet that exists.

JEAN-CLAUDE GAUTRAND, *VISIONS DU SPORT: PHOTOGRAPHIES, 1860–1960*

• • •

French screenwriter and novelist Pierre Bost has said all art is an attempt to make gesture permanent. *Who Shot Sports: A Photographic History, 1843 to the Present* is a book about the art of sports photography and the men and women who have captured the fleeting, exquisite, exciting gestures sports present. This is their story. They have given sports its image. When the action stops, the still photograph remains.

Robert Riger was one of the first people to be hired by *Sports Illustrated* to ensure that the magazine lived up to the "illustrated" part of its name. A trained artist, he did mostly illustration for the magazine. When he started using a camera, he set the bar high for sports photography. Hugh Edwards, the art historian and former curator of photography at the Art Institute of Chicago, wrote that Riger's photographs show the "nobility of the completed gesture" and "this was something we believed possible only in the hands of geniuses of draughtsmanship like Géricault and Degas." Riger's photographs are fully resolved as pictures, as are most of the photographs in this book. Sports photographs have inspired artists since the mid-nineteenth century. And art has informed sports photography for an equally long time.

Distinguished art historian Jane Livingstone, writing in the introduction to the catalogue for her exhibition *Visions of Victory: A Century of Sports Photography* (1996), explained that her motivation for doing the project was based on the "the

simple conviction that the endeavor of photographing sports has been underappreciated in comparison to photography's other genres." Others who identified the omission of sports iconography in the discourse on photography and its role in art and society, or just recognized that sports photographs are some of the most exciting and beautiful photographs ever taken, are Ruth Silverman *(Athletes: Photographs, 1860–1986);* Jean-Claude Gautrand *(Visions du Sport: Photographies, 1860–1960);* Ellen Dugan *(This Sporting Life: 1878–1991);* and David E. Little *(The Sports Show: Athletics as Image and Spectacle). Sportscape: The Evolution of Sports Photography,* selected by Paul Wombell from the Allsport and Hulton/Archive, with an introduction by Simon Barnes, is an excellent overview of these important collections. Jean-Denis Walter runs an art gallery in Paris showing exclusively sports-related photographs, and the photographer Brad Mangin and writer David Davis, two photo historians who specialize in sports photography, honor men and women in the field by telling their stories. Publications that traditionally have supported great photography, such as *Sports Illustrated* in the United States and *L'Équipe* in France, know their audience is sports enthusiasts and write about the athletes, not the photographers. *Who Shot Sports* places sports photographers front and center and puts them in historical context. The photographs are chosen on pictorial merit, not sports history, and the text addresses cultural, historical, and aesthetic concerns.

Beauty is not the goal of competitive sports, but high-level sports are a prime venue for the expression of human beauty. . . . The human beauty we're talking about here is beauty of a particular type; it might be called kinetic beauty. Its power and appeal are universal. It has nothing to do with sex or cultural norms. What it seems to have to do with, really, is human beings' reconciliation with the fact of having a body. . . . Genius is not replicable. Inspiration, though, is contagious, and multiform— and even just to see, close up, power and aggression made vulnerable to beauty is to feel inspired and (in a fleeting, mortal way) reconciled.

DAVID FOSTER WALLACE, "FEDERER AS RELIGIOUS EXPERIENCE,"
NEW YORK TIMES MAGAZINE, AUGUST 20, 2006

• • •

The ancient Greeks celebrated the earthly but seemingly heavenly powers of athletes and revered their physical beauty. It was upon the finest artists of antiquity to preserve these transcendent qualities. Still photographers have taken up the artist's task to preserve and illuminate the grandeur and thrill of sports; to compose portraits of these heroes; to make pictures that encapsulate, subtly or boldly, the reasons sports are universally loved.

Marta Braun, in her wonderful and meticulously researched biography of Étienne-Jules Marey, *Picturing Time,* noted that Marey twice, once in 1878 and again in 1888, pointed out that "only the ancient Greeks came close to 'seeing' motion correctly and to incorporating that vision into their art. Photography, [Marey] showed, now enables us to return to that original vision." The gauntlet had been passed. From the time of Eadweard Muybridge, Marey, Georges Demeny, and others in the nineteenth century, it would be the photographers who would show the body in motion and depict the drama and beauty of sports. Genius may not be replicable, as David Foster Wallace knew, but seeing it in action is breathtaking and inspiring.

Daniel Okrent, inventor of Rotisserie League Baseball (a form of fantasy baseball) and the baseball stat WHIP, and a distinguished journalist and author, wrote in "The Rules of the Game: An Essay on Photography, Sports, and a Thing Called Magic": "Those who photograph show us what sport *is.* The sports photographer is artist, technician, and chronicler, but he's also something more. He (and it's still almost always a he) is the magician whose single image can contain a three-act drama."

The ancient Greeks understood the human need for spectacle. Theater and sports both satisfy.

Roland Barthes, in his book *What Is Sport?,* illuminates sports as spectacle. He also discusses beauty, specifically the beauty inherent in athletic form, from the perspective of *style.* "What is style?" the semiologist asks. "Style makes a difficult action into a graceful gesture, introduces a rhythm. . . . Style is to be courageous without disorder. . . . Courage, knowledge, beauty." The reader will be in awe of the beauty, courage, and style manifest in these photographs of athletes, famous and unknown.

The story of sports photography is also the story of innovation in photographic technology. In the early days, cameras were too slow to stop motion, and athletes assumed poses suggesting their vocation. Gradually, photographers on their own and with the help of others tinkered with shutters, plates, films, and lenses in order to stop and get closer to the action, and make sharper, more detailed images. Sports, which is inherently movement, has always acted as an impetus to move camera technology forward. Improvements in the form of flashbulbs and strobes; underwater and waterproof cameras; remote controls; longer lenses and telephotos; autofocus; motor drives; analog to digital; drones; and software for cameras and computers for editing and faster transmission gradually appeared. Getting photographs quickly published is the name of the sports photographer's game. The Associated Press has said its wire service started, in large part, because people wanted sports photographs in the newspapers immediately after the game. Those photographers who knew how to develop their glass plates

and later film in closets, bathrooms, and the backs of cars; who had pigeons, bicycles, motorcycles, automobiles, or airplanes at hand for racing pictures to press; who had portable transmitters that could be hooked up to telephone lines in order to wire photos to their editors, and now, the most high-tech digital equipment won the race.

The best sports photographers do much more than capture the winning goal, the mind-boggling basketball dunk, the terrifying tackle, the finish of the race by a two-legged human, four-legged horse, or four-wheel vehicle—although their publications demand they do so. They are on the front lines of human drama, witnessing and preserving bodies in motion, the refined gesture, the thrill of victory and the despair in defeat. Okrent calls it "magic." Others may say that the best sports photographs capture the spirit of the game and the nobility in athletic pursuits. These pictures resonate, linger in the mind's eye, and are retrieved from our memory banks when we recall moments of greatness, tension, disappointment, celebration.

Still photography and memory have a symbiotic relationship. Roland Barthes, again, with great understanding of the medium, writes, "Photography exists not to represent but to remind." Vicki Goldberg, art and photo historian and former photography critic for *The New York Times,* wrote an essay titled "Photographs and Memory" for *American Photo.* "Whatever communal memory exists is largely a shared visual memory, one of the few binding elements in a heterogeneous world," she observed. "Someday brain researchers may discover why people embrace certain images willingly, eagerly, and stay married to them for years."

When people remember moments in sports, it is often a still photograph that comes to mind. For Americans (for our memories are cultural), some examples are:

- the Miracle on Ice photograph that ran without a caption on the cover of *Sports Illustrated* after the United States defeated Russia in ice hockey at the Lake Placid Olympics in 1980
- two African Americans on the podium giving the Black Power salute at the Mexico City Olympics in 1968
- Green Bay Packers players lifting coach Vince Lombardi on their shoulders after winning Super Bowl II, January 14, 1968

- Jackie Robinson stealing home in the 1955 World Series
- Ty Cobb stealing third base on July 23, 1910, in a game against the New York Highlanders
- Dwight Clark of the 49ers catching a game-winning pass from Joe Montana in the 1982 NFC Championship game
- Brandi Chastain of the U.S. women's soccer team on her knees holding her jersey in celebration of winning the 1999 World Cup
- Kerri Strug of the U.S. gymnastics team landing her vault in the 1996 Olympics despite a badly sprained ankle
- Yogi Berra of the Yankees jumping into the arms of Don Larsen after Larsen's perfect game in the 1956 World Series
- Willie Mays's over-the-shoulder catch in the 1954 World Series
- Jack Nicklaus following his putt into the hole on his way to victory in the 1986 Masters
- Lou Gehrig's farewell at Yankee Stadium on July 4, 1939
- Chuck Bednarik of the Philadelphia Eagles standing over Frank Gifford of the New York Giants with arm raised after knocking out Gifford with a big hit in 1960
- Secretariat running away from the field in the Belmont Stakes as he won the Triple Crown, June 9, 1973
- Y. A. Tittle, bloodied, on his knees in 1964

The missing link in this lineup is the photographer. Each picture was taken by someone. If the photograph is well known, the photographer should be, too. Two exceptions are the photograph of Babe Ruth saying goodbye at Yankee Stadium by Nat Fein, who won a Pulitzer Prize for the emotive image of the Babe (page 75), and Neil Leifer's triumphal photograph of Muhammad Ali (then known as Cassius Clay), arms raised, standing victorious over Sonny Liston (page 173). Even sports photographers themselves, who stand on the shoulders of their predecessors, often do not pay due respect to those who have innovated, experimented, and led the way. The multifaceted photographer David Burnett, in a 2008 interview with his colleague at Contact Press Images, Kenneth Jarecke, said, "It bothers me with all of the talent that's floating around . . . that they [sports photographers] are oblivious to the people that went before them in this profession." *Who Shot Sports* addresses Burnett's concern.

These men and women see and capture more than what

ostensibly transpires during the hours of the game, the meet, the race, the event. Their photographs are *larger* than any momentary action. "Every moral value can be invested in the sport: endurance, self-possession, temerity, courage," Roland Barthes observes. Photographic curators and historians have been locked in traditional hierarchies when determining which subjects are worthy of inclusion in the photographic canon. Sports photography has been left out. But look at the pictures; consider the moral lessons; appreciate their structure; see their beauty. The time has come for their reevaluation and acceptance into the history of photography.

Robert Riger wrote in his book *The Sports Photography of Robert Riger*:

> When I take a photograph during a football game I am making an illustration, a representation of that game and of all football too. As in any art, the photograph must transcend the actual fact. The universality of the picture, its intimate yet heroic scope, will give it clarity and strength. Art needs conviction. You have to believe that a young baseball player sliding into third base on a steal and losing his cap is the subject of art, that art is fixing an image in a ballpark in Brooklyn where a few thousand people are watching on a Wednesday afternoon.

Art, like sports, depends on belief. In art, one has to believe that a picture is richer, more nuanced than it might initially seem. In sports, one has to keep believing in one's team, win or lose.

Social scientists conclude sports/games are basic to human life. They engage, whether we are spectators or players. Still photographs, too, engage, allowing for contemplation and transformation, from seeing to understanding. They require more effort than watching television. Looking at a still photograph demands imagination. We bring ourselves into another world. Viewing pictures is active, not passive. When people read newspapers daily, they often turned first to the sports pages. If they had seen the game, they wanted to relive it; if they hadn't seen or heard it on television or radio, they wanted a photograph to trigger their imagination. Many people will maintain that the best photographs in the newspaper were the sports pictures. But they had a short shelf life. Sports photographs, appearing in weekly magazines or newspapers, were published to delight, inform, and discard. Favorites might be cut out and taped on the wall, but most were destined for the garbage or recycling bin. Today, in a digital universe, photographs are even more fleeting. See it now, gone in the blink of an eye.

In 1924, the great art photographer Alfred Stieglitz, in a letter to Sherwood Anderson, wondered, "Would a crowd of Americans ever stand before a picture of real value with a fraction of the enthusiasm spent on baseball." *Who Shot Sports: A Photographic History, 1843 to the Present* believes they will.

WHO SHOT SPORTS

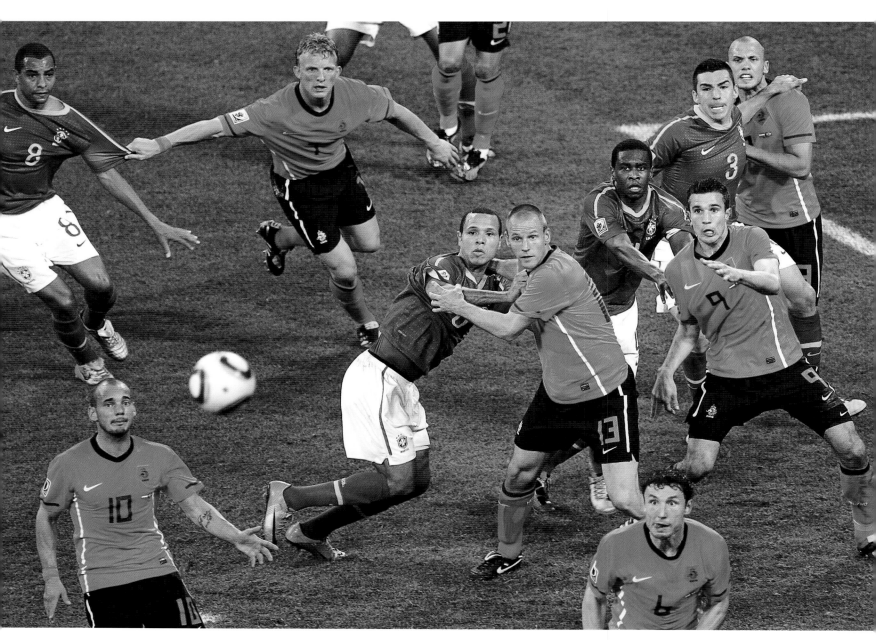

Mark Leech, Players from both sides hold each other as the ball is delivered from a Brazilian free kick, Netherlands vs. Brazil, World Cup, Port Elizabeth, South Africa, July 2, 2010.

CHAPTER ONE
THE DECISIVE MOMENT

Henri Cartier-Bresson coined the phrase *the decisive moment* to describe the instant when the action before the lens is not simply captured by the photographer, but organized in such a way as to give it power and grace, balance and form. *The decisive moment* is one of the core concepts in the history of photography.

The photographer's decisive moments are not the same as those of the athletes or the fans watching the game.

Photographing the winning touchdown, the diver's perfect entry into the water, the power of a skier racing in the giant slalom, can make for an image that will go down in sports history, but are not necessarily *decisive moments* in the photographic sense. In addition to satisfying their editors and the public, who often want to see only the highlights of the game, the finest sports photographers are seeking to make *pictures* that are greater than a single defining action, pictures with aesthetic qualities that last through time.

Leslie Jones, New York Yankees vs. Boston Red Sox, Fenway Park, Boston, 1937

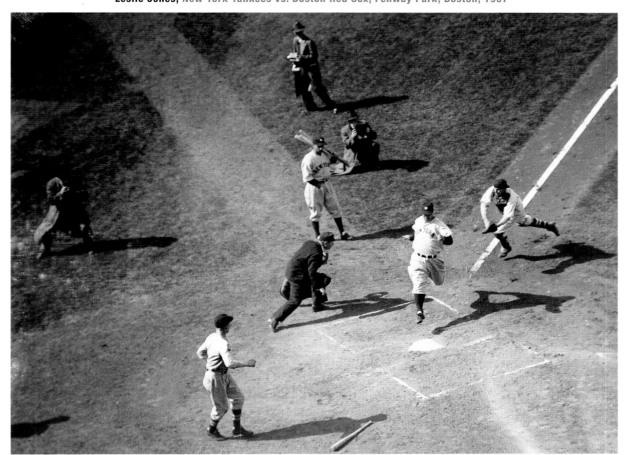

• • •

LESLIE JONES (1886–1967) was a staff photographer for the *Boston Herald-Traveler* from 1917 to 1956. He covered all types of events, and his archive at the Boston Public Library of approximately forty thousand glass plates is especially rich in sports history.

• • •

"That was all there was to do on a Saturday," **MARK LEECH** told me. "Kick a ball around or go to a football game. I played on Saturday mornings and got the money together to go to a match on Saturday afternoon, then played again on Sunday morning. If I washed a few cars, it was off to Arsenal or Tottenham. If I didn't have much money, I would go to a local amateur match."

Leech tried to get his O levels (a midlevel high school degree) but passed only two of the seven exams. Too proud to go to summer school, he found that his job prospects were slim, but at the employment agency they actually had a job that appealed: "Trainee Sports Photographer."

He got the job based on his knowledge of sports, not of photography. Those Saturdays of doing nothing other than watching sports on television and kicking a ball paid off.

The job description wasn't quite correct. Leech spent all his time with his hands in chemicals or cold water. But he

Damian Strohmeyer, Tyler Graham of Oregon State safe at home ahead of tag by North Carolina catcher
Benji Johnson, College World Series, Rosenblatt Stadium, Omaha, Nebraska, 2006

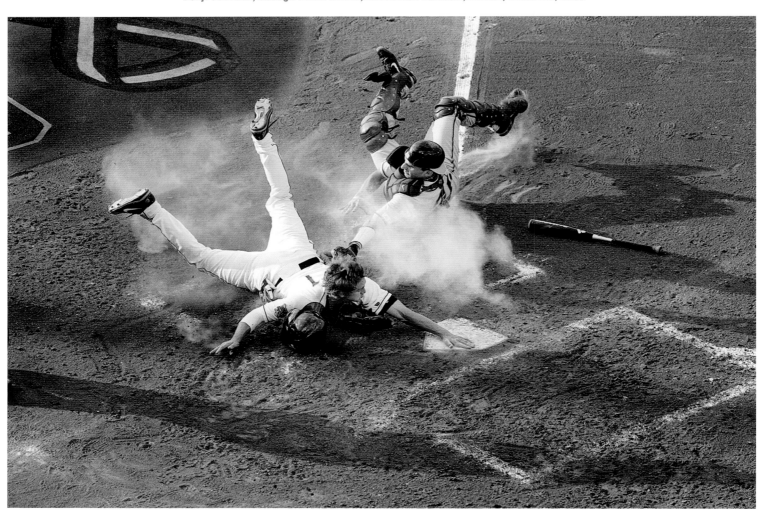

could ask the photographers questions. That Christmas, he was given a Russian-made Zenith B with a 50mm lens. It cost his family £40, a lot of money, but it marked the beginning of Leech's career. He started by photographing his own soccer games and the results were good enough to be published. He soon became a "sports photographer."

Mark Leech is much more than an excellent cameraman. He is an archivist and historian and the founder of his own independent agency, Offside Sports. Because he knows what is good and what is important in sports photography, he purchased and now champions the photography of the greatest British sports photographer of the past, Gerry Cranham.

The "couple" in the center of the photo on page 2 is doing an illegal dance. At free kicks and corner kicks in this tournament, both teams held on to their opponents to restrict their attacking runs. For the most part, the referees ignored it. Leech was sitting in the elevated press tribune with his 500mm lens, the best place to register the choreography—as well as the looks on the players' faces. Leech admits it was "luck" that all of them were looking in his direction as the ball arrived in the Dutch penalty area. Each face is a study in focus and every muscle is taut in anticipation.

• • •

It is a beautiful time of day at the old Rosenblatt Stadium in Omaha. "The light could be to die for in the early evening," says **DAMIAN STROHMEYER**. And, he adds, "The old stadium afforded a unique vantage point."

In his classic *The Photographer's Eye,* John Szarkowski divides the book into five chapters: The Thing Itself, The Detail, The Frame, Time, and Vantage Point. Szarkowski, the legendary director of photography at the Museum of Modern Art, would have found many of the key elements he valued in photography in Strohmeyer's photograph.

"The frame" is perfect, the third base line leading the eye to the excitement surrounding the dust storm at home. The "vantage point" is high enough to show the gradations of color, textures, and markings on the field, but close enough for the viewer to feel part of the action. Strohmeyer made a picture with all the elements in balance. The shapes of the bodies are part of "the thing itself," the "detail" is the hand on home plate, and "time" is what the photograph is all about.

• • •

Michaela Pfundner, head of the Department of Photographs at the National Library, Vienna, knew **LOTHAR RÜBELT** (1901–1990). So did her professor, the social historian Gerhard Jagschitz, and together they have provided biographical information and penetrating insight into one of the most prolific European sports photographers from the 1920s and 1930s.

Pfundner is in charge of the Rübelt archive, on loan from his son, born in 1938, who never lived with his father. The life story of Lothar Rübelt and his activities before, during, and after World War II was carefully edited by the photographer himself. Pfundner's scholarship shows the contradictions in this story and also highlights Rübelt's significant contributions in moving sports photography from the static to the dynamic.

Rübelt, born in Vienna, was proud to claim Austrian citizenship, frequently mentioning that he was the only official Austrian photographer at the 1936 Berlin Olympics. Technically, he was German. During the Austro-Hungarian Empire, nationality was passed through the mother, not place of birth. Rübelt's German mother, with whom he lived his entire life, never married and raised her two sons, Lothar and Ekkehard, on her own. All three were passionate about photography and worked together to turn their passion into a successful family business.

Even as students, Lothar and Ekkehard recognized they could, because of their own athleticism, take very different types of sports photographs than those that were currently being done and started selling their pictures to publications. They had their mother develop the plates and film and make prints, as well as do the bookkeeping. In 1924, each brother purchased a motorcycle, earning them the title of Austria's "first motorized photojournalists." They consistently beat the competition in getting their photographs to publications. They were using faster and lighter cameras, too. In the mid-1920s they used the Ermanox, which had smaller glass plates than previous cameras and faster exposure times.

Their interest extended to cinema and they made an original and delightful, if somewhat blurry, film of their 1926 trip by motorcycle in the Dolomites titled *By Motorcycle Through the Clouds.* Tragically, during the editing of the film, Ekkehard, still in his twenties, was killed in a motorcycle

accident. When Michaela Pfundner entered Rübelt's home sixty years later, the shrine to his brother was still in the corner of the apartment the three Rübelts had shared.

No camera suited Rübelt, the skier, the runner, the mountain climber, better than the Leica, which he purchased in 1929.

My camera dealer eloquently and enthusiastically sold me a funny little thing, that produced negatives the size of a postage stamp . . . and with this Leica I was able to take photographs like I would never have done before. . . .

All of a sudden, I had endless amounts of negative reserves, did not need to be greedy with the glass plate negatives and could develop a completely new mentality of Photography. . . . It did not take long before the image quality had so much improved that I could completely switch to 35 mm.

Rübelt was never interested in posing athletes or taking pictures of the winners receiving their medals. For him, as for his contemporaries—the Swiss photographer Lothar Jeck; the Hungarian Martin Munkacsi; and the German photographers

Lothar Rübelt, *Der Zieleinlauf* (The Finish): Berman Sachert beats Kaindl von Rapid of Vienna, international meet at the Jewish sports club Hakoah Vienna, 1921.

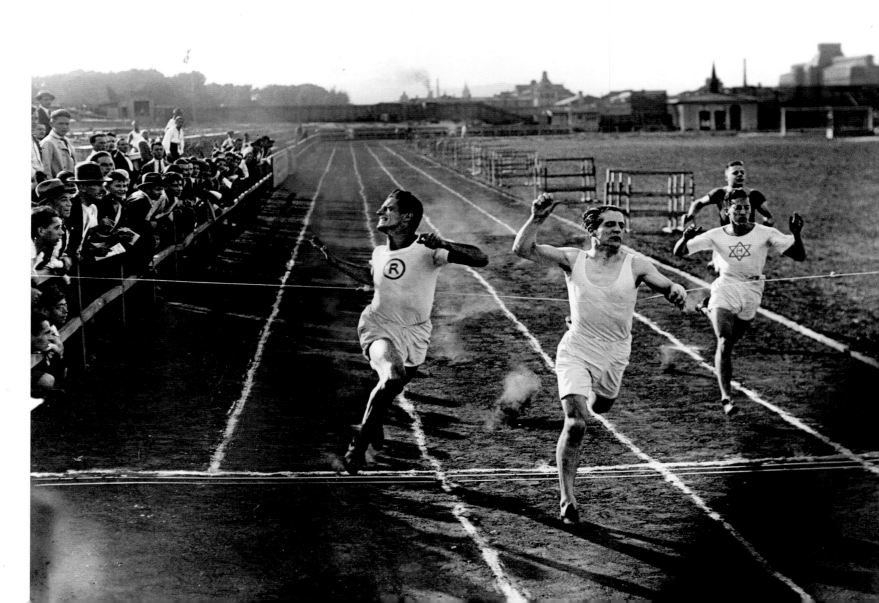

The mentality of the sports photographer, at least the one who deserves the name, is that of a hunter. Who does not feel the tension before the shot while stalking the prey?

LOTHAR RÜBELT, QUOTED IN "TO SNATCH THE MOMENT'S SECRETS" BY MICHAELA PFUNDNER

• • •

Gerhard Riebicke, Max Schirner, and Paul Wolff—the *new vision,* made possible by new camera technology, was catching movement, showing action, conveying the excitement of sports.

As early as December 19, 1934, Rübelt applied for admission to the Third Reich's Committee of Photojournalists and became chairman of the Organization of Austrian Photojournalists. This helped him get work with the premier publication in the German-speaking world, *Berliner Illustrirte Zeitung,* which had a circulation of nearly two million. In 1936, he became an "official photojournalist of the Olympic Summer Games in Berlin," the "high point of my career," he said. The second special Olympics edition of *Berliner Illustrirte* was half filled with his pictures. Rübelt was one of the most prolific photographers at the Berlin Olympics, and the International Olympic Committee has a large collection of his photographs, purchased directly from him.

Rübelt was unscrupulous about moving into positions of authority in photographic unions and companies that were made vacant by Nazi racist regulations. After movie theaters were "Aryanized," Rübelt's application to purchase shares was accompanied by a note stating his commitment to the Reich and that he had "successfully repelled the Jews in my field of work."

Even before Kristallnacht, November 9–10, 1938, which marked the date after which no Jewish athlete could participate in sporting events, Jewish sports photographers Herbert Sonnenfeld, Abraham Pisarek, and Martin Dzubas, who died in a concentration camp, were only permitted to work for the Jewish press under highly restrictive conditions.

The photograph published here shows runners from three Viennese athletic clubs. The runner on the right wears the team shirt of Hakoah, the Austrian Jewish sports club, which had the Star of David as its logo. As this photograph illustrates, one of Rübelt's strengths was capturing not only the body language of the athlete but also his facial expression.

During World War II, Rübelt was assigned to the propaganda division of the German army. After the war, denial about being a Nazi aside, he was no longer in much demand as a photojournalist and switched to advertising. His best pictures during the postwar years are composite photographs showing a complete sports action, such as skiing down a mountain, often composed of eight to twelve individual photographs mounted together. He continued to shoot sports, going to all the Olympics through Tokyo in 1964. And he was an avid athlete till the end of his life.

• • •

The six-day bicycle race that took place at the Vélodrome d'Hiver in Paris, near the Eiffel Tower, was one of the most popular French sporting events. The great French photographer **HENRI CARTIER-BRESSON** captured it all: families with baskets of food, famous actors giving their encouragement, masseuses rubbing the tired legs of cyclists, athletes reading newspapers while going round and round, and competitors taking catnaps off the circuit with their legs perched high on the handlebars of their bikes. Cartier-Bresson showed the spare wheels, rims, and chains neatly stored in the center of the velodrome, lovers in quiet corners, onlookers with their baguettes before going home. The French, as exemplified by the Tour d'France, enjoy lengthy bicycle races. Endurance is valued as much as speed.

And endurance was at the heart of Cartier-Bresson's war experience. He was captured by the Nazis and held as a prisoner of war for thirty-five months. His two early attempts at escape failed and resulted in his solitary confinement. His third escape was successful and he immediately went to work for the French Underground. His film about returning French prisoners and displaced persons *(The Return)* is heart-wrenching and poetic.

When Cartier-Bresson photographed the six-day bicycle

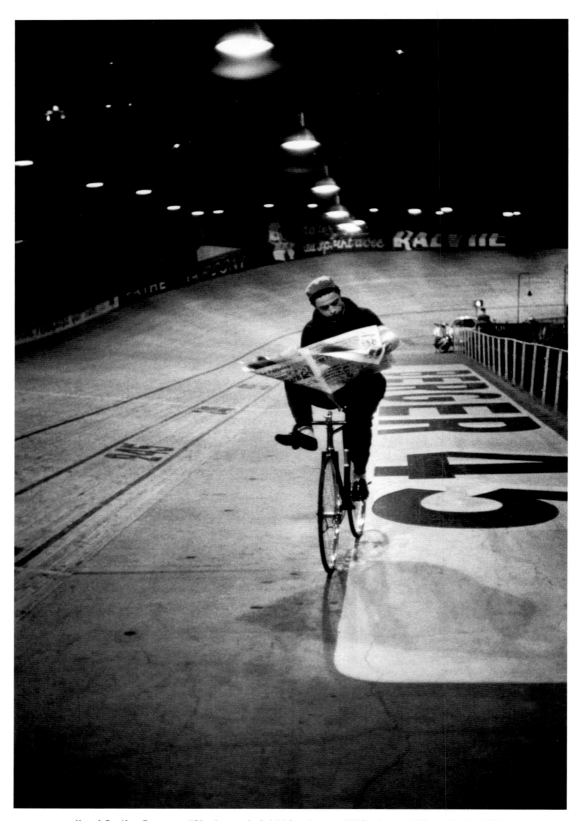

Henri Cartier-Bresson, "Six day and night bicycle race," Vélodrome d'Hiver, Paris, 1957

race at the Vélodrome, he was also photographing ghosts. The greatest mass arrest of Jews ever carried out on French soil, known as the Vél' d'Hiv Round-up, took place there. French officials collaborated with the Nazis in 1942 to bring, over a two-day period, more than thirteen thousand persons, mostly Jewish women and children, to this sports arena. From Vél d'Hiv the victims were deported to death camps in Poland. What Cartier-Bresson felt in this cavernous hall, taking his photographs, is impossible to know. Two years after Cartier-Bresson completed his photo essay, this winter stadium of shame, as well as sports, was demolished.

. . .

AL BELLO, chief sports photographer for Getty Images North America, is warm and modest and begins the interview with "My parents raised me right. To say please and thank you. Two sisters. Being raised right has a lot to do with doing things right." His stellar career as a sports photographer and the friends and associates he has made over the years attest to his "doing things right."

Al Bello went to South Shore High School in Canarsie, Brooklyn, a very large high school (at its peak, there were 6,800 hormone-charged teenagers in attendance). Even though Bello is not very big, he played football in high school and at Stony Brook University and was captain of both teams. His success, in part, as one of the world's leading sports photographers is because he knows how to train. "Sports photography," Bello comments, "is very physical. Like being an athlete."

Bello took only one photography class at Stony Brook, but it was enough to "catch the camera bug." He joined the school newspaper and started doing freelance work for the local newspaper, *Three Village Herald.* Except for that one photo class, he has done all his training on the job—but he has trained with many of the best photographers and editors in the field.

Bello recalls, quite tenderly, showing his father his portfolio after he graduated and his father saying it was good, "but what are you going to do now?" What Bello did was call around. He found a job at *Ring* magazine in the darkroom. He printed by day, and at night and on weekends he photographed boxing and wrestling matches. By shooting, printing, and being a voracious reader of photography books

and articles, he started to learn his profession. But he wanted more varied experiences than *Ring* could provide.

The most important sports photo agency in the world was Allsport, started by Tony Duffy in London in 1968, and by 1990, when Bello visited Allsport's office in Los Angeles, they also had a thriving business in the United States. He showed his portfolio to Steve Powell, who had joined the agency in 1971 and as general manager helped transform it into the leader in the field. Powell did not offer Bello a job. Bello went back two more times and finally said, "I can't leave here without a job. I want to work for you." When Powell asked Bello "What else can you do?" Bello said, "Roofer, busboy, etc." and that convinced Powell that Bello knew how to work hard. He reminded Bello that other job-seeking photographers had better portfolios.

Allsport produced phenomenal photographers through the apprenticeship system. Bello was pushed hard, and made to do the daily chores of captioning film and transparencies, taking orders, and filing transparencies (an opportunity to look carefully at the ones marked as the best), but he was also allowed to go out, shoot, and make mistakes. Tony Duffy encouraged Bello, gave him assignments and room for error. Bello assisted the much more experienced Mike Powell, Steve's younger brother.

Bello was at Allsport in Los Angeles from 1993 to 1996 and then, missing home and engaged to be married, came back to New York to work out of Allsport's New York office with the deeply caring and beloved photo editor Darrell Ingham from 1996 to 1998, the year Getty bought Allsport.

No one in Bello's family was an artist, but from the very beginning of his career he had ideas about how a photograph should look. He speaks about a minimal palette, and enthuses about the "gracefulness of sports." He tries to have "an idea in my head" and figure out how to get it to work. Knowing the underwater photographs he wanted to make at the London Olympics in 2012, he planned and prepared for four years.

Bello remembers that when he started out, he spent most of his money on equipment and no one gave him contacts. "I busted down doors. I just did it. I did it with a smile and a please and a thank you and I did it politely"—just as his parents taught him.

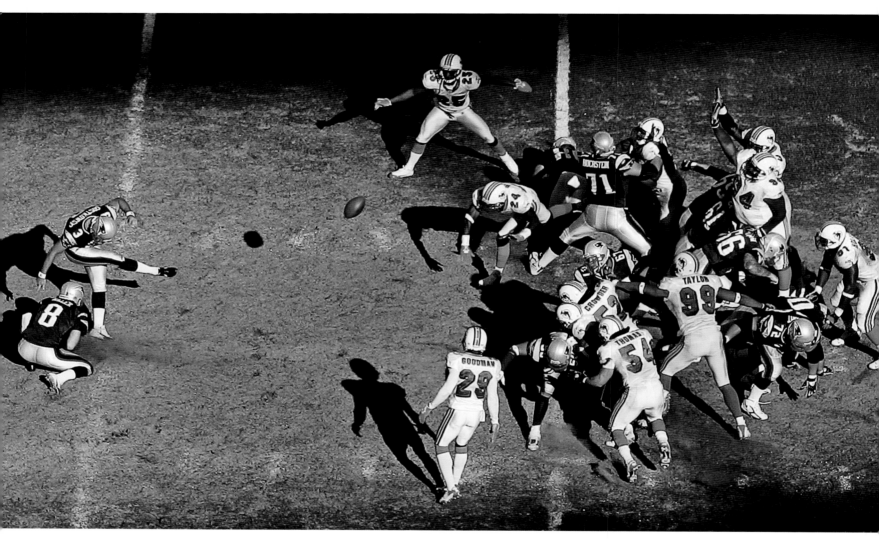

Al Bello, Stephen Gostkowski of the New England Patriots kicks a field goal against the Miami Dolphins during their game at Gillette Stadium in Foxboro, Massachusetts, October 8, 2006.

• • •

On the page opposite is a pas de deux by Córdoba and Valdez in front of thousands of soccer fans who wouldn't be caught dead going to the ballet and watching men in tights and dance slippers. But men in shorts and cleats—well, that is different. Yes, different in purpose but not in grace. The *beautiful* game got its sobriquet because it is beautiful to behold.

In an interview with the Italian photographer **LUCA BRUNO** conducted by art photographer and professor Alessandra Capodacqua, Bruno said, when shooting a game, "I feel I am on the edge of a stage with the actors in front of me. I choose where to position myself. . . . I know the rules and I have all these regulations in my head, but what I really need to do is capture an image of what I have experienced without a caption—*it is a trace.*" (And Bruno is not schooled in postmodernist theory.)

Luca Bruno was born in Milan in 1964, started studying visual communications in school, and by the age of twenty was working as a photographer. A passionate Italian (what else is there?), he "loves desperately photography and music—they are both universal languages." At twenty-five, he was an intern at the Associated Press, shooting sports and "developing photographs in 'emergency darkrooms' set up in hotel bathrooms." And, like his colleagues, he proclaims how

much easier life is in the digital age when he doesn't have to carry with him all the equipment and chemicals to process photographs in the shortest time possible. And, again like his colleagues, he believes his years printing in darkrooms gave him an intimate understanding of light—photography's most important tool.

· · ·

This is an emotional photograph on page 12 for many reasons (the central figure is a convicted murderer), but also a technically superb one. **HEINZ KLUETMEIER** knew he had to come in tight on the action on the field, "Shot loose," he wrote, "it would have been nothing but a field of darkness with just a glimpse of a focused 'sun strobe.'" The stadium was cloaked in shadow, so Kluetmeier walked to the other

side, where there were no photographers, hoping to capture a narrow tunnel of light.

He saw the helmet come off a "tattooed, well-muscled superhero." The problem with superheroes is that they generally lead double lives. The violence in Aaron Hernandez's public life is played out for all to see on the football field. The violence in his private life is played out of view.

Kluetmeier's photograph recalls Picasso's many paintings and sketches of the Minotaur, a male body with the head of a bull. Rarely does Picasso have the Minotaur erect. He is often bent over, back arched, ready to charge with his fearsome head and muscular body. In classical mythology, the Minotaur fed on human flesh; today, it refers to any person or thing that devours or destroys.

Luca Bruno, Inter Milan's Iván Ramiro Córdoba challenges Werder Bremen's Nelson Haedo Valdez, September 14, 2004.

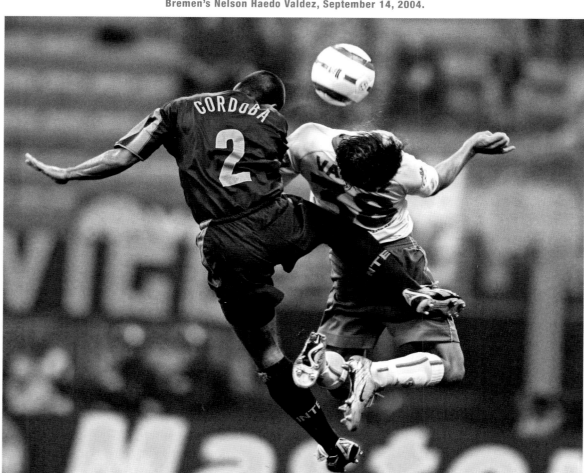

I think that technique and technical stuff is absolutely irrelevant to the picture in terms of what you do as a photographer. I think the most important thing is to have a vision, to have an emotional feeling, to care about what you're photographing, and to have something that's already there in your heart, in your eye.

HEINZ KLUETMEIER, QUOTED IN THE LUCIE AWARD FOR ACHIEVEMENT IN SPORTS PHOTOGRAPHY, 2007

• • •

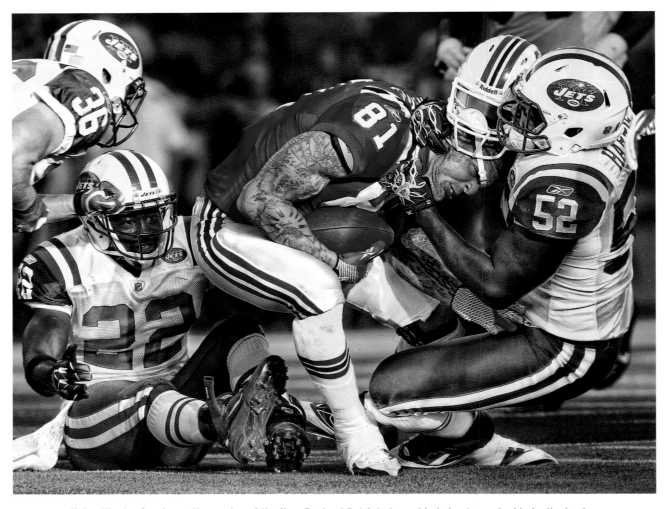

Heinz Kluetmeier, Aaron Hernandez of the New England Patriots loses his helmet on a tackle by linebacker David Harris of the New York Jets, Gillette Stadium, Foxboro, Massachusetts, October 9, 2011.

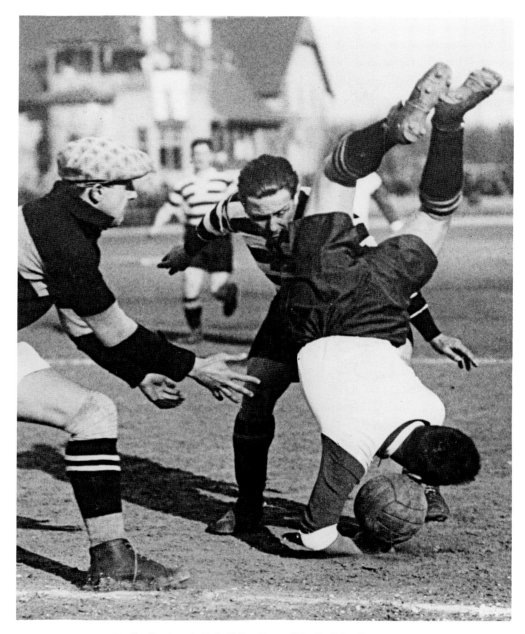

Martin Munkacsi, *Fuβall-Zweikampf* (Football Duel), ca. 1928

• • •

He [Martin Munkacsi] would never simply throw a piece of paper in a
wastebasket. He would toss it first in the air, butt it with his head, bounce
it off his elbow, and kick it backward with his foot into the basket.

MARTIN MUNKACSI loved physical challenges. He played soccer until almost the end of his life. He died in 1963, age sixty-seven, watching a soccer game. Known as a fashion photographer, he began his career as a sports photographer.

Restless, he left his small Hungarian village at sixteen for the capital, Budapest. At eighteen he was contributing articles and poetry to the sports paper *Az Est.* After teaching himself photography and making his own camera, he started taking sports photographs regularly for *Az Est.* He often cropped pictures to make them more dramatic, isolating the goalie in mid-catch or the motorcyclist speeding and blurred. He photographed wrestling, swimming, car racing, soccer, and spectators. His work benefited from the introduction of smaller, faster cameras, especially the Leica.

In 1928 Munkacsi moved from his native Hungary to the "capital of exiles," as Nabokov described Berlin in the 1920s. It was also a city with 120 newspapers that needed photographs. He had signed a three-year contract in 1927 with the publishing house Ullstein Verlag. His first story appeared in 1928 in *Berliner Illustrirte Zeitung,* circulation two million, and he got the cover one year later. The publication sent him all over the world, and his work appeared regularly. One of his most famous photographs, taken in Liberia around 1930, of three boys running into the surf, was, said Henri Cartier-Bresson, "the spark that set fire to the fireworks and made me suddenly realize that photography could reach eternity through the moment. It is only that one photograph which influenced me. There is in that image such intensity, spontaneity, such a joy of life."

With the rise of the Nazis, Munkacsi, born Mermelstein or Marmorstein, emigrated to New York in 1938. Carmel Snow, editor of *Harper's Bazaar,* gave him a contract and he was blessed to have Alexey Brodovitch, art director, lay out his pictures as double-page spreads. More staid publications were shocked by running, jumping women in beautiful clothes, but *Harper's Bazaar* allowed him to stay true to his love of spontaneous movement seen from every imaginable angle, an approach he had mastered as a sports photographer.

Martin Munkacsi's fashion photographs, Cecil Beaton told me, changed everything in the field. He said, before Munkacsi, fashion photographers had to make certain a model's feet were always together, not even spread apart a little. The heel of one foot should be touching the instep of the other. Munkacsi's models were leaping ladies, legs' splayed in gay abandonment. Munkacsi literally gave women a great leap forward—and license to be physical beings.

• • •

Color! Excitement! Opposite is one of the earliest color strobe pictures ever taken. **DR. HAROLD EDGERTON** could not have chosen a more seductive palette.

The ball only *looks* stationary. It is caught in the instant before it starts moving through space, expanding and contracting on its trajectory. The player is clenching his fist in concentration. He can't see the ball; the studio is in total darkness. But Doc was famously patient and would take many photographs of the same situation. The laws of physics do not change, but Doc could have fun with his stroboscopic flashes (his own invention) and his composition, color, and cropping.

• • •

"Keep your eye on the ball" could be the caption for the stunning photograph of Serena Williams (page 16). As she keeps her eye on the ball, every muscle of her body is straining to get her racket to connect to it. Being Serena Williams, she will. But that is still a split second in the future. For now, we have Williams in flight. And **BOB MARTIN** shows us something television cameras cannot capture: the frozen beauty of the fully extended body, framed and timed with perfection.

Tennis photography is difficult. The photographer doesn't see the tennis ball as much as sense it. He needs 1,000th of a second or less exposure to stop it. In all sports, not just tennis, Martin considers first the background and then positions himself, as he told me, "where the background is best. I don't necessarily choose where the action might be best."

Martin left school at sixteen, assisted a wedding and industrial photographer (he already knew his "destiny" was photography and had a darkroom in his house), then did two years at Twickenham Technical College, where he learned how to use a large view camera, light still lifes, even the history of photography. His father, a trained chemist who worked for the BBC, looked down on photography and encouraged his son to go back to school and do A levels so he could go to university. Martin got his A level in art by "messing around

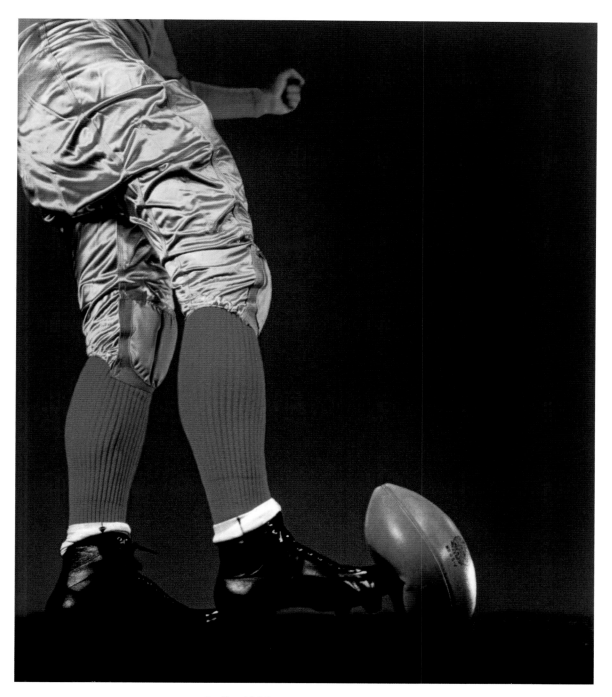

Dr. Harold Edgerton, *Football Kick,* 1938

with color," and A levels in mathematics and English. But he decided to go to art college instead.

Martin had been working as a technical photographer at Imperial College when "one day," he said, "I saw an ad in the *British Journal of Photography* for a job at Allsport." He knew he wanted to be a photojournalist but not a newspaperman because he loved color. The route for being a color photographer went through the picture agencies. He got the job at Allsport.

Martin's technical skills in the darkroom and shooting were extraordinary, almost from the beginning. "I loved the gadgetry, I loved the technical voodoo, my hobby was connected to the allure of complicated cameras." A lot of sports photographers have to be technically adept because sports photography is difficult, but most are not as enamored with the equipment as is Martin.

Martin says "he came into his own" after Allsport. When he went to work for *Sports Illustrated* in the United Kingdom, he was encouraged to spend two or three days to get one photograph. "I tried to make my pictures evolve," he told me, "stand out from the mill. Better technically, better aesthetically. A picture has to stand the test of time."

Bob Martin is acknowledged as one of the best sports photographers in the world. He is the official photographer for Wimbledon. For him, the Olympics are the pinnacle of sporting events. Every four years he tries to peak at the games. In 2012 he tried not to collapse at the London games. He was the English nanny—the man in charge—for more than 1,450 press photographers at the London Olympics. Not only were 1,507 photo press credentials given out (not all used), but Martin and his team had to determine where the photographers sat, what photo positions they had,

Bob Martin, Serena Williams, French Open, Paris, France, May 28, 2004

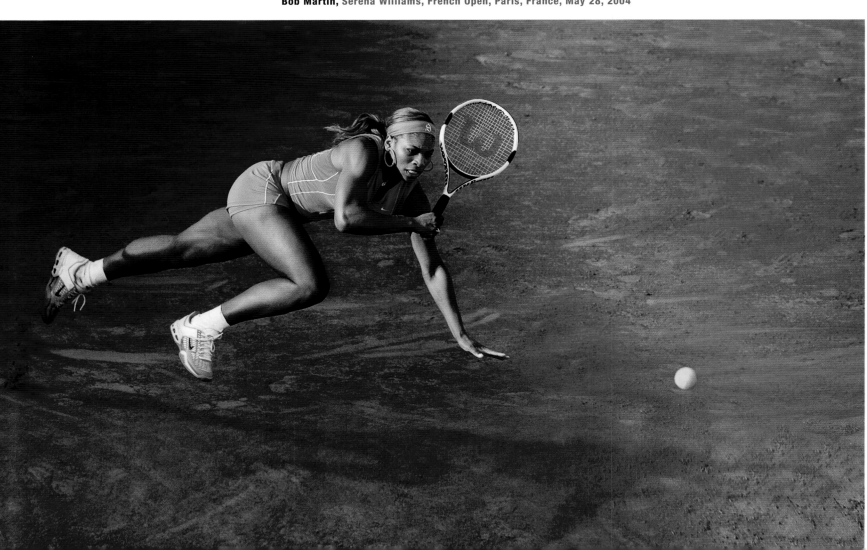

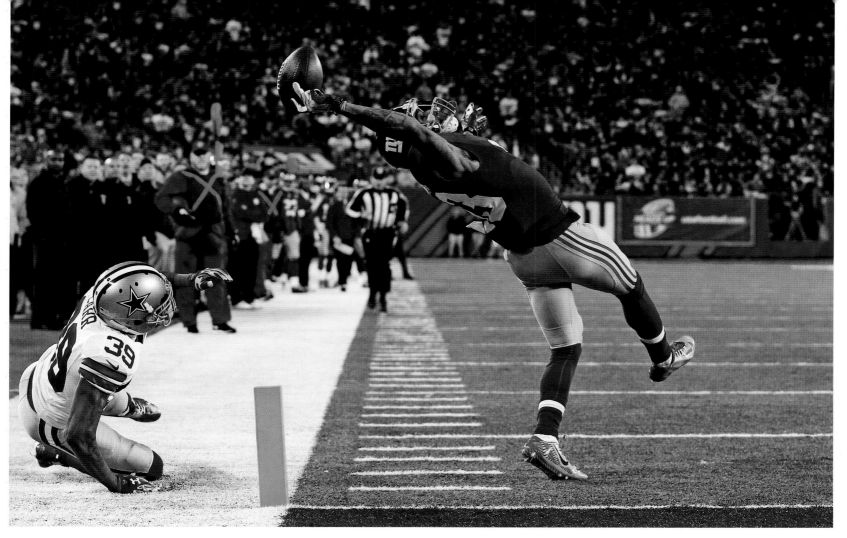

Al Bello, "The Catch," Odell Beckham Jr. of the Giants suspends disbelief with the "Greatest Catch Ever," against the Cowboys, East Rutherford, New Jersey, November 23, 2014.

their facilities, and what they were allowed to do at each of the venues. He was glad to get back to just taking the best photographs he could.

Depending on one's level of engagement with the game of football, this catch is either "impossible" or just "wow." It doesn't take knowledge of the game to see "toes to fingertips at absolute full extension," says my son-in-law Stephen Taylor. He, like the millions of others who delight in watching games played well (but particularly by their favorite team), live not only for the final outcome but also for the surprises, the aesthetics, the skill displayed.

Plenty of people were surprised by "The Catch" but no one who knows sports photography was surprised that

AL BELLO got the best shot. This image now joins another famous "catch," that of the 49ers' Dwight Clark catching a game-winning pass from Joe Montana in the 1982 National Football Conference Championship. Walter Iooss Jr. took that one. Sports photography has its share of iconic photographs: Willie Mays's over-the-shoulder catch in the 1954 World Series by Frank Hurley; Y. A. Tittle on his knees in 1964 by Morris Berman; and Chuck Bednarik of the Philadelphia Eagles standing with arms raised over a knocked-out Frank Gifford in 1960 by John Zimmerman. These still images form a collective memory. No matter how often one sees a replay, it is the still image that remains locked in the brain.

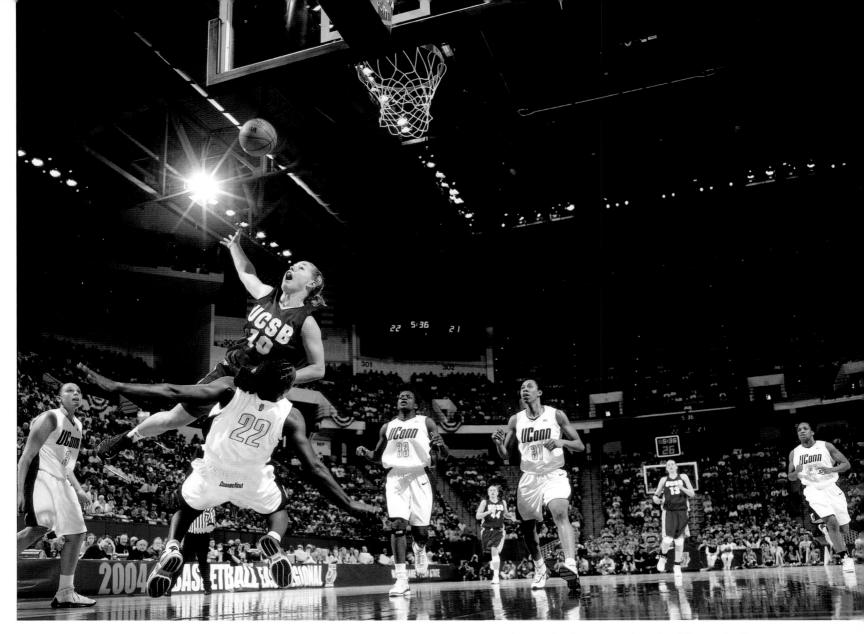

Bill Frakes, University of California Santa Barbara's April McDivitt (10) in action, getting fouled by University of Connecticut's Ashley Battle (22), Women's National Collegiate Athletic Association finals, Eastern Region, Hartford, Connecticut, 2004

• • •

BILL FRAKES has a business administration degree from Arizona State University, a law degree from the University of Mississippi, and a journalism degree from the University of Kansas. This fifth-generation Nebraskan credits his mother with developing his eye and artistic talent and revered photographer Heinz Kluetmeier for encouraging him to become a photojournalist. He never intended to devote

so much time to shooting sports, but for as long as he can remember he devoured *Sports Illustrated*, where Kluetmeier is a superstar.

At Arizona State, Frakes took three photography classes with photographer Cornelius M. Keyes, who was later at the *Los Angeles Times*. The college assignments were rigorous: shoot ten pictures a week plus make the prints in the darkroom and write the captions. Keyes taught his students

to never submit a photograph "you aren't proud of" and introduced them to professionals in the field. Frakes caught the photojournalism bug.

Frakes did an internship with Rich Clarkson, one of his professors at the University of Kansas, at *The Topeka Capital-Journal* during one semester. Clarkson trained scores of photographers in photojournalism and may be the single most influential person in the United States in the teaching of men and women to be sports photographers. Frakes, early on in his career, won the Newspaper Photographer of the Year award and a Pulitzer. He credits Joe Elbert as being the most influential editor of his career.

Sports photographers spend a lot of time hanging out together, even rooming together. They are a competitive lot on the field but have a great sense of camaraderie off

it. Sometimes. Personalities clash and the world of sports photography is full of characters.

Frakes, six foot four, towers above the rest of the photographers huddling on the sidelines and finish lines of ball games, horse races, and track and field events. A single 800mm lens for one camera weighs between 16 and 20 pounds. Just the lens! Frakes carries a lot of equipment. Not only does he stand out in height, but he is one of the few photographers still focusing his lenses and not relying on autofocus.

The past thirty years in sports photography have seen the most remarkable changes in the speed of transmission. Frakes recalls that at his first Olympics, in Los Angeles in 1984, it would be eight days before one of his photographs was published; now people see them on the Web in seven seconds.

Paul Mohan, Greece vs. Ireland in the UEFA men's under-seventeen football championship, Lissywollen Stadium, Athlone, Ireland, March 15, 2008

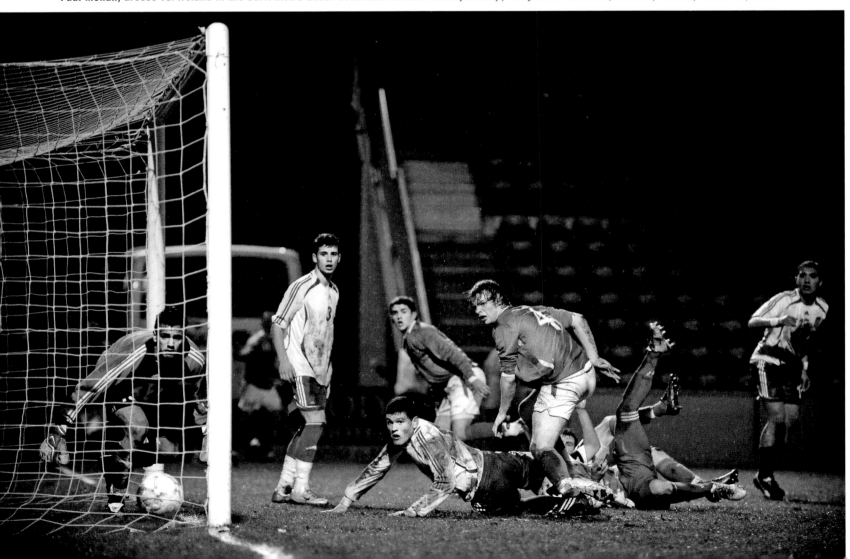

In 2014, Frakes worked 329 days, 58 for *Sports Illustrated,* where he was a staff photographer. In the beginning of 2015, the entire roster of *SI* photographers was laid off. "I'll miss the excitement of picking up the phone and hearing from an editor in New York what challenge they will have for me," Frakes wrote in an email. "The pride in being one of a very exclusive group—*Sports Illustrated* staff photographers. The best thing about working for *SI,* though, was that I was always encouraged to grow, to move beyond the confines of the field of play, to interpret things my way, and to bring back something different. It was a great place to grow up."

<center>• • •</center>

Thank goodness for the dependable Irish weather that turns turf into mud. Sports become much more picturesque when players are covered in muck.

Here is Blackrock College scrum half Conor Crowley releasing the ball after a ruck. It is hard for the non–Rugby Union playing world to understand the rules to begin with, but a "ruck" in the muck just adds a giggle for the noninitiated, like a sticky wicket in cricket. Here are some of the things to know:

- **If you were not in the ruck at the beginning, you have to enter through the "gate" (no diving).**
- **You can crouch or bend, but your shoulders must be equal to or higher than your hips.**
- **Pushing, shoving, battering are allowed, but don't trample anyone.**

Irish sports photographer **RAY MCMANUS** takes pictures for "the love and the mud" and keeps his camera mostly focused on his beloved Gaelic football and hurling. The founder in 1980 of Sportsfile photography agency, McManus generally assigns rugby to one of his ten younger staff photographers. This award-winning photograph was from the only rugby game McManus photographed in 2011.

McManus never played sport, but "Gaelic sports are in my blood," as is the competitive spirit. "When I am at a match, I am dedicated to the match. The athletes are trying to win

Ray McManus, Scrum half, Anglesey Road,
Dublin, February 5, 2011

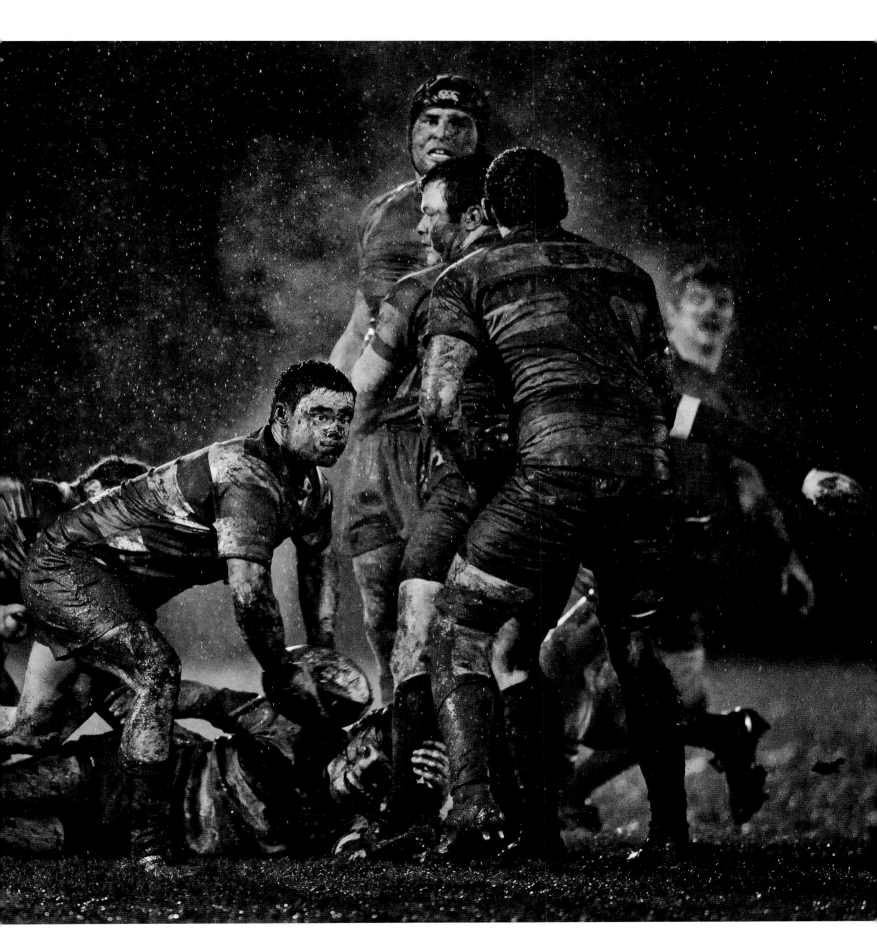

and I am trying to beat the competition. I don't want to be beaten," McManus related in a telephone conversation from Ireland.

Ireland's population is a mere 4.5 million, yet it has eight daily newspapers. (Take that, New York!) Sports photographers still see their pictures every day in print. For this reason, and because McManus is not a greedy man and wouldn't sell his agency for any amount of money, Sportsfile is a rare phenomenon—a small photo agency in the world of giants.

· · ·

The new floodlights in the recently constructed Lissywollen Stadium gave a Renaissance glow to the immortal tale of boys with ball (see page 19). **PAUL MOHAN** was excited by the lighting possibilities in the new stadium. He used it to illuminate the drama and the perfectly poised bodies of these young men. The goal could not be clearer—all eyes are on it, for indeed

the great *goal* of these young men is twofold: get the ball into the net; keep the ball out of the net.

Mohan was aware the lighting "felt old-style." What surprised him was the concentration on each individual face. Soccer is all action, a running game, yet the beauty of the picture is its frozen, sculptural values. Rodin comes to mind.

Mohan started photographing at the age of sixteen, the same approximate age as the boys in the photograph. By eighteen, he was working full-time, and ten years later he won first prize in the sports action photography category at the prestigious World Press Photo awards with this mesmerizing picture. He works for Sportsfile in Dublin.

· · ·

The "golden age of baseball" was also the golden age of baseball photography. The New York *Daily News* photographers from the 1940s through the 1960s were a championship team that has never been equaled. Charles

Leroy Jakob, *Carl's Playing Hard to Get.* Yogi Berra dives at Carl Furillo, World Series, Yankee Stadium, New York, October 1, 1953.

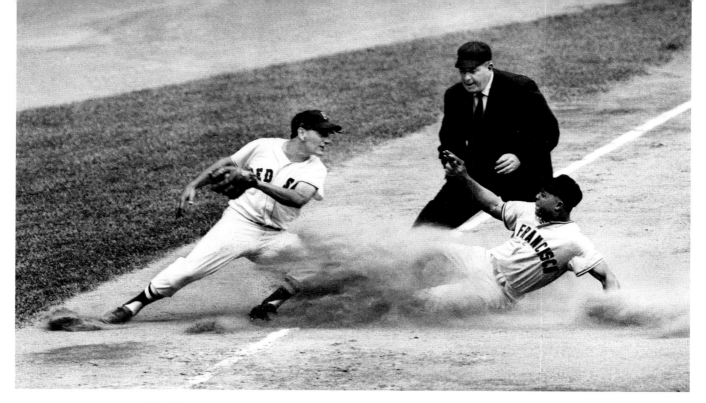

Ernie Sisto, *Willie Mays Steals Third*. Frank Malzone, third base, Tom Gorman, umpire, All-Star Game, Yankee Stadium, 1960 (Ernie Sisto/*The New York Times*)

Hoff, Frank Hurley, Hank Olen, **LEROY JAKOB,** Fred Morgan, and the youngest, Dan Farrell, were photographic giants working for the daily that called itself "New York's Picture Newspaper" and has a camera in its logo.

In its heyday, the *Daily News* had a photo department of more than sixty, two airplanes, motorcycles, and radio cars. And there were dynasties: Dan Farrell "inherited" Charlie Hoff's prime spot at the boxing ring in Madison Square Garden—dead center with no photographers on the left or right. Farrell had paid his dues. Twenty years Hoff's junior, Farrell assisted Hoff, learned from him how to use Big Bertha with its 400–500 mm monster lens, and wrote his captions. Then he became one of the stalwarts of the photo department, starting out with the Speed Graphic (even with its 4 × 5-inch plates it could shoot at 2,000th of a second) and flashbulbs and ending his days at the paper with 35mm cameras and electronic flash. His most published picture, taken with a 300mm lens on a Hasselblad, is the heart-wrenching photo of John John saluting the coffin of his father, John F. Kennedy, at the funeral.

Hank Olen took the picture of Jack Dempsey getting knocked out of the ring. Frank Hurley caught "The Catch," an eloquent evocation of the brilliance of Willie Mays: back to plate, reaching overhead to stop a three-base hit in the World Series of 1954. Hurley used a Hulcher, the only sequence camera available to sports photographers. It was designed at the end of World War II to photograph exploding bombs at twenty frames a second!

There are a few memories of people who worked with the dedicated Leroy Jakob, but unfortunately not too much is known about him other than that he took great photos.

• • •

ERNIE SISTO spent his final years in Rough and Ready, California. Could there be a more appropriate final resting place for the tough *New York Times* photographer? He served the Gray Lady for fifty years, and even a little guy like him would sometimes carry a hundred pounds of equipment. His photographs were the reason so many *Times* readers started their day's perusal of the paper in the sports section. No one felt a politician slipping and sliding around an issue had the excitement or grace of Willie Mays gracefully sliding into third. In this photo, Frank Malzone of the Red

Sox and umpire Tom Gorman complete the pas de trois.

Sisto recalled in an interview the days of using foul-smelling flash powders: "shoot and get the hell out fast." He literally went to great lengths to get his photographs—climbing a cable of the 363-foot Bronx-Whitestone Bridge to get a bird's-eye view, hanging over a parapet eighty-six stories above the ground to photograph the plane that smashed into the Empire State Building in 1945, and thousands more mundane and historic events. When he was at *Times* headquarters, he was famous for fixing watches and cameras. An article in the paper stated he invented the first synchronized flash used on the streets of New York. Later, he invented and sold outright a focal plane synchronizer for high-speed photography.

His passion was always photographing sports, especially baseball, which he did with cameras ranging from the stationary Big Bertha, with a six-foot lens (the monster camera sports photographers used when they were relegated to the "cage" far away from the field), to 35mm. The sports world was smaller in Sisto's days and a photographer could call sports giants friends: Joe DiMaggio, Mickey Mantle, Phil Rizzuto among them. The latter, when about to bunt, would signal Sisto to get his camera in position. Now that is friendship.

Born in Princeton, New Jersey, in 1904, Sisto started in the newspaper business in 1918 as a "squeegee boy" running errands for International News Photos and soon after became a photographer. He went over to the *Times* as a printer in 1923, turning out up to three thousand prints a night. When he was promoted to photographer a few years later, he still had to make ninety to a hundred prints from each of his negatives, caption them, and put them in envelopes he addressed, stamped, and mailed. When asked if the *Times* made him work hard, he answered, "They're humping my rump."

Sisto shot plenty of prosaic pictures and also many of beauty and grace. Some of his photographs are in the permanent collection of the Museum of Modern Art. Being at *The New York Times* for fifty years meant more than just producing pictures that delighted and informed readers: he also mentored generations of photojournalists at a time when photographers learned their trade on the beat, from their colleagues, and in that notorious school of hard knocks.

• • •

Sports photography isn't just "luck or circumstance," as many people believe. The great sports photographers have a point of view—literally—that is honed from years of practice. "You are in position for the picture you want," stated **ROBERT RIGER,** "because in your conceptual design of the action, balanced with the style and skill of the athlete at that moment of the game, there is only one position. Yours."

Hugh Edwards, former curator of photography at the Art Institute of Chicago, gave Riger three one-man exhibitions at his museum: *The Pros* (football photographs in 1961–1962), *The Track* (thirty-two horse racing photographs in color), and in 1978–1979, *The Athlete: The Influence of the Athlete on American Life,* which included his drawings, photographs, and films. The 1961 exhibition was "proof," the *AIC Bulletin* wrote, "that photography could attract large audiences within the museum, in part because Riger's photographs were not typical 'sports photographs.'" They showed, Edwards said, "the completed gesture . . . something we believed possible only in the hands of geniuses of draughtsmanship like Géricault and Degas" and "in some inexplicable way . . . suggest what comes before and after each flash of movement." John Szarkowski, who, as director of photography at the Museum of Modern Art was the most powerful arbiter of art photography in the world, said: "[Riger's] photographs . . . would have given intense pleasure to George Stubbs and Winslow Homer and Thomas Eakins." Vince Lombardi, one of professional football's most famous coaches, remarked, "Bob Riger is a fine reporter with great imagination and he can capture football in pictures better than any man I know." Johnny Unitas, quarterback for the Baltimore Colts and the man with the "golden arm," observed, "Bob Riger sees a football game as we see it. No one shows playmaking like this."

There you have it. The pivotal figure in the history of sports photography. The scholarly art historian Edwards considered him one of the greatest photographers of the twentieth century. Those on the front line of sports thought he got the shots that showed the world the *truth* about their game. Riger knocked down the barriers between "high" and

"Sports pictures," as they are called, are a national language. They are as continuous and rhythmic as the seasons and as faithfully changing and as surely recurring. They never stop. With each passing year, in each sport, they give us another hero. A few of these photographs find the true character of the action and the sensitivity of the athlete. Others are only evidence.

ROBERT RIGER, *THE ATHLETE: AN ORIGINAL COLLECTION OF 25 YEARS OF WORK*, 1980

• • •

"low" art as surely as a linebacker hits a running back. Riger's children observed when their father made a photograph that had universal qualities, one that transcended the skill of the athlete or the dramatic moment, he titled it, as would an artist naming his work. *Mudhead, Over the Top,* and *The Golden Arm* are the most famous Riger pictures.

Many of Riger's action shots are art. They are clear and precise when they focus on a single player or action. They assume the quality of a great historic painting when the frame is full of bodies suspended in movement: Mickey Mantle twists, swings, and grimaces in a photo from the 1961 World Series that Riger titled *Pain;* a silhouette of Hank Aaron poised to swing a light-colored bat; a character study of umpire Hank Soar, jaw structure and cheekbones reading "don't mess with me"; Mickey Mantle hitting a home run, bat and first base line parallel; the grace of Willie Mays at the moment he hit a triple, one arm reaching out, the other delicately still holding the bat—a stance worthy of a sculpture; Jackie Robinson doing his little dance at Ebbets Field between third base and home, a photograph titled *The Great Intimidator;* Willie Mays again with his million-dollar smile in the dressing room after San Francisco beat Los Angeles in the 1962 National League playoffs; Billy Martin not looking managerial; Branch Rickey behind a puff of cigar smoke appearing powerful; Kyle Rote and Frank Gifford as locker room pinups in their underwear; Y. A. Tittle 100 percent focused during a practice drill; Roosevelt Brown, Gene Filipski, and Don Chandler of the New York Giants, invincible, impenetrable human barricades sitting on the bench, 1956; *Over the Top,* Redskin John Olszewski flying over a pyramid of men to score against the Giants in 1960; a

photograph of Jim Brown being tackled that evokes religious paintings of martyrdom or hunting canvases depicting the pack finally tearing apart its prey; Frank Gifford draped in a cape next to a rain-soaked Vince Lombardi, a double portrait worthy of a Rodin sculpture; and *The Mudhead,* a close-up of Forrest Gregg, mouth opened, slits for eyes, suggesting primitive man and primal scream. And then there is a generally overlooked panorama of a football game, all action in the foreground but between the players, on the sideline, is a young boy in a wheelchair, bending his head to see his heroes.

And these are just football and baseball pictures. Riger also photographed boxing, swimming, basketball, golf, tennis, track and field, gymnastics, hockey, and horse racing. The common denominator, as the host of ABC's *Wide World of Sports,* Jim McKay, said, was that "his pictures and opinions are always kind. . . . I feel that it is easier to shatter an icon than it is to search out and portray skill and virtue."

Riger went to the High School of Music and Art, in Manhattan, and Pratt Institute, in Brooklyn, majoring in fine art and graphic design. He left after the first year to join the Merchant Marine when America entered World War II, and then returned to complete his education. After graduation he needed to find a niche, and his research showed that in 1948 there were only three good sports artists in the United States and they were all newspaper cartoonists. Riger knew and loved sports. (He grew up overlooking the Polo Grounds.) He began doing sports illustration, and in 1954, the year *Sports Illustrated* was launched, he was retained as a freelance artist. The magazine published more than 1,200 of his editorial drawings and over 200 of his promotional

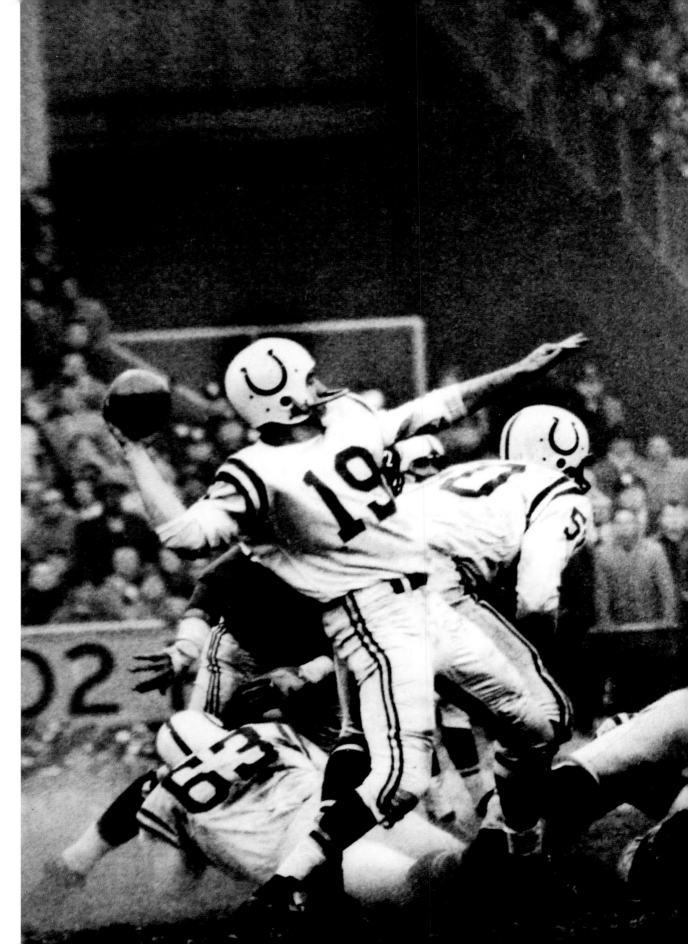

Robert Riger, *The Golden Arm.* Johnny Unitas of the Baltimore Colts about to throw a pass during sudden death overtime in the NFL championship game against the New York Giants, Yankee Stadium, December 28, 1958

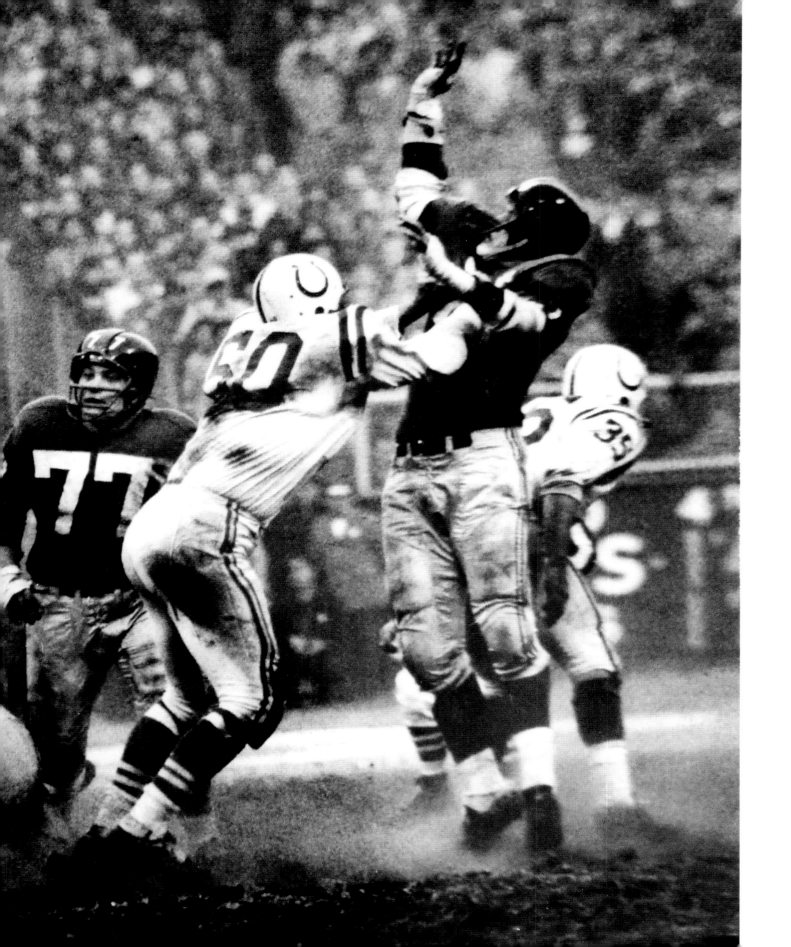

and advertising drawings. His and Branch Rickey's book, *The American Diamond,* has many of these great character drawings of Major League Baseball figures, along with Riger's photographs. From 1950 to 1994, Riger took more than 90,000 photographs, at a time when film came in twelve-, twenty-four-, and thirty-six-exposure packs and rolls. He began photography simply to help with his drawing, eventually using eight different cameras, starting with a large Speed Graphic and ending with 35mm. He loved sports photography because it "showed the beauty and power of man."

But those who knew Riger also knew of his ambition. Television sports coverage in the early 1960s was the new visual frontier, just as *Sports Illustrated* was when he began there in the 1950s. And he called himself a sports journalist, leaving room for whatever opportunities presented themselves. He was part of the early team at ABC's *Wide World of Sports,* leaving print journalism and joining the network in 1961. He worked as a writer, director, cinematographer, and producer. He noted, "Roone Arledge, my executive producer at ABC Sports, and a benefactor in the early sixties, saw in my work the natural journalistic transition from print to television and guided the changeover." ABC Sports was huge and Riger was a key player, moving at times to a role as an on-camera commentator covering the Olympics and other special events. Later, he was asked by NBC's *Today* show to join them as "Monday Morning Quarterback," holding up his drawings while discussing the weekend's games.

Riger never ceased seeing himself as an artist, but two marriages (the first to Eleanor Sanger, the first woman television sports producer) and six children meant mouths to feed and a lifestyle to maintain. In television he not only was paid well but met dynamic people doing groundbreaking work and traveled the world.

Riger's exhibition *Man in Sport: An International Exhibition of Photography* was his homage to his colleagues in still photography. It opened in December 1967 at the Baltimore Museum of Art with an astonishing 642 prints on the walls, including more color photographs than had ever previously been exhibited in any museum. Ken Lieberman, master printer and longtime favorite of many of the world's great photographers, made these dye transfers, the most stable and beautiful of color printing processes at the time. (Riger had photographs in Edward Steichen's 1955 *Family of Man* at the Museum of Modern Art, and that exhibition appears to be the model for *Man in Sport,* organized by Riger to suggest the universal qualities of sport and the power of photography.) After the Baltimore Museum of Art, the exhibition went to the Gallery of Modern Art at Columbus Circle in New York City from March 17 to May 12, 1968, the HemisFair, in San Antonio, Texas, and then from August 10 to October 5, 1969, it was on exhibition at the Art Institute of Chicago. The original prints cannot be accounted for, a sad chapter in this exhibition's history. Sports photographs, even dye transfers, were not considered art, and many of the photographs were simply discarded and destroyed.

· · ·

ARTHUR THILL's sequence of this harrowing event starts familiar enough. Jos Verstappen of the Netherlands stops to have his Benetton-Ford serviced and refueled during the 1994 German Grand Prix. Photos one and two are overall blue, the crew in the pit wearing their fire-resistant blue jumpsuits and caps, and the tarmac is grayish blue. In the third photograph, a red and yellow inferno appears, which lasts through image number seven, when the flames are brought under control. Fuel was accidentally sprayed onto the hot bodywork of the car, causing the conflagration. The final photograph shows Verstappen miraculously stepping out of the car with minor injuries. He was lucky. On May 1, three months earlier, the Brazilian Formula One world champion, Ayrton Senna, died when his car hit a concrete barrier during the San Marino Gran Prix.

Only four photographers were allowed on the racetrack's "pit wall" that day in July 1994. Thill, who has his own sports photography agency in Luxembourg, was one of them. He shot twenty-five frames, not knowing if the entire area would, within seconds, explode. He describes it as "professional shooting . . . very tough."

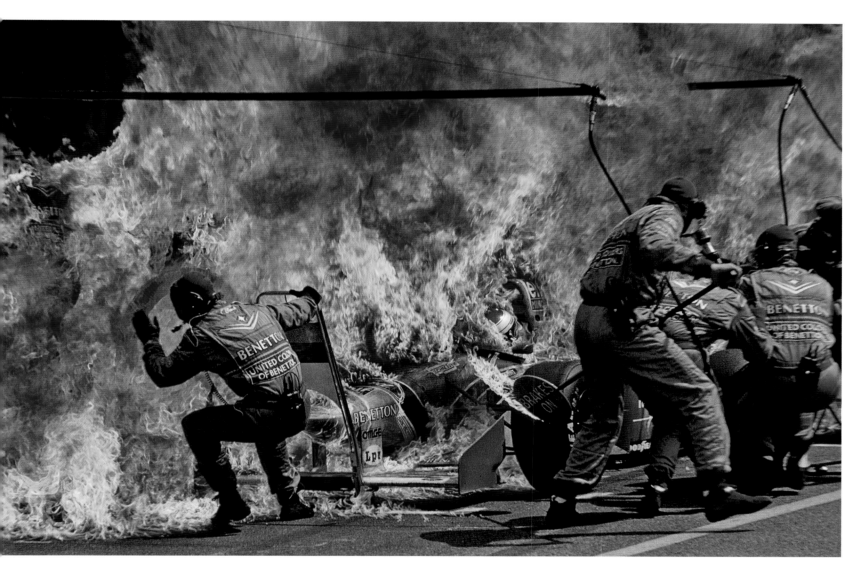

Arthur Thill, "Jos Verstappen trapped in his race car during German Grand Prix," Hockenheimring, Hockenheim, July 31, 1994

Down through the ages, references to surfing have survived; first via the chant, later in writing, and now most eloquently by the medium of the camera.

TOM BLAKE, PIONEER SURFER AND SURF PHOTOGRAPHER

• • •

LeRoy Grannis, *Mickey Muñoz*, Mākaha, Hawaii, 1963

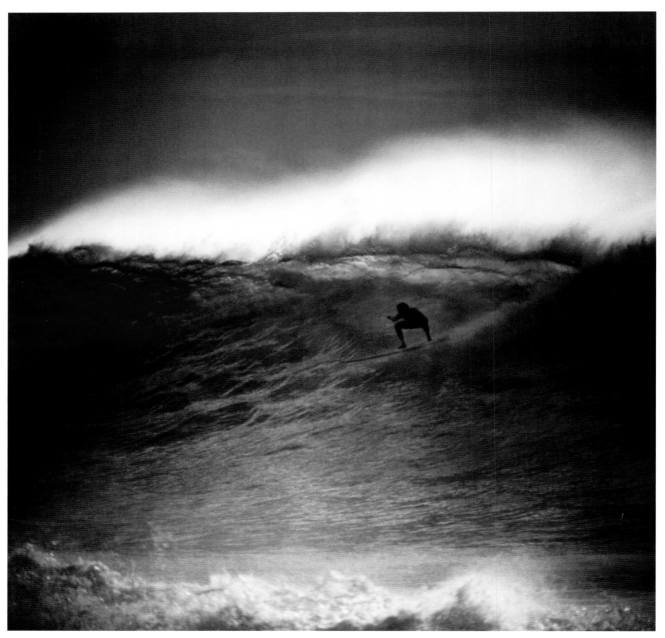

LEROY GRANNIS, born in Hermosa Beach, California, in 1917, started surfing at the age of fourteen. He began photographing surfers in 1959 after he was diagnosed with a stress-related ulcer and his doctor recommended a "relaxing pastime." Still living near the beach but now with four children, one a surfer, he built a darkroom in his garage and decided to see where a camera and his favorite sport might interconnect.

Jacques Cousteau, famed deep-sea explorer and coinventor of the Aqua-Lung, had designed a lightweight camera boxed in Plexiglas that was waterproof. Grannis used this camera to take his early surfing photographs until he purchased Cousteau's next invention, the Calypso amphibious 35mm camera, which came on the market in 1960. This smaller camera allowed Grannis to ride the waves and shoot simultaneously (in 1963, Nikon took over production and renamed it the Nikonos). Later, with the help of his friend Doc Ball, Grannis designed and built his first rubber-lined, suction-cupped waterproof box, which permitted him to change film and shoot from water level with longer lenses. Now he could sit in the water for hours without returning to shore. That sounds like following doctor's orders for finding a relaxing pastime.

Surfing did not start in Southern California, but in the 1960s it became an American cultural export, just as rock 'n' roll had been the decade before. "Surfin' USA," the Beach Boys, *Gidget, Beach Party,* with the pretty, petite blondes and restless boys, were based, in part, on Grannis's iconography. California youth were tanned, carefree, looked great in bathing suits, and, unlike most young people around the world, had cars to prop their boards against and pose. LeRoy Grannis photographed surfing and the surfing heroes of his day; his photographs also provided a cultural history of Southern California in the 1960s and 1970s.

Like the prehistoric creatures who decided to leave the oceans and give dry land a try, surfboards morphed into skateboards (then snowboards). Among the very finest skateboarding photographers are Glen E. Friedman, Stacy Peralta, and Craig Fineman.

KRYSTLE WRIGHT (see pages 34 and 35) is from a one-street town, an hour north of Brisbane, Australia. There is a general store, a primary school, and a post office. Her family was in the business of drilling and blasting—"blowing up rock," as she describes it. Wright is in the business of rock climbing and outdoor adventure, all the while capturing photographically nature's splendor—and doing no harm.

Born in 1987, she is glad to be alive after careening into a pile of boulders during a paragliding accident. She had two cameras around her neck when she crashed (she doesn't like to change lenses when paragliding). The Canon EOS 5D Mark II is still working. She is a Canon spokesperson, but honestly, she doesn't have to try that hard to prove the durability of their cameras.

Wright is brave and bold. She is one of the finest adventure photographers working today. It is still a man's field of endeavor and women have to "work harder than the men," she said in conversation with me. She talked about the challenges she faces as a woman who "rarely sees another woman" while shooting: 1) water sports—free diving, surfing, kite surfing, wind surfing, kayak and sailing expeditions; 2) land sports—mountain biking, rock climbing (on ropes, on cliffs), bouldering, BASE jumping, power gliding, highlining, mountaineering, skiing, snowboarding.

She grew up active and athletic, loving the outdoors. She "stuck it out" for three years at Queensland College of Art in Brisbane majoring in photojournalism, but sitting in classrooms learning theory was not her style. She describes herself as "very practical, hands on." Before taking off around the world (she has no permanent address) and becoming one of Red Bull Illume's fifty great adventure photographers, she worked at *The Sydney Morning Herald* with the creative team of sports photographers: Tim Clayton, Steve Christo, and Craig Golding.

Wright is now freelance, taking the advice of one of her friends: "If you follow what you love, it will not lead you astray." She told me she has less fear of extreme sports than of living a life with regrets. Creativity and adventure are her driving forces.

Wright has always drawn and sketched. Sometimes she preconceives a photograph and takes four years preparing for

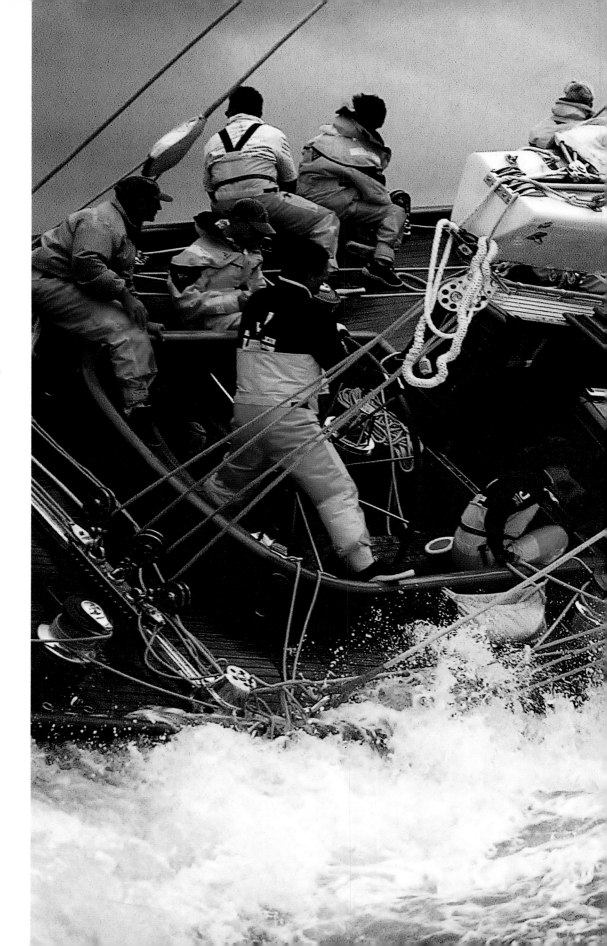

Bob Martin, The *Velsheda,* skippered by Roald de Waal of the Netherlands, racing in the Solent between the Isle of Wight and Southampton, England, in preparation for the following week's America's Cup Jubilee celebrations, August 12, 2001

• • •

In her heyday, she raced against the best of them—*Britannia, Endeavour,* and *Shamrock V. Velsheda,* a grand old dame of the J-class, built in 1933, was laid up in 1937, became derelict, and was then completely resurrected in 1997. If only humans could have such luck.

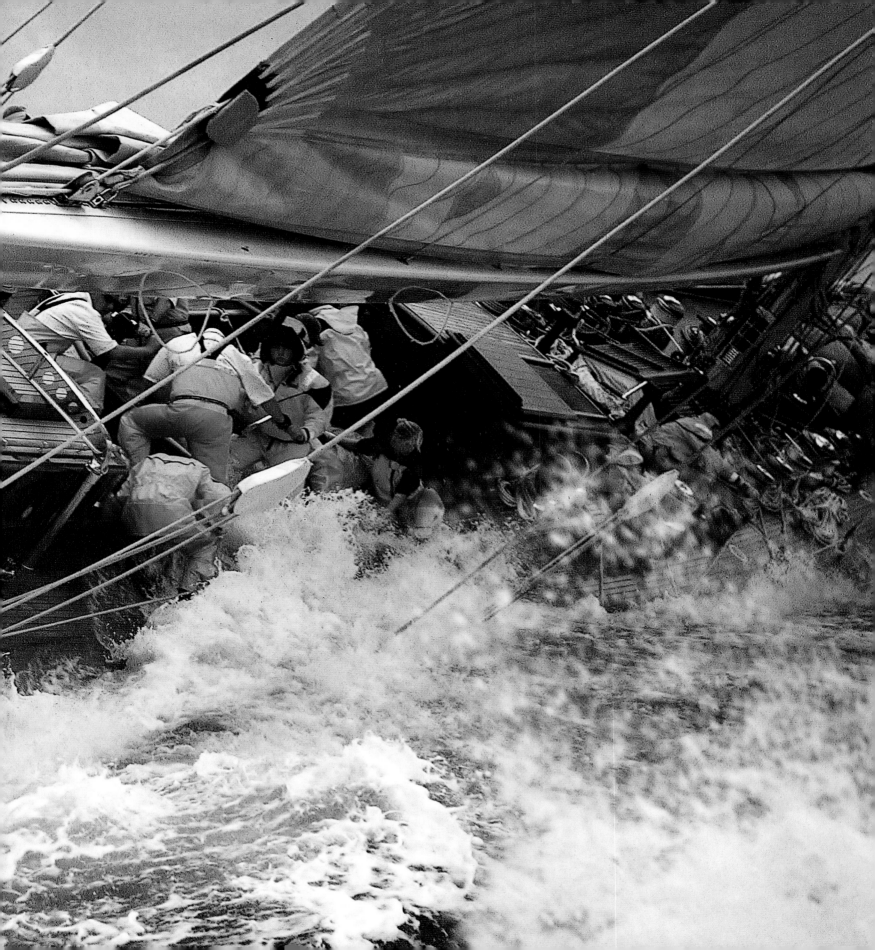

Krystle Wright, *Highlining in Cascade National Park,* Washington State, 2014

it. Other times she turns and sees the unexpected. She jokes that people call her a landscape photographer with action figures. Rarely does a person in her pictures upstage nature. Because she keeps her athletes small, the scale of the landscape is conveyed, and also something about the humility of being in nature and respectful of it.

"I won't work with a prick," she told me. "The idea of this job is to have fun. Gamble. Work with people you are fond of. Have good energy around you." She is often off in the wilderness for weeks or months with her group. She likes this type of sports photography much better than "pushing into a stadium, showing her press card to a guard, being told where to stand." She gives herself supremely challenging assignments in the hopes that someone will eventually publish her pictures.

"I haven't had a home for four years," she acknowledges. "All my belongings are in a shipping container at Grandma's."

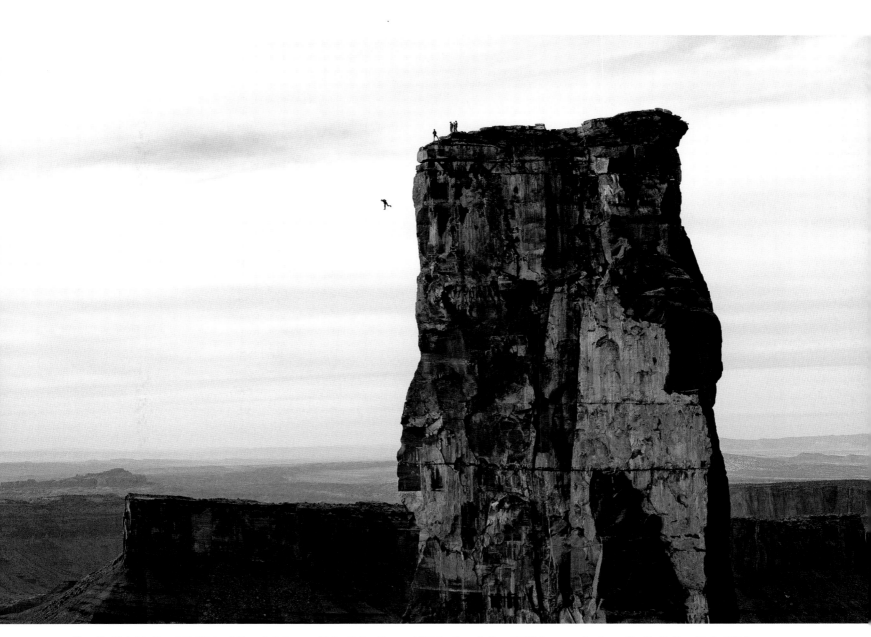

Krystle Wright, *Freefall.* Michael Tomchek leaps off Castleton Tower (400 feet) as fellow BASE jumpers look on, Castle Valley, Utah, 2014.

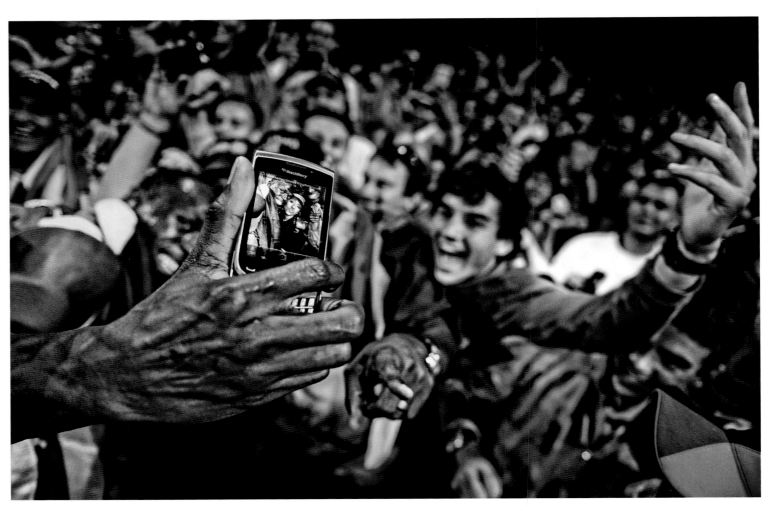

Adrian Dennis, Usain Bolt taking a selfie with fans, Olympic Games, London, 2012

CHAPTER TWO
FANS AND FOLLOWERS

Kevin Baker, baseball historian par excellence, describes Jonathan Schwartz's book *A Day of Light and Shadows* as a "lovely little book, no more than a magazine article, actually, that conveys what it's like to be a fan better than anything I've ever read." And what does the book convey? The irrational passion, the love that knows no bounds, the crazy, heart-throbbing anxiety of a fan when his or her team is playing. Those who aren't fans and followers don't understand it; those who are across the globe, regardless of nationality, race, economic status, or any other designation, do. Fanhood is universal.

A book on sports photography must include the fans and followers. Whether sitting on a bench with a few friends in Mississippi or Namibia watching a game or cheering with 60 or 100,000 attendees in one of the big stadiums around the world, fans know they are a vital factor in sports. The followers—cheerleaders, boosters, band members, pit crews, attendants—all have a special relationship to the men and women who run, kick, and jump their hearts out, who take death-defying risks that give vicarious thrills and chills.

Sports photographers know they must communicate the body language of athletes—how they move, the grace and power with which they perform. When photographing the fans, the story is on the faces. And the expressions of joy, anxiety, grief, and relief are also universal.

. . .

ADRIAN DENNIS took the required shots of victorious Usain Bolt with winning grin, arms raised, and flowing Jamaican flag at the London Olympics. Dennis then saw Bolt moving toward the crowd after his victory lap, and Dennis, who prides himself on still having some "speed," bolted off after him. He got there before any of his colleagues, and like the experienced photojournalist he is, he planted his feet and

stretched out his arms to keep the other photographers away. He started shooting Usain Bolt's face when someone tossed Bolt a phone. Bolt knew exactly how to take a selfie with the phone's owner. The experienced Dennis paused for a split second and then realized he could focus on the screen of the telephone and make a unique picture. We have Bolt's powerful hand in the foreground and two versions of the gold winner behind.

Englishman Adrian Dennis left school at sixteen and started working for British Aerospace. He spent lunch breaks talking about the art of photography with the company photographer. Two years later, he took the radical step of applying to American colleges to study photography. An only child, he went off for three years to the University of Florida (was it the academics or the weather?), and came back with a vision of what he might accomplish in photography. He was going to be a sports photographer, but one who constantly makes, as he told me, "photographs different from anyone else." He is well aware he is "out there competing." He joined Agence France-Presse in 2000, an agency that gives him the creative license he needs to flourish and survive in this competitive field.

. . .

MARK KAUFFMAN started his career as a *LIFE* photographer. He was only sixteen years old when he had his first *LIFE* cover. He was known as a "quiet sensitive photo essayist," and his picture of a hot dog vendor at Yankee Stadium shows his Norman Rockwell bent. When other photographers were pushing to get closer and closer to the playing field, Kauffman liked to move back to show sports in a larger context. He loved the excitement of sports and also its ability to highlight the "human condition." He was part of the core group in 1954 that started *Sports Illustrated*.

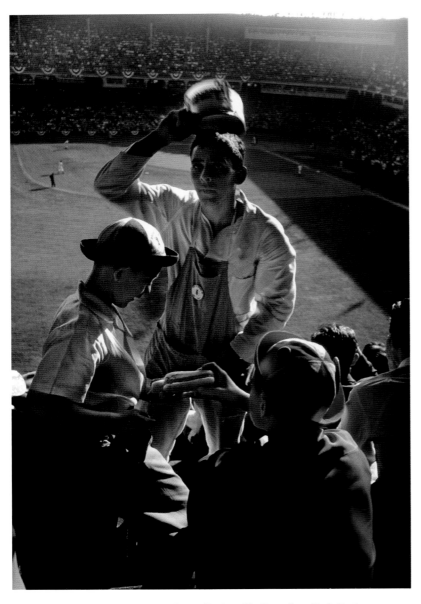

Mark Kauffman, *Hot Dog Vendor at Yankee Stadium,* New York Yankees vs. Brooklyn Dodgers, World Series, Bronx, New York, September 30, 1953

Kauffman learned photography at John C. Fremont High School in Los Angeles from the legendary Clarence A. Bach. (Bach also taught John G. Zimmerman, John Dominis, Bob Landry, and George Strock.) Kauffman said, "Bach emphasized sports photography because it offered so many approaches. We could do portraits, still lifes, mood shots, play with the extremes of things like the seams and surfaces on balls and, of course, there was always the action."

Bach also encouraged his students to grab a Speed Graphic, jump into an old car (this was California), and, like Weegee, listen to a police radio and chase ambulances, police cars, and fire engines. When you have had a good teacher, such as Bach, Kauffman noted later in life, you never forget him.

Photography was a lifelong learning experience—technically and aesthetically. After the 1948 Olympics in London when, even though he was a *LIFE* photographer, he didn't have a field pass and had to photograph from the stands using long lenses, he was determined to design a better camera for shooting sports. He worked with Marty Forscher, America's most famous camera-repair and problem-solving genius, taking apart a Bell & Howell camera called a Foton and getting it to take ten photos in four seconds. Then they tore a pair of binoculars in half and made a monocular finder. "When I went to an event, I could focus on what I was going to shoot," Kauffman told John Loengard, former *LIFE* picture editor, "lift the mirror and then look through the monocular finder and get a series of pictures." No other camera with these capabilities existed in the early 1950s.

Cartier-Bresson inspired him to pay attention to the full frame and background—and to move away from the other sports photographers to get shots truly unique. "Calculation" also helped, as Sean Callahan and Gerald Astor explain in their book *Zimmerman & Kauffman.* When Kauffman was

· · ·

Photography was magic—press a button and produce a picture. That hooked me.
You were a kind of sorcerer, standing in the dim red light of the darkroom and
summoning a print to life in the chemical tray. I also saw in photography a way to
become a traveler, to roam the world, to be in the middle of exciting events.

MARK KAUFFMAN, IN *ZIMMERMAN & KAUFFMAN: MASTERS OF CONTEMPORARY PHOTOGRAPHY,* 1975

asked to cover John Landy vs. Roger Bannister running the mile in 1954, he learned that Landy usually started strong and Bannister made his push toward the end. So Kauffman did some calculations and chose to position himself back from the finish line, hoping to get Bannister challenging Landy for the lead. All other photographers were at the finish line but Kauffman got the more emotional shot of Bannister making his final thrust. Of course, luck is part of sports photography—just as it is in sports itself—but skill, professionalism, preparation, intelligence, and practice make for the most winning photographer—as well as athlete.

• • •

When **GEORGE SILK** arrived in New York from his native New Zealand after covering the war for *LIFE* magazine, he was assigned to go to Yankee Stadium to photograph a baseball game. An avid athlete who skied, sailed, mountain climbed, fished, and played rugby and cricket, he didn't know what to make of professional baseball. The one thing he was sure of, he told John Loengard, former *LIFE* picture editor, was that "I hated crowds and I hated stadiums and I couldn't work with all that noise in my ears." In an earlier interview he was even more scathing: "Stadiums are noisy, crowded and dirty. Really disgusting places to work. I hate them. I mean, if you manage to get to the sidelines to take a picture, half the time you get knocked on your ass by somebody else trying to get the same shot." He made a stadium photograph at the University of Pittsburgh, but he made it his way. It is a *quiet* photograph, as if the students are communicating their exhilaration in sign language, not shouts. Even the new modern transistor radio in one boy's hand feels muted.

George Silk, University of Pittsburgh students cheer from the Cathedral of Learning as they watch the Pittsburgh Pirates winning their first World Series in thirty-five years, Pittsburgh, 1960.

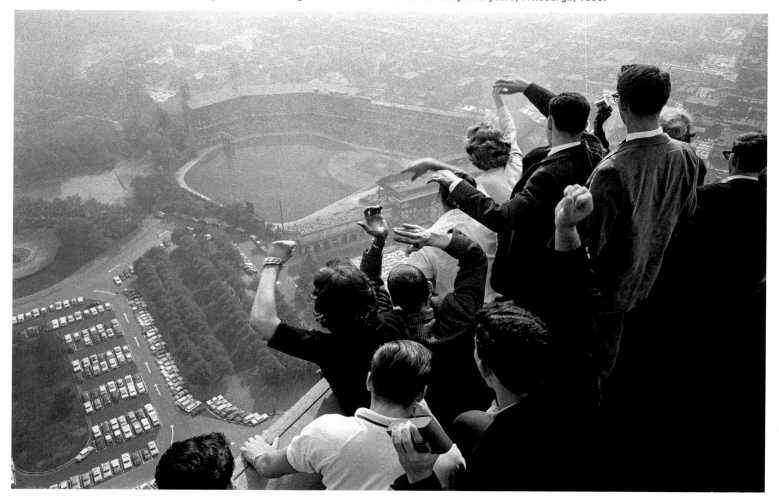

of the shifting quality of time and how it impacts on memory is the inspiration for this extraordinary body of work.

Stephen Wilkes has been photographing since the age of twelve, when he made his first photo-micrograph. He recognized the power of art during a class trip to the Metropolitan Museum of Art, where he saw the dense, strange little bodies in Pieter Bruegel's paintings. Being Jay Maisel's assistant during his junior year in college was "life-changing," and Maisel did not *encourage* Wilkes to be a photographer, he said he *had to be* a photographer. Wilkes listened and has soared, both in the commercial and art worlds.

. . .

LARRY SCHILLER, a college kid at Pepperdine with a good quality camera, shot this 4 × 5 color transparency of young girls on campus learning how to twirl. He always had an eye for the "fabric of America." He sent the photograph off on speculation to the magazine synonymous with clean-cut American values, Mom, and apple pie—*The Saturday Evening Post*. They ran it across two pages.

Schiller has photographed it all—from girls twirling metal bars to murderers behind bars. Comparing Schiller to almost any other photographer on the planet makes them appear limited in scope. Look at where he has been and what he has photographed: Hollywood sets to the real-life drama of Gary Gilmore's execution; Richard Nixon conceding defeat to John F. Kennedy and Clint Eastwood waiting to check into a hotel; Marilyn Monroe on set and naked in a swimming pool; Lee Harvey Oswald in the police station just prior to being murdered by Jack Ruby. And the incredible list goes on. Schiller has given us America's complicated, compelling story.

Lawrence Schiller, Summer camp for drum majorettes, Pepperdine College, Los Angeles, ca. 1955

Toby Old, *Cheerleaders, National Cheerleaders Convention,* Daytona Beach, Florida, 1998

• • •

It's a bird, it's a plane, it's a cheerleader. **TOBY OLD** sees the oddball, kooky, far-out in the everyday. Disco nightlife is Felliniesque and downright naughty, politicians are preening and pretentious. In the weirdly wonderful, what I call "World of Old," men who punch each other (boxers) have the most compassion and humanity.

Warm climates where people wear a minimum of clothing and display their bodily imperfections are especially rich territory for Old's visual juxtapositions and investigations into life's absurdities and rituals. He is a master of the square format, knowing exactly how to compose to engage the eye.

Old's father was an artist and he grew up in an artistic family in Stillwater, Minnesota. Being somewhat practical,

he went to dental school and practiced dentistry for thirty years. Dentistry didn't keep him out of the army, but it did keep him from being sent to Vietnam. He was stationed in North Carolina and hung out with the man who ran the darkroom on the base. By the time he was discharged in 1973, he knew he wanted to be a photographer, and three years later moved to Manhattan. He went to Apeiron Workshops to study photography with Charles Harbutt, Elaine Mayes, and George Tice. Ralph Gibson was a friend. Ted Hartwell at the Minnesota Institute of Arts encouraged him and gave him his first museum exhibition. Old reduced the days he worked in his dentist office to two so he could wander the streets, boardwalks, beaches, and gyms and make his atypical pictures. By 1998 he stopped looking into people's mouths and concentrated on their idiosyncrasies.

Burt Glinn, *School Spirit,* Seattle, Washington, 1955

• • •

This is the first time in three years this high school football team has won a game. Head cheerleader embraces football captain, an American idyll. In the same year, 1955, **BURT GLINN,** a renowned Magnum photographer, caught the hysteria around Davy Crockett coonskin hats. The year before, he did a serious study of the Assiniboine Indian reservation. Two years later, in 1957, he was in Little Rock, risking his life to show the ugly face of segregation and the beautiful face of desegregation. In 1959 he was in Havana to witness and record Castro's revolution. He was a sensitive, intelligent, and probing photographer whatever the subject.

Burt Glinn had a scholarship to Harvard University, but after a year he was called up to serve in World War II. Jaundice saved him from the Battle of the Bulge. When he returned to college, he continued studying English literature and wrote and photographed for the *Harvard Crimson.* "I think that what you've got to do is discover the essential truth of the situation, and have a point of view," he said.

GEOFF WINNINGHAM has spent decades trying to understand Americans through their sports. His first extended essay and book was on wrestling, *Friday Night in the Coliseum*. The next project this native Tennessean did was *Going Texan* (a lot of livestock with their people). His *Rites of Fall* is an original visual investigation of high school football. He did an impressionist study of the Houston Rockets basketball team. In the mix, he photographed the Destruction Derby.

Winningham does not photograph the loneliness of the long distance runner. All his athletes perform for crowds, big crowds generally. He focuses on the fans as frequently as the athletes. His picture of the Oklahoma band at the Cotton Bowl is a tour de force of syncopated rhythm. He brings the viewer right into the noisy, excited crowd. The irony is that marching bands practice hard to be a unified whole, and in this photograph everyone is doing their own thing—from a guy hiking up his pants to a young woman fixing her hair to someone else drinking a Coke. Only the drummer seems concerned to keep the beat to the "Beat Texas" chant.

Oklahoma fans are seen turning the "Hook 'Em Horns" hand gesture of the University of Texas Longhorns upside down.

• • •

JIM DOW studied with Harry Callahan, Minor White, and Walker Evans and received a BFA and MFA from the Rhode Island School of Design. He didn't waste his remarkable education. He has passed it on, over many decades of teaching at Harvard, Princeton, and Tufts universities and the School of the Museum of Fine Arts, Boston.

Dow first gained recognition in the art world with his panoramic triptychs of baseball stadiums. The first was done in 1980 at Veterans Stadium in Philadelphia, and the project now extends to more than three hundred major and minor league ballparks in the United States, Canada, England, Mexico, Portugal, Scotland, and Uruguay. His use of an 8 × 10 camera makes every detail razor sharp.

Dow's ballparks suggest human presence without including people. Precision, balance, and a brilliant use of color mark Dow's oeuvre.

Geoff Winningham, *Oklahoma Band at the Cotton Bowl*, Dallas, Texas, from portfolio *A Texas Dozen*, published 1976

The giant edifices of Shea and Yankee Stadiums grace the urban scene in as
spectacular a fashion as a medieval cathedral might dwarf a market town. Indeed,
all my baseball stadium panoramas have been made with this metaphor in mind.

JIM DOW, *SUBWAY SERIES,* BRONX MUSEUM, 2004

• • •

Jim Dow, The Astrodome, Houston, 1982

Ezra Shaw, Barry Zito and his wife, Amber, celebrate after the San Francisco Giants defeated the St. Louis Cardinals 9–0, game seven, National League Championship, AT&T Park, San Francisco, California, October 22, 2012.

• • •

EZRA SHAW learned from the best, having assisted Bob Martin in London from the end of 1996 to the beginning of 1997 and then getting a job at Allsport in New York, working with photographer and editor Darrell Ingham and photographer Al Bello.

Publications don't necessarily want extended sports stories, but that is what Shaw loves best. Ezra Shaw, born in 1974, was brought up on old *LIFE* magazines and photo books, and had a darkroom in his childhood home. He studied journalism at Syracuse University's Newhouse School of Communications and never lost his love of telling or reporting a great story. His photo stories include covering a 500-mile wheelchair race across Alaska; tracking a bike race across 580 blistering kilometers in the Simpson Desert in Australia; covering the

1,000-mile Iditarod dogsled race in Alaska from the air and from snowmobile.

Ask Shaw what makes him different from the hundreds of other photographers taking thousands of photos at sporting events and he will admit that he, too, shoots thousands of pictures to get the winning one. But his love is not "in-your-face hard action." He looks for context and lighting, and often keeps people small in a vast landscape. Or he catches them up close and personal, as in the tender photograph above.

• • •

They are all so young and earnest—the boy football players, the girl cheerleaders, the coed boosters. There is nothing frivolous about **BRIAN FINKE**'s photographs of American youth. They hold a key to the culture, a culture as exotic to outsiders

Brian Finke, *Untitled (Cheerleading #81),* Orlando, Florida, 2001

as the Dani people of western New Guinea are to Westerners. If you have lived it, you recognize it; if you haven't experienced high school and college football and cheerleading, then you need take a trip to Brian Finke's exotic world. Two, four, six, eight, who do we appreciate? Brian, Brian, Brian!

After studying at the School of Visual Arts for four years with Marc Asnin, Stephen Frailey, Marc Saba, and others and winning many of the school's top awards, Finke decided to do "social" photography in India. The experience convinced him to come home and concentrate on "where I came from." That was Texas and a family of cheerleaders. He remembers going to national cheerleading competitions to cheer on his two sisters. And when most Texas high school kids spent Friday nights in autumn in the bleachers watching their football team win or lose, Finke was rushing up and down

the sidelines with his camera as photographer for the school newspaper and yearbook.

Finke conceived of his project in three parts: cheerleaders, football players, parents. First he photographed the cheerleaders at competitions in Daytona Beach and Orlando, Florida. Then he photographed what he calls "their counterparts," the football players. "Parents" never materialized. "Doing this photo essay was like going back to high school," Finke observes.

Brian Finke brings a heightened quality to his documentary photography, achieved with the use of small Q flashes handheld by him or his assistant to overpower daylight. His work is immediately recognizable, both for its saturated color and for the subjects appearing larger than life, no matter the size of the print or reproduction. The series of cheerleaders

Norman Mauskopf, Spectators at Goodwood Racecourse, West Sussex, England, 1987

an Irish horse show demonstrates, a phenomenal people photographer, calling his camera "observant." Discussing his picture of the four-time Olympic discus champion Al Oerter, he said that if he photographed him too close up, he would make him look "superhuman." "I wanted to show that this was a sporting event," Cooke wrote, "performed in front of real people, and that Oerter was a very human being, struggling to do a very mighty thing. In the picture he's just a tiny figure. In Olympic history, of course, he's huge." And, perhaps his most revealing statement shows that his work and his life shared the same core values: "It [the horse jumping at the 1960 Rome Olympics] is a moment of grace, and gracefulness. That's what the Olympics should always be like."

It is certainly was what he felt life should be like, too.

• • •

Three bit players in search of a winning horse. Character studies don't get much better than this. **NORMAN MAUSKOPF** has a great track record. He has been photographing for thirty-five years, winning awards and publishing stunning books. His finest sports-related books are *Rodeo* from 1985 and *Dark Horses,* about the world of Thoroughbred horse racing, published in 1988.

• • •

Before **OSVALDO SALAS** went back home to Cuba to become one of Fidel Castro's most trusted photographers, he had a studio in New York City opposite the old Madison Square Garden, the one on Eighth Avenue. It was a perfect location for taking portraits of the boxers and other athletes who came to the Garden. But Salas's great love, before the Cuban Revolution, was photographing another revolution—the integration of American baseball in the 1950s. As Latinos and African Americans joined baseball teams, Salas made certain they were not invisible. He worked for Spanish-language newspapers and magazines published in New York, in Cuba, and throughout Latin America. His photographs helped turn scores of nonwhite baseball players into heroes for millions of people, especially nonwhite young men raised in poverty who imagined themselves playing professional baseball one day—and making good money.

Salas did not investigate photographically the "psychology" and physiology of the players as Charles Conlon did a few decades before. He was not as thorough as George Brace, who started photographing every aspect of baseball in 1929 with his mentor, George Burke, and continued through 1993, compiling an archive of more than ten thousand portraits of baseball players. Salas took many photographs not connected to his mission of celebrating baseball players of color, such as the one reproduced here, but his commitment to Latino and African American players was unwavering.

There is a portrait of Salas in the dugout with Yankee manager Casey Stengel, taken in 1958. The photographer is trying to size up the manager, the manager not giving an inch. One of his best pictures is of Minnie Miñoso, the "Latino Jackie Robinson," the first Afro-Latino big leaguer and the first to wear a Chicago White Sox uniform. Ernie

Banks, the first black player for the Chicago Cubs, is all youthful optimism in Salas's photograph. Willie Mays, the New York Giants superstar, shakes (white) hands and signs autographs. Salas photographed the first all-black outfield— Hank Thompson, Monte Irvin, and Willie Mays. When Salas made the decision to return to his homeland in 1959, he may not have known Castro would ban all professional sports, including his beloved baseball.

* * *

GERRY CRANHAM would never describe himself as an artist, he just is. He has the instincts without the rhetoric. But he can talk—and talk—about his life as a sports photographer. And how, with five children and a wife and no regular income, he supported his family and became the most distinguished and famous photographer of sporting events in the United Kingdom.

Osvaldo Salas, Cy Young throws the ceremonial first ball, caught by Yogi Berra, in the opener of the World Series, fifty years after he pitched for the Red Sox in the first unofficial World Series in 1903, October 1, 1953.

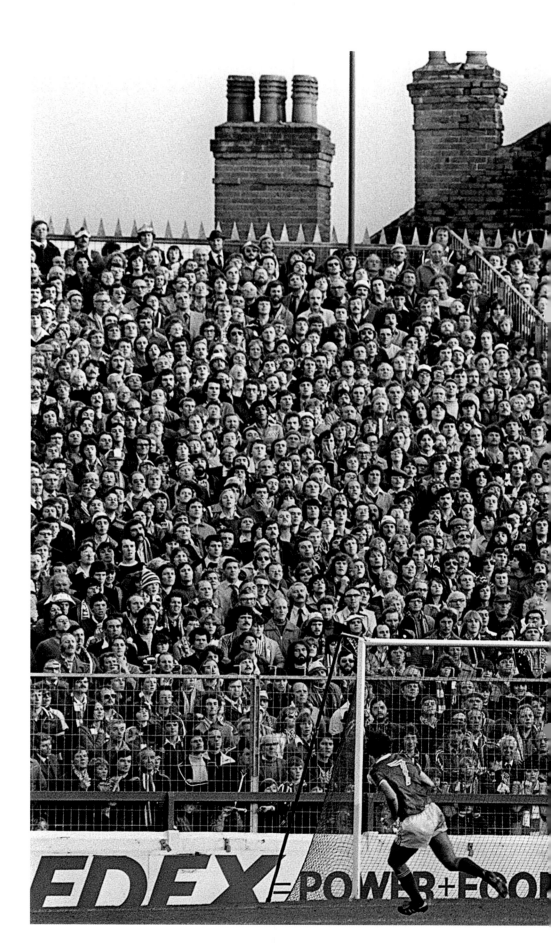

Gerry Cranham, "Fans filling the terraces behind the goal at the Nottingham Forest vs. Bolton Wanderers game," City Ground, Nottingham, England, October 20, 1979

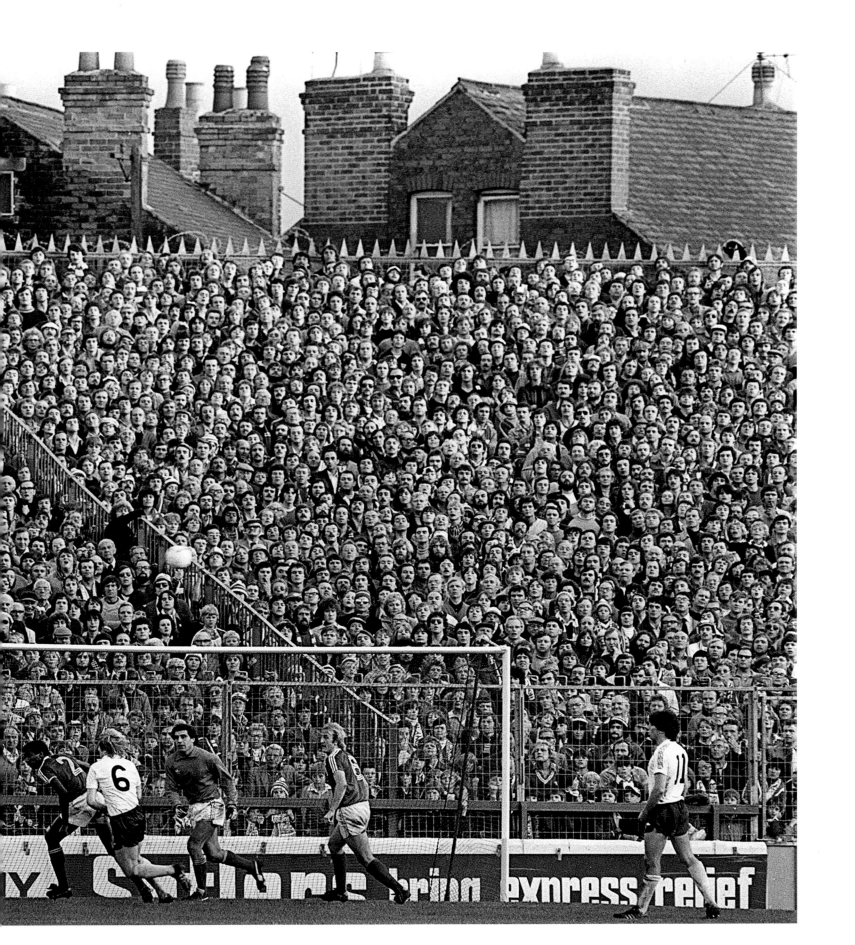

Cranham was an athlete, a middle distance runner, twice Southern Counties junior half-mile champion, and a torch bearer for the 1948 London Olympics. He picked up a camera only to help with his coaching responsibilities after a foot injury took him out of competition. He liked sports photography because he liked sports. Sports photography is physical and he wanted to stay active. At twenty-eight he became a part-time professional photographer, self-taught but inspired by the creative sports imagery of Erich Baumann and Mark Kauffman. Eventually, he joined Rapho picture agency, which also represented Bill Brandt and Yousuf Karsh. In the late 1960s and early 1970s, when there were almost no photography exhibitions in major museums in the United Kingdom, the Victoria and Albert Museum had a Henri Cartier-Bresson exhibition in 1968 and not another photography show until Gerry Cranham's in 1971.

The best way to understand Cranham's approach to photography is to look at his contact sheets. Yes, he would photograph the game competently and creatively, but he always turned his camera to the spectators. At the annual New Year's Day Celtic vs. Ranger soccer game (a hundred-year-plus feud between Catholics and Protestants) on January 1,

1963, in Scotland, the fans with hangovers from New Year's Eve were as interesting to Cranham as the players on the field. And the British newspaper *The Observer,* where his photographs regularly appeared, was happy to run the gamut of his imagery—straight, strong sports pictures; human interest stories; experimental photographs resulting from his innovations with multi-exposures, fish-eye lenses, remote control exposures, and dazzling new ways of depicting movement.

• • •

MAURICIO LIMA, a Brazilian working for *The New York Times,* did some of the finest coverage of the 2014 World Cup—of a sort. His first thought, when he received the assignment, was not about the championship competition. "Football could be the least important thing about this," he said. He was much more interested in how the World Cup presented an opportunity to focus on different rural communities living close to nature, with their own identities, but all loving football and rooting for their country. A man in the Amazon village of Sateré-Mawé, where this photograph was taken, told him he needed to hunt twice a day so his family did not go hungry. "But you could see, in his soul,"

Mauricio Lima, "Sateré-Mawé Indians watching the Brazil-Mexico match," World Cup, Nova Belo Horizonte, Brazil, 2014 (Mauricio Lima/*The New York Times*)

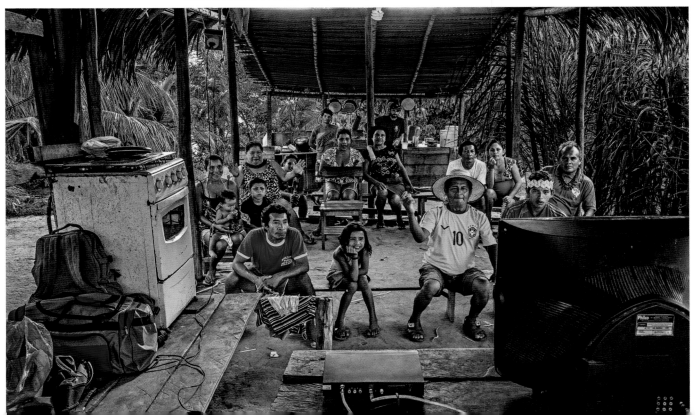

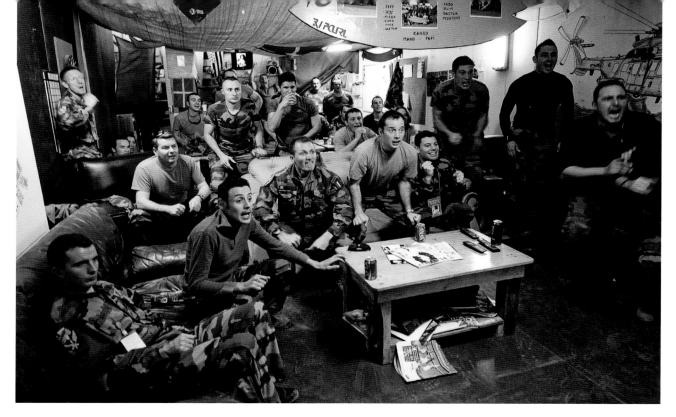

Franck Seguin, From the story "Afghanistan: Sport Under Fire," International Security Assistance Force watching as New Zealand defeats France by one point in the Rugby World Cup final, Kabul International Airport Base, Afghanistan, October 23, 2011

writes Lima, "he didn't need material things. He had the river, the fish, wild animals and, above all, the spirit of the community." But he did need to watch Brazil vs. Mexico.

Although now a recognized and award-winning conflict photographer working in hot zones around the world, Lima started his career as a sports photographer at a local newspaper. When doing this assignment for *The New York Times,* he had a déjà vu moment. Growing up in a poor neighborhood of São Paulo, he and his friends had no proper balls and made them from "socks stuffed with paper stuffed into more socks. We made it into the size of a grapefruit, until it was big enough to kick." While photographing the World Cup, Lima saw children playing with the same homemade balls. These children's football games became part of Lima's World Cup coverage.

• • •

Sports photography is, for the most part, a boys club, and within that fraternity is an inner circle of shaved-

head pros—Al Bello, Adrian Dennis, and **FRANCK SEGUIN**. American, British, French—but from the back, almost indistinguishable.

Enter the home of Franck Seguin, chief photographer for the French sports paper *L'Équipe* and deputy picture editor of the syndicate L'Équipe SNC, and his wife the picture editor Nathalie Franck Seguin, and you see books by Henri Cartier-Bresson, Walker Evans, David Doubilet, Margaret Bourke-White, and Ansel Adams. All the superior sports photographers—with and without hair—honor the great photographers and have learned from them. They see sports photography as part of the larger history, and do their best to elevate their profession.

Seguin speaks about the challenges:

In my opinion, sports photography is the most challenging specialty [of photography] as it requires physical qualities, technical abilities (using several lenses, shooting on the spot, working in the studio), and being able to adapt to

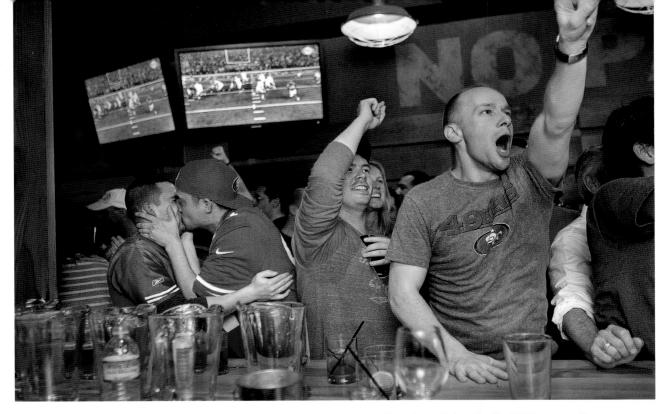

Deanne Fitzmaurice, Patrons at High Tops, San Francisco's dedicated sports bar for the LBGT community, watching the San Francisco 49ers beat the Atlanta Falcons 28–24, January 20, 2013

different places: sea, stadium, mountain, desert, boat, helicopter. . . .

Moreover, when you cover a sport event, it is being seen by everybody on different media—TV, internet . . . and the photographer has to catch THE moment that everybody saw. . . . There is a lot of pressure . . . [and] most of the time, the photographer cannot move. . . . It is so difficult to be creative . . . [yet] this is the sport photographer's job: making the best image despite the rules to obey and the many obligations.

A sport photographer can become a fashion photographer, a war photographer, a documentary photographer . . . but the contrary is extremely rare.

Oh, for the days when a photographer *could* move around the field. That is the one thing all the sports photographers lament. There was a time when they could stand, within reason, where they wanted and snap efficiently. Now they are herded together, contained in a small space, and take thousands of pictures every game. As one of France's most

respected photographers, Seguin still photographs the major sporting events, but he now prefers extended picture stories that give him both time to think and freedom to move. The photograph on page 57 of the International Security Assistance Force in Afghanistan is part of the extended, conscientious, creative documentation he enjoys.

Franck Seguin was born near the port of Dunkerque, where his grandfather worked. He learned to deep-sea dive at sixteen and has always loved the sea. (His underwater photographs of divers are sublime.) He enlisted in the French navy and was placed in a special unit that provided Seguin with the excitement he craved. Jumping out of an airplane, however, he injured his ankle. He was twenty-seven years old when he left the navy. He only knew he wanted a job with action, sports, and adventure. On a ski holiday in the French Alps, he saw people photographing skiers at the top of the mountain and thought as "that looked like a fun way to earn a living," as he told me. He did this for three years before someone, seeing his pictures, called him a "sports photographer." After that, he was hired to take the photographs for seventeen books,

each focusing on a different sport. In 2008 he joined *L'Équipe,* France's most prestigious sports publication.

. . .

This watering hole in the Castro district of San Francisco caters to the LBGT community, but is known for welcoming everyone not welcomed in regular sports bars. **DEANNE FITZMAURICE**'s assignment from *Sports Illustrated* was to capture the diversity of 49ers fans. She nailed it.

Fitzmaurice came to sports photography via photojournalism and the Academy of Art in San Francisco. She started shooting sports for the *San Francisco Chronicle.* She thought it would be fun to photograph the 49ers at the Super Bowl. At the end of the game, the editor asked her if she got the "blocked punt." She didn't have a clue what he was talking about, but good instincts resulted in her getting that and many of other key moments of the game. Learning terminology is easy compared to the art of seeing significant moments in sports and in life.

She was never happy, however, just photographing the games. She wanted to know who each athlete was—off the field as well as on. At spring training she walked up to Barry Bonds and asked him point-blank, "Do you have any problem with me photographing you and do you have any boundaries?" Her direct approach resulted in bonding with Bonds, and she has some of the most revealing pictures of the slugger. She admits that being a woman goes both ways in sports photography, but mostly it has been helpful.

Fitzmaurice, a Pulitzer Prize–winning photojournalist, is known for her compassionate coverage of sports figures and sports-related activities. She works for *Sports Illustrated* and ESPN, doing extended stories that often require special access, gained, she would say, through perseverance and a distinguished reputation. Her sports photography is centered on her search to understand what sports means in people's lives. She tries to tell the stories not being told.

. . .

The young nuns are ecstatic and the older nun holds a banner. The 76ers are their team and they are going to cheer as loud as anyone. This picture is an excellent example of **JOSÉ MIGUEL VILLEGAS**'s comment in an interview with me in San Francisco: "I am always looking for more than peak action. Something that has a longer life. Sometimes in a reaction. Sometimes a reaction to a decisive play. . . . The emotion is more appealing than peak action."

José Miguel Villegas, "Dominican nuns from Philadelphia, working in the San Francisco Bay Area, cheer their team," Oakland Coliseum, Oakland, California, 1986

• • •

Someone always has to be first and Michael O'Brien, seen here in all his glory, has the honor of being the first streaker in England to catch the country's attention. If this wasn't such a great photograph, his "historic event" would have ended up in the trash heap of history. Plus, if **IAN BRADSHAW**'s photograph didn't have the helmet covering O'Brien's privates, it would not have been published hundreds of times. The photograph launched scores of naked bodies running around in public. In Bradshaw's perfect depiction of the event, O'Brien's body language and long hair are reminiscent of many paintings of Jesus Christ. Tony Duffy captured the scene in color, but in his picture O'Brien's right arm is clasped by the English bobby, not outstretched with pointed finger. It makes all the difference.

Incidentally, the Twickenham crowd was gathered to see England play France in rugby. Duffy and Bradshaw, a freelancer for the *Sunday Mirror,* broke away from the pack shooting at the other end of the field and were the only two to record this great moment in British history.

• • •

THEO EHRET was "house photographer" for the seedy, raucous Grand Olympic Auditorium, where wrestling and boxing matches were hooted and hollered at by the joyous fans of boxing legends such as Ruben Navarro, Danny "Little Red" Lopez, Carlos Palomino, and Mando Ramos, and wrestlers such as Hulk Hogan, Jesse "the Body" Ventura, Killer Kowalski, and, of course, the incomparable André the Giant.

How rowdy were the fans? According to journalist and photo historian David Davis, "When fans approved of the fighters' efforts, they showered the ring with coins.

Ian Bradshaw, Twickenham streaker, London, 1974

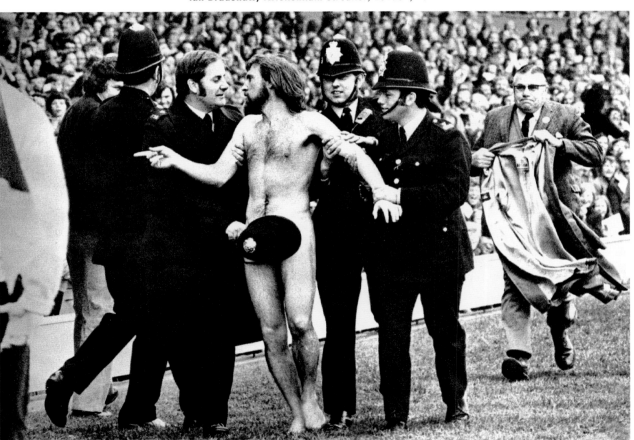

• • •

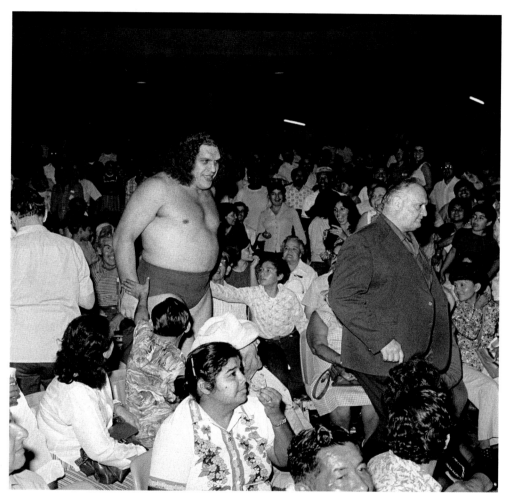

Theo Ehret, André the Giant, Grand Olympic Auditorium, Los Angeles, 1976

Displeased, they filled cups with urine and hurled them at the participants." Ehret covered every aspect of the goings-on at the Grand Olympic—press conferences, training, weigh-ins, the crowds, the fights, and general craziness—with his trusty Rolleiflex.

Davis met Ehret in 2004, eight years before his death at the age of ninety-one. Most of what is known about Ehret comes from Davis's intimate knowledge and his efforts to preserve the archive. Ehret was born in Mannheim, Germany, in 1920, lost a finger during World War II, and was in a prisoner of war camp in Italy. He and his wife arrived in Los Angeles in the early 1950s, and after working as a car mechanic, he finally could purchase a large format camera and found work as a photographer, setting up his own studio in 1963 on Sunset

Boulevard. His premises were near Dodger Stadium, but his personality drew him to the Grand Olympic Auditorium, where, as reporter Richard Meltzer wrote about the arena in *L.A. Weekly,* "What loomed as a sure-fire theatre-of-cruelty performance has turned out . . . to be something wholly other, maybe Pirandello by way of Bukowski, maybe pre-aesthetic ghetto street theater. . . . But no matter how you look at it, this is the thee-ate-er bargain of this or any year."

Ehret also shot lots of "girlie wrestling" photos, and these have been published by Taschen (naturally) in a coffee-table book titled *Exquisite Mayhem.*

· · · ·

Gordon Parks, writing in the introduction to *Muhammad Ali: A Thirty-Year Journey* by **HOWARD BINGHAM,** says that to know and really understand Muhammad Ali, one has to "sink deep into the geography of his soul." He continues, "Howard has done that with the sensitivity of a blind man." The dedication page of Ali's own memoir contain these words: "For Howard Bingham, there's no one like him." The boxer and the photographer are best friends.

Hundreds have photographed Ali, including some, such as Gordon Parks, who are among the greatest in the history of photography. But among professional photographers, only Howard Bingham photographed him like family. That is to say, with boundless love and little ego. Only Bingham had free rein. Over decades, Bingham captured the man he loved and who loved him back. "Perhaps once in a lifetime you meet a person who is so special that you think yourself blessed to have that person as a friend," Ali wrote in Bingham's book. Ali's wife, Lonnie, adds, "For the past thirty-one years, Howard and Muhammad have shared much: The victories and defeats in the ring. Muhammad's three-year exile from boxing. His conversion to the religion of Islam and the changing of his slave name [Cassius Marcellus Clay] to his chosen name of Muhammad Ali."

The boxing journalist Reg Gutteridge said Ali's most frequent refrain was not "I'm the greatest" but "Where's Howard?" Bingham was much more to Ali than "personal photographer." Sportswriter Jim Murray wrote, also in the introduction to Bingham's book, "He [Bingham] was best man at Ali's wedding. He went on the honeymoon. The

tabloids would have made him a rich man. Howard would have been horrified at the thought." Bingham "never betrayed a confidence."

Bingham wrote:

I have watched for thirty years how he [Ali] has changed the lives of people he has touched, making old people smile and feel loved, giving them a hug or a kiss on the cheek, showing terminally ill children his magic tricks and making them laugh, taking money from his own pocket to give to the hungry strangers he meets on the street, visiting homeless shelters and street people . . . soup kitchens . . . visiting those in prison . . . and standing in hotel lobbies and on sidewalks signing autographs for adoring fans.

Howard Bingham, born in Jackson, Mississippi, in 1939, the son of a minister and his wife, was also a child of segregation. He moved to Los Angeles with his family in 1943. In 1961, while working for the black-owned newspaper the *Los Angeles Sentinel,* he was assigned to cover the young boxer Cassius Clay, only a few years his junior. Neither he, nor most of the world, had yet heard of Clay, although he had won a gold medal in the 1960 Rome Olympics as a light heavyweight.

Bingham can't remember if it was a day in February or March 1962, but the events are forever fixed in his mind. Bingham attended Clay's press conference. Afterward, Bingham spotted Clay and his brother walking down the street and offered them a ride and to show them around the city. It was the moment their lifelong friendship began.

Bingham's earliest photographs of Ali were made in Los Angeles in 1962. From then on, they traveled together all over the United States and the world. Bingham's photographs show Ali with the kids he met on the street and the celebrities he met formally: the Beatles, Malcolm X, Jackie Robinson, Sam Cooke, President Nkrumah, Joe Louis, Nelson Mandela. Bingham was also there for the quieter moments with his trainer, Angelo Dundee, his parents, his wife and children. And to observe Ali's raised arms at the end of a successful match. Bingham, the sensitive and loyal friend, also felt the blows Ali took, in the ring but also during troubling times in the Champ's life.

Howard Bingham is not a one-subject photographer. Among his greatest photographs are those of the Black Power movement in the charged year of 1968 and an intimate portrayal of the often clandestine activities of the Black Panthers during the same period. *LIFE* gave him the original assignment in 1967 but never ran the story because they were never sure of the angle to take on the Panthers. That only means Bingham's recent book, *Howard L. Bingham's Black Panthers 1968,* with mostly unpublished photographs, is that much more important.

• • •

GEORGE STROCK was a crime and sports photographer before joining *LIFE* magazine and going off to the Second World War. In the annals of the history of photography, he is best known for his photograph of three dead American soldiers on the beach after the Battle of Buna, in Papua New Guinea, which cost three thousand Allied lives. Censors banned showing American war dead, but *LIFE* challenged the ruling. There had been two years of carnage and World War II was far from over. Even President Roosevelt, in 1943, gave permission to desanitize the visual coverage. Strock's picture

George Strock, Pitcher Satchel Paige with fans, New York City, 1941

changed Americans' perception of the war and the course of photojournalism.

A seeming lifetime before, but really only two years prior, Strock did a story for *LIFE* about the baseball pitcher Satchel Paige. The photo is self-evident. Nevertheless, the caption read, "Negro kids all over the country mob Paige." Teammate Buck O'Neil noted Paige was more popular among African Americans than Joe Louis, Count Basie, Duke Ellington, or Langston Hughes. Paige had an exuberance and fun-loving nature, which clearly comes across in this spirited picture. Look at the eyes of the boy second in from the right. Idol worship!

• • •

When *Sports Illustrated* started its trial dummy year, **TONI FRISSELL,** the only woman in the initial group of photographers, was assigned to photograph fox hunts, steeplechase races, and mule pack trips. The male photographers, many from working-class, immigrant families, would hardly know what end of the fox to photograph. Frissell was brought up with holidays at Newport and lunches and garden parties with the likes of Margot Asquith, Diana Duff Cooper, Lady Mendl, Katharine Hepburn, and Lillian Gish. She was experienced in the recreational activities of the upper classes, in the United States and Europe. Her two most famous bodies of work are the Jacqueline Bouvier and John F. Kennedy wedding and an extended essay on the huge and fabulously wealthy King Ranch in Texas.

Frissell had done fashion photography for *Vogue* in the 1930s and distinguished herself by taking her models outdoors and letting them move freely. She had a successful career, but when war broke out, she twisted some arms and was sent abroad to cover Red Cross operations. She had 250,000 flashbulbs shipped from the States and her work was published in *Collier's, LIFE,* and *The Saturday Evening Post.* When the war was over, so was her career in fashion. She wanted something more "real." She started doing photojournalism.

"My years working for *Sports Illustrated,*" she wrote in an essay for the catalogue that accompanied the exhibition *Man in Sport,* organized by Robert Riger for the Baltimore Museum of Art, on view from December 12, 1967, through February 11, 1968, "were very happy ones. How great to get paid for going to all the places you want to be anyway." She loved to ski, sail,

shoot pheasants and quail, mountain climb, and watch cricket, polo, and horse racing, and she persuaded the managing editor to let her photograph them all. Except for Jerry Cooke, no other *SI* photographer would feel so at ease at Blenheim Palace, Foxcroft in Virginia, or at the Vanderbilts' residence. She was to the manner born; Cooke was not but he had great style and spoke with an English accent. As George Plimpton wrote in the introduction to Frissell's book, "Toni was not one to be found in the photographers' pens at the ballparks or crouched at court's end at basketball games."

Man in Sport was the largest group of sports photographs ever assembled in a museum. There were sixty-eight photographers and two were women. Ylla had one picture; Toni Frissell had forty-nine.

Toni Frissell, Boccie players, Bois de Boulogne, Paris, 1964

Robert Capa, "Watching the Tour de France," Pleyben, Brittany, France, July 1939

• • •

The year was 1939. The photographer was only twenty-six, but already **ROBERT CAPA** had been described by *Paris Match* as the greatest war photographer in the world. For Capa, the Tour de France was a sweet twenty-day interlude between the recent war in Spain and the one he was about to record with brilliance, humanity, and bravery.

Europe was on the cusp of World War II when Capa was invited by *Paris Match* to cover the thirty-third Tour de France. Italy and Germany were no-shows. The Spanish team had been decimated in the civil war. This would be the last year of the Tour until 1947, when peace, the roads, and the strength of the people were restored.

Roland Barthes wrote a short book titled *What Is Sport?* to accompany his screenplay for the Canadian Broadcasting Company of the same name. He helps us understand that the Tour is more than a race; it is an annual renewal and connection of the French with their homeland:

> The Frenchman's geography [is known] by means of the Tour . . . the length of his coasts and the height of his mountains. Each year he recomposes the material unity of his country, each year he tallies his frontiers and his products.

After Germany occupied France in 1940, the Nazis recognized the nationalistic importance of the Tour de France and wanted it to continue. But it could never be. As well as a geography lesson, the race was also, according to Barthes, a morality lesson (making the Lance Armstrong doping scandal even more onerous):

Muscle does not make the sport; that is the evidence of the Tour de France. Muscle, however precious, is never anything more than raw material. It is not muscle that wins. What wins is a certain idea of man and of the world, of man in the world. This idea is that man is fully defined by his action, and man's action is not to dominate other men, it is to dominate things.

Capa used a light 35mm camera, better to shoot with from the back of a motorcycle over the 2,624-mile course. Capa, never a "sports photographer," shot a human interest story. The photograph of the children in front of the bicycle shop owned by French racer Pierre Cloarec is an example of Capa turning his back on the athletes in order to capture the excitement of the fans. Capa's documentation depicts multigenerational outings on summer days with the occasional biker pedaling past or changing a tire, having a rest, or picking himself up after a fall. The winter winds of war are only months away.

• • •

PAOLO PELLIZZARI, an Italian living in Belgium, travels the world with one companion named Noblex. It is a panorama camera with a lens that rotates 360 degrees for one exposure. The result of the curved film plane and constant shutter slit is an almost distortion-free 135-degree panoramic photograph. The view is similar to human vision. The Italian Pellizzari

Paolo Pellizzari, *Tour de France,* **Saint-Macaire-en-Mauges, France, July 2000**

and the German Noblex see alike. Pellizzari will not go to the Indianapolis 500, the Olympics, the Tour de France, or a rodeo in Albuquerque, New Mexico, without it. And he has to pack the only thing it likes for breakfast, lunch, and dinner—400 ASA color film.

Pellizzari started his professional photographic career at forty. He studied architecture and engineering at university and had successful careers in industry, finance, and as an inventor before committing to photography. Nothing he did in boardrooms compared to "watching people, their faces, bodies, and how masses move. I compare it to an opera stage," he told me; "the figures are around but it only gets interesting when the singing begins." He won't photograph a sporting

event unless there is real sports action. He is cognizant that most people experience professional sports on television. He is determined that his photographs give them another experience. He cites historical painting as inspiration as well as Jeff Wall and Andreas Gursky.

• • •

Great golf photography is great landscape photography. The best golf photographers in the field, such as **FRED VUICH,** respond to the contours and colors of the course, the shape and scale of the trees, the shifting clouds in the sky, and the patterns formed by sand pits, ponds, and shadows.

Vuich often uses a Mamiya 7 (6 × 7 cm format) manual focus rangefinder. No motor drive. He takes a picture the old

way—hold your breath and depress the shutter release at the perfect moment. The camera gives great quality, but equally important, it is quiet. This is golf. Shush. The Tiger Woods photograph, taken with this camera, became an instant classic when it appeared on the April 16, 2001, cover of *Sports Illustrated*. The picture editor, Matt Ginella, observed that the subject, Tiger Woods, shown at the top of his backswing, was only two inches tall, unlike most *SI* covers where the athlete's body and face fill the cover. It was subtle, it was elegant, it was golf.

Tiger is centered and the ball is between the two long shadows of his legs. You feel the balance in the photograph; you feel the balance of Woods's body as he executes his powerful, perfect swing. Vuich captures the bent shaft of the club. And the red polo shirt pops against the green grass.

In a telephone conversation with Vuich, he spoke passionately about making great pictures—but not great prints. His vehicle, like most magazine photographers, is the printed page, not the gallery wall. He has honed his skill to brilliantly capture the feeling of being on a golf course, not just the body language of the players. For sixteen years, Vuich was a staffer on *Golf Magazine* and then in 2001 started working with *Sports Illustrated.* His picture of Woods reproduced here was taken on his first assignment for the magazine. Hardly, though, beginner's luck. Vuich remembers holding a camera at the age of three and became a "professional" in 1981.

. . .

Google "Guillermo Vilas," the Argentine Grand Slam tennis star of the 1970s, and you get statistics. Study **RUSS ADAMS**'s photograph and you get passion and the elevation (literally) of the victor—be it war or sports—as old as the ancient Greeks. Many recall the last U.S. Open played in Forest Hills as the most bizarre—a transgender controversy, shocking breaches of etiquette, riotous fans, a jerry-built "spaghetti" racket made of Venetian-blind cord, a spectator in the stands shot from a

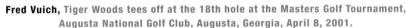

Fred Vuich, Tiger Woods tees off at the 18th hole at the Masters Golf Tournament, Augusta National Golf Club, Augusta, Georgia, April 8, 2001.

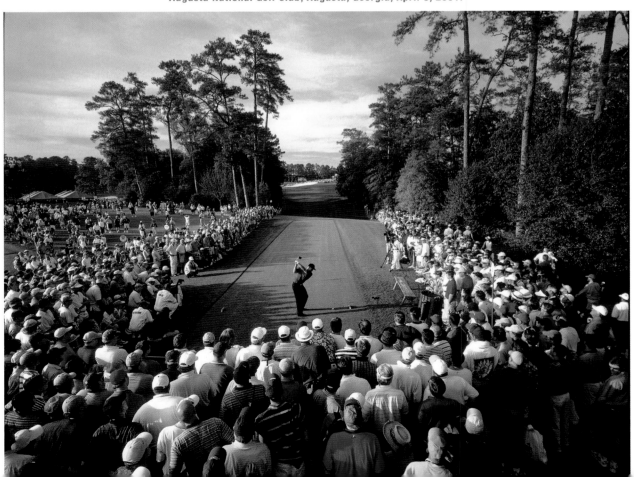

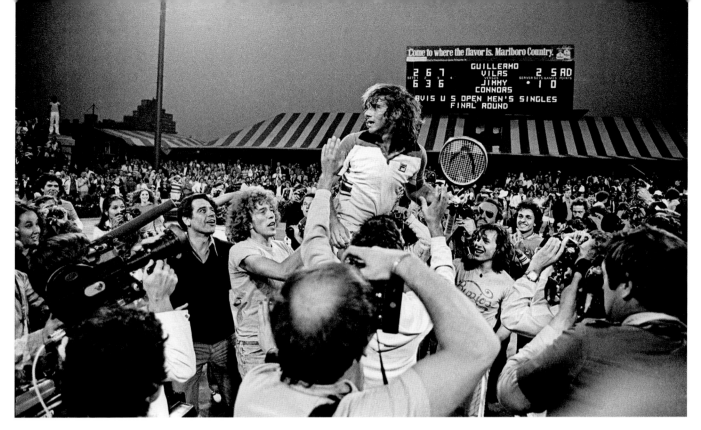

Russ Adams, "Guillermo Vilas carried off court after defeating Jimmy Connors," U.S. Open, Forest Hills, Queens, 1977

nearby building, and, as the photograph shows, a stampede onto the court by Vilas's supporters after he won the title.

Ask many of tennis's legendary players to name their favorite photographer and they will say Russ Adams. He is the only photographer inducted into the International Tennis Hall of Fame. If some of the players in 1977 forgot their manners, Adams made certain the photographers did not, and one of his contributions is a universal code of conduct for the profession. He is a father figure to many sports photographers, especially those who cover tennis, and has been around longer than most of them have been alive. At age fourteen, he started photographing in 1944 for his local newspaper. After shooting all types of stories for the *Boston Herald* for twenty years, he went freelance in 1971, eventually focusing exclusively on tennis.

For fifty years Adams photographed tennis matches around the world. He estimates his archive contains over 1.6 million images. But it is not just quantity that distinguishes his work. There is heart, as well as action. One of his most famous pictures shows Arthur Ashe's father weeping as he stood in 1968 on the podium next to his twenty-five-year-old son.

Arthur Ashe was the first African American to win the U.S. Open.

Sports photographer Clive Brunskill, writing about Adams, makes an analogy to top tennis players: "They can all play well in the top 100." He then goes on to explain how difficult it is for a photographer in this field to stand out and stand the test of time, as Russ Adams has done. "It is a bit of an art for us," Adams acknowledges. Russ Adams, who is proud of his years courtside, tells younger photographers that "if you see the ball, you don't have a good tennis shot." Anticipation is the name of the photographer's game.

• • •

On page 70 we have one of the greatest photographs ever taken at a sporting event, yet it is of one of the worst moments in sport's history. Thirty-nine people died, most Juventus fans, and six hundred were injured that infamous day.

EAMONN MCCABE took this picture for his paper, the London *Observer.* He took dozens of rarely seen photographs that day: people trampling each other, bodies pushed together so tightly they were being crushed, people lifting collapsed and

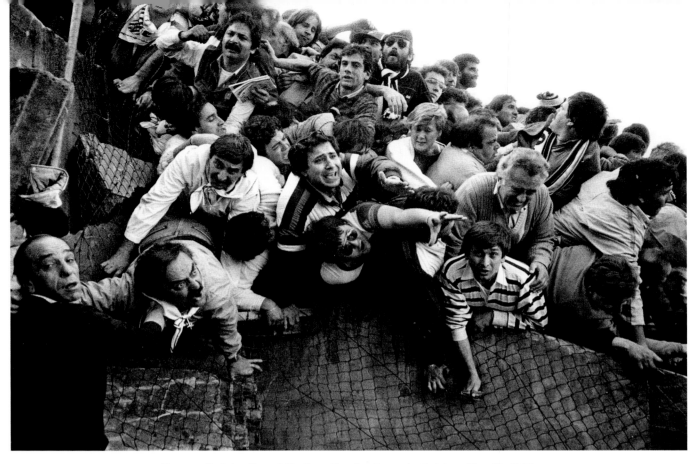

Eamonn McCabe, Heysel Stadium disaster, Brussels, Belgium, May 29, 1985

injured friends, firemen hauling dead bodies, people bleeding on stretchers, rubble everywhere. Unbelievably, after so much death and destruction, the European Cup final between Juventus of Italy and Liverpool of England was played in that stadium of disaster a few hours later. Juventus won 1–0.

McCabe hated that day. He was a sports photographer because the only front line he wanted to be at was at a sports event or, previously, the stage of a rock concert. His chosen level of discomfort was standing in the rain during a game. He wasn't a conflict photographer and never wanted to be one. He was, however, a keen observer, and he had noticed, before the start of play, a red "wave" going from one side of the stadium to the other. It was Liverpool fans moving over to Juventus's area and wanting trouble. "I ran over and shot two quick frames and then the wall fell," he told me. "All the people in the picture got out, but the next group got hurt or killed." He then ran down to the pitch and spent the next two hours photographing the wounded and dying. The picture was taken on a Wednesday but not published until the following Sunday. His reportage of the Heysel Stadium disaster won him News Photographer of the Year in 1985 and second prize in spot news in the World Press Photo contest.

• • •

CHRIS SMITH saw the Roma fans at the European Cup holding up their fireworks. He quickly put a 35mm lens on his camera and jumped the fence. He wanted to get face-to-face with these young men who look like revolutionaries at the barricades. You can almost hear the music from *Les Misérables.*

Smith was chief sports photographer for the London *Observer* from 1970 until he joined *The Sunday Times* (London) in 1977, where he worked for thirty years. Harold Evans was editor in chief during some of those years and valued strong, bold photography used well. With Chris Smith doing the black-and-white coverage of rugby, soccer, tennis, golf, horse-racing, and track and field, the back of

• • •

the paper held as much interest as any other section in this distinguished newspaper.

"You can't predict what you are going to take," Smith told me, but "in your mind's eye you can conceptualize a picture and focus on that." He gives as an example a photograph of the sprinter Allan Wells. "I . . . explore the idea of the energy he uses to come out the starting block."

When Smith started shooting sports, there were no telephoto lenses for his 1920s Zeiss Icon quarter plate camera that took ten glass plates. To hear sports photographers speak about "the early days" is a little like a Charlie Chaplin movie of constant running back and forth—from the playing field to the newspaper offices and back again. Meeting the deadlines for each edition meant shooting only the beginning of the game to meet the 4 p.m. deadline for the Scotland, Ireland, and Wales editions, then going back to the game because the second edition had a 7:30 p.m. deadline. And in between often developing their own film, making a quick print, writing their own captions, and handing it all off to the picture editor.

Chris Smith, Roma fans, European Cup Final, Rome, 1984

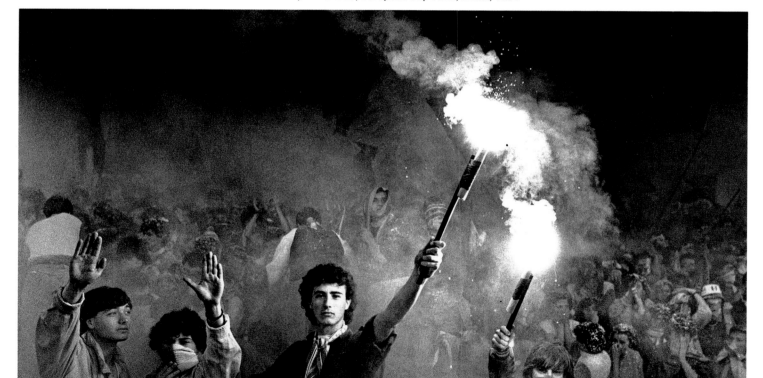

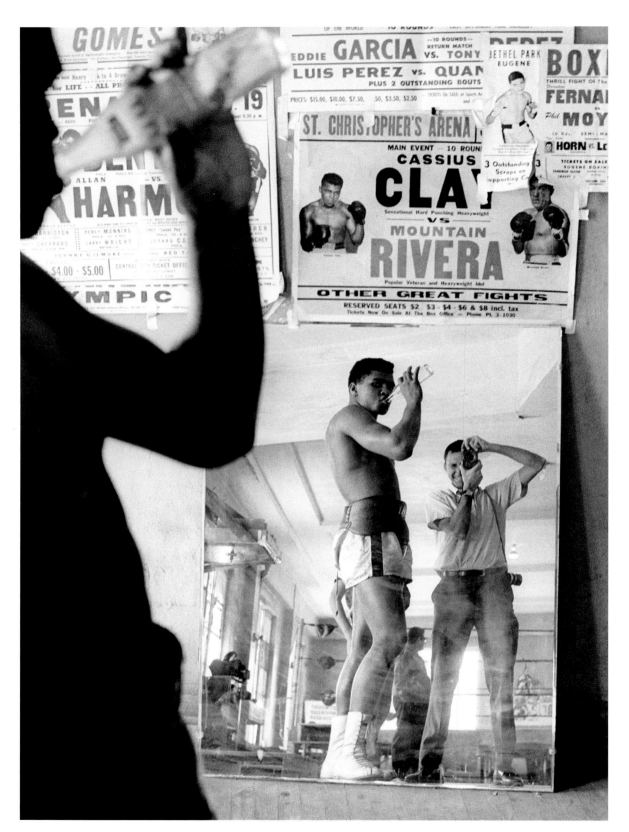

Marvin E. Newman, Marvin E. Newman photographing Cassius Clay in locker room, 1963

CHAPTER THREE
PORTRAITS

Portraits . . . one can feel the balancing strain between . . . reality and desire. . . . Now, just as two points determine a line, three a plane, and four a solid, so with five or more points of character we begin to imagine a human being. It is precisely this zigzag geometry which constitutes the art of the portraitist.

BEN MADDOW, *FACES*, 1977

• • •

Photographic portraiture has been described as both an ultimate lie and a great truth. Most portraits fall firmly in between. We don't become what we behold, but we do learn something about ourselves when we direct our focus on another human being. Portraiture allows for connection, and how and why we connect with another individual is fascinating. There is no doubt that millions of people throughout the world want to connect with their sports heroes—through trading cards and Panini collectible stickers, posters, and Wheaties boxes, signed prints and surfing the Web, and, of course, the covers of sports magazines.

Still portraits of athletes, famous and obscure, are the counterweight to the action. They allow for reflection. Most young people will not go deeply into the reasons sports heroes grace their bedroom walls. They simply *love* them, *admire* them, want to *emulate* them. These giants of the sports world stand guardian over these children while they do their homework, talk to their friends, sleep soundly in their beds. Sports magazines with their glossy portraits on the cover and inside are still some of the most popular publications in the world. Programs are purchased at the stadium, in large part, so that star athletes go home with the fan.

There are indelible portraits of the nonfamous athlete, the one who will never be on the cover of a sports magazine. Art photographers are drawn more to the high school footballer, the amateur boxer, the struggling gymnast, the young bullfighter. Artists such as Catherine Opie, Nicolai Howalt, and Rineke Dijkstra capture the look of transformation in an individual when they pass from a position of safety to physical and mental risk taking. These artists make us care about their subjects as individuals, their struggle, not their ultimate achievement.

Most portraiture is of the human face, but details of legs, necks, hands, and feet provide an intimacy with athletes not gained watching them compete. Athletes have mastery over their bodies even when they can be tentative and shy staring into the cold camera lens. These "portraits" sometimes have a fluency not achieved by more traditional representation.

Arthur Griffin, *The Swing*, Ted Williams, 1939

• • •

ARTHUR GRIFFIN photographed the same way he was trained as an illustrator—to look for the line. In his photograph of Ted Williams, known as the Splendid Splinter, Williams's arms are parallel, perpendicular to the bat; his legs form an equilateral triangle; the face, in three-quarter profile, has the long neck lined up with the right ear; the twist of the body reveals the essential words—Red Sox. The bonus—color. It was the first known color photograph ever taken of Ted Williams. Arthur Griffin was a pioneer in the use of color film.

Griffin was born in Lawrence, Massachusetts, in 1903. After a number of jobs in design and illustration and studying photography with John Garo, whose students included Yousuf Karsh, he became in 1936 the exclusive photographer for the new *Boston Globe Rotogravure Magazine*. He photographed many subjects in color for the first time, including boxer Joe Louis. His archive of 75,000 images is housed in a nonprofit photographic museum, the Arthur Griffin Center for Photographic Art, outside Boston.

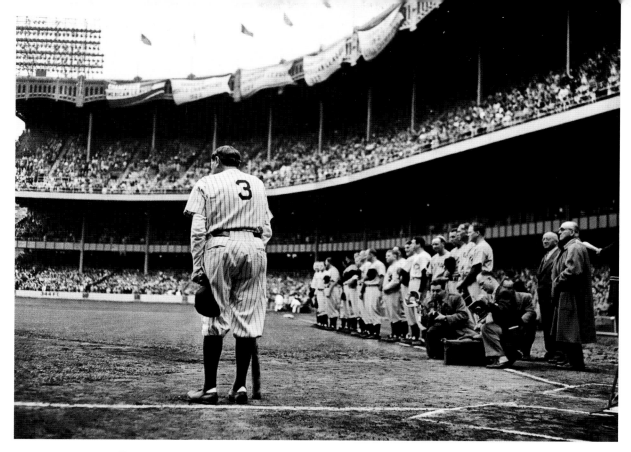

Nat Fein, *The Babe Bows Out,* **the final farewell, Yankee Stadium, June 13, 1948**

• • •

What makes for an iconic photograph? It is not simply that the subject or the event is significant, although that is part of it. It is because the image locks itself in the brain and holds on tight. In this photograph, the fifty-three-year-old Babe Ruth is saying goodbye in the house he built, leaning on his bat as if it were a cane, body bent but still stately and wearing the number 3 that would soon be retired. The genius of this photo, the first sports photo to ever win a Pulitzer Prize, is that it is taken from behind. Because, without a face showing, the body is a blank canvas upon which the viewer can project whatever memory of Babe Ruth they choose: the Babe is young, the Babe is bold, the Bambino is hitting a home run to right field, the Sultan of Swat as every boy's hero. We feel close to Babe Ruth in this photo, standing right behind him, experiencing the emotional moment with him. **NAT FEIN** told the legendary sportswriter Roger Kahn, "I shot the Babe from behind because all the photographers' spots up front were taken." The power of this picture is that we know Babe Ruth is *remembering his days of glory* as he takes his final bow.

CATHERINE OPIE has been photographing her LGBT community ever since art school. Her friends and life experience ground her work. As the mother of a boy, she is naturally inquisitive about, as Guggenheim curator Jennifer Blessing writes in her catalogue, *Catherine Opie: American Photographer* (2008),

> how masculinity is constructed for male subjects. Now, rather than traveling the country to document lesbian families or the American landscape, she travels to shoot high school football games. She has begun to look at a different community while continuing to explore her perennial interests in gender construction and notions of documentary reality.

Catherine Opie has a huge heart. It is impossible to view her photographs without experiencing the tenderness and care she feels for each person before her camera. She understands that to ignore/not see another human being is a terrible

indignity. Growing up gay, she insisted on being seen, and she enables others to be seen as well.

Opie photographed two sports: football, described by others as not a contact sport but a collision sport, and surfing. Her surfers are embraced, womblike, in large bodies of water. In one group, they are points on the horizon and it is the gradations of color in the sky and water that is her subject. When the surfers emerge, however, holding their boards, we are back to her penetrating portraiture. She follows a

similar model with her football photographs taken five years later. She sees the team playing in a distant landscape—mountainous, suburban, or ill defined. The action she captures is the anti–*Sports Illustrated* version. Nothing on the field is dramatic. What is dramatic are the portraits of the young, expectant, unsure faces of the teenage players. One wants to thank Catherine Opie for introducing us to them. It is an honor and a privilege.

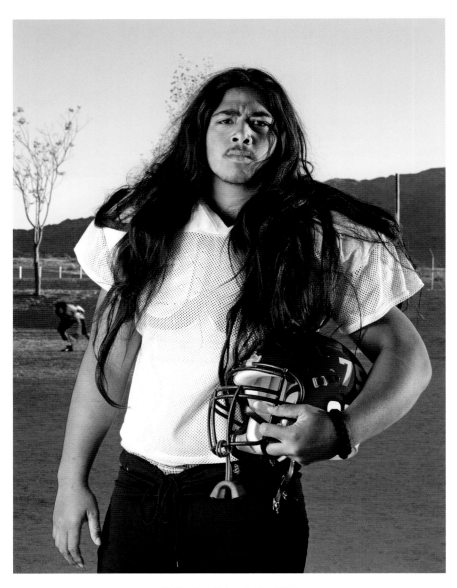

Catherine Opie, *Rusty,* **2008**

In the gloom of 1939, at the age of sixteen, the Czech photographer **VÁCLAV CHOCHOLA** began taking sports photographs and having them published. He was an active sportsman and had a Voigtlander camera. Why not photograph what he loved and make some money? He was young and going to do what he enjoyed, even as the old men of Europe led them to war.

The following year, Chochola buys a Zeiss Ikon camera, drops out of school, enrolls in photography classes, and apprentices to a photograher in Prague. In terms of photography, Prague was not just "another" European capital. It had one of the richest photographic histories and some of the greatest living photographers, including Josef Sudek and Jaromír Funke.

While branching out into other areas of photography, especially theater, Chochola always returned to photographing his first love, sports. With an understanding of modernism, he photographed fencing, soccer, hockey, track and field, and horse, car, and motorcycling racing.

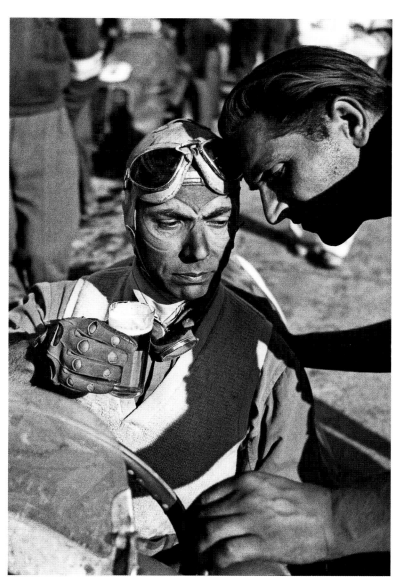

Václav Chochola, Racer, Grand Prix, Brno, 1949

· · ·

Among sports photographers, the name **VERNON BIEVER** is spoken with reverence. His two sons, John and Jim, keep the Biever name alive with their own contributions to sports photography, but that is not the reason that Vernon is remembered. He was from another era when because of his passion for photography and the Green Bay Packers, he showed up every week no matter what the weather (a trait of all Packer fans) to photograph the game. He almost always got something wonderful on one of his six pieces of film for his Speed Graphic. Perhaps that is the reason for the reverence. In the 1940s and 1950s he had to pre-focus his 50mm lens on a spot on the field and wait until the players ran into his sightline. If it was a special game, he might shoot eight or ten pictures. He wrote:

By the nature of that equipment, a kind of discipline was forced on us. It was good training in learning how to anticipate action. You could practice your knowledge of football. You learned to be precise. You had to learn to really wait until you thought it was the exact time to snap the shutter.

By 1959, things had changed. He had a Nikon with a 135mm lens and would shoot three rolls of 35mm film. Still, it was single frame, no motor drive, and you had to follow focus. He would produce a few hundred pictures in a season. There were few lucky accidents in Vernon Biever's day. To get a good picture, you had to be a good photographer. And, for Biever, a good picture wasn't just a well-focused and well-seen shot. The photograph had to "tell a story."

Vernon Biever, Forrest Gregg (left) and Vince Lombardi (right), ca. 1960

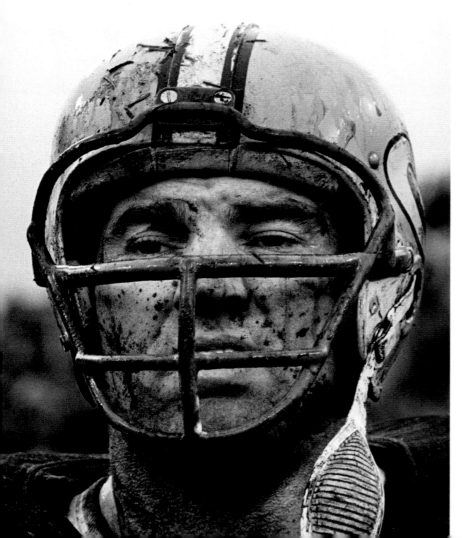

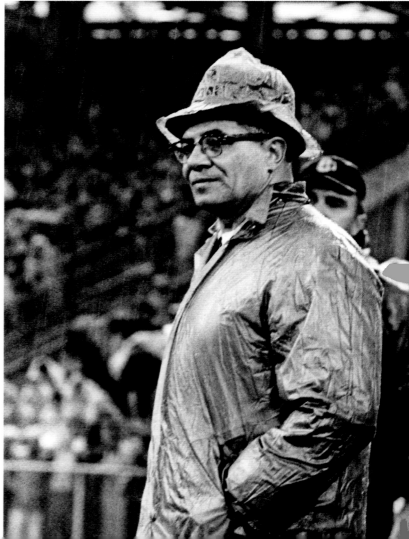

• • •

The Biever story is an American immigrant story. His grandfather came in the 1820s or 1830s from Luxembourg. Vernon Biever was born in 1923 in Sheboygan, Wisconsin, which was the closest hospital to Port Washington. Port Washington had Bievers owning the Ben Franklin five-and-ten-cent store for generations. Jim Biever is the official photographer for the Green Bay Packers, and still lives and manages the Vernon Biever archive in the town where his father lived his entire life. The site of the former corner five-and-dime is still owned by the family but is now the Biever travel agency. It isn't a denigration to say that Vernon Biever couldn't have achieved what he did in a big city. He was a small-town boy who liked to tell small-town stories, even when the football team that held the small towns together was big league and big time.

There was not much to do in Green Bay, Wisconsin, on a Sunday afternoon except attend a Packers game. That is why the stadium, which holds 80,000, sold out every week. (Green Bay itself has a population of 100,000.) The fans didn't seem to mind the variable, and often almost unbearable, weather. Vernon Biever loved it because it meant his pictures never looked the same, and rain, snow, and mud are the stuff of great football photos.

Another reason sports photographers revere Biever is because he was loyal to one team and photographed them for seventy years. He started photographing the Packers in college and didn't get paid by them for his work until the 1970s. He did make a few dollars when he sold a picture to the newspaper.

By the 1960s, Vernon Biever had enough Packers photographs to come up with book projects—and this from a man whose goal was one great photograph a year. He continued to photograph, with assistance, until 2007, three years before his death. Some people say his photographs put the Packers in the public consciousness as much as their winning records. He gave them their history and is in their Hall of Fame. Because he saw the drama of football, his photographs have as much emotion as action.

• • •

CHRISTINE OSINSKI is such an excellent professor of photography at the Cooper Union that it is easy to forget she is also a masterful photographer with a deeply moving and intelligent body of work. A graduate of the School of the Art Institute of Chicago (BFA) and Yale University (MFA), she is best known for her series *Drawn to Water,* done between 1984 and 2006, with long breaks in between. The photographs are of the Staten Island Synchrolites, a female synchronized swimming team whose members range from young to old.

Osinski reminds us that before Title IX provided more opportunities for women in sports, synchronized swimming

• • •

Christine Osinski, *Boy with Catcher's Mask,* ca. 1995

was a popular team sport for girls and women. They learned discipline while benefiting from the exercise. Competing gave the swimmers a sense of closeness and pride. As an artist, Osinski was *drawn to* the patterns the bodies made in the water. She was also *drawn in* by the looks on their faces and their body types, seen so clearly in bathing suits. Her locker room and poolside pictures are never demeaning, nor are they flattering. They are, however, honest. The media makes us believe there is only one slim, young body type worth looking at and valuing. Osinski's photographs prove otherwise.

The break Osinski took from photographing the Synchrolites coincided with motherhood and the demands of a full-time teaching position. As her son joined Little League and her sculptor husband coached the team, she was a dutiful mom coming to the games. But she couldn't leave the artist behind. She did wonderful black-and-white pictures of children *drawn to* bat and ball. The young catcher Michael, on her son's team, is seven years old. He had crossed eyes and poor vision and had magnifiers in his glasses, but "he could hit the ball with strength and ran the bases with a lot of speed," Osinski recalls. She says of her picture of Michael, "He seems encaged, a bit lost in there, but protected . . . his vulnerability comes across."

• • •

NICKOLAS MURAY was born Miklos Mandl in Hungary in 1892. Many Hungarians, past and present, say Hungary produced

the best photographers in the world. They have a strong case—Robert Capa, André Kertész, László Moholy-Nagy, Sylvia Plachy, Martin Munkacsi, Nickolas Muray were all born in Hungary.

Muray was a successful portrait photographer in New York City in the 1920s and 1930s. His portraits of celebrities in New York, California, and Europe ran in most of the major magazines and newspapers. His 1927 picture of Babe Ruth seated, holding a bat, and wearing Yankee pinstripes and cap, is the image of Ruth many people remember best.

Muray was a pioneer in the use of color photography in mass-market magazines. When the *Ladies' Home Journal* gave him a four-year contract in 1930 to do fashion in color, he traveled to Germany to buy the most up-to-date equipment. He became known as the master of the Carbro process, the most beautiful color process at that time and the most permanent.

Cream of Wheat Boys Playing Football is a wonderful example of his commercial work and Carbro printing. You can feel Muray directing the boy models. A makeup artist probably rubbed the mud on them. In the foreground, we see a boy from the waist down—bare calves, woolen britches, leather shoes unconvincingly unscuffed. In the middle of the picture is a boy with a radiant smile holding the football, pretending to be tackled by the helmetless, shoulder-padded boy whose face is turned away. All eyes are glued on our little hero. There is a mysterious bent leg wearing a Converse sneaker. In the background, adding balance and weight, is a faceless boy topping the human pyramid.

In 1934, the first year Wheaties put portraits of athletes on their cereal boxes and declared their cereal "the breakfast of champions," Lou Gehrig figuratively sat at the breakfast table with thousands of Americans. He was the first champion on the cereal box. The portraits of famous athletes on Wheaties boxes, still popular today, are an important part of sports

Nickolas Muray, *Cream of Wheat Boys Playing Football,* 1936

Keith Sutton, Aryton Senna, Jyllandsringen, Denmark, August 22, 1982

photography. Cream of Wheat had a different angle, but also associated sports and a good breakfast.

Three photographers in this book went to the Olympics as athletes: Thomas Pelham Curtis (1898), Nickolas Muray (1928 and 1932), and Co Rentmeester (1960). Muray was on the Olympic fencing team and was at the Tokyo Olympics in 1964 as a judge.

• • •

KEITH SUTTON and Aryton Senna had a special relationship, but when Senna got behind the wheel of his race car, the concentrated look on his handsome young face was captured by many of the world's best motor-racing photographers. It was behind the scenes that Keith Sutton's photographs of Senna stand alone. At Senna's second race, the Brazilian asked Sutton if he would provide him with the photographs he needed for his own use. The two men were the same age, liked each other, and together built an important archive of Senna's all-too-short racing career.

• • •

Black boxers were the first athletes to break the color barrier of sports in America, and Joe Louis was the first to become a national hero. Writing a profile of him for *Vanity Fair*'s September 1935 issue, Paul Gallico fell into racial stereotyping without even trying: "I felt myself strongly ridden by the impression that here was a mean man, a truly savage person, a man on whom civilization rested no more securely than a shawl thrown over one's shoulders" and then added admiringly, "perhaps for the first time in many generations the perfect prizefighter." And this compliment is immediately followed by "I had the feeling that I was in the room with a wild animal," and then Gallico commented on his "fine white teeth," with its double meaning—Louis has done a good job protecting his face; the "whiteness" is stark against dark skin.

The elite media introduced its readers to very few African Americans, and most of these were accomplished athletes or musicians. Describing great sports figures in terms of

animalistic traits did them and their minority communities no service. This is the reason the photographs in a publication such as *Vanity Fair* are so sociologically fascinating as well as artistically significant. The pictures published of African Americans are much more dignified than the words accompanying them. Photographs, of course, lie, but they can also tell a greater truth than prose.

In **LUSHA NELSON**'s photograph of Joe Louis (page 84), he is portrayed as strong and sensitive, due in large part to the modeling of his face and shoulders with beautiful light. Ironically, this black man, born in Alabama, whose grandparents were slaves, was the great American hope against the German Max Schmeling in the heavyweight championship title fight of 1936. Ironically, too, Schmeling was Hitler's great Aryan hope against the Negro, but Schmeling was no Nazi and carried the German Iron Cross with a strong dose of shame.

Accompanying Paul Gallico's article on Joe Louis is, for some bizarre reason, the photograph of Jesse Owens by Lusha Nelson. (Nelson's photograph of Joe Louis appeared in the following month's issue.) The single portrait titled *Dark Lightning* is described as a "group photo" of "Jesse Owens, colored 100 yard star; Jesse Owens, 220 yard world's record holder; Jesse Owens, broad jump champion and world's record holder at 26 feet, 8½ inches; and Jesse Owens, 220 hurdle champion and world's record holder." It is a powerful portrait making good use of the diagonal to suggest forward motion. Nelson skillfully shoots a bolt of light (lightning) along Owens's left arm, along the ridge of his head, and down over his shoulder. Owens did not compete shirtless, but in this photograph he wears only white shorts, showing off a powerful thigh. It is hard to know if Nelson was consciously referencing Mercury or unconsciously a slave.

Lusha Nelson might be as well known as his contemporaries at Condé Nast, Edward Steichen, Cecil Beaton, and Baron de Meyer, if he had not died in 1938 at thirty-one. He took many of the best portraits of athletes in Condé Nast publications between 1933 and his death. Another notable picture is his photograph of Mildred Ella "Babe" Didrikson, champion female track star and golfer and all-American basketball player, published in *Vanity Fair* in January 1933. Nelson's straight-on portrait of "Babe" in dark

sweatshirt and short-shorts, with her closely cropped hair, is one of the most sexually ambiguous portraits the magazine ran in this period. Compared to all the frilly-frocked, demure ladies and Hollywood femme fatales that were a dime a dozen in *Vanity Fair* in the 1930s, this photograph comes as a shock.

<center>• • •</center>

Soon after **GJON MILI**'s stroboscopic photograph of fencer Arthur Tauber was taken, both he and Dr. Harold Edgerton, his mentor and associate at Massachusetts Institute of Technology, were engaged in the war effort. Their knowledge and experience with the newly developed electronic flash and stroboscopic technique were invaluable for aerial reconnaissance, ballistic testing, night photography, and more.

Beaumont Newhall, director of photography at the Museum of Modern Art in New York, also went off to war and put his wife, Nancy Newhall, in charge of the new photography department at the museum. If the men were engaged in direct action, she would devise an exhibition that showed how photography straddled science, art, technology, and even the war effort. In 1943 *Action Photography* opened at MOMA and then traveled for the next two years to twelve museums. Gjon Mili's contribution to "action photography" was considerable.

Dr. Harold Edgerton cared about aesthetics, but his primary concern in his high-speed photography was always scientific knowledge. Mili, born in Albania in 1904, had a degree in electrical engineering from MIT and for ten years did research at Westinghouse Electric Company while working with Edgerton producing electronic flash and stroboscopic images. His photographs were so impressive they caught the attention of *LIFE* editors, and in 1939 he became a freelance photographer working for the magazine. It is often mentioned that Mili was the first person to use electronic flash and stroboscopic light to create photographs that had more than scientific interest. The point of Nancy Newhall's exhibition was to show the relationship of photography and time; the show was divided into "Highspeed Photography," "Normal Exposure," and "Prolonged Exposure." Although Moma never has done a "history of sports photography," in some ways the 1943 exhibition *Action Photography* is the closest they have come to a scholarly review of the development of this branch of photography.

Lusha Nelson, *Joe Louis* for *Vanity Fair,* October 1, 1935

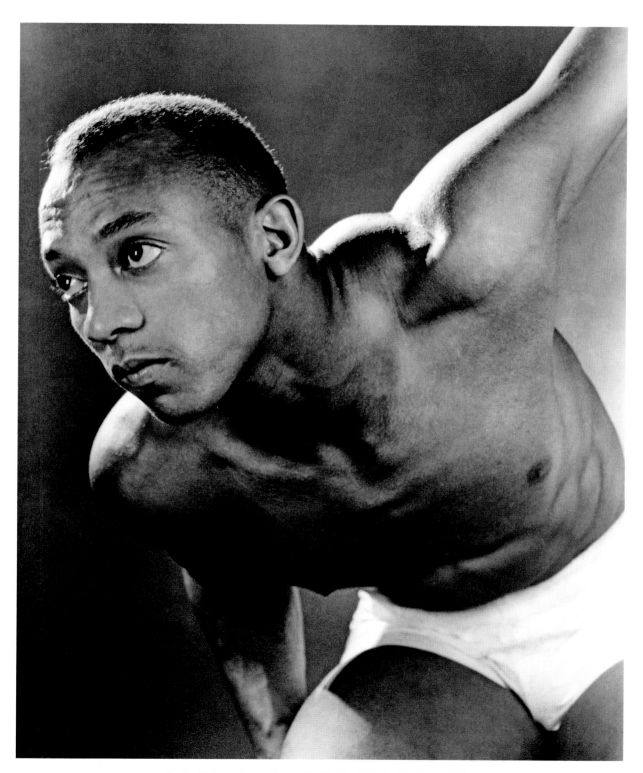

Lusha Nelson, *Jesse Owens* **for** *Vanity Fair,* **September 1, 1935**

Gjon Mili, Arthur Tauber, fencer, performing a counter-parry, 1942

Annie Leibovitz, Magic Johnson, Los Angeles, 1989

ANNIE LEIBOVITZ has photographed many athletes. "Athletes are proud of their bodies," she wrote, and few photographers are as skilled as Leibovitz at showing bodies sensually and dramatically. Because they use their bodies in "performance," athletes are comfortable being directed and controlled by Leibovitz. They know the resulting picture is going to be special. Leibovitz brings lights, cameras, assistants, and her enormous creative talent; the athletes bring their primed and muscular bodies. The fun of the Magic Johnson picture is that he is normally reaching for the rim. Bent over, boxed in, he is all arms and legs, and one could swear his right arm palming the basketball is an extension of his leg.

Leibovitz enjoys photographing athletes training. She gets the movement, the speed, the action but not the stress of competition. One of her earliest sports photographs was of Edwin Moses preparing for the Los Angeles Olympics in 1984. She was learning how to get a moving athlete in the frame. She discovered if she saw Moses jumping the hurdles in the viewfinder, she was too late.

The Atlanta Committee for the Olympic Games in 1996 commissioned her to do a portfolio of portraits of American athletes. She spent two and half years on the project, resulting in the book *Olympic Portraits.* It is lovely to see these young men and women centered, calm, and doing what they do best.

• • •

LYNN JOHNSON, a contract photographer for *National Geographic* and frequent contributor to *Sports Illustrated,* is known for her deeply researched, carefully crafted photo essays in black and white. Even though one of her photography teachers was John Pfahl, the experimental color art photographer, Johnson is "old school," her work more like Dorothea Lange and Margaret Bourke-White, two of her photographic heroes.

In an interview with me in 2013, she said, "The photographer as celebrated entity is off the mark and troubling. . . . You should stand with your work, not in front of it. . . . Hopefully, [I] bring to stories a thoughtfulness and patience and try to understand what is going on—not the action, the humanity on and off the field of play. Who are these people?"

Studying the trajectory of Johnson as a photojournalist, especially in sports-related fields, is a crash course in how not to be pigeonholed as a woman. Her photographic education at the Rochester Institute of Technology was rigorous and prepared her for all types of assignments. Unfortunately,

Lynn Johnson, "Romanian women's team gymnasts, world champions," Deva, Romania, 1996

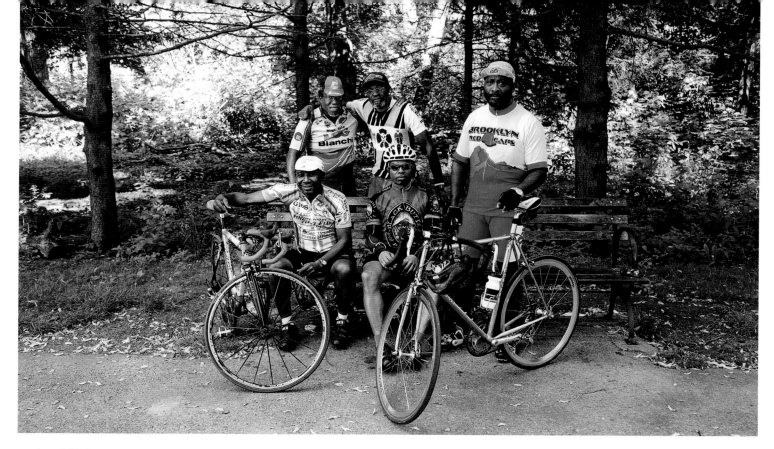

Jamel Shabazz, "Veteran Brooklyn professional bikers relaxing after completing a traditional Sunday morning bike ride in Prospect Park," 2009

turning up at her job at the *Pittsburgh Press* as the first woman staff photographer, she was assigned "tea parties and social events." The editors refused to give her hard news, so she just took the assignments and went out the back door before anyone could stop her. She soon recognized that her métier was the extended picture story.

Steve Fine, former director of photography at *Sports Illustrated,* saw that Johnson could bring something to sports photography the guys were missing. He sent her to the Olympics in Athens. She said that her approach to photography compared to the men's was like "being in a different culture, speaking a different language. Their gear was big and grand and they set up tons of remotes and had lots of assistants. I had a knapsack full of gear."

Johnson has done picture stories on the Paralympic athlete and model Amy Mullins. Another is on women who train for the Olympics but who are stopped from going to the Games: in Muslim countries it is because of religion; in Uruguay because of machismo; and in Botswana because of lack of money.

One of Lynn Johnson's most moving essays is on the Romanian girls gymnastic team. She shows their six-hour daily training and their communal life. In our interview, she spoke about how these young gymnasts are "manipulated psychologically." Speaking about the photograph of the puzzle reproduced here, she says, "For me, it is an image about a child who is broken as an athlete. She is allowed to stay because she serves a purpose. She is almost like a mascot. She is playing with this puzzle. Clearly in this puzzle, any girl is expendable and can be removed."

. . .

For more than forty years, **JAMEL SHABAZZ** has photographed his community in ways radically different from the news media. Shabazz's tender pictures of ordinary people doing their thing serve as counterweight to the sensationalism that rules the day. America is a richer, more honest place because of Shabazz's understated but profoundly important pictures.

Shabazz grew up in Brooklyn looking at the photo books belonging to his photographer father. The work of Robert Capa, Leonard Freed, Gordon Parks, Philip Jones Griffiths,

Jill Freedman, and Robert Sengstacke helped him understand composition and commitment to a subject and a cause. But their style would not be his. Shabazz is known for his unique vision—a street photographer who allows each subject to bring out the best in himself or herself. In this regard, he is most closely aligned with Walker Evans.

The most kindly and generous of men, Shabazz looks for nobility and goodness in each and every one of the people he photographs. The people shine, wearing contemporary fashion. *Where* the photographs are taken—on the mean streets of New York, against graffiti-covered walls, in subway stations and in courtyards of public housing as well as in parks and at the beach—adds complexity to his richly colored, beautifully lit, straightforward portraits.

. . .

The diptychs in the series *Athlete/Warrior* by **ANDERSON AND LOW** are formal portraits of young men and women in uniform—the uniform of the cadet/the uniform of the athlete. The military requires external uniformity, but neither warfare nor sports can be controlled or predicted. In this series of portraits, every soldier and sailor is centered and self-possessed. The black-and-white photographs evoke classic sculpture. This approach is meaningful as the artists are depicting mythological archetypes. Soldiers train physically to prepare for the worst, but what they want more than anything is to prove themselves worthy without the cruelty, death, and destruction inherent in battle.

Anderson and Low, *William Reynolds, Gymnast,* United States Military Academy, West Point, New York, 2001–2002

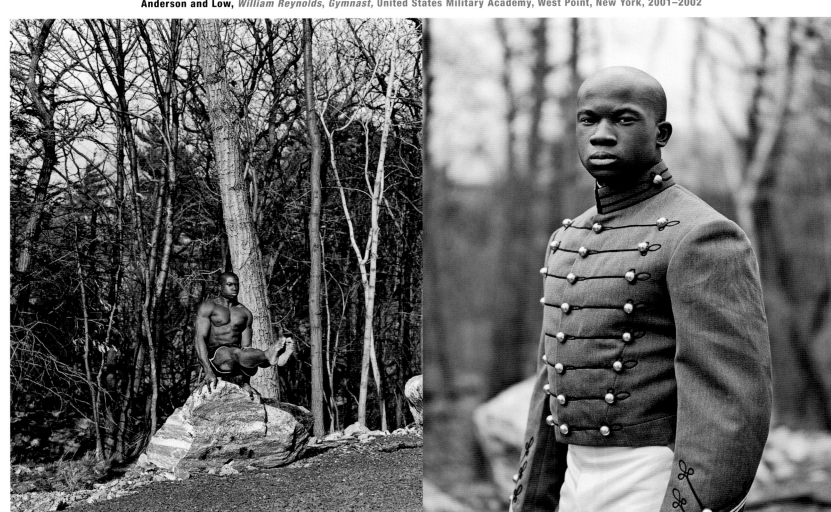

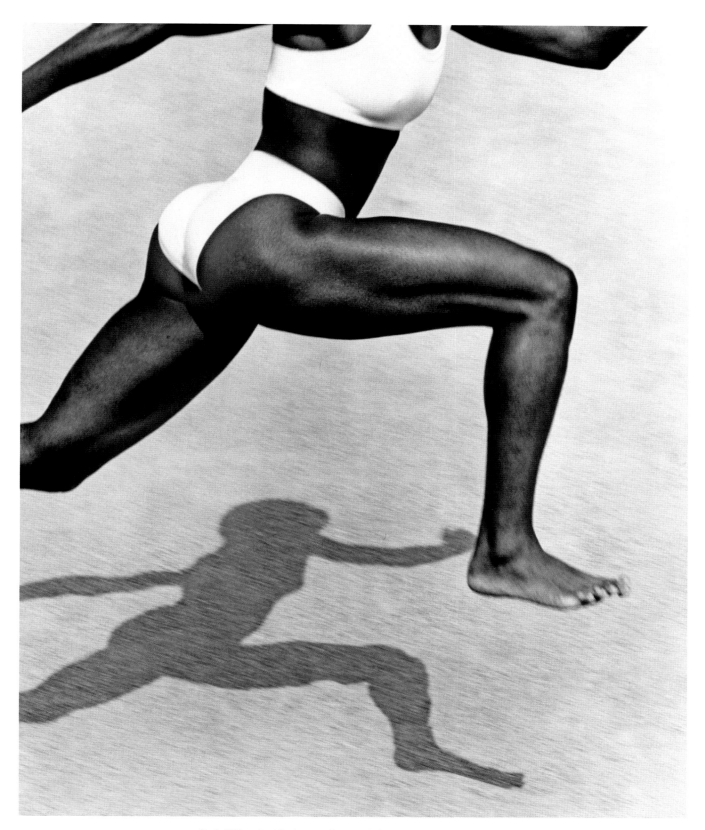

Herb Ritts, *Jackie Joyner-Kersee,* Point Dume, California, 1987

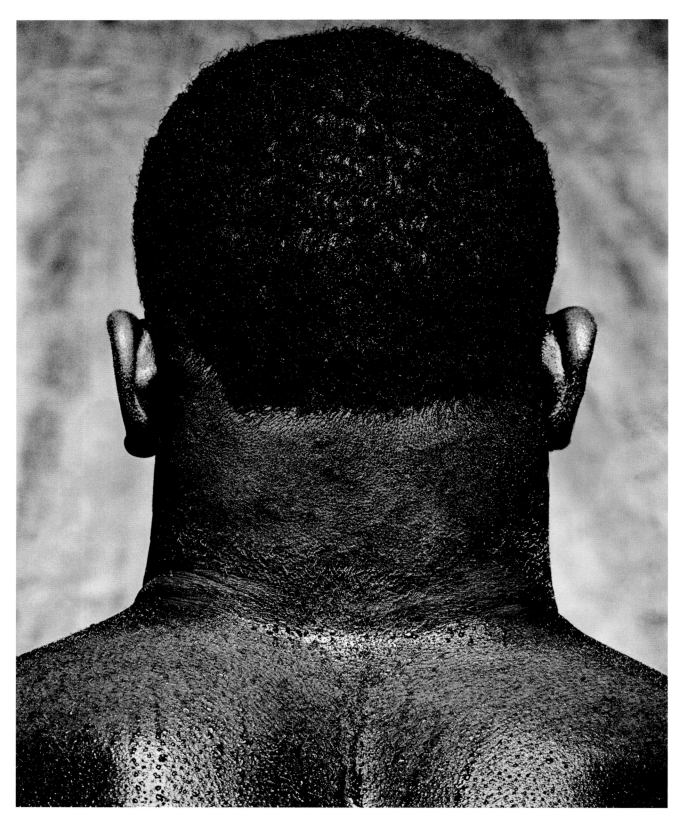

Albert Watson, Mike Tyson, Catskills, New York, 1986

Many male photographers have decapitated, in their photographs, beautiful women, each for his own aesthetic or personal reasons. There is nothing sordid or sexual in **HERB RITTS**'s brilliant, alive, and sublime photograph of the gold medal Olympic athlete Jackie Joyner-Kersee. Joyner, black and beautiful, is racing her own shadow.

Herb Ritts is best known for his fashion photographs. Models running, dancing, moving sensually along the California coast is one of his hallmarks. Normally, in a Ritts photograph, it is the men who are mighty, but not here. In this photograph, the attention is on Joyner-Kersee's muscular and elegant legs.

• • •

Many can see the breadth of Mike Tyson's neck, but only one artist could give it monumentality: **ALBERT WATSON,** master photographer. There is no formal guild for "master photographer," but if there was one, Watson would be an inductee.

Albert Watson collects wooden hat blocks and photographs them as still lifes. With his unparalleled lighting technique and ability to balance objects within the frame, these utilitarian objects assume a clarity reserved for great sculpture. And, so, too, with Tyson's head, neck, shoulders. It is the harmony, texture, and flow from hair to wet skin that makes the viewer want to linger, explore, and come back to this majestic picture. Master of lighting, master of composition, master of focus, master of seeing, Watson creates a unique universe of images. He can give a hat block or a head the mass and perfection of a great work of sculpture.

• • •

ANDY WARHOL, more than any artist of his generation, understood the public obsession with celebrity—earned or otherwise. As art dealer Tony Shafrazi wrote, "Warhol's greatest innovation was in accepting the photograph as the supreme vehicle of fixity and change. He recognized that photography, like cinema, was the driving force in modern life—a tool of both the factual recording of reality and the romantic projection of magic and make-believe."

Collector Richard Weisman, a friend of Warhol's, asked him in 1977 to do a series of art works of contemporary sports stars. Weisman loved and knew sports; Warhol didn't.

Weisman chose the most prominent athletes and together they visited them or they would come to Warhol's studio to have their multiple Polaroid portraits taken. Weisman thought joining art and sports would bring a new audience into art galleries. He acknowledged they were two different worlds, but Warhol or "a Warhol" could bring them together.

The backgrounds may be blank in Warhol's Polaroids, but they are hardly mug shots. Warhol actively arranged his sitters' pose, hair, and clothes; he was creating a "look." He then took around sixty Polaroids with his Big Shot camera. He included tennis rackets, hockey sticks, golf clubs, baseball mitts, ice skates, and balls—soccer for Pelé, basketball for Kareem Abdul-Jabbar, and football for O. J. Simpson—in the tight frame. Shafrazi calls Warhol "a gentle magician who stole the hypnotic eye of the photograph and gave it to us as a gift." We feel much closer to Chris Evert than if she were whacking a ball across the net. Polaroids are taken at "conversational" distance. Annie Leibovitz says she enjoys shooting athletes because they know how to use their bodies. Warhol's portraits prove athletes are much less comfortable engaged in a visual dialogue where the attention is on their face. The remarkable thing about the series of portraits of these truly great athletes is that they look so unremarkable—as well as so very young—

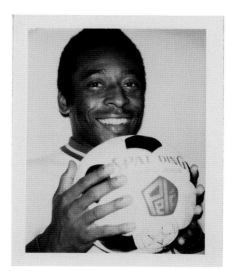

Andy Warhol, Pelé, 1977. Following page: Top row (left to right): Chris Evert, 1977; O. J. Simpson, 1977; Willie Shoemaker, 1977. Middle row (left to right): John McEnroe and Tatum O'Neal, 1985; Dorothy Hamill, 1977; Tom Seaver, 1977. Bottom row (left to right): Wayne Gretzky, 1983; Vitas Gerulaitis, 1970; Jack Nicklaus, 1977.

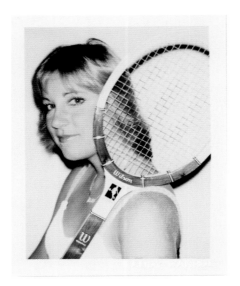 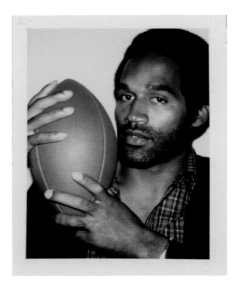 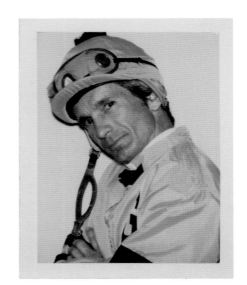

• • •

but that look is exactly what Warhol wanted, and his vision is fascinating. Later, these Polaroids would be converted into silkscreens with brilliant Warholian brushstrokes, colors, and panache.

• • •

FLIP SCHULKE was an experienced and respected photojournalist when, in 1961, *Sports Illustrated* asked him to photograph a young boxer named Cassius Clay. He didn't know who he was, only that he was training in Miami, where Schulke lived. The photo editor said, "Go to the gym . . . spend three or four days with him."

It was love at first sight, and for five days they were nearly inseparable. Schulke took the young Olympic gold medalist, who was still too poor to have much clothing, shopping. The only problem, even a big *SI* budget didn't open the doors of prejudice; Clay wouldn't be served. When Schulke found a shoe store that would let Clay try on the good-looking shoes that Clay spotted, the Champ had to put on such thick socks he could not tell if the shoes really fit. Schulke started to lose it; Clay stayed cool.

Schulke mentioned, in passing, that he specialized in underwater photography. Clay came up with a ruse. He told the gullible photographer that he worked out every day in the water; that an old trainer had told him that water resistance would add strength to his arms and quickness to his punches. They arranged a photo shoot at the pool at the hotel where Clay was staying. Schulke showed up in bathing trunks and scuba gear. Clay performed underwater and Schulke took dozens of gems. The photograph of the boxer in profile, mitts up, is justifiably famous. It ran with others from the shoot in *LIFE*'s September 8, 1961, issue. It was the first time Clay was in the magazine. He didn't train underwater—*he couldn't even swim*—but he wanted to do something special to get into *LIFE.* He was willing to go under in order to come out on top.

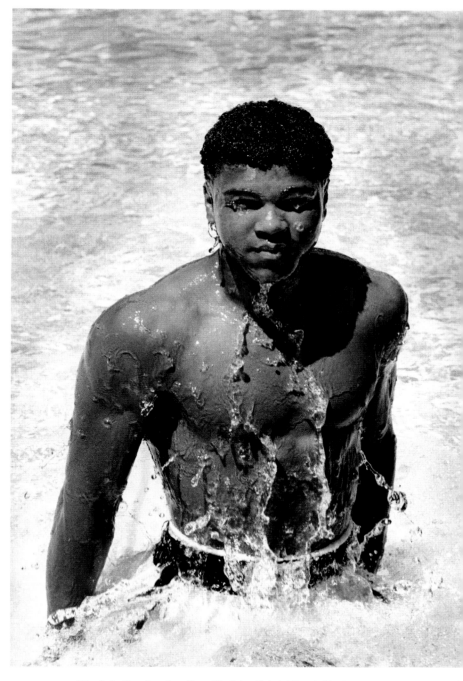

Flip Schulke, Cassius Clay, Sir John Hotel, Miami, Florida, 1961

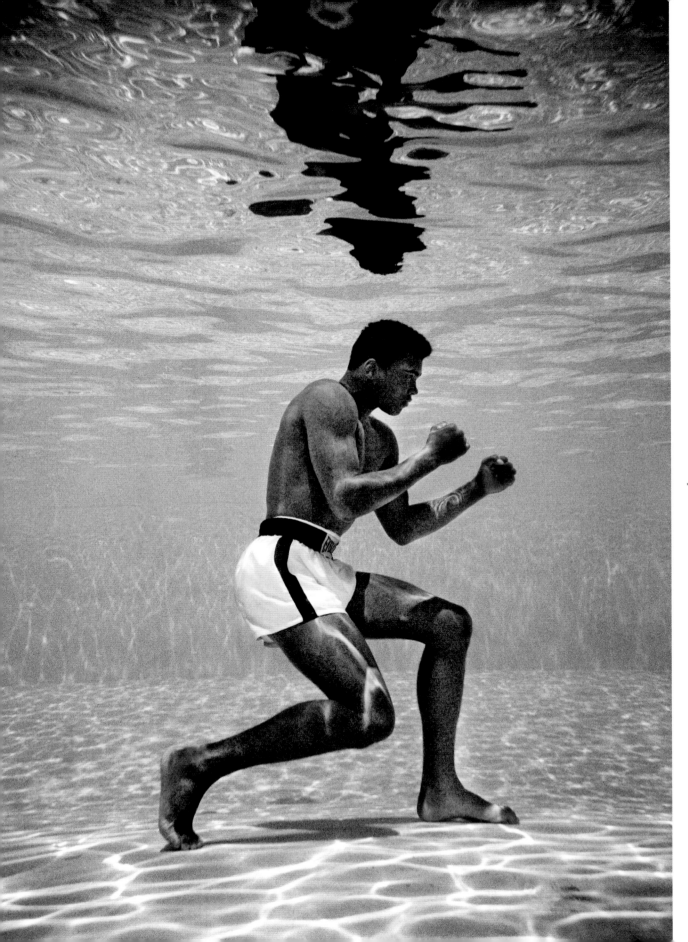

Flip Schulke, Cassius Clay, Sir
John Hotel, Miami, Florida, 1961

"Slammin' Sammy" Snead was following his shot with every nerve ending in his body when the twenty-four-year-old **WALTER IOOSS JR.** made this photograph. That dinky hole in the distance may be small, but it means the world to Snead and every golfer.

ESPN ranks Secretariat as the 35th best athlete of the twentieth century, immediately after Lou Gehrig. The other racehorse, Man o'War, ranks 84th, after Honus Wagner of baseball card (value) fame. Secretariat and Man O'War are the only four-legged athletes making the top 100.

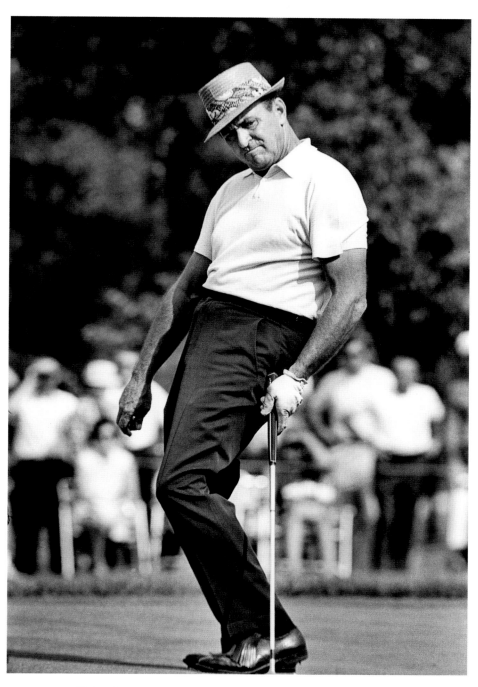

Walter Iooss Jr., PGA Championship, Sam Snead reacting to shot
at Firestone Country Club, Akron, Ohio, July 22, 1966

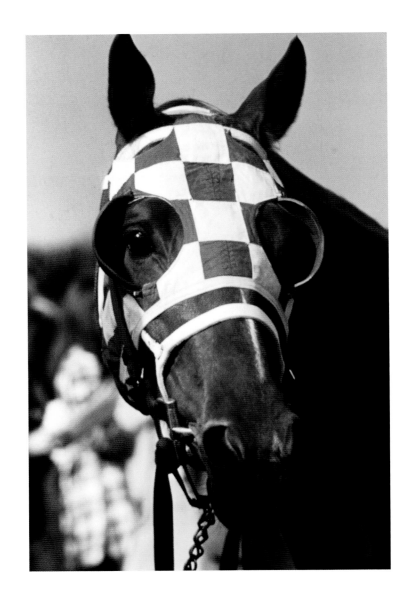

Ken Regan, *Secretariat,* **1973**
U.S. postage stamp of Secretariat
issued November 8, 1999
Cover of *Time* magazine, June 11, 1973

KEN REGAN took the affable portrait of the three-year-old Thoroughbred that ran on the cover of *Time* magazine June 11, 1973, and that was turned into a postage stamp. Great portraiture is about connection with another living creature, normally of the human kind. Regan photographed Secretariat against a clear blue sky and his thoughtfulness, sweetness, and stature are well captured. The horse has as much personality as any two-legged athlete. How can one not love Secretariat, with a face like that?

Ken Regan, who died in 2012, was the consummate professional and a gracious gentleman. His body of work is wildly diverse: documenting poverty in Harlem and famine in Africa; shooting stills for Hollywood movies; covering politics. He had close ties to the Kennedys and to the Rolling Stones. He photographed Keith Richards's wedding—as a friend. Sports had a special place in Ken Regan's personal and professional life. He did in-depth studies of Muhammad Ali, Mike Tyson, Wilt Chamberlain, and Mario Andretti. His boxing photographs are collected in his book *Knockout: The Art of Boxing.*

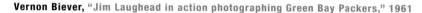

The photographer **JIM LAUGHEAD** confessed to loving his hat almost as much as his wife and dog—years before Oliver Sacks's *The Man Who Mistook His Wife for a Hat*. He always wore the floppy felt hat, which made his subjects—mostly young college-age football and basketball players—laugh. As in Tom Stoppard's play *Jumpers,* where every surname gives a clue to a characteristic of the person whose name it is, Jim Laughead was known to make his subject laugh even while they were doing dangerous tricks strictly for the camera.

In a 1964 profile of James F. Laughead, *Sports Illustrated* writer Edwin Shrake declared Laughead "the most successful, if artistically undemanding, photographer of athletes in the land." He took pictures for National and American Football League teams and seventy-four colleges, turning out more than 100,000 *prints* a year. He found success in the cliché, and the cornier the pictures, the more people loved them. "I've tried to come up with new poses. But the newspapers like the old stuff," he told Shrake, who commented that Laughead's photos were phony, but always in focus.

Before Laughead got the kids moving—diving, reaching, throwing—formal college and team sports portraiture was just that—formal. Laughead is credited with getting star high school athletes to apply to particular colleges because the brochures with Laughead's photos were enticing. He made sports look like fun and risk. His famous "death dive" shot has a footballer against the sky, diving nose first, but there isn't a swimming pool or trampoline. If they got hurt, Laughead would say it was for a good cause—his type of popular portraiture. A history of sports photographers would be remiss without this memorable character included.

Vernon Biever, "Jim Laughead in action photographing Green Bay Packers," 1961

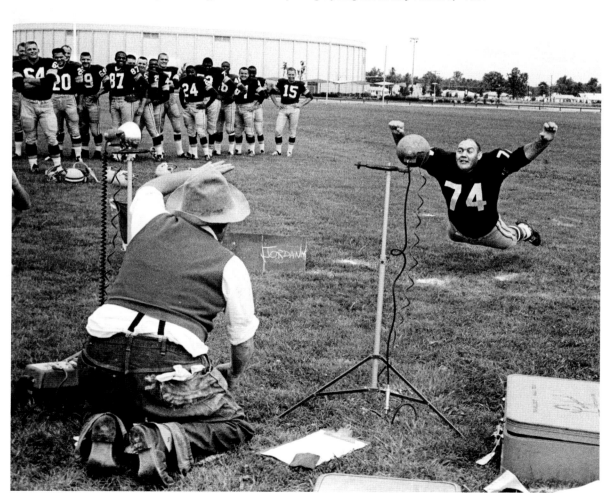

In a career spanning seven decades, **OZZIE SWEET** shot nearly 2,000 magazine covers. When he won the prestigious Lucie Award in 2005, the committee cited "legions of young Americans [who] would razor Ozzie photos out of *Sport* [magazine] and pin them up on their walls." "I'm a photo illustrator," Sweet said at the time. "It starts with an empty canvas, and I use a camera instead of a paintbrush."

Other photographers stood at the sidelines shooting the game. Sweet preferred to draw the lines, create a stage, and direct the action. The usual meaning of "photographic truth" held little sway with him. His imagination and the needs of

Nick Scutti, "Ozzie Sweet directing Jackie Robinson for the cover of *Sport*," October 1951

his clients took precedence over stopping an action in real time.

Sweet photographed Robinson the year he broke baseball's color barrier and every year of the Dodger's career. Sweet set up "simulated action" to show what a third baseman would see with Robinson sliding toward him. Nick Scutti was Sweet's photographic assistant from 1948 to the early 1960s and was charged with helping create a cloud of dust (made out of ash) around Robinson's feet. He also captured his boss and one of the world's most famous athletes fabricating an image.

• • •

Any photographer who stumbles upon or intentionally visits a *lucha libre* wrestling match reaches for his or her camera as quickly as a gunslinger at the O.K. Corral reaches for his gun. Of all the sports in the world, Mexican wrestling may be the most colorful. It has stupendous masks and costumes.

And the most dedicated photographer of *lucha libre* is **LOURDES GROBET**. A Mexican artist trained in sculpture and mural painting, since 1975 Grobet has published eleven thousand photographs of the sport. She knows her subjects personally, and this differentiates her work from that of almost everyone else who is attracted to the spectacle of Mexican wrestling.

Some of Grobet's earliest photographs are of *lucha libre* legend El Santo in his recognizable silver mask. He first entered the ring in 1942 and gradually started starring in films and appearing as the hero in comic books. His fifty-year career wearing the silver mask helped popularize and democratize the sport.

Grobet's latest book, *Lucha Libre: The Family Portraits,* was published in 2009. Her approach, as in previous work, is straightforward; the flourishes are amply provided by the subjects. The *luchadores* (wrestlers) pose at work (there is a masked dentist drilling and a masked policeman sitting in his car) and while receiving awards, but mostly they are photographed at home with mothers, wives, children, and trophies. Teenage daughters are proud to pose with their costumed, muscular dads. There is a mother wrestler, too, who holds open her cape to shelter and reveal her two young sons tucked underneath. The households look completely normal except for the fact that the adults dress outrageously while the kids are in jeans and T-shirts.

Lourdes Grobet, *Mathematics, Lucha Libre,* 2006

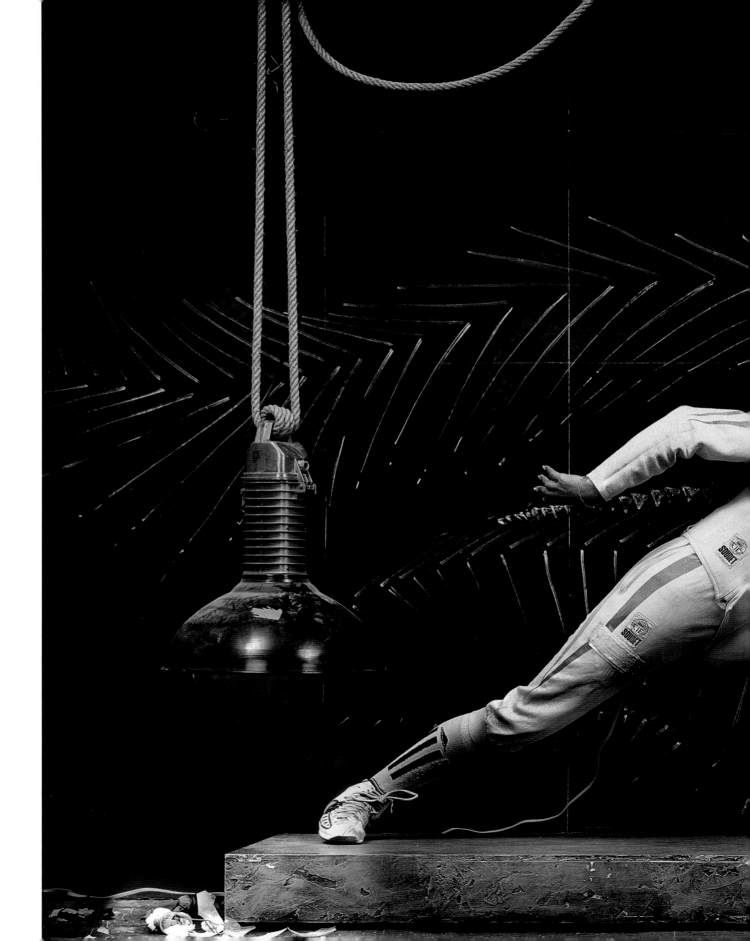

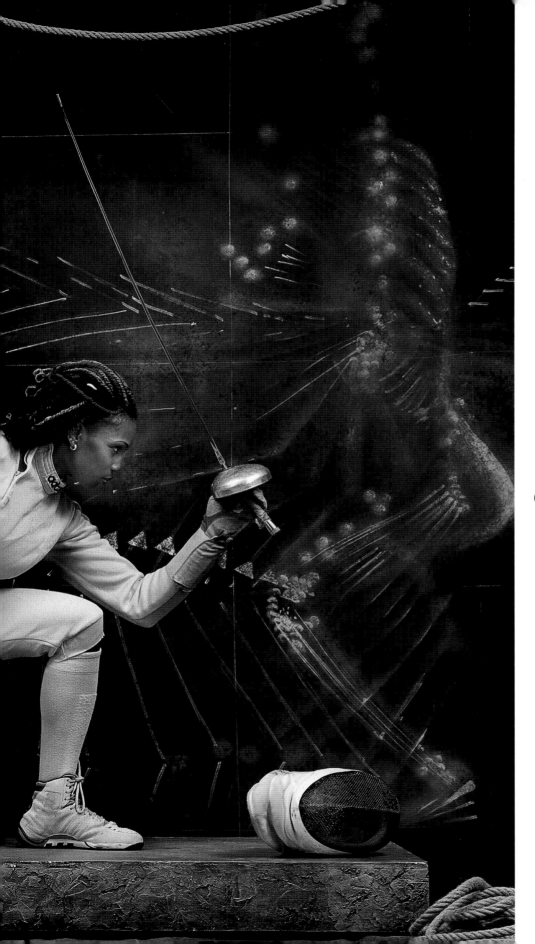

Gérard Rancinan, Laura Flessel, French épée fencer, five-time Olympic medal winner, March 31, 2004

Photography has the capacity to transport the viewer to other worlds. The "optical wonder of the age," the stereoscopic viewer, was advertised to an awestruck nineteenth-century audience as giving them the opportunity to be "armchair travelers" and view the world from the comfort of their sitting rooms. **GÉRARD RANCINAN**'s official biography begins: "[He] travels the globe, bearing firsthand witness to events of historical importance. Natural catastrophes, civil and ethnic wars, and urban riots."

But as much as photography is grounded in external reality, it also can be built upon fantasy and imagination. A shortcut to "another world" can be through make-believe. Clean and comfortable in one's own home, the viewer of Rancinan's portrait of the rugby player Serge Betsen is, nevertheless, down in the mud with him. Betsen's communion with the earth is also the viewer's. We have seen more war photographs from this angle than sports pictures; that is the point. Betsen is a fallen warrior, but he will rise again.

The French artist Rancinan appeals to many audiences. He has done brilliant commissions for sports publications such as *L'Équipe* and *Sports Illustrated;* general interest magazines such as *Paris Match* and the London *Sunday Times Magazine;* has exhibitions of his art all over the world; wins awards ranging from World Press Photo to Chevalier des Arts et des Lettres; and publishes books of his art and others. Somehow, much of what he creates combines fun and profundity.

Gérard Rancinan, like his countryman Jean-Paul Goude, has limitless imagination. Steve Fine describes Rancinan as a "certified genius." When you Google the name Rancinan, the name of another genius, the Romantic painter Théodore Géricault, will come up. Rancinan seeks inspiration freely, and Géricault's *Raft of the Medusa* begat the photographer's wildly original *The Trilogy of the Moderns.* Working conceptually with the writer Caroline Gaudriault, they describe the *Trilogy* as "a Revolution in three acts. Between comedy and tragedy, it paints a picture of confused humanity, blindly groping in the darkness, guided by an absolute desire for generalized happiness."

Étienne Marey and Georges Demeny's early photographs (see pages 272–6) of human movement inspired the backdrops of Rancinan's extended 2004 series of Olympic athletes. This series is effective pictorially and historically. Rancinan borrows liberally from the great artists before him, and, in his own imaginative way, helps keep their work alive.

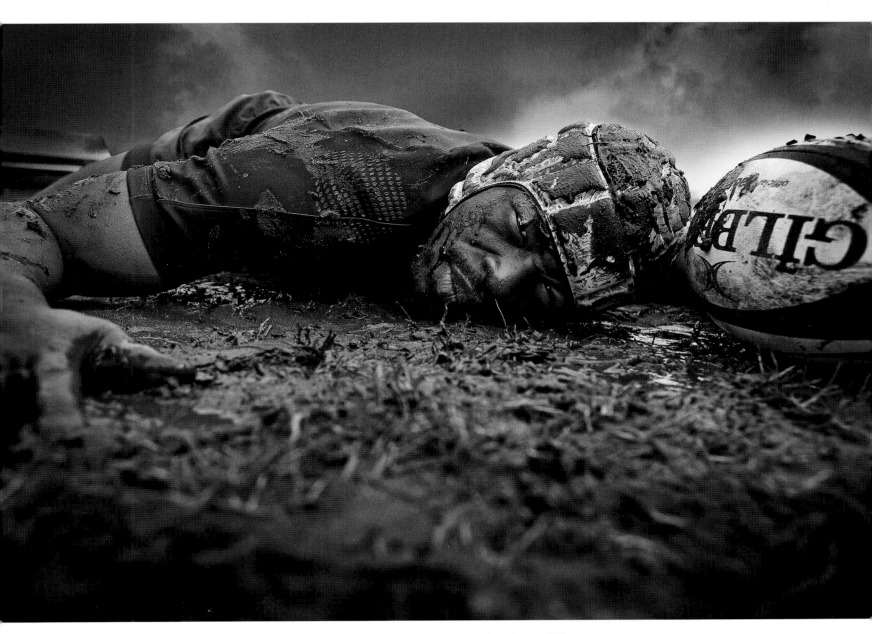

Gérard Rancinan, Serge Betsen, star rugby union player, 2007

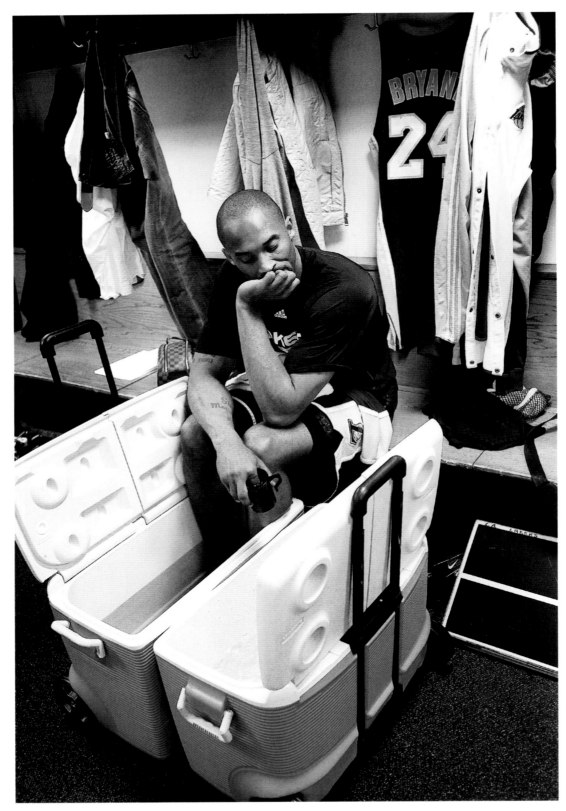

Andrew D. Bernstein, "Kobe on Ice," Madison Square Garden, New York City, January 22, 2010

CHAPTER FOUR
OFF THE FIELD

Behind the scenes, off the field. It is a different story than watching athletes play. Nail biting and nervous energy. Training and training and training.

Aches and ice. Team spirit as manifested in silence, reflection, comic books, and prayer in the locker room. At the sidelines, all variety of expression. Exertion and repose. Anticipation before the encounter; relief, dismay, or exhilaration afterward.

These are the things sports photographers want to photograph. They need access to players so that they can tell a fuller story—and the story the fans very much want. Almost every sports photographer over fifty talks about how things have changed in their field. Not just cameras, lenses, autofocus, and the shift from film to digital. Their relationships with the players have changed; they don't have the access they used to. Sports photographers want to show the emotional life of the athletes off the field; they don't always want to be celebrity photographers.

Some creative partnerships between photographers and athletes and coaches still exist—Walter Iooss and Michael Jordan; Howard Bingham and Neil Leifer and Muhammad Ali; Barton Silverman and Joe Namath; Andrew Bernstein and Phil Jackson and Kobe Bryant. Each of the photographers knows the line they can't cross, but each has greater access to these superstars than anyone else. The reason—mutual respect.

Photographers covering extreme sports are the one contemporary group still able to shoot an athlete's life in great fullness—because there is only one helicopter to take everyone to the top of the mountain; one hotel to stay in and restaurant to eat in in the middle of nowhere. And these daredevil athletes are not, for the most part, making millions of dollars. The photographer is told to jump in the van and get going.

• • •

The best caption for the photograph opposite is the one Phil Jackson, former coach of the L.A. Lakers, wrote in *Journey to the Ring: Behind the Scenes with the 2010 NBA Champion Lakers,* the book he did with **ANDREW D. BERNSTEIN**: "Ritual before the game . . . Kobe sits with his feet in ice . . . small cup with ice for his finger. This is not Rodin's *Thinker,* but he is thinking. . . . Last year he put 61 points on the Knicks. They will be ready to play a different defense on this night and maybe try to double-team him."

Earlier in the book, Jackson wrote about the experience of being a young boy and peering into the lives of his baseball heroes through still photographs. In the photos on his bedroom wall and at the ballpark, he saw his heroes at bat, playing the game, scoring the run, but he hungered for the behind the scenes. Later, photography gave him that entrée into the more complex person that he knew was key to understanding the athlete. Later still, he was the one physically behind the scenes, dealing directly with the emotional lives of athletes.

Andrew D. Bernstein is the NBA's longest-tenured photographer. He has unparalleled access to National Basketball Association players but is as discreet as he is gracious and mellow. Although now mostly known for his basketball photographs, for eleven years he was the Los Angeles Dodgers team photographer. He also shoots hockey games as the longtime team photographer for the Los Angeles Kings. He and his group of photographers shoot all the entertainment events at the Staples Center and the neighboring Microsoft Theater. Having this dream job couldn't have happened to a nicer guy.

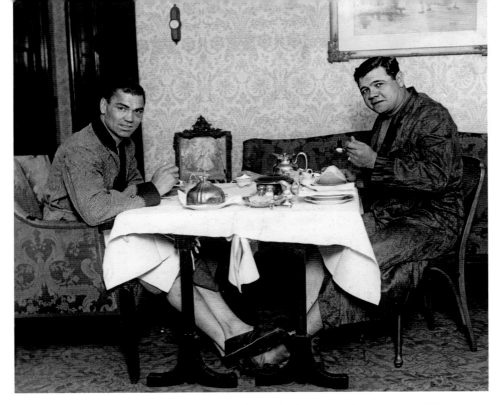

Anonymous, Jack Dempsey and Babe Ruth, the Hotel Ansonia, New York, 1922

Before a Lakers game at the Staples Center, Bernstein passes Kobe Bryant, says hi, and receives the warmest smile in return. The players not only know Bernstein but like him. He joined the NBA in 1983 and has been its senior official photographer since the position was created in 1986. He can photograph it all: the heartbreak and the joy; the sweat and exultation; the seriousness and the playfulness; the pain, both physical and emotional; the leaps, dunks, and hustle; the tenderness between players and coach—and he does it in black and white, which he loves, and color, which the media demands. He also knows how to make himself scarce when the coach gives the "click click" signal with his fingers.

Bernstein was a smart kid from Brooklyn whose clinical psychologist father taught at Brooklyn College. Dad loved taking his son to New York Rangers hockey and Mets baseball games. He also encouraged Andrew's passion for photojournalism, buying him a camera and building him a darkroom in the family home while he served as photo editor of the Midwood High School newspaper and yearbook. He continued shooting everything he could for the University of Massachusetts, Amherst, newspaper and describes himself as a "born hustler" but "in a good way." His sister, however, was

having a lot more fun in Los Angeles not being in college. She is Didi Conn, born Edith Bernstein, and played Frenchy in the film *Grease*. She called out to her brother to come west and he did.

Bernstein received a scholarship to the prestigious Art Center College of Design in Pasadena. There he learned technique and apprenticed to commercial photographers, including Lane Stewart, a sports photographer. When Bernstein started shooting sports, he had two cameras, then a third, and some gigantic strobes—capturing the same moment from different angles. Now when he is shooting almost nightly at his home base, the Staples Center in Los Angeles, he places about a dozen cameras (some held with clamps and duct tape) all over the arena, keeps a Nikon around his neck and a remote at the ready to activate all those hidden cameras. He helped to invent a way for these multiple cameras to go off within milliseconds of each other wirelessly. He places eight strobes in the ceiling, each strobe pack giving 2,400 watts (the equivalent of two hundred camera-mounted-flash blasts) while the shutter is open. These days, sports photography is about speed of transmission and quantity of pictures sent out electronically—not just about making the

best, most memorable photographs. Bernstein personally shoots six to eight hundred pictures for an average game; two thousand for an All-Star Game or NBA Finals game. Some of the cameras are tethered through a high-speed line straight to an editor at NBA Photos in Secaucus, New Jersey. Some go directly to his on-site editor, working in a room off the court, who sends the pictures out on the feed. Within five or six minutes of the picture being taken, it has gone out to Getty and the world.

But scratch the surface of this tech genius, and you find the dedicated photojournalist. W. Eugene Smith, Dorothea Lange, and Margaret Bourke-White are his photographic heroes. "I got into this for a reason," Bernstein told me, "to be part of the history of photography."

. . .

The morning after the night before.

Jack Dempsey and Babe Ruth (opposite) in silk dressing gowns and slippers, having a leisurely breakfast in Ruth's Upper West Side apartment in the Ansonia. Could there be two more famous athletes anywhere in the world in 1922?

On the back of the print is written: "Exclusive Photo for papers using our service The Christy Walsh Syndicate No Charge! To Babe Ruth papers Not available to others. Copyright 1922 by the Christy Walsh Syndicate." Christy Walsh was many things to Ruth. It was no problem to send a photographer into the hotel suite to get this tête-à-tête between the two sports giants. Walsh was the Babe's agent (considered to be sports first super-agent) and also his ghostwriter and financial advisor. The photo op with Dempsey was orchestrated by him and distributed only to publications he approved.

. . .

"Can you imagine what would happen if Tom Brady tried to do this today?" asks Walter Iooss Jr.

In the book *The Best of Sports Illustrated,* this masterful photographic evocation of cool (below) opens the chapter titled "The Age of Audacity." Why not? Joe Namath, the quarterback for the New York Jets, underdogs in Super Bowl III, was confident of victory. Even without Florida sunshine, the high-powered sportswriters and hotel guests were bathed in the warmth of Namath's smile and personality. **IOOSS** got

Walter Iooss Jr., Joe Namath holding court poolside before Super Bowl III, Miami Beach, Florida, 1969

the perfect angle. He has us, the viewers, right in among the attentive journalists and fans, leaning over and practically touching the man about to make football history.

Steve Fine tells how disappointed Iooss, a lifelong Colts fan, was when Neil Leifer, his senior, chose to follow the Colts during Super Bowl III, leaving Iooss to shoot the behind-the-scenes activities of the Jets. Everyone knew the Colts were going to win. Hence, most of the pages in next week's *SI* would be devoted to them. Not even a photograph of Namath chatting up bikini-clad girls on the beach might make it into the magazine if the Jets lost as predicted.

Leifer's pictures were at his usual outstanding level, but didn't run in the magazine because the Colts lost, to everyone's surprise except Namath's. The Iooss shot of the

Robert Riger, New York Giants Dick Lynch, Dick Modzelewski, and Buzz Guy go over a play one hour before the championship game against the Baltimore Colts. The Giants lost in the first sudden-death overtime in an NFL championship, a game referred to as "The Greatest Game Ever Played," Yankee Stadium, New York, December 28, 1958.

relaxed and confident Namath became a classic. Steve Fine adds that around the time this picture was made, "Namath 'guarantees' the Jets victory, which was insane at the time (they were about 18 point underdogs). So this picture becomes the visual element in Namath's boast (although I don't think it actually happened poolside). So yeah, this picture shows what was possible back in the day and no longer available to the media now. It's a momentous picture of a moment that's gone."

• • •

They are the Three Graces in jock straps and T-shirts. Elegantly posing, studying their plays.

"My original gods in art school days were five artists who could draw people and horses," **ROBERT RIGER** wrote, "Toulouse-Lautrec, Edgar Degas, Daumier, Frederic Remington and Winslow Homer." Over and over again Riger calls forth his art school training. David Halberstam, journalist and historian, commented that "Riger was an artist thinly disguised as a journalist covering other artists thinly disguised as athletes."

• • •

Many photographers take pictures because they can be more expressive with images than words. Not **MICHAEL ZAGARIS**. He has almost as many observations, anecdotes, and opinions as he has photographs—and he has been the team photographer for the San Francisco 49ers since 1973 and the Oakland A's since 1981.

Words from Z-Man:

1. Give the people bread and games.
2. [Some sports are] fast, violent spectacle; stylized warfare represents our culture.
3. Allegiances to teams. It is very tribal.
4. Increasing corporatization of sports. You can buy players, but you can't buy team chemistry.
5. There is no "I" in team.
6. Baseball—the great leveler. You have rednecks with college-educated guys with urban blacks with Venezuelans. Great melting pot.
7. Footballers basically gladiators.

Michael Zagaris, San Francisco 49ers Dwight Clark (87), Freddie Solomon, and Joe Montana (16) all sit in various states of pregame contemplation and focus while Fred Dean, in the background, massages his knee and Roger Craig, on the right, stretches his foot moments before leaving the locker room to beat the Dallas Cowboys 42–17, Candlestick Park, San Francisco, December 19, 1983.

Michael Zagaris, Greg Roberts of the Houston Oilers flips through a *Gameday* program with his teammates in the visiting locker room, an hour before taking the field against the San Francisco 49ers, Candlestick Park, San Francisco, December 7, 1975.

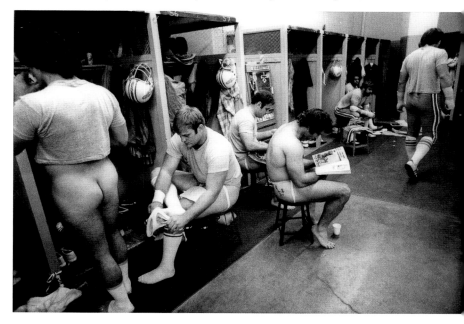

Zagaris, who also is known for his rock 'n' roll photography, likes to say he has not made much money but he feels like he has never really worked a day in his life. Playing college baseball and football paid his tuition and shooting sports pays his rent. He will wax poetic on his method. "I become what I photograph," he says, citing Stanislavski. He goes on the bus with the team to the stadium, tapes his ankles, puts on cleats. And he goes into the locker room and photographs what few people besides the athletes, coaches, and trainers ever see. His is an intimate view of sports, understated and revelatory.

Adrian Murrell, Ian Botham of England smokes a cigar in the changing room after his match-winning performance in the third international cricket Test Match, England vs. Australia, at Headingley in Leeds, July 21, 1981.

. . .

When Ian Botham began his historic innings, the bookmakers were offering odds of 500–1 against an England victory, which eventually came by the narrow margin of eighteen runs. The London Stock Market stopped trading to let brokers view the finish. Unbelievable.

When being interviewed, **ADRIAN MURRELL,** cricket photographer and former executive at Allsport and Getty Images, talks numbers. Murrell's camera bag weighed 56 kilos. He carried a 600mm lens to cricket matches. As a top executive, he managed a staff at Allsport of over 150 and made sure the agency got paid. When he went over to Getty, he was in charge of many more people and much more money. He witnessed many changes in sports photography in the late twentieth and early twenty-first centuries. He was instrumental in bringing some of these changes about.

Adrian Murrell was shooting mostly black and white but was also using Kodachrome ASA 64 for color when he began in the late 1970s. English weather was not conducive to slow film. And slow didn't only describe the film speed. The entire process of getting a color photograph to press was slow. In England, the film was sent to Kodak in Hemel Hempstead. It took three days to send and get the color slides back. It took another three days to edit, send the selects back for duplication, and get them returned. By the time a picture appeared in the press, it could easily be ten days after the event. When Murrell retired from Getty Images, digital had a rating of 6,400 ASA and transmission and appearance on the World Wide Web was nearly instantaneous.

Murrell says he was destined for a career in journalism. His parents were the publicans at the Rose & Crown and then the Printer's Devil pubs, both off Fleet Street in London. He was surrounded by newspapermen his entire childhood. He apprenticed with photographer Bob Dowling in the summers. Dowling did the Benson & Hedges ads that everyone in the U.K. remembers. He studied photography at Guildford College of Art and Design, whose principal was Walter Nurnberg, one of the most distinguished photographers in Britain at the time. However, he balked at the assignments, especially when asked to photograph an egg, and took off for India in 1976. With £750, he spent three months in the country, riding third-class trains and photographing the

Jesse Alexander, *Stirling Moss, Aston Martin,* Le Mans, France, 1958

British cricket team's 1977 tour. Fifty-five of his pictures were published back home.

Murrell was twenty-three years old and had made a name for himself as a leading cricket photographer. Two years later, he was invited to join the Allsport picture agency. In 1986, at the age of thirty, he became Allsport's U.K. managing director, replacing Steve Powell, who went to Allsport USA. Murrell sees the arc the industry took from an insider's perspective. In management for a long time, he remembers, too, with great affection, when shooting cricket meant going to parties and dinner with the players, and knowing exactly what not to photograph. For Murrell, "the heart and soul" of sports photography included developing relationships with the athletes, something that, he says, in today's big-money sports industry, is almost impossible.

. . .

The American photographer **JESSE ALEXANDER** considers the golden age of motor racing to be from 1953 to 1967. His French counterpart, Bernard Cahier, would have agreed. Fortunately for them, that is when they were covering Formula One and the greatest race car drivers and the sexiest cars.

The drivers were known for their individual characteristics. Their clothes ranged from tweed jackets and bow ties to bright blue polo shirts. Helmets were required but flame retardant coveralls were not. And the cars had as much personality as the men who drove them. A Cunningham did not look like a Ferrari; a Gordini handled differently than a Maserati.

Jesse Alexander made intimate, brilliantly revealing photographs because he was close to the drivers, managers, and mechanics. He often traveled with them, ate with them, stayed at the same hotels. To read Alexander's memoirs is to know that the cars turned him on but the people were what held him in the embrace of the racing circuit.

Almost every Alexander photograph tells a fascinating and dramatic story. This doesn't just happen. It is the result of a deep understanding of his subjects and the psychology as well as the mechanics behind it. His mastery is putting us, the viewers, in this elevated world of the rich, the famous, and the daring.

Alexander photographed Graham Hill in color, pale blue jumpsuit, navy helmet, gray slinky sports car with red seats. His visage is confusing: headmaster at a British public school

or international playboy? But his concentration, as Alexander captures in many photographs, is superhuman, and that transports him to the realm of world-class athlete.

A deeply moving portrait by Jesse Alexander is of the Scottish race car driver Jim Clark taken in 1960. It shows Clark, indentations from his goggles still marking his face, as he learns his teammate, Alan Stacey, has just died in the Belgium Grand Prix. The emotional pain is palpable; the response deeply internalized. Clark was a hero in 1965, being the first non-American to win the Indianapolis 500 since 1916. Three years later, he, too, would be dead, testing a car at Hockenheim, Germany.

Risk isn't confined solely to the drivers. Alexander understood, because of his own need, as he said, to get the shot with the "car coming straight at you, at speed, just ready to fly out of control," that he was pushing fate, too, and eventually backed off and backed out of photographing Grand Prix racing. His archive is forever a testament to a generation of men, many of whom were glad to have survived the war in the 1940s, only to put their lives on the line in the 1950s and 1960s for something most of us will never fully understand. Alexander captured it all: the waiting for the race to begin, the start of the race, the magic, the spellbound audience, the winning, the celebration, the tragedies, and the sophistication of Formula One motor racing.

• • •

A perfect subject for **DANNY LYON** is an angry young man revving up and raring to go. He made his name riding with and photographing the Chicago Outlaw Motorcycle Club. He did a brilliant body of work in a Texas penitentiary. No one photographs a male ready to reach for the throttle better than Lyon.

Lyon understands anger. He witnessed firsthand the injustices and violence during the civil rights movement of the 1960s. He documented the destruction of lower Manhattan. He could do only so much for the abandoned, homeless street children of Colombia he cares so passionately about. He was at Zuccotti Park in 2011 with Occupy Wall Street, recognizing his younger self in the 99 percent.

• • •

Rookie Miguel Tejada had never before seen the breaking balls major league pitchers were throwing at him. In the minors, the pitchers had trouble throwing them as strikes. He was despondent after two major league games without a hit.

Danny Lyon, *Demo Driver, Wall Stadium,* New Jersey, 1987

José Luis Villegas, "Miguel Tejada being consoled by Oakland Athletics' hitting coach Denny Walling after the rookie went hitless after two consecutive games," Oakland, California, ca. 1996

JOSÉ LUIS VILLEGAS's great subject is Latino baseball players, and he followed many of them from their impoverished homes in Colombia, Venezuela, the Dominican Republic, and Puerto Rico to the big time in the United States and back again, sometimes defeated, sometimes as reigning heroes. He took his first photograph of Tejada when the ballplayer was just sixteen years old. He photographed him with his family and friends, some with the same talent as his, but unable to make it. The visual story Villegas tells in his book, *Home Is Everything,* is the struggle Latino baseball players face overcoming problems of language, culture, prejudice, and intense competition on and off the field. But missing *home,* too, is a reality while needing to hit a *home* run, get to *home,* and win the hearts of the *hometown* fans. As the title says, *home is everything.*

Villegas describes his book as an "immigration piece," not a book on baseball. "I could easily relate to them," says Villegas, "to the immigrant's plight. If you don't succeed, you fall back into poverty."

Villegas is the youngest of eight children of Mexican parents, half born in Mexico and half born in Texas. He tells the story of all ten of them in one car, driving to Los Angeles from El Paso with $56 to start a new life. Not surprisingly, Dad got distracted, missed the L.A. exit, and the family ended up in San Jose.

Many of the photographers in this book started their relationship with sports as young, ambitious high school and college athletes. Villegas wanted to be a professional baseball player and even played a little semipro ball after college. Growing up in the 1960s he collected baseball cards and noted that many of the greatest San Francisco Giants had Spanish names. His English improved as he listened to the games on his transistor radio, tucked under his pillow. His father wanted him to be a doctor or lawyer but recognized his passion for photography and bought a $100 camera from a pawnshop for his son while he was still in high school. There are many American dreams and some of them manifest between the covers of *Sports Illustrated,* a magazine Villegas's

father realized his son should have. The family did not have a TV until 1969.

José Luis Villegas graduated from the University of San Francisco with a major in photography. Ken Light was one of his teachers. He has worked on some of the West Coast's finest newspapers. He went to the *San José Mercury Record* in 1985 and left in 1992 for *The Sacramento Bee.*

. . .

Before 1947, when Jackie Robinson integrated Major League Baseball, the only group banned totally from professional baseball was African Americans. Immigrants, regardless of nationality, could play; felons could, too. Baseball has always been as much a part of American identity as Mom and apple pie. Major league players were as close to royalty as there existed in the United States. Barring African Americans, who were often such talented athletes, was especially cruel and malicious.

In the foreword to **ERNEST C. WITHERS**'s book *Negro League Baseball,* Willie Mays said of his early days in baseball, all he

had to do was "throw, run and hit"—play ball. And he, and everyone else, knew he was good at it. At sixteen, he was a Chattanooga Choo-Choo, playing for "pc" (percentage of the gate), which meant very little cash. But it was fun—as long as the players didn't focus too much on the grossly discriminatory practices in professional sports.

Ernest Withers, a Memphis photographer, preserved for posterity Beale Street musicians, civil rights activists, recreational activities within his community, and Negro League baseball. The reason for writing his book on the latter, Withers explains in the introduction, was to "show the result of the time I spent professionally and pleasurably viewing some of the greatest ballplayers that ever played."

Larry Doby was the first African American in the American League and Jackie Robinson the first African American in the National League. The photograph was taken after they had been signed by the majors and were playing a barnstorming All-Star game.

Ernest Withers, left to right: Ernie Banks (sitting), Larry Doby (in Cleveland uniform), Matty Brescia, Jackie Robinson (in Dodgers uniform), Martin's Stadium, Memphis, 1953

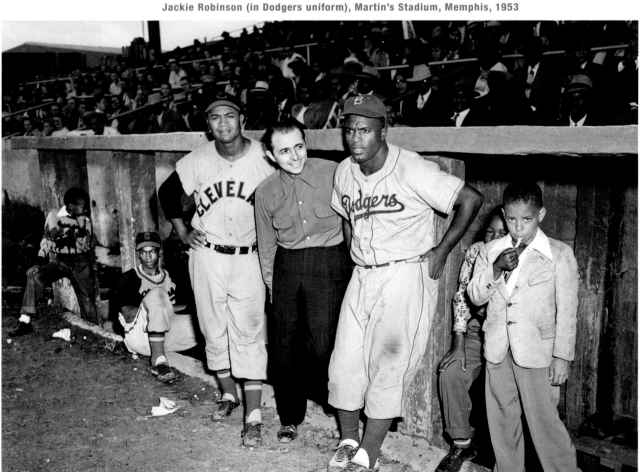

Rich Clarkson, University of Kentucky coach Adolph Rupp (with basketball) and his team watch as Texas Western receives the championship trophy, 1966.

• • •

This is what a lily-white basketball team, coach, cheerleaders, and fans look like after they lose to the first all-black starting lineup in NCAA championship history. It is also what a master photographer like **RICH CLARKSON** was able to capture for posterity—a transformative moment in college basketball. The sidelines of college basketball would not again look so homogeneous.

No photographer is as closely associated with the National Collegiate Athletic Association as Rich Clarkson. He photographed his first Final Four basketball championships in black and white in 1952, age twenty, and his last in 2015. He grew up in Lawrence, Kansas, the home of the University of Kansas, where the "only thing to photograph was sports." Clarkson first met coach Dr. Forrest "Phog" Allen in 1941 when he was nine years old and had sneaked into practice with his friends. Ten years later, as a freshman at the university, he asked Allen if he could go on the bus with the Jayhawks to away games and take photographs. He watched

as the team's first black player, LaVannes C. Squires, was told he could not join the team at a restaurant, that he had to eat in the kitchen. The entire Kansas team, which would win the NCAA championship that year, followed him back to the kitchen, where they all ate together.

Clarkson, a wonderful raconteur, loves telling stories because he has witnessed so much of sports history firsthand. He is the senior member of the elite club of sports photographers who have come up the ranks of newspapers and magazines. Clarkson, in an interview with photo editor Jim Colton, describes what "transmitted" meant at the beginning of his career:

In those first years, I would photograph the first half of the game, race to my basement darkroom, process the film and make prints and then run to the bus station to make the 9 o'clock bus to Kansas City (for the Kansas City Star, the Associated Press and sometimes Acme . . . the predecessor to UPI).

117

He brought color sports photography to *The Topeka Capital-Journal* when he was director of photography, but could run the picture only if there was also a color advertisement in the paper that day. He remembers the novelty of shooting color transparencies, making the separations and the masks, and shepherding the picture right up to press time and telling the printers what inks to use.

He likes to go up in the stands, get an overview, and tell a more complete story than just the jump shot. "Where [the action] is taking place" is just as interesting as "what is taking place," he told me. He has always befriended coaches and gotten privileged access to locker rooms. He cares about the atmosphere of the place.

Clarkson is not only a great photographer, he is a legendary teacher and boss. Brian Lanker, Bill Frakes, Amy Sancetta, Jeff Jacobsen, and Damian Strohmeyer are some of the best-known photographers who worked under him as a photographer and picture editor at the *Kansas City Star, Topeka Capital-Journal, Denver Post, Sports Illustrated, National Geographic,* and other publications. His workshops and classes have taught generations of men and women to shoot sports.

• • •

TOD PAPAGEORGE, head of Yale University's graduate photography department from 1979 until his recent retirement, was awarded a Guggenheim Fellowship in 1970 to document "the phenomenon of professional sport in America." But it was going to be an alternative view to "sports illustrated." As he wrote in his application, "It takes

Tod Papageorge, Central Park, New York, from *Passing Through Eden: Photographs of Central Park,* New York City, 1979

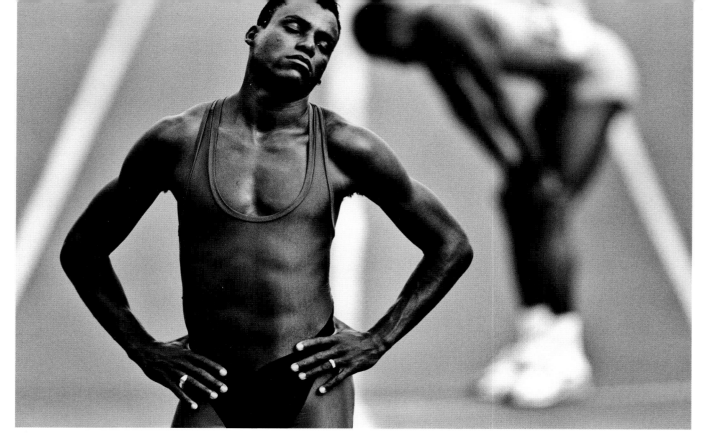

Mike Powell, "Carl Lewis warms down during training session at the Santa Monica Track Club," Los Angeles, 1992

a thousand brief acts to create the theater of spectator and sport, and my concern would be to present them with an accuracy and power which would provide much more than the sports, illustrated."

Papageorge was never the star on the playing field; he was the kid in a fancy uniform playing a drum at half time. That memory informed his yearlong study of sports in America. He saw spectators, majorettes, and the band as central to the story of American sports as the game itself. In an interview with the writer David Davis, whose research into sports photography has contributed greatly to the field, Papageorge noted that he was interested in the spectacle of sports and the challenge. He wanted to take photographs "of very complicated visual events and to make them clear and powerful."

Three decades later, Aperture published Papageorge's *American Sports, 1970, or How We Spent the War in Vietnam.* The reference to Vietnam confuses many people, but not those who were young adults in that seminal year in U.S.

history. Papageorge started to photograph around the same time as the killing of four students by National Guardsmen on the campus of Kent State University. He said, "I began to look at this project as a collective picture of the psychic state of America at a key point in the history of the Vietnam War." His study of sports in America is as individual as his motivation.

The photograph reproduced here of women runners in the 10K L'eggs mini marathon is from *Passing Through Eden: Photographs of Central Park,* a very different body of work from *American Sports.* Central Park, New York City's primary playground, is used for every manner of recreational activity, and Papageorge saw the park as New York's Eden, with all the literary and biblical overtones the name implies.

• • •

MIKE POWELL started shooting sports in 1982 at age sixteen. He likes to say that in those days, he had only "natural light, a sharp eye, and a split second to get the shot." His big brother Steve (six foot five) was a photographer and a director

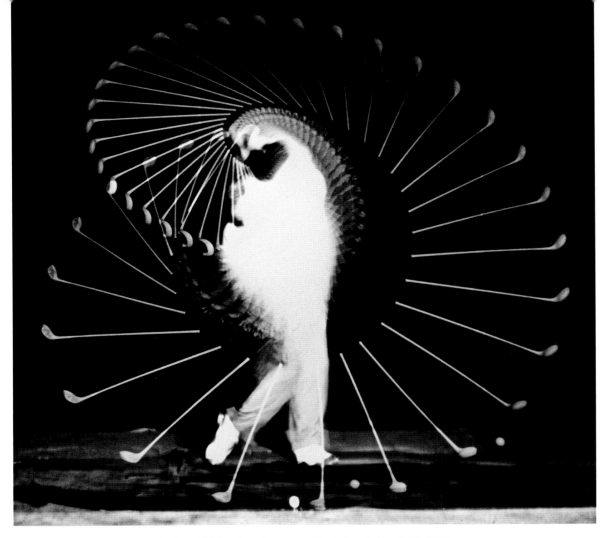

Dr. Harold Edgerton, *Densmore Shute Bends the Shaft,* 1938

at Allsport in London, where the younger Powell started in the darkroom and library before advancing to junior photographer. Allsport founder Tony Duffy moved to Los Angeles in 1984 to establish Allsport Photography USA, and the following year Mike Powell joined him in the California sunshine. (Neither of these two Brits returned to reside in their often gray and rainy homeland.)

In ancient Greece, the finest artists were commissioned to celebrate the greatest athletes. Statues, friezes, and black-incised silhouetted figures on pottery transcend time, show athletic prowess, and are deeply moving works of art. These ancient Greeks are heroes, not gods. As is the great Carl Lewis. Of all the wonderful pictures showing the grace of Carl Lewis's running, this picture of him in repose comes closest to the Greek ideal of manhood.

Both Densmore Shute and **DR. HAROLD EDGERTON** carefully examined the negative of this classic golf swing: the pro golfer Shute with an eye toward improving his stroke; Edgerton, "Doc" to his students at MIT, to expand scientific knowledge. "A good experiment," Edgerton said, "is simply one that reveals something previously unknown."

To the satisfaction of golfers, himself included, he was able to show what happens after the "click"—the "all-important event when the club imparts its energy and the intentions of the player to the ball," Edgerton wrote in the book he authored with James R. Killian Jr., *Moments of Vision: The Stroboscopic Revolution in Photography.* He deduced that the time of contact between club and ball is about six thousandths of a second, and the distance they travel together

is about 0.3 inch. But that is just the beginning of what he learned.

Doc was never satisfied with his photographs giving only quantitative information. He wanted them to be qualitative, too. He was meticulous in making images that were aesthetically satisfying as well as scientifically illustrative of kinetics. Dr. Deborah Douglas, director of the collections at the MIT Museum, knew Edgerton. She told me that "Doc was a different kind of scientist. He had a strong aesthetic. He believed in public engagement of the sciences and making science accessible."

Gus Kayafas, Doc's former student, photographic printer, and research affiliate in the Stroboscopic Light Laboratory, writes of this photograph: "Shute swings his driver into an Archimedean spiral—photographed at 100 flashes per second. His torso dissolves into a ghostly shape, superimposed on itself 50 times by the flashing strobe." And Edward Steichen, famed art and commercial photographer and a former director of photography at the Museum of Modern Art in New York, noted, "How well I remember my excitement on seeing the succession of exposures of a man swinging at a golf ball. . . . It not only opened a new vista from a scientific standpoint, but [it was] also a new art form."

Dr. Edgerton, with his partners, Kenneth Germeshausen and Herbert E. Grier, developed the electronic high-speed flash system, also known as stroboscopic photography. Phenomena never before seen were captured for the first time: a milk splash that appears as a coronet, a bullet piercing a playing card, a lightbulb shattering. In the world of sports, Edgerton "stopped" a tennis swing, a softball being hit, a high jumper, an archer releasing an arrow, a diver coming off the high diving board, a Ping-Pong ball being batted back and forth. Look closely and the softball looks like the bat took a bite out of it. In an Edgerton photo, a ball is rarely round and nothing is how we see it with the naked eye.

Dr. Harold Edgerton, "Papa Flash," as Jacques Cousteau dubbed his friend and colleague, is the father of stroboscopy (pulsing light) and electronic flash photography. He published his first strobe photographs in 1932 in *Technology Review* and in his book *Flash: Seeing the Unseen with Ultra-High-Speed Photography* in 1938. An important part of the history of photography, and sports photography in particular, is

the ability to reveal and stop action. Edgerton's inventions changed photographic time. They allowed for exposures shorter than $\frac{1}{10,000}$ of a second and for motion picture cameras to operate at speeds of 300 frames per second. Before long, Doc was shooting at $\frac{1}{50,000}$ of a second, then $\frac{1}{100,000}$, and then unbelievably $\frac{1}{1,000,000}$ of a second. Doc Edgerton's invention allowed the invisible to become manifest.

• • •

Very few fine art photographers have embraced sport as a subject as broadly and profoundly as have **ANDERSON AND LOW**. They never photograph actual sporting events. Rather, they concentrate on the psychology and body language of

Anderson and Low, "Deng Xiaofeng, left, and Zhang Leyang, right, gymnastic training facility," Beijing, 2010–2011

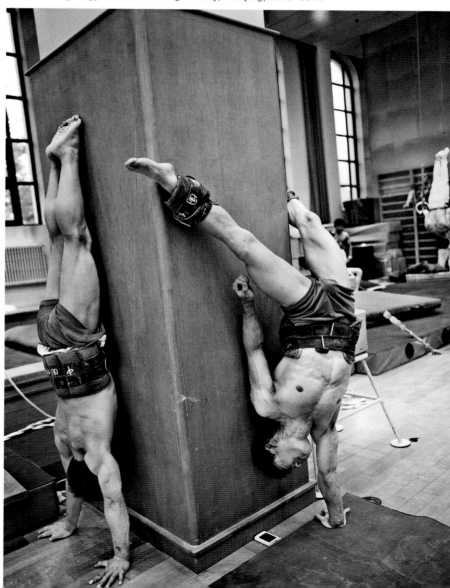

the athlete during training or after practice. The line of scrimmage they photograph is an internal one.

Endure: An Intimate Journey with the Chinese Gymnasts is the result of two years photographing at the elite Chinese gymnast training facilities. This is a closed world. The artists used a muted and unfamiliar color palette to convey an otherworldliness. Their exhibition prints are beautifully crafted with fine inks on art paper, dreamscapes born of reality. The viewer is asked, in many of Anderson and Low's bodies of work, to cross over to an unknown territory.

Jonathan Anderson, born in the United Kingdom, and Edwin Low, born in Kuala Lumpur, hardly finish each other's sentences, but they are of one mind with their conceptual approach to photography. They would rather switch cameras than change lenses. They don't always remember who took which photograph, and sometimes setting up the camera and looking through the viewfinder is a joint effort anyway. They admit that athletes are their muses and keep going back to them for inspiration.

They began collaborating in 1990 around the concept of sport and their first commission, awarded by the National Art Gallery of Malaysia in conjunction with the 1998 Commonwealth Games Cultural Festival, was titled *The Athlete.* This was followed by *American Athletes* for the United States Olympic Museum and *The Contenders,* an exhibition of British athletes commissioned by the National Portrait Gallery, London. They would again present their work at that venue for another National Portrait Gallery commission connected to the 2012 London Olympics. Many other

Howard Schatz, U.S. Olympic hurdler Allen Johnson, at Baker Field, Columbia University, New York City, March 2001

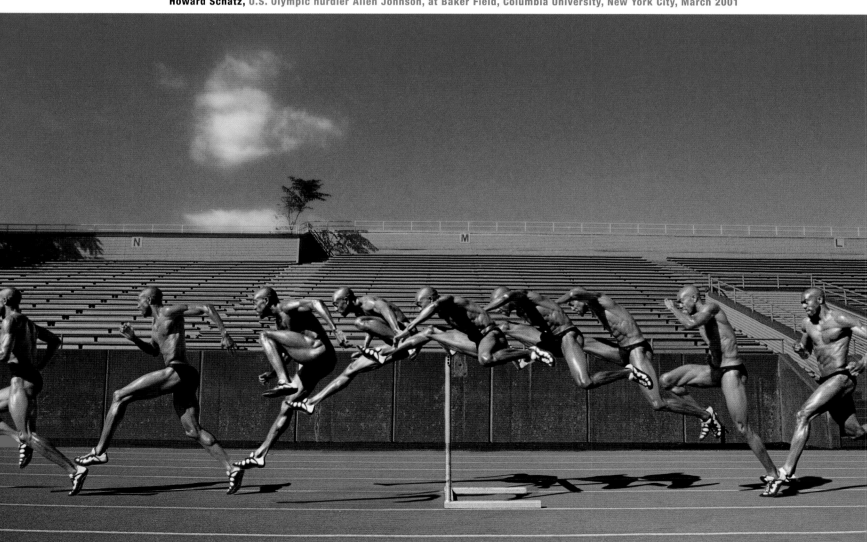

Bob Martin, Roger Federer and Rafael Nadal, Wimbledon Men's Singles Final, July 6, 2008

projects continue their exploration of the athletic body and mind.

· · ·

"Most athletes are not interesting to interview," **HOWARD SCHATZ** told me, "but they are great to photograph. . . . They can generally do one thing, [and it is my challenge] to find an original way to show that one thing they can do."

The human body is Schatz's inspiration; he never leaves home—or enters his studio—without his creative imagination. Each day he describes as a "treasure hunt" to come up with something new while drawing on his technical expertise.

Trained as a physician and experienced in the operating room, he is meticulously prepared, compulsive about details, and precise in every way. He has developed ways of showing motion that bring greater understanding to human physiology, similar to Dr. Étienne Jules Marey and his assistant, Georges Demeny. But the priorities are flipped.

Marey and Demeny sought knowledge first and beauty was a by-product. Schatz is the consummate artist, seeking beauty and aesthetic expression before all else.

· · ·

Of course, the two tennis greats, Roger Federer and Rafael Nadal, will not heed Rudyard Kipling's famous words to "meet triumph and disaster . . . just the same." Federer and Nadal seek only triumph. In **BOB MARTIN**'s brilliant real-life tennis tableau, they walk out under Kipling's words headed toward Center Court.

On that legendary day at Wimbledon, sometimes described as the greatest match in tennis history, the men's singles final was fought with such skill, power, and finesse the outcome was never assured until the final point scored. Martin's photograph is an image of composure, a prelude to the great battle ahead. Four hours and forty-eight minutes later, the two men were exhausted and spent. For Nadal, there was triumph; for Federer, disaster.

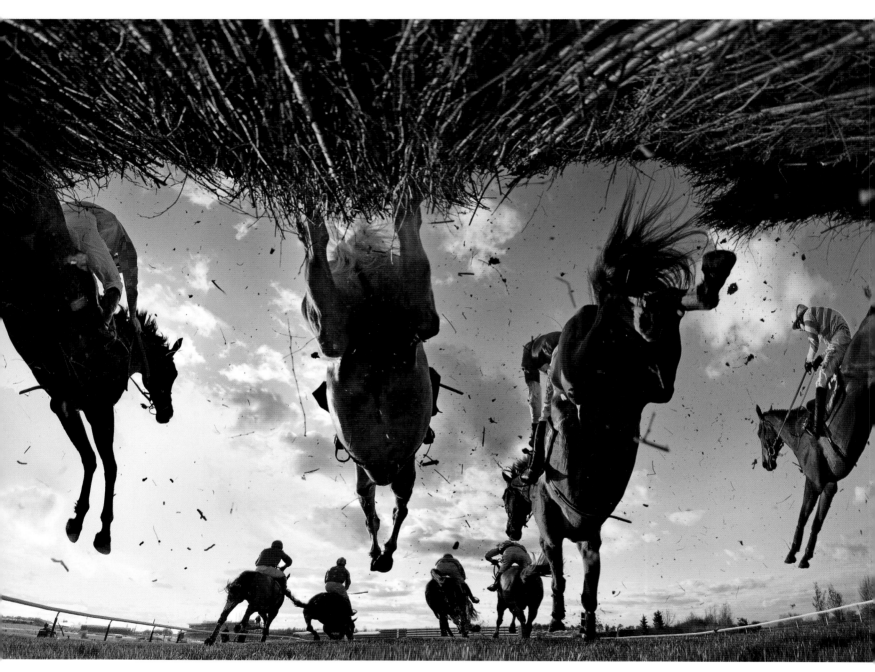

Bob Martin, Equestrian racing, April 4, 2007

CHAPTER FIVE
VANTAGE POINT

If the photographer could not move his subject, he could move his camera. To see the subject clearly—often to see it at all—he had to abandon a normal vantage point, and shoot his picture from above, or below, or from too close, or too far away, or from the back side.

JOHN SZARKOWSKI, *THE PHOTOGRAPHER'S EYE*, 1966

• • •

Sports photographers attend a lot of games, but among themselves they play the game called "find the best place to put your camera." In the old days, the photographer needed to be next to or holding the camera in order to remove the lens cap or depress the shutter. Later, they could be as far removed as the length of their cable release. With radio control, photographers tape their cameras to the most advantageous and dramatic positions on the field and trigger them remotely—often many going off simultaneously. Today, sometimes cameras are in drones and secured on catwalks, controlled by computers, and nary a human is in sight.

Vantage points make sports photographs exhilarating. More than any other element, they are what give excitement to the image. Photographers look for vantage points providing unusual and dramatic insights into the subject. Photography extends vision, and sports photographers are at the top of their game placing cameras for new perspectives and drama.

In addition to discussing the *vantage point* in his book *The Photographer's Eye,* John Szarkowski, former director of the Museum of Modern Art in New York City, highlights other considerations that relate to sports photography: *the frame,* within which all the action must be contained— just as on the playing field; *time,* a split second of which changes everything—in a game as well as in a photograph;

the detail—the smallest of elements that reveals the skill of a photographer and athlete.

• • •

Not only has **BOB MARTIN** found the perfect spot to situate his remote-controlled camera, he chose the perfect lens. Wonderfully elongated and exaggerated horses and riders help dramatize the power of the horses coming over the hedge. Martin considered where the light would be at this particular time of day. Only then did he carefully place his camera. He couldn't predict the colors of the jockeys' shirts from left to right but he knew what he wanted from the green grass, blue sky, and white clouds. A painter might use the same colors, try for the same energy, but forget the turf kicked up by the horses' hooves, which makes Martin's picture resemble a dusty old transparency from photography's earlier days. But this isn't an imperfection; it is wonderful to have dirt kicked in the camera's face in a horse race.

• • •

WALTER IOOSS JR. wanted to photograph one of his favorite subjects, Michael Jordan, airborne. He conceived of a shot from above; he got himself a cherry picker. But first, he had to paint a parking lot blue and truck in an NBA regulation basket. Jordan had to seem suspended in heaven.

The photograph has an eccentric perspective. Rather than feeling that we are looking down on Jordan rising up, we have

an equal sense that Jordan and his shadow have been painted on a ceiling—a Sistine Chapel for the saints of sports. The red and blue palette, reminiscent of Renaissance royals, enhances the effect.

Mystery is paramount in art. Through elimination of extraneous details, the photographer left the viewer with the impression that Jordan is playing basketball with his shadow (which was carefully rendered). The hoop a holy grail.

"You get bored doing the same thing over and over again," said Iooss. Michael Jordan, a friend as well as one of Iooss's great subjects, speaks about knowing that when it came time for a photo session with Iooss, "I wasn't the only professional in the room." And like Jordan, Iooss strove to soar above all others in his field.

Iooss speaks about conceptualizing everything in a shot, edge to edge. He grew up on photography that was full frame;

Walter Iooss Jr., *Blue Dunk,* Michael Jordan, Illinois Benedictine College, Lisle, Illinois, 1987

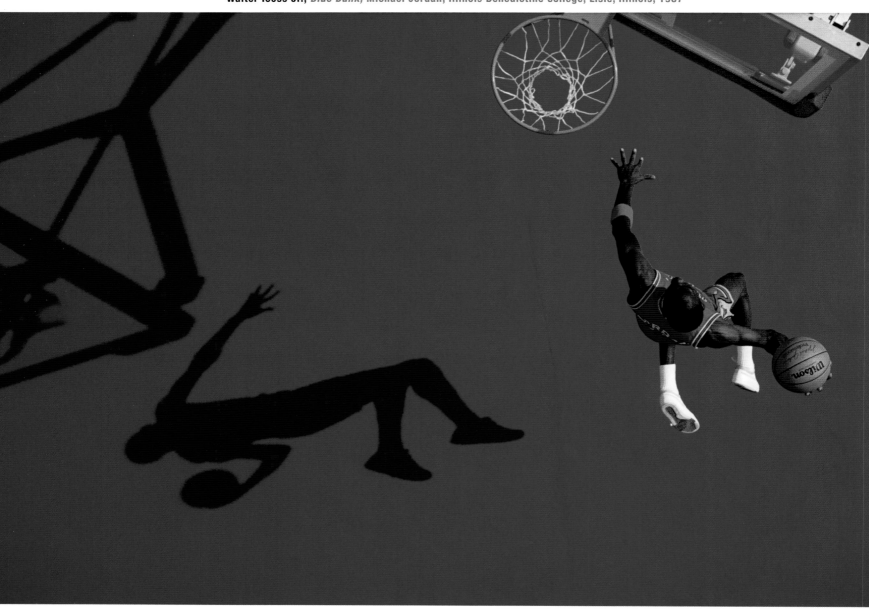

there was no need to crop because the challenge was to make it right, not tamper with it later. Above all else, backgrounds are his forte; he is "crazy" about them. "I want to know what the background is before anything else," he told me.

He added, "If the message in your picture is confused, or if it is distracted by something growing out of someone's head, the picture is not perfect," and perfection is a hallmark of Iooss's photography.

"I would rather make one beautiful picture from one perfect location in exquisite light rather than chase the ball," he said. His photographic role models—John Zimmerman, James Nachtwey, Pete Turner, and Jay Maisel—all have one thing in common—they make photographs that are carefully crafted and original. Annie Leibovitz is a newer influence. Iooss has always cared about the *one* shot; he was never interested in getting many pictures in *Sports Illustrated,* the publication he has long been associated with. He wanted the picture that once seen would not be forgotten.

Iooss always got the shot *SI* needed and the shot they couldn't have imagined. On the same roll of film, he could capture the defining moment of a game and make an artistically satisfying picture for himself. Neither is an accident. He knows both sides of photography. Some of his most aesthetic images employ chiaroscuro: an action shot shows Willis Reed's eyes raised and looking like a detail in a Caravaggio. He is more than reliable as a portraitist, he is imaginative and original. It isn't just that he made a portrait of Yogi Berra from behind. It is that you feel that Berra's body contains every inning of every game he ever played and attended. Even the rumpled pinstripes are perfect. And his photograph of Greg Louganis fully extended in a dive but flipped 180 degrees is transcendent. "It was like God jumped in our camera for one picture and said, 'Okay, this is it.' I was moving the camera so quickly that it was taking the red of the sky and swirling it. It looked like the flames of hell coming out of the pool."

Between his junior and senior year of high school, Iooss took some photography classes at Germain School of Photography. The rest of his technical knowledge he picked up along the way. The only thing he was sure about as a teenager was that he loved photography and he loved sports. When he processed his first roll of film in 1959,

in the darkroom he set up in his house, "my future was unlocked," he said. At sixteen, with braces still on his teeth, he was shooting for *Sports Illustrated.* His real teachers were his colleagues at the magazine: Robert Riger, John D. Zimmerman, and Heinz Kluetmeier.

In the introduction to Iooss's 1988 book, *Sports People,* Frank Deford writes about the need for still photography in an age of television sports coverage. "Miller Lite and Midas Muffler aren't paying $300,000 a commercial minute for aesthetics and humanity. They're paying that for touchdowns and home runs."

And there you have it, the need for Iooss's photography—aesthetics and humanity possible in the still photograph. He loves one particular Henri Cartier-Bresson quote: "To take photographs . . . is putting one's head, one's eye, and one's heart on the same axis." He doesn't always want to be photographing millionaires. He loves photographing kids playing sports as much as affluent pros.

· · ·

TIM CLAYTON has such high standards for sports photography, just being around him makes one want to do better. He is a rare bird in sports photography because he cares nearly as much about the profession as he does about his own work. He believes that sports photography lends itself to truly great, artistic, and expressive imagery. He knows the public often sees only mediocre work. He takes issue with agencies and/ or individuals that are just in it for the money although that is the current reality. His website is unique in that it has a mission statement: "Tim is a keen campaigner on ethics in photojournalism and a keen advocate of developing photo essays in sports photography to help put the profession on a par with other areas of photojournalism."

In conversation, Clayton said he "tries to shoot artistically, to look at things differently." And he does. Sometimes the photograph becomes mysterious because of a ray of light; sometimes it is because he is shooting from below and watching a figure do a flip on a snowboard against an expansive sky; sometimes he photographs the shadows, not the substance.

Born in Leeds in 1960, he didn't have an easy life. Both his father, a journalist, and his mother died at the age of thirty-nine. He was adopted by his maternal aunt and uncle.

His sister got married at seventeen. Sports, especially soccer and cross-country running, were an escape. He left school at sixteen, and almost miraculously his first photograph was published. By the age of twenty, he had won one of the most prestigious awards in photojournalism, a World Press Photo award.

Clayton got a job on the *Yorkshire Post* when he was twenty-one, working in the darkroom and shooting sports. He stayed ten years. He had to; he had a wife and two young sons to support. In 1988 he decided he should branch out: he went to Uganda, got shot at, and decided he really should stay with sports.

He emigrated to Sydney, Australia, which was another smart career move. Sydney in the 1990s and early 2000s was a magnet for some of the world's best sports photographers. Photographers who were with the Allsport photo agency reminisce about the high caliber of their agency; the former *Sports Illustrated* photographers remember the days of big budgets and great photo editors. The team of photographers at *The Sydney Morning Herald*—Tim Clayton, Craig Golding,

Tim Clayton, "Snowboarder takes to the air," the Remarkables Ski Fields, Queenstown, New Zealand, July 23, 2011

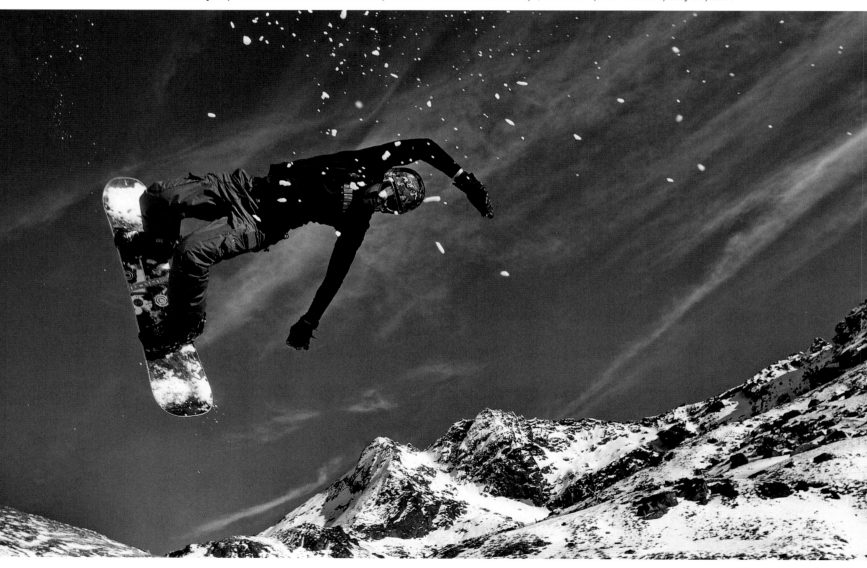

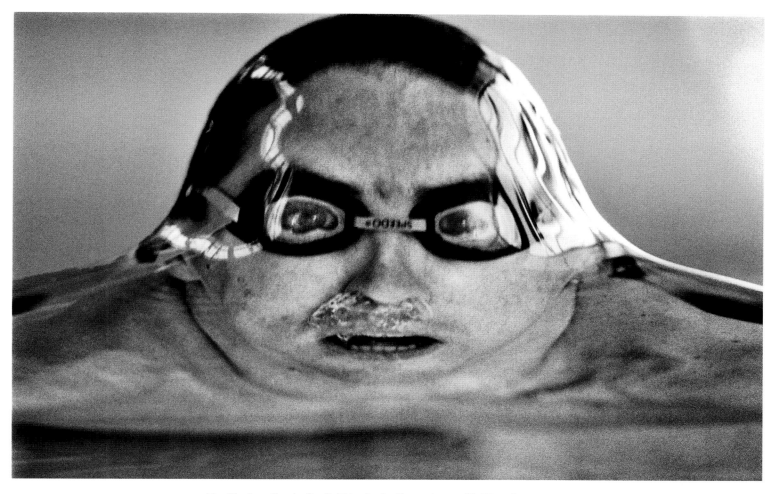

Tim Clayton, *Boy in the Bubble,* **Australian swimmer Matthew Dunn, 1993**

Steve Christo, and eventually a very young Adam Pretty—had similar talent and camaraderie. Across town at *The Australian* was Trent Parke, also shooting sports, before joining Magnum.

And now to "Bubble Boy," as he is fondly called. Clayton had not seen a photograph like this before (they are now quite common). He had observed this effect when swimmers surface at the start of the race. The water settles and the speed of swimmers' dives means they beat the ripples of water, so as they rise, they break the surface tension. Clayton had learned that the Australian swimmer Matt Dunn would be practicing in a fifty-meter pool which would allow him to be close enough with his 300mm lens to get a good tight frame and capture the split second before the swimmer breaks the water

tension. Complicated description. Primal image. It won first prize in the sports category in the 1993 World Press Awards.

. . .

LIFE photographer **CO RENTMEESTER** made a series of famous photographs of Mark Spitz training for the 1972 Munich Olympics. The photograph used on the *LIFE* cover of August 18, 1972, shows Spitz without goggles from a slightly elevated position. Rentmeester took that shot with a Hulcher camera as his assistant pushed him in a wheelchair alongside the pool—a practical solution for moving effortlessly alongside Spitz as he swam laps, but it didn't result in the best photographs.

The most brilliant portrait of Spitz, reproduced here and which ran inside the magazine, was taken by Rentmeester

standing in the water with a camera in a waterproof casing perched on a tripod. He used a slow shutter speed to make the water look like it is in motion. (The quality is so painterly, it also looks like it was done with brushstrokes.) This picture is the one that shows Rentmeester's art school training, his love of Irving Penn's photography, and his superb technical ability. From the top of Spitz's head to his chest there is a strong diagonal. The picture is both intimate portrait and action photograph. There are thousands of photographs of Spitz winning races and standing with gold medals around his neck—public displays of victory. Rentmeester has captured something very different—Spitz as one with the water and an intimate glimpse into how he won the gold.

Water is something Rentmeester knows well. As a young athlete in Holland, he trained five hours a day for three years to earn a place on the Dutch rowing team at the 1960 Rome Olympics. That intense training served him well, especially when photographing athletes. He has always understood what it took to excel, both in himself and his subjects. From his home on Long Island, he coaches young athletes in rowing.

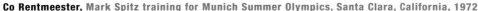

Co Rentmeester, Mark Spitz training for Munich Summer Olympics, Santa Clara, California, 1972

LEV BORODULIN, a major press photographer in the former Soviet Union, had to leave the country quickly in 1972, for dual offenses. His first crime: His photographs were too original, too imaginative. Nailya Alexander, a leading gallery owner specializing in Russian photography, told me, "Yes, formalism was a crime, anything beyond the socialist realist canon was a crime." His second offense: being Jewish. He arrived in Israel in 1973 and still lives there.

Both *Forward* and *Girl Archer* show how well he absorbed Russian Constructivist and Bauhaus theory. Borodulin was born in Moscow in 1923; he later started art school, but was then called to the front in 1941. He served for the entire war, was badly wounded twice, received medals for the defense of Moscow and taking of Berlin—but little did those deeds outshine the crime of "formalism." He was too young to experience the often murderous attacks on artists in the 1930s. After World War II he had steady work for many of the USSR's leading publications. Although photography was supposed to be for propaganda purposes, shooting sports gave him, he said, "a certain freedom of artistic expression, and the freedom to travel." The problem was that he strove to revive the formalist photographic principles of his forgotten teachers—Aleksander Rodchenko, Boris Ignatovich, and Arkady Shaikhet. His colleague at the Soviet magazine *Ogonyok* was the famous Dmitri Baltermants, with whom for fifteen years he shared a small darkroom.

Even though Borodulin won international awards, including a gold medal at the Munich Olympic Photographic Exhibition held just prior to the opening of the 1972 Olympics, Soviet officials banned him from attending the Munich Olympics, accusing him of "formalism." Today we are grateful for his "crimes," as his body of work is bold and original—hence, unacceptable to a totalitarian state. His young female archer could be aiming at the men in power.

In addition to Borodulin and Rodchenko, the other important Russian sports photographers in the early and mid-twentieth century are Max Penson, Georgi Petrusov, and Olga Ignatovich. Alexander Abaza did sports photography in the 1970s and 1980s.

Lev Borodulin, *Girl Archer,* 1956

Lev Borodulin, *Forward,* Moscow, 1959

DONALD MIRALLE JR. describes his early years as half the time in and half the time out of water. His grandfather may have come from Italy to the Bronx, but the family ended up near the beach in Los Angeles. Miralle still lives next to the ocean and keeps two surfboards on top of his van.

After applying to Columbia University, the University of California, Berkeley, and Brown and being accepted at all three, he decided he couldn't be far away from the beaches of Southern California and started a premed program at UCLA. He was on the swim team, training four or five hours a day and weight lifting for two hours more. Miralle was an All-American athlete in water polo and swimming. After attending a full day of lectures (and the prerequisite undergraduate partying at night), he had no time for studying biology and organic chemistry, and downward went his grades.

After his sophomore year, Miralle transferred to the UCLA art school. It was a world apart from premed; he soon was immersed in a 100 percent creative environment and his grades went to straight As. Two of his teachers were Sharon Lockhart and John Baldessari. He studied painting, drawing, sculpture, and welding, as well as photography. He did mostly black and white because he liked being in the darkroom. He graduated with a great portfolio and great grades.

Miralle's father, son of that original Italian immigrant, was worried about his son's prospects finding a job with a degree in art, so he started scouring the classified ads in the *Los Angeles Times.* The only possible fit was for someone to work at Allsport photo agency as an assistant filing slides and in

Donald Miralle Jr., Conservationist, photographer, and dive safety officer Ocean Ramsey poses for photos during a cover shoot for *Pacific Magazine,* free diving, Shark's Cove, Haleiwa, Oahu, Hawaii, May 15, 2013.

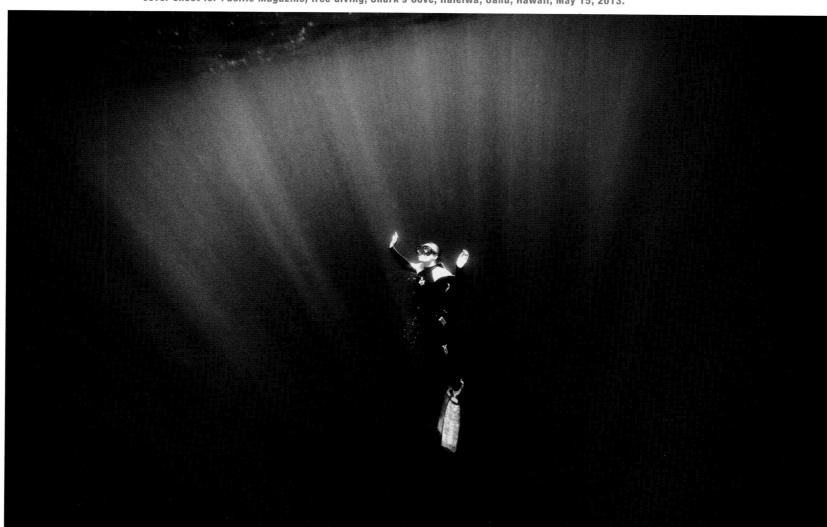

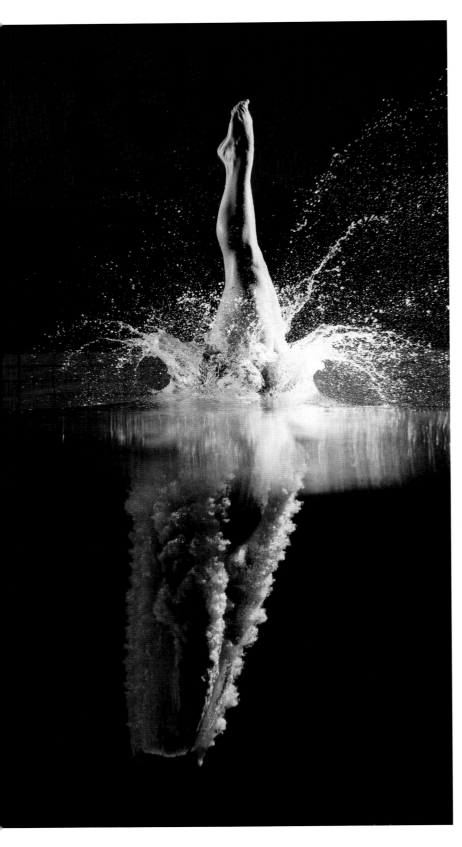

the darkroom. Miralle had concentrated on photography his senior year and went for the interview. Mike Powell hired him immediately. Miralle told me: "Coming out of art school, I saw that sports photography can be an art because the human body is such an amazing thing."

Like Simon Bruty and Al Bello, Miralle started at the bottom but had the opportunity to look at the best pictures shot each day. It was a wonderful learning experience. The name Darrell Ingham always comes up when Miralle's generation of Allsport photographers speak about the people who influenced them the most. Ingham was a tough teacher and a demanding editor. All the photographers learned from him.

After one year of photographing sports on weekends and working in the office Monday through Friday, Miralle was promoted to junior photographer; his niche was underwater and water sports. "If you grow up in the water, it is a form of escape. It is an alien environment, different laws of physics—a dreamscape," he said. "I was trying to convey how I saw it, combining athleticism and aesthetic beauty of the underwater. . . . Water and light—my strength."

· · ·

There are just so many dives you can ask a person to do and still expect each one to be flawless. In the days before digital, the only way to see if you got what you wanted was to use a Polaroid camera. **GEORGE SILK** pre-conceptualized the entire series of *The Dive,* going so far as to drop the level of the swimming pool to halfway up the coaches' viewing window. From that vantage point he photographed. Silk mastered the camera, but balancing his strobes above and below the water was a challenge.

Silk was always aiming to make memorable photographs. For him, that meant a new and original way of seeing. While he was capturing the perfect dive by the fourteen-year-old Olympian, he also took funny and bizarre pictures of her in the pool, head seemingly floating away from her body.

George Silk, *The Dive,* Kathy Flicker, Dillon Gym Pool, Princeton University, 1962

Facing page: **Mark Fisher,** Sage Cattabriga-Alosa, extreme skier, Neacola Mountains, Alaska, 2010

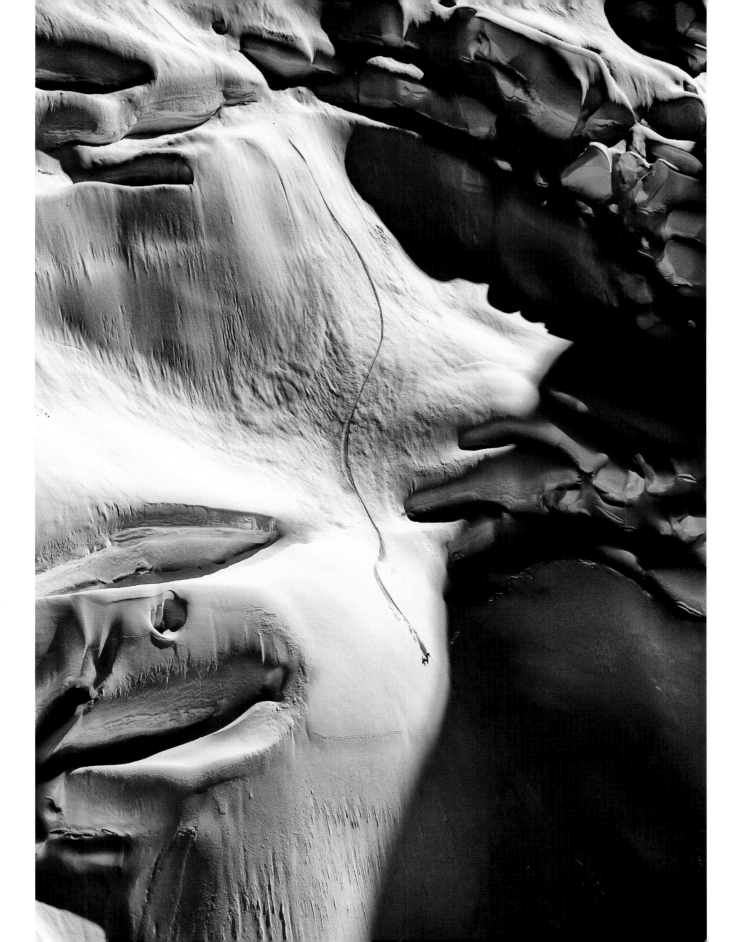

· · ·

Like Ansel Adams's early work and all of Bradford Washburn's oeuvre from 1929 through the late 1970s, **MARK FISHER**'s photographs are illustrative of transcendence through nature. For Fisher, the word "extreme" has to be inserted somewhere, everywhere. In a Fisher photograph, the landscape is sublime, but there is almost always an audacious (madcap) skier somewhere in the terrain. First Fisher mastered photography. Then he mastered extreme sports photography.

In an age of GoPro and 35mm digital cameras with resolution unimaginable a decade ago, not many extreme sports photographers will wax poetic about the days trudging a Linhof 4 × 5 camera with a tripod in their backpack all over Colorado. But it is exactly this experience of working slowly and deliberately, concentrating on the full frame, recognizing the salient details, conceptualizing what he wants the photograph to communicate, that has elevated Fisher above most photographers in his field. It is not just about thrills and chills in Mark Fisher's work. It is about beauty. The athletes in his photographs do not seem to *challenge* nature but to commune with it.

That classy, historic, sensual Linhof camera had to be sold when Fisher was broke. He learned, as many aspiring art photographers learn, that art doesn't put food on the table—or pay for a plane ticket when you have a burning desire to see another part of the world. Now Fisher has a successful still and film business, journeying with and photographing many of the world's premier extreme sports athletes. Planning the trips together is central to his work. Organizing the helicopters from which the skiers and mountaineers are dropped and from which he will photograph is a requirement of most trips. It isn't easy for a skier perched on a precipice not knowing what lies beneath him; it isn't easy for the photographer hanging out the door of the helicopter, hands so frozen that he or she wants to scream and vomit. Fisher says that after the months preparing with the athletes for a descent down a mountain or surfing the waves in Alaska when the temperatures are well below freezing, he has only one chance at a shot. He communicates with the athlete by radio, but anything can go wrong. And sometimes everything goes right. Fisher explains that his work is about showing "the drama and consequences" of what the athletes are facing. I asked him why he does what he does, and his answer was exactly the same as when he was carrying around the Linhof. "I go [to the extremes] because I hope to pull out one or two pictures that *transcend*."

· · ·

La Grande Odyssée Savoie–Mont Blanc sledding race, one of the most challenging in the world, takes place in January in the French and Swiss Alps. The course is more than 900 kilometers long and involves 25,000 meters of vertical ascent. **JEFF PACHOUD,** a French photojournalist, shows the beauty from afar, shooting scenes from a helicopter. He also descends to the ground, bends his knees, goes eye to eye with the heroes of the race, the dogs, and watches them being hand-fed by their musher. The dogs need up to ten thousand calories a day during the race, the equivalent of a cyclist competing in the Tour de France. They also need to feel loved and appreciated, hence the musher feeding his dogs with his battered "paws." But possibly this analysis is incomplete. The dog licking the hand that feeds it may also soothe the musher, a balm for the bruises his hands and body endure during the two-week race. Dogs and humans are a team as surely as the San Francisco 49ers, Barcelona's Barça, or New Zealand's All-Blacks rugby team. But probably, living together and training together all year, they love each other more.

Pachoud, a contract photographer with Agence France-Presse, is a powerful, artistic storyteller. His pictures have an edge, as well as beautiful lighting and color. He shoots a variety of subjects. His two other outstanding photo essays related to sports are *Hunting with Hounds* and *Wrestlers*.

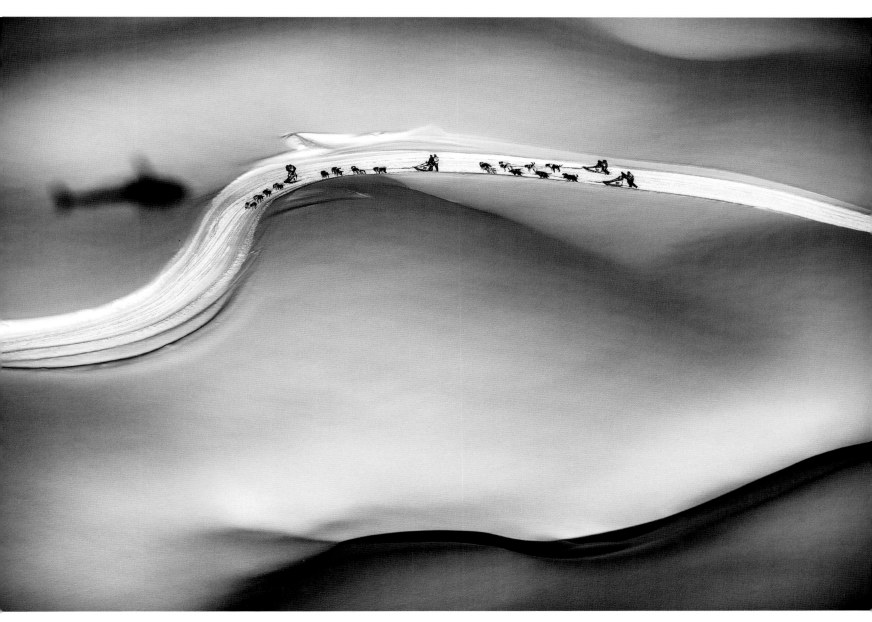

Jeff Pachoud, "Mushers compete in La Grande Odyssée Savoie–Mont Blanc," Megève, France, January 18, 2013

Andri Pol, "The highest football pitch in Europe," Gspon, Switzerland, 2006

• • •

If you are a good sports photographer, you feel the situation and know what will happen. I can't. I am not a fan. The good sports photographers know what to do. I don't know these things. I am always too late. I ask myself why am I always too late. For me, seventy-five minutes of a soccer game is just boring. I prefer to walk around the stadium and illustrate the feeling, the emotion that comes out of the people. They have this common ground, the passion for the game.

ANDRI POL, INTERVIEW WITH AUTHOR, AUGUST 1, 2013

ANDRI POL isn't looking at the game per se, but he is always looking. He admits to "quite often being astonished by what athletes do. They are very creative."

Like many photographers before him—Eugène Atget to name but one—Pol is looking for the cultural bonds and visual clues that give identity to a populace. A Swiss who has traveled widely and photographed reflectively, Andri Pol starts by pulverizing stereotypes in his own native country. *Grüezi: Strange Things in Heidiland,* the book he did with anthropologist David Signer, ponders the question, with images and text, "Is strangeness an internal or external condition?"

There is nothing particularly "strange" about this top-of-the-world soccer photograph . . . except the strangeness of creating a field for competitive sport surrounded by such magnificent nature. Why not just go for a walk? Why keep your eye on the ball?

Pol studied painting at art college in Lucerne and photography at the Royal College of Art in London. He sees no divide between his commercial and personal photography. Surprises to reflect upon are everywhere.

Golf isn't just a good walk spoiled. Golf photography is keeping an eye on a little white ball when nature on its own has such allure. **DAVID CANNON,** a leading golf photographer, has published two "landscape" books: *Golf Courses: Fairways of the World* and *Golf Courses: Great Britain and Ireland.* They show undulating green grasslands and sublime coastlines punctuated with sandtraps and picturesque ponds and lagoons. Look carefully at this picture and you will see, among the luscious foliage, an airborne golf ball.

David Cannon, born in London in 1955, played in the amateur golf circuit after leaving school in 1973. Not quite good enough to go pro, he bought himself an SLR camera, got a job photographing sports for the Leicester News Agency, and discovered he was good enough to go pro in the photo world. In 1983 he was invited to join the premier sports photography agency Allsport. Going back to his roots, he became their golf specialist, and to this day he is considered one of the finest golf photographers in the world. He has photographed all the great golfers and normally has been able to show just how emotional a sport golf really is. His advice to would-be golf photographers: make sure your camera has a quiet shutter.

David Cannon, Russell Henley plays a shot from the flowers on the 13th hole during the first round of the Masters Tournament, Augusta, Georgia, April 10, 2014.

Garry Winogrand, *Austin, Texas,* **1974**

"I photograph to find out what something will look like photographed," **GARRY WINOGRAND** famously said. And here, in a book of sports photography, we pause to see what a football game *photographed* looks like. For Winogrand, winning or losing, who has the ball, the line of scrimmage, is irrelevant. The true excitement is what will end up in the frame, not on the scoreboard. "Photography," he believed, "is not about the thing photographed. It is about how that thing looks photographed." Photographed slightly off kilter, a Winogrand hallmark, the moving bodies are spread across the field, given equal weight and importance, not at all similar to the long lens close-up showing the key play common in the sport media. Winogrand wants to see how it all comes together,

and no particular action has more importance than another. There is a rhythm, flow, and complexity across the "stage" that Balanchine might applaud. And because Winogrand is a photographic genius, one headless body on the right creates pictorial balance and mystery as he flies out of the frame.

• • •

"If my maid of all work, after I have posed myself before the looking-glass, takes off the cap of the lens when I cough, and replaces it at my grunt, has she taken the picture?" asked Oscar G. Rejlander rhetorically in 1866. Of course she hadn't (or had she?). "Authorship" of a photographic image has been queried since photography's invention. The one thing agreed upon is that the camera doesn't push its own button—or in the nineteenth century, take off its own lens cap.

ADRIAN DENNIS, a British photographer working for AFP, shot this dramatic picture remotely. The camera that took the picture was set up behind the net fifteen minutes before the game. It was triggered whenever Dennis fired the camera around his neck with the 70–200mm lens. Dennis viewed the action from one angle, and although his viewpoint differed from the camera that took this picture, his reaction was in real time to real events. Even blind people have been known to take outstanding photographs. We assume photography is always about vision; sometimes it is a sensation, a feeling, a hunch.

Many will say a photo from a camera triggered remotely is just a "lucky" shot. No, not really. The photographer sets up the remote camera based on years of experience. The best spaces behind the net get taken early. Dennis uses an old wide-angle lens taped at a focus of ten feet. All photographers have had "expensive days" when their camera and lens have been smashed unintentionally (or intentionally).

Even if a photographer isn't holding the camera, he or she still has to compose the frame and factor in the direction of the light, the symmetry of the background, the color of the net (black is best), and prior knowledge about where the goalie hangs his towel. Dennis, who normally sets up only one remote camera unless it is a very important game, says the winning shot is often not the one taken with the camera in his hand but by its Siamese twin behind the net. Both cameras share Dennis's heartbeat.

Adrian Dennis, Wolverhamton Wanders vs. Tottenham Hotspurs, March 6, 2011

"Art follows focus," says **SIMON BRUTY** (perhaps referencing the famous phrase by architect Louis Sullivan, "form follows function") about his early days shooting sports for Allsport. Bruty laments that technology has "taken away the art of follow focus." There was a time when a sports photographer had to master focus just as a painter has to master a brushstroke. Now anyone with an autofocus camera can get a sharp picture, but there are only a handful of people who can achieve a high level of aesthetic quality in a sports photograph. Simon Bruty is one.

Bruty, born in Portsmouth, England, did his college-entry A levels in geology, geography, and zoology and applied to universities and polytechnics (including Trent Polytechnic, which had one of England's finest art photography departments) before deciding to become a gym teacher. He really had his heart set on being a professional cricketer. To earn money in the summer of 1984, at the age of eighteen, he sold stationery, and one of his clients was Allsport photo agency.

Bruty had done a yearlong O level photography course in secondary school ("Mr. Gibbon was a great teacher") and decided Allsport might be a fun place to work. He got through on the telephone to Steve Powell, managing director, who told him to come up from Winchester to London for an interview. When he arrived, Powell wasn't there, but Adrian Murrell, chief cricket photographer for Allsport, was in the office and showed him around. Bruty started falling hard for the pictures he saw and the ambience of this storefront business. Two or three weeks later, Murrell called him to

Simon Bruty, Ohio State University vs. Oregon State University, National Championship, Dallas, Texas, January 12, 2015

Brad Mangin, "Ivan Rodriguez of the Houston Astros throws to first base against San Francisco Giants during the game at AT&T Park," San Francisco, July 5, 2009.

say there was a low-level job for him. Out went plans for university, art college, gym teacher, and professional cricketer. He joined the Allsport family in October 1984.

Low-level meant making the tea, being the gofer, filing and duping slides, running to the post office. But Tony Duffy, Steve Powell, Trevor Jones, David Cannon, Bob Martin, Mike Powell, Simon Miles, Don Marley, Lee Martin, Gerard Vandystadt (Paris office), and about seven to ten other darkroom and other staff in the London and L.A. offices made for an electrifying atmosphere for a young man. He lived and breathed sports photography. "I had no social life," he told me, but he didn't mind. He could go out on weekends with a press pass and a camera and shoot sports.

Bruty, born in 1965, feels fortunate that his experience in the field bridged "the older sports photographers always talking about the halcyon days" and the younger, digital generation. Bruty, a former staff photographer for *Sports Illustrated* for many years, would say he worked with the best

sports photographers on the planet. They, in turn, would acknowledge Bruty to be one of the finest in the field.

"I am a defender of sports photography," Bruty told me. "It is a bit of a bastard child in the whole photography scene . . . it does not get its just rewards. . . . We make something artistic out of something we have no control over. War photographers and sports photographers are very similar," he says about going to the front lines and coming back with a defining picture.

●　●　●

Everyone knows baseball fans can be obsessively loyal to their team. Occasionally, so can photographers. Case in point— **BRAD MANGIN**'s devotion, emotional and photographic, to the San Francisco Giants. Most sports photographers have a favorite team (they were born *somewhere,* they had parents and siblings who drilled team loyalty into them), but they recognize that to survive in the big league of sports photography, favoritism has no place when focusing one's lens. Mangin is crazy about baseball. "From the first pitch of

spring training," he says, "to the final out of the World Series, I'll shoot at least ninety games a year, sometimes a hundred. It's a lot of fun. I love it." Mangin shows favoritism toward the Giants but is still asked to photograph other teams.

Worth the Wait is his first lovefest book about his team winning the World Series in 2010. When the Giants did it again and again, he did more books, *Never Say Die* and *Championship Blood*. Everyone who knows Mangin (and that is almost every sports editor and sports photographer) puts him in a special category. More than a fan, more than a photographer, Mangin keeps alive the spirit of sport through photography. He is the "ambassador of sports photographers," says his friend and fellow San Francisco photographer

Michael Zagaris. Zagaris considers Mangin the "best baseball photographer because (a) he has the eye, (b) he has the technical skill, (c) a burning love of the game" and then adds, "Baseball is his wife."

Unlike rock photographers, who often are friends with the musicians and party hard with them, sports photographers don't generally socialize with the athletes. Mangin recognizes they have "enough bullshit to deal with and are busy dealing with writers," so they don't need to be unduly hassled by photographers.

Portraits are not what Mangin does best, although he has some beautiful, tender ones, often in the dugout. He likes to integrate the player into the field, show the action, convey

Barton Silverman, Derek Jeter steals third base in the first inning of a game with the Baltimore Orioles, Yankee Stadium, New York, June 3, 2010. (Barton Silverman/*The New York Times*)

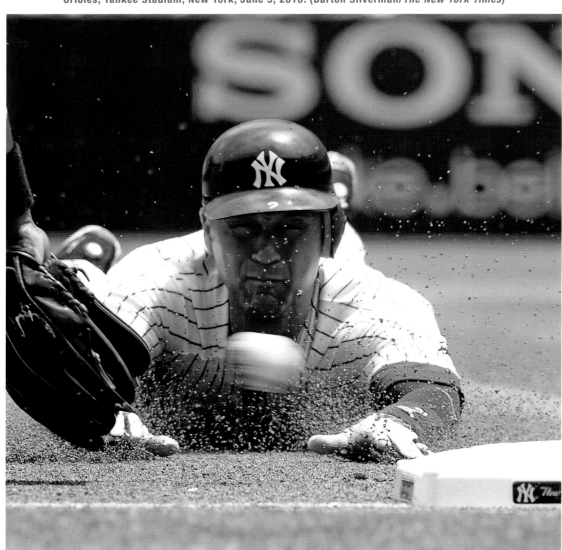

• • •

a sense of the light, smell, and even sound of the field and stadium. His book *Instant Baseball: The Baseball Instagrams of Brad Mangin* celebrates beer, hot dogs, bats, balls, and big-name players all in one compact square book. He recognizes that camera phones are great democratizers, like earlier Kodaks, and even though everyone takes pictures with them, he loves shooting with his iPhone. It gives him more freedom and a more spontaneous, fun-loving approach.

But when he gets "serious," he uses his state-of-the-art 35mm and looks for an uncluttered background and lets "the action come to me." He might shoot every day, but gets "only five pictures a year I really like when the light and the action and the backdrop harmonize."

• • •

When a great photograph appeared on the sports page of *The New York Times* for nearly fifty years, it invariably had the byline "**BARTON SILVERMAN**." The incomparable Silverman produced sufficiently exciting sports imagery to ensure that thousands of readers of the Gray Lady would begin their day looking at his photographs in the sport pages of the *Times*. Asked about his staying power, he answers, "I like sports," but there is more. He likes the challenge of sports photography, "figuring out where the play is going to happen" and "knowing where to stand." The famous former picture editor John Morris described Silverman as the "spark plug of a talented staff." Artist LeRoy Neiman describes his friend as a "sociologist," not just someone just looking for "peak of action."

Silverman loves the relationships he formed with players in the early days, most notably Joe Namath (he was the Jets' photographer for seven years and also photographed for the New York Rangers hockey team), and having dinner or a drink with the athletes, which he could do early in his career. Barton Silverman is not a slight man; he carries a few extra pounds. He cannot be missed on or off the field. He can't run as fast as the other photographers, and there are stories of him slipping on ski slopes at the Olympics, but like the sheriff in the Wild West who always got his man, Barton Silverman always got his picture.

Like many of the photographers in this book, he joined the photo club at school and became enamored at the age of twelve with photography. He became photo editor of Lafayette High School's newspaper and then its photographer. He got out of class; he hung out with the cheerleaders; he felt important. At Brooklyn College, where he was a business major with a minor in communications and advertising, he was the college photographer and picture editor of the paper. It was his introduction to journalism.

Silverman began at the *Times* in the lab in 1962. He retired in 2015 as chief sports photographer. At first he shot on weekends or carried equipment for a staff photographer. In the early days he learned from the best in the field of sports photography—Ernie Sisto (1904–1989) at *The New York Times;* Charlie Hoff (1902–1985), Frank Hurley (ca. 1914–2004), and Dan Farrell (1931–2015), who worked for the *Daily News;* and Harry Harris (1913–2002) at AP, men who moved from the Big Bertha and the speedy Hulcher and Speed Graphic cameras to the Rolleiflex and finally to 35mm. His heroes were not the athletes but photographers—George Silk, John Dominis, Mark Kauffman, John Zimmerman, Irving Penn, Bert Stern, and Richard Avedon. When Silverman retired, he was shooting sports five days a week with a digital camera and was a legend in the field.

Silverman reminisces about photographing the Super

• • •

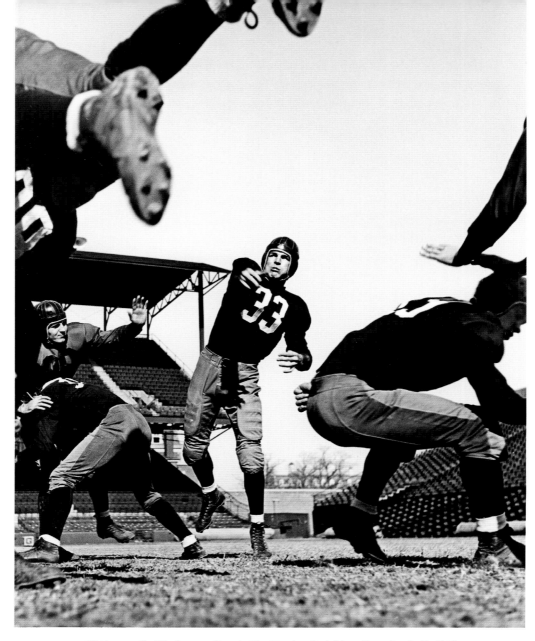

W. Eugene Smith, Sammy Baugh, Washington Redskins, throwing ball, 1940

Bowls in the 1970s and 1980s when he would send only eight to ten photographs back to the *Times* via a drum scanner and a phone line ("wire photo"). It took only eight minutes, after processing the picture, for the photo to reach the paper. There was also a pigeon coop on the *Times* building, and via carrier pigeon the film got back to the paper. He also speaks about the freedom he had to photograph, even at Yankee Stadium, "now like a prison," when he could go into the locker room and take original pictures of the players—

pictures the fans craved and never had seen. At the end of his career, Silverman, the pro, shot relatively sparingly for the twenty-first century with his digital camera. He said he might shoot seven hundred to a thousand photos a game while the other sports photographers were shooting two or three thousand exposures. But what he liked best before his retirement was seeing a series of his pictures on the *Times'* "Lens" blog. "Always my shtick," he concludes, "was to cover sports."

W. EUGENE SMITH, known for his brilliance as a war photographer and photo essayist, also photographed sports—occasionally. In 1940, he received the assignment from *LIFE* to photograph Sammy Baugh of the Washington Redskins in their game against the New York Giants. This picture, probably taken with Smith's Ikoflex II camera (by Zeiss), which used 6 cm square film, was never published by *LIFE*. Although the bleachers are empty in this particular shot, others in the series show the fans, some in Indian headdress, and the coaches on the sidelines. The photograph is so perfectly seen and composed, it could be taken for a posed shot, but the game was being played and the photograph is just another example of why W. Eugene Smith is considered one of the finest photographers of all time. A Eugene Smith photograph is infused with emotion, drama, and complexity, tightly held within a perfectly balanced composition. Smith wanted nothing less than to "sink into the heart of the picture," he said.

In 1940, World War II had begun but the United States had not yet declared war against Germany and Japan. Smith, who would soon insist on being on the front lines, was still doing a wide array of assignments for *LIFE*. After photographing "Loading Mattresses on S.S. 'Washington,'"

"George Kaufman and Moss Hart," "Aviation Training at the University of Michigan," he photographed the 1940 Little World Series. His next assignment was Katharine Cornell's Red Cross Drive, followed by the pro football assignment of Sammy Baugh and then soon after "Women's Field Hockey" and the Amherst vs. Williams football game in the autumn.

• • •

The ground is cold and hard in Durham, in the north of England, on New Year's Day. The Nigerian team were not wearing boots for a game against Bishop Auckland on that day but their ankles were bound with support straps and their knees were protected. **CHARLES "SLIM" HEWITT** was a "workhorse" of a photographer, said legendary *Picture Post* editor Tom Hopkinson, who hired him after World War II. He produced more than five hundred photo essays for the illustrated magazine, many of which were sports-related.

This photograph shows what a pro Hewitt was. The photograph is so much more than "playing without boots." It is lively, syncopated, shot on a diagonal to help the eye move from bottom left to top right. Hewitt wants the viewer to pay attention to the toes that will soon do what no toes locked in boots can do. He asks us not to generalize about the Nigerian team—one is reading, one is writing, one has his hands

Charles Hewitt, "Nigerian footballers, playing without boots but with support straps for their ankles, before a game against Bishop Auckland during a tour of Great Britain," January 1, 1950

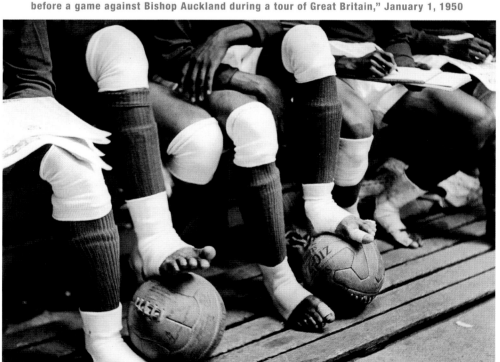

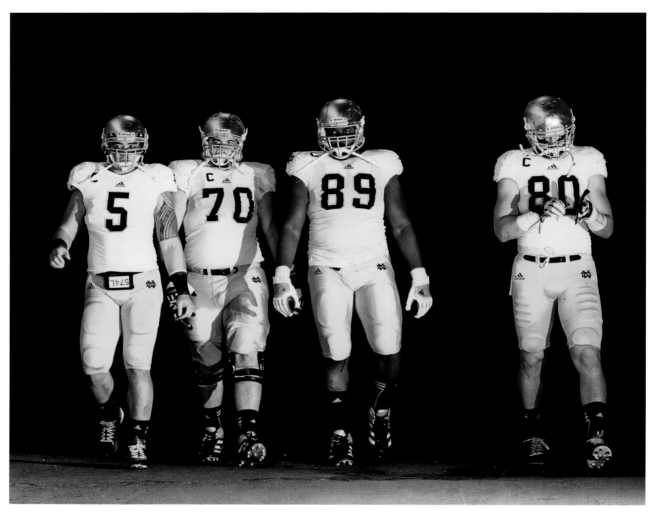

Robert Beck, Notre Dame players, Los Angeles Memorial Coliseum, Los Angeles, California, November 24, 2012

gracefully posed. He abstracts the bodies so that the picture is also a study in black and white.

This, then, is truly *foot ball*—how the game began thousands of years ago.

. . .

Former *Sports Illustrated* photographer **ROBERT BECK** describes his photograph as follows:

> Those are four Notre Dame football players walking down the tunnel of the Los Angeles Memorial Coliseum for a game they would win against USC [University of Southern California] 22–13 and vault them to the national championship game.
>
> There is a lot of history and "feel" in that tunnel. It

opened in 1923 and has hosted two Olympics (1932 & 1984) along with being home to numerous football teams through the years. I lit that shot to create a darker mood. (email January 10, 2015)

. . .

A painter, graphic designer, sculptor, collagist, and photographer, **ALEKSANDR RODCHENKO** was born in St. Petersburg in 1891. Photography was his revolutionary weapon of choice. He first picked up a camera in 1924, the year Lenin died. He abhorred the "belly button view"—the lazy man's approach to photography. "Take photos from all angles," he advocated in 1928. "We must rediscover the visible world. We must revolutionize our visual perception."

Shooting from a high window, at an askew angle, Rodchenko made marching athletes slide off the edge of the photograph. Catching a diver against the sky, rolled tight in a ball, clouds *below,* was part of his disorienting style. Wrestlers never looked like such pals as when seen by Rodchenko's camera from underneath their embrace. His most famous sports photograph is of a back dive taken from above, the arched body against a dark background with a diagonal of mostly headless bodies sitting on wooden bleachers cutting across the top left of the frame—"dynamic diagonal," as it was known. Radical, too. Rodchenko believed the candid photograph had great value in presenting the complexities of life.

Rodchenko was in France in 1925, the year Oskar Barnack's Leica was put on the market. Three years later he was able to buy this "snapshot" camera, but he actually had a 35mm prototype camera before he owned his first Leica. Mobility and ease were essential in his photography. Once he had the reliable and versatile Leica, it became, according to a Getty Museum publication, "his constant companion."

• • •

German photographer **ERICH BAUMANN** has a special place in many sports photographers' hearts. The reason is quite simple: he attempted to make photographs as exciting as the sports themselves. Sports, of course, are inherently exciting, but photography is not. Only the best photographs take your breath away or convey a mood, not simply a fact. Erich Baumann, born near Stuttgart in 1919, was consistently experimenting to convey speed. He mastered "the blur," common now but still experimental in 1965 when he first used

Aleksandr Rodchenko, Horse race, 1935

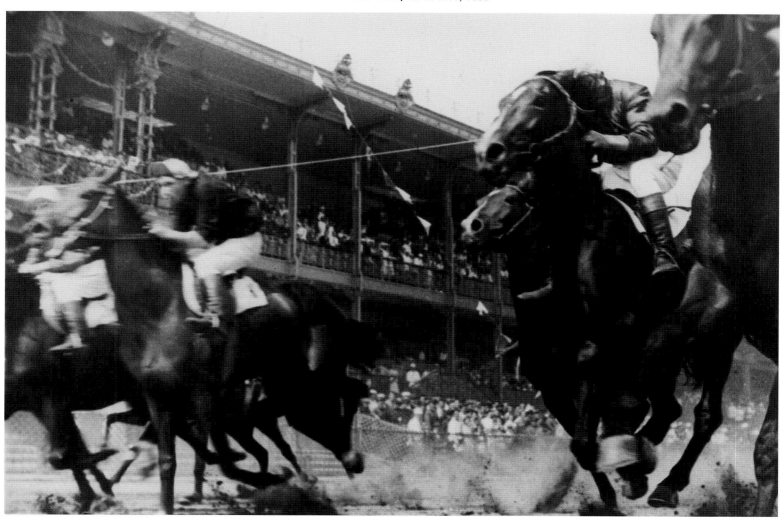

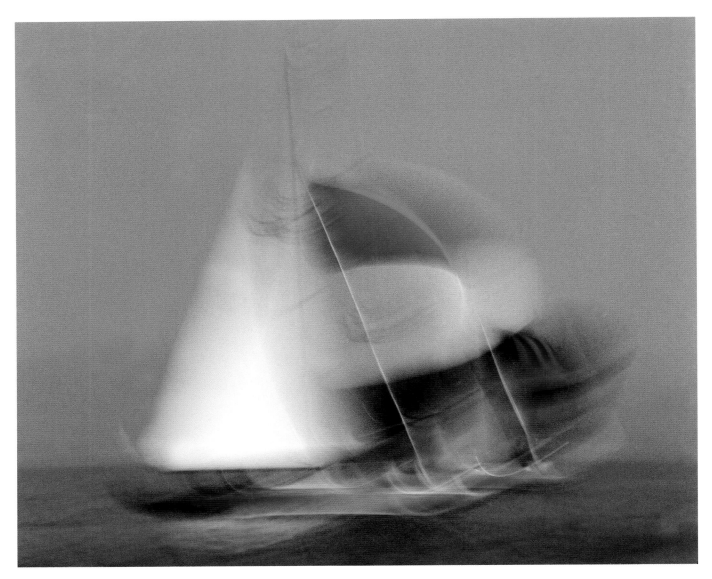

Erich Baumann, Sailing, Lake Constance (German: Bodensee), ca. 1968

it while shooting a Formula One race on the Solitude track near Stuttgart. He called these nonrealistic pictures "sports impressions." Up to then, the thrust of sports photography was toward *sharpness* and *stopping motion*.

Baumann began photographing sports in 1950, and by 1952 he established his own sports photography agency. He worked with his wife, Hannelore, his daughter, Heide, son, Dieter, and a creative team of photographers: Michael Steinert, Franco Zehnder, Eugen Zimmermann, Markus Leser, Matthias Hangst, Hansi Britsch, Alexander Keppler.

. . .

In a way, every sporting event **HEINZ KLUETMEIER** attends is like a horse race. He wants to come in first among his stiff competition. "Kluet" is one of the most respected and revered sports photographers in the world. Most of his colleagues will report that he is gracious with his vast technical knowledge and experience, but his generosity doesn't preclude battling for position with anyone who gets in his way.

Kluetmeier, born in Germany but raised in Milwaukee, has photographed professionally since the age of fifteen and

was offered a full-time job by the Associated Press right out of high school. He decided to go to Dartmouth College and study mechanical engineering. He wasn't cut out for a desk job and spent only a short time as an engineer. Kluetmeier loves adventure and the thrill of sporting events. He flies his own plane, skydives, and is notorious for racing his motorcycle from the stadium to the airport to get his film on the first flight back to New York. In 1969, Kluetmeier joined the staff of Time, Inc., working for both *LIFE* and *Sports Illustrated.*

In an interview in 2013, he spoke to me about the changes he has witnessed in the field of sports photography. He used to be able to move around the field, find the best locations. Now sports photographers are locked in one place, playing second fiddle to TV cameramen and corporate logos. When "access is taken away," there go the opportunities for great imagery. Kluetmeier was at *SI* when a good idea was met with excitement—and financial support. He remembers when "Why not?" was the refrain from editors when he presented even an outrageous idea.

It was Kluet who first put a camera in an Olympic swimming pool. He went to Barcelona a year before the

Olympics to scout out the location. When he finally placed the camera in the pool during practice, a man with a submachine gun yelled at him to take it out. A camera underwater cannot be triggered by radio waves, so it has to use a hardwired remote trigger. We don't have a transcript of exactly what Kluetmeier said to the armed guard, but it was something like, "If any of the swimmers complain, I will remove it, but if they don't, please let me leave it." At the 1992 Barcelona Olympics, the first great underwater racing photographs were produced by Heinz Kluetmeier and changed forever how we experience swim meets. He gave viewers an entirely new way of seeing the human body moving quickly through water. He also gave judges another tool to determine who touched the wall first. His series of photographs of Michael Phelps and his Serbian rival Milorad Cavic, taken on August 16, 2008, in Beijing were instrumental in awarding the gold medal to the American, who won the 100-meter butterfly by .01 second.

• • •

Quidditch, a cultish sport for the Harry Potter initiates, is chaotic. To the layperson, it seems like confusion, but

Heinz Kluetmeier, Edgar Prado riding Barbaro, Florida Derby, Gulfstream Park, Hallendale, Florida, April 1, 2006

for those who understand "Brooms Up," it all makes sense.

A few things to know about this sport that began in the twenty-first century at Middlebury College, a creation of Alex Benepe and Xander Manshel:

- On the field there are 3 beaters, 2 chasers, 1 keeper, and 1 seeker who run around on broomsticks.
- A chaser is the only one who can score using the Quaffle.
- Beaters throw the bludgers; there are no bats like in the books. If a player is hit by a bludger, they are "knocked off their broom" and remain out of play until they can tag one of their own goals.
- Positions are identified by colored headbands: black = beater, white = chaser, green = keeper, yellow = seeker.
- A score with the Quaffle is 10 points.
- The snitch is a person with a ball on his/her tailbone.
- (Unlike in the books, a snitch grab is worth only 30 points, not 150.)
- The game lasts until the snitch is caught without any innings or time-outs.

WILL MICHELS, a renowned specialist on the history of war photography, needed a release from the intensity of his research for the major exhibition *WAR/PHOTOGRAPHY* he had worked on for ten years with Anne Tucker for the Museum of Fine Arts, Houston. Not that much of a reader, but a Harry Potter fanatic, he realized the perfect release from his stressful day and night job was to attend and capture the crazy, wonderful world of quidditch. What is especially endearing about his reportage is that he still practices "black magic": shooting film, entering the darkened chamber, mixing his potions, and magically producing pictures from blank sheets of paper.

Will Michels, *Nick Semon as the Silver Surfer,* Rice Quidditch, the Midnight Luau, Sam Houston State University, Huntsville, Texas, 2012

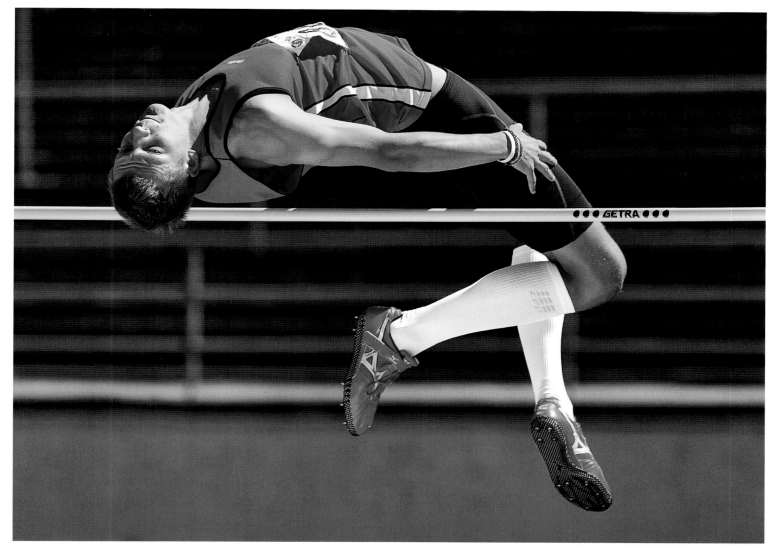

Rainer Martini, "High jump Bavarian Track and Field Championships," Passau, Bavaria, 2011

. . .

Many photographers stop the body in motion. It is what sports photographers do. But **RAINER MARTINI** sculpts the body with light and in doing so isolates the movement to its most sublime elements. He captures bodily shapes, from a muscular leg to a bent thumb, that continually surprise and seduce the viewer. The photographs are motionless yet fluid. In the history of photography, Martini's series of high jumpers are closest to Aaron Siskind's 1953 series *Pleasures and Terrors of Levitation* (divers in midair).

Rainer Martini has been taking photographs since the age of ten. Born in Germany in 1948, he was lucky that his father owned both a Leica and a Rolleiflex and built a darkroom in their home. In 1970 he was conscripted into the German army to do his compulsory military service. As soon as he was out, he got an entry-level job at a small photographic agency. After six weeks, his facility with a camera was so apparent, he was assigned to cover crime, strikes, and fires. An athlete himself, he suggested to his boss that he should be shooting soccer matches as well. At the Germany vs. Scotland

qualifying match for the World Cup, he sat next to Axel Springer Jr., who had recently started the Sven Simon Picture Agency in Munich. He joined the agency but soon went out on his own. In 1973 he had two epiphanies: he should always keep his own copyright and color was the future. He has photographed all the Olympics and World Cups since 1972 and many other sporting competitions as well—always keeping his copyright.

· · ·

RAINER W. SCHLEGELMILCH has been photographing Formula One since 1962. He began when he was a student at the Bavarian State School of Photography in Munich studying creative photography and design. Like his American counterpart, Jesse Alexander, he began shooting in black and white when drivers were dashing and their goggles would dangle around their necks, "like my camera," a camera

Rainer W. Schlegelmilch, Ferrari Turbo—Stefan Johansson in Monaco, Grand Prix, Monte Carlo, May 19, 1985

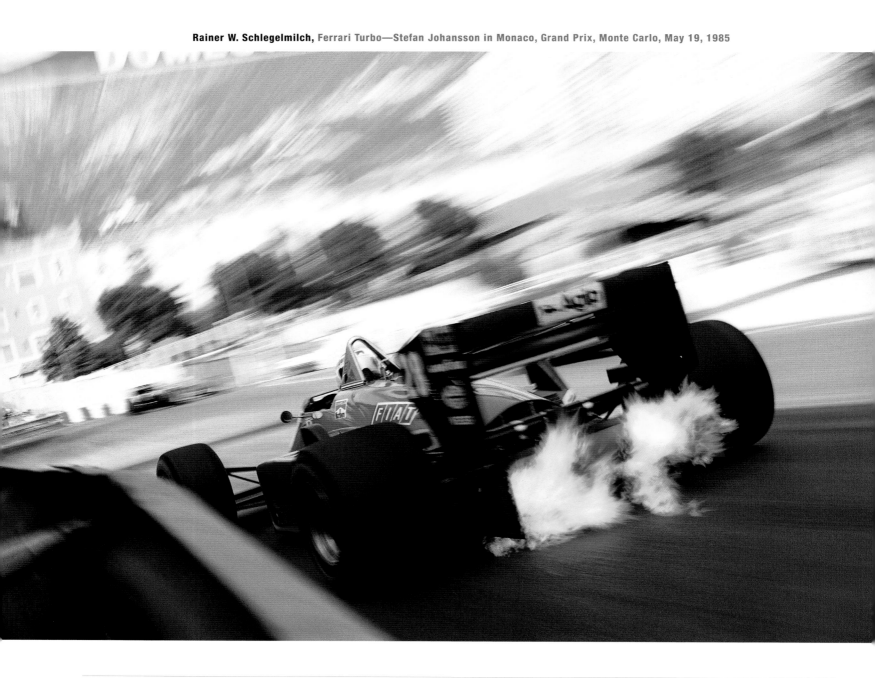

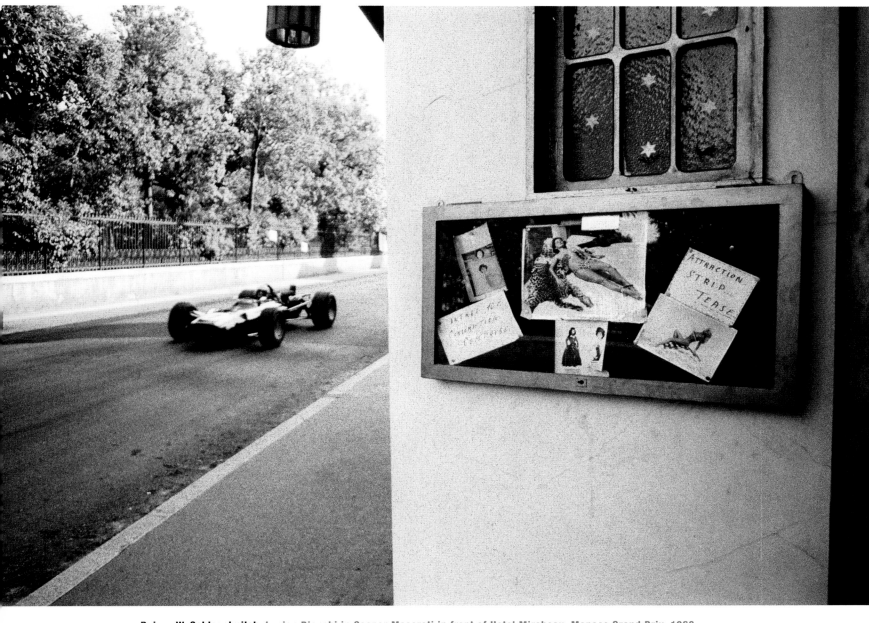

Rainer W. Schlegelmilch, Lucien Bianchi in Cooper Maserati in front of Hotel Mirabeau, Monaco Grand Prix, 1968

that had "no telephoto, no motor drive, and of course, no automatic focus. It was a question of waiting," he said, "for a facial climax: joy, anger, disappointment or, simply, a conversational scene."

His deeply humanistic portraits of the drivers play against the race cars he describes as "sheet-metal containers filled with highly explosive fuel." His fine study of Ayrton Senna in color, balaclava already on his slightly turned head, gives him

a dreamy, far-away, tragic-hero look. The contrast between flesh and metal, man and machine, is a constant theme.

Schlegelmilch is as good at shooting color photographs as he is black and white. Schlegelmilch's "aspiration," he says, is to "freeze the speed in a photo" which he often does by using a zoom lens with a slow shutter speed, as in the photograph of the Ferrari spitting fire from the rear.

His black-and-white photographs are often panoramic

scenes giving a larger sweep of the racing scene than just drivers and cars. One of his best shows Graham Hill racing down a Monte Carlo street in his Lotus 49. A bulletin board on the building to the right has a nude photo of a woman reclining, her figure strikingly echoing Hill's automobile. Racing cars—low, lean, and highly charged—are sexy. Everyone knows it. Vroom vroom vroom.

• • •

There is no one comparable to **ERNST HAAS** in the history of photography. He went from experiencing war-torn Europe to imagining the "creation of the world." His book *The Creation,* published in 1971, showed, nearly for the first time in the history of photography, that color can have the same aesthetic weight and spirituality as black-and-white photography. Before Haas, this was a point of contention in photographic circles.

While photography was not rare in the 1950s and 1960s, it was not ubiquitous either. Each photograph we saw registered—be it a family photograph, an advertisement, or a reproduction in a magazine. Art photography and its claim

of "equivalency" or "transcendence" was almost always black and white. Eliot Porter, an astute observer, captured nature in color in exquisite detail and masterful compositions. Marie Cosindas worked in the tradition of oil painting, but with camera, film, and Polaroid. Earlier in the century, photographers working with color thought the best way to make "art" was to copy "art." Paul Outerbridge and then Irving Penn did wonderful color still lifes on commercial assignment, but only after the fact have they been valued as art. Only Ernst Haas was making color photographs that transported the viewer to an inner place, a sacred space. Haas was always asking what the inherent nature of photography was, what was particular to his medium.

Was Haas a "sports" photographer? He was a "movement" photographer. He writes well about his intentions:

> To express dynamic motion through a static moment became for me limited and unsatisfactory. The basic idea was to liberate myself from this old concept and arrive at an image in which the spectator could feel the beauty

Ernst Haas, *Handball*, Central Park, New York, 1974

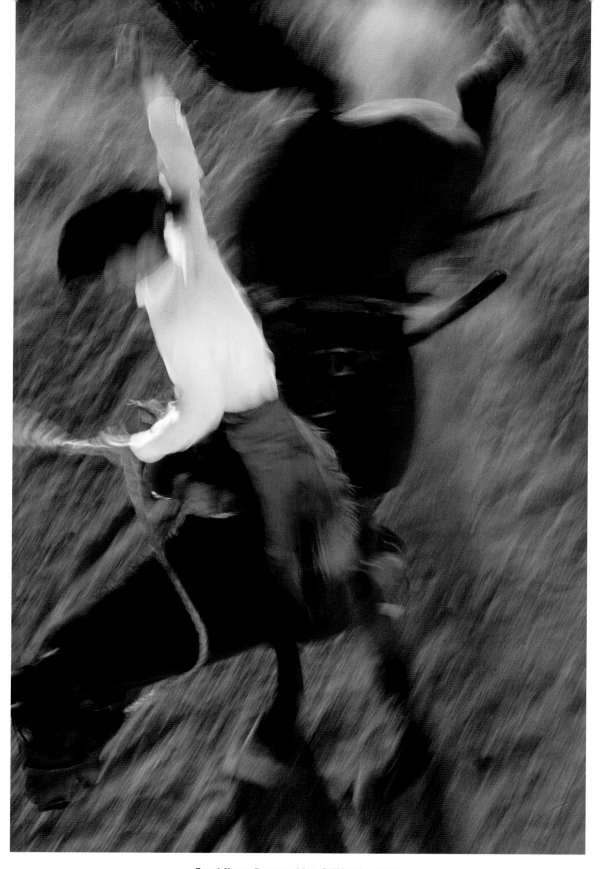

Ernst Haas, Bronco rider, California, 1957

of a fourth dimension, which lies much more between moments than within a moment. In music, one remembers never one tone but a melody, a theme, a movement. In dance never a moment but again the beauty of a moment in time and space.

. . . I work by moving my whole body and not only my head and hands. . . . I study the movement until I feel in tune with them so I can control and decide what to do during the length of the shutter opening. . . . Color fades in motion and becomes transparent. I take this as a visual advantage.

"A picture is the expression of an impression," he wrote. He was never a documentary photographer even when working for the picture magazines. He was always the artist, aware that the quest was not to find new things to photograph but to "see things new."

. . .

All the drama in a basketball game must take place within the white lines delineating the boundaries of the court. The connection with photography is obvious: the photographer, too, must contain the action and communicate his intention within the tight constraints of his frame.

In this static basketball photograph by **WALKER EVANS,** the action is psychological; the narrative sociological. *West Side Story,* the film, came out in 1961, although the play on which it was based was set slightly earlier. Evans uses the white lines of the basketball court to build tension, trapping the players within the confines of the court's rigid geometry. The four on the right, possibly Puerto Rican, form a tight-knit group; the white youth on the left stands alone warily watching, but if this is truly a pickup game, his buddies are just off court/ outside the frame. Will the next move be to get the ball and resume play, or rumble?

In a lecture titled "Lyric Documentary" at Yale University the year after this picture was taken, Evans said, "What I believe is really good in the so-called documentary approach in photographs is the addition of lyricism. . . . The real thing that I'm talking about has purity and a certain severity, rigor, simplicity, directness, clarity, and it is without artistic pretension."

Walker Evans's contribution to photographic seeing is so enormous, it can't be easily articulated. He taught generations to see subtly and profoundly. He gave weight— and balance—to objects, people, and relationships, animate and inanimate, that would never have been noticed without

Walker Evans, *Five Men Playing Basketball,* for the series *Dress,* New York City, April 19, 1963

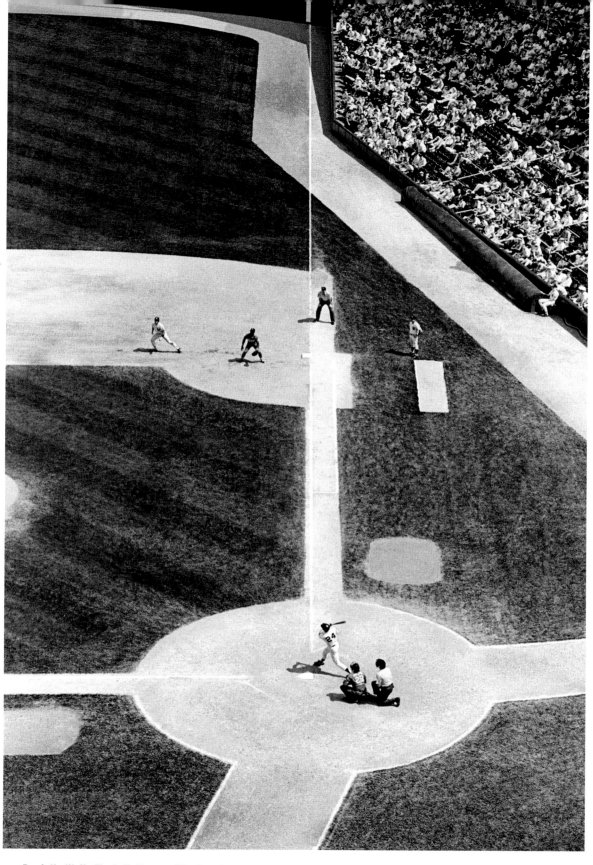

Danielle Weil, *Fly Ball,* Kansas City Royals vs. New York Yankees, Yankee Stadium, Bronx, New York, July 1990

his intelligent eye. Overt emotion has no place in an Evans image. He forces viewers to look hard, long, and deep. Only then, what is recondite is revealed.

. . .

In the introduction to **DANIELLE WEIL**'s book *Baseball: The Perfect Game,* David Halberstam writes, "She . . . has a remarkable sense of the lines, of the *geometry* of the game, of angles and proportions." For Weill, baseball has always been visual. Her first experience of the game was as a ten-year-old Belgian émigré to New York via Brazil being taken by her stepfather to Yankee Stadium and not understanding any of the rules. Decades later, Weil still recalls the *beauty of the diamond.* In her baseball photography, the diamond is the star and no player outshines it.

Weil initially started to learn photography when she modeled for Richard Avedon and other top photographers. She knew Hiro, Diane Arbus, Robert Frank, and Ernst Haas socially. The latter encouraged her to take Lisette Model's famous class, and there she started photographing seriously.

Weil was in love with photography and baseball. She had a very specific idea how to photograph baseball, but she needed the perfect vantage point—not too high but high enough to show the patterns on the field. Fortuitously, in the late 1980s and early 1990s, Weil's partner was a good friend of George Steinbrenner. She could sit in the owner's box to photograph the diamond with her telephoto lens and then wander in and out of locker rooms and dugouts searching for not top athletes, but rows of bats, cubbyholes with hats, and boxes of balls. Weil makes baseball seductive whether you are like her ten-year-old self and don't understand the game, or know every statistic and obscure rule.

. . .

RALPH MORSE started at *LIFE* in 1939 at age nineteen. He was at the magazine for thirty years, one of the remarkable photographers who gave *LIFE* its heart, soul, and visual might. Former managing editor George Hunt said, "If *LIFE* could afford only one photographer, it would have to be Ralph Morse."

Ralph Morse, "Brooklyn Dodger Jackie Robinson charging wildly from third base as unwary New York Yankee catcher Yogi Berra squats behind Dodger batter during Jackie's steal of home plate in the eighth inning of the first game of the World Series at Yankee Stadium," New York, 1955

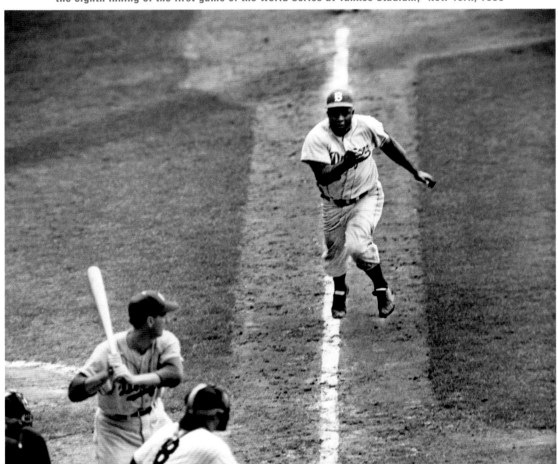

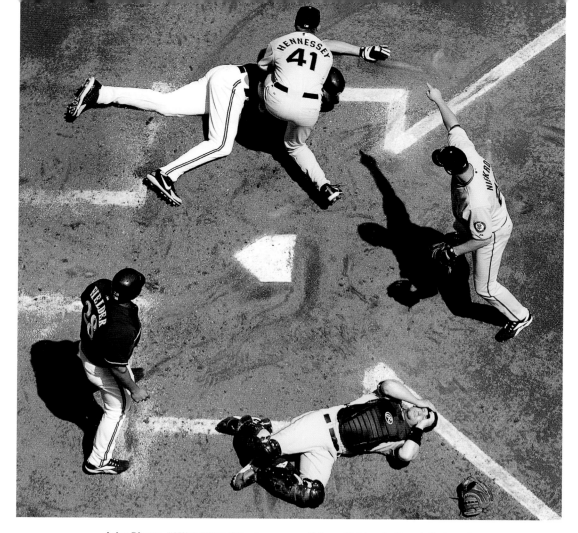

John Biever, "Milwaukee Brewers runner Prince Fielder, bottom left, is safe
at home after barreling into San Francisco Giants catcher Todd Green and
injuring him," Miller Park, Milwaukee, Wisconsin, May 4, 2006

Morse got his first break when, working as an assistant at the picture agency Pix, he borrowed darkroom printer Cornell Capa's Contax camera for the weekend. He photographed a father tossing his son up in the air at Jones Beach and this was the beginning of his career behind the camera. He never stopped looking upward. His coverage of every stage of the United States space program is unrivaled.

Morse was a terrific sports photographer because he was so technically adept. Few photographers, for example, could have taken a time-lapse photograph of a 60-yard dash that shows the start, middle, and finish of the race in one frame, as Morse did in 1956. He took the photograph of Jackie Robinson attempting to steal home during the 1955 "Subway Series" between the Brooklyn Dodgers and the New York

Yankees with a camera he wasn't even holding. He had two cameras with him, one in his hands that had a long lens and one perched below pointing at the third base line and operated by his foot.

Everyone knew Robinson stole bases. The challenge for the Yankee players was knowing when. Yogi Berra always maintained that Robinson didn't score, but the umpire saw it differently and Robinson was safe at home in the eighth inning with the Dodgers trailing 6–4. It is an iconic image, one that many people recall when they think of Robinson because it seems to encapsulate his courage as well as his skill.

• • •

After the smash-up, the Brewers' Corey Koskie, at top, legs splayed, also tried to score, but pitcher Brad Hennessey

Al Bello, "Ryan Lochte of United States (top) and Markus Rogan of Austria compete in Men's 200m Backstroke Heats," 13th FINA World Championship, Stadio del Nuoto, Rome, July 30, 2009

tagged him out. The fleeting scene probably seemed like chaos from the stands, but **JOHN BIEVER** captured from the catwalk something else: drama and pictorial balance. Once again we see that it isn't only the field of green or the field of dreams that satisfies the eye in the game of baseball. Bodies move along and within defined boundary lines, and in doing so create fascinating patterns within a tight frame.

John Biever was born into sports photography royalty, but he is the most modest of men and very hardworking. Born in Port Washington, Wisconsin, on February 17, 1951 (he shares a birthday with Michael Jordan and Jim Brown, he proudly states), he was photographing alongside his father, Vernon, at fifteen years of age at the first Super Bowl in 1966. He is the youngest of the four photographers, which include Tony Tomsic, Mickey Palmer, and Walter Iooss Jr., who have photographed all the Super Bowls. On December 31, 1987, he froze with everyone else at the "Ice Bowl" in Green Bay,

Wisconsin, temperature minus 15 degrees Fahrenheit. Neither his fingers nor his camera froze. (He had the advantage. He was brought up in this type of weather.) He captured quarterback Bart Starr scoring the winning touchdown with less than thirty seconds to play. His dad, Vernon Biever, taught him—and his brother Jim—well. John Biever is the quintessential sports action photographer, says Steve Fine, former director of photography at *Sports Illustrated*. He sent back, three times a week, fifty weeks a year, pictures that Fine was proud to publish.

• • •

Heinz Kluetmeier, thirty years **AL BELLO**'s senior, initially helped Bello figure out how to photograph swimmers from underwater. He even lent him the light he needed. Now elite photographers working for Getty, Reuters, *Sports Illustrated,* AFP, and *L'Équipe* form an "underwater club" at important swimming events. They are the only ones given permission to

submerge their cameras. And Bello almost always gets some of the best shots.

Setting up the cameras in the pool three meters down is what takes time. The photographer must get the exposure right and set the speed, normally around 1,600th of a second at f5.6 with a 1250 ASA. Bello became a certified scuba diver because he spends so much time underwater setting up his cameras. But the technical aspect is only one part. Bello determines where a swimmer will break the water (creating the famed "bubble shot"—see page 129) or where he can get the best backdrop with the best lighting, to create a *picture,* not just capture an action. "You've kind of got to visualize what you want," Bello told *The New York Times* when he was in London for the 2012 Olympics. "You have to look under there and see the ceiling or a clean pool with no swimmer in it and just think to yourself: this is what's going to happen, this is where the swimmer's going to break the water, this is where a reflection might be, this might be a good angle where a swimmer might come into your frame."

Triggering an underwater camera from a distance is not the same as on land. The photographer has to hardwire the cable to the camera. These underwater cables run about two hundred feet. Bello elaborates: "As the systems and technology evolved, we are now able to run power to the camera as well as see the camera from a computer and retrieve the images in real time as you are firing the camera. This way you do not have to wait till after the event to get the images from the camera's disk. You can also adjust focus and exposure, and with the inventions of robotic heads you can move the cameras around in place and zoom in and out of the frame." Sports photographers have come a long way since 1927 when the January issue of *National Geographic* magazine reproduced the first blurry color photographs (Autochromes) taken underwater—of fish!

. . .

PREDRAG VUCKOVIC is known for either riding a BMX bike freestyle or photographing someone else doing it. Born in Belgrade in 1973, he started photographing in 1989 while

Predrag Vuckovic, "Slobodan Vlahovic of Montenegro fly fishing," Tara River, Kolasin, Montenegro, August 30, 2012 (Predrag Vuckovic/Limex Images)

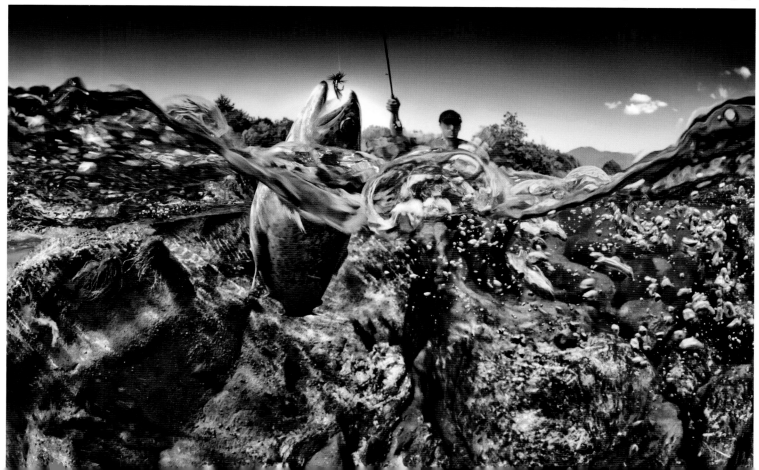

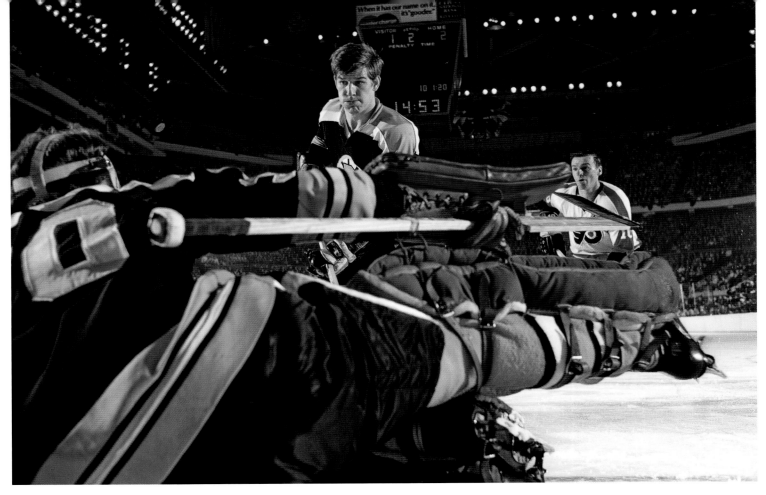

John G. Zimmerman, "Classic photograph of Bobby Orr, taken for *LIFE* magazine, as he helps goalie Gerry Cheevers deflect a lofted puck (visible upper left) from Boston Bruins' goal," 1970

still competing in motorcycle competitions, snowboarding (he helped introduce the sport to Serbia), in-line skating, skateboarding, windsurfing, and deep sea diving. He honed his photographic skills while doing extreme sports. A shot like this one shows off his knack for making remarkable pictures, if not his famous daring.

• • •

In 1962, **JOHN G. ZIMMERMAN,** the most experimental photographer at *Sports Illustrated,* had the idea to do a story from inside a hockey net. No photographer or camera had been there before.

He chose a Rangers vs. Canadiens game at Madison Square Garden to execute his experiment. He hung four electronic flashes from the mezzanine. He secured a seat in the first row behind the net for himself. He put his cameras behind

the net. The wires for the remote, however, had to be buried under the ice (this was before wireless technology—there had to be a cable from camera to photographer). The skate blades, however, exposed the buried cable, and a player tripped but didn't know why. Nor did he take the time to find out. Zimmerman got amazing shots that ran seven pages in *Sports Illustrated.* In 1970, John Zimmerman reprised this procedure in a story for *LIFE* on Bobby Orr. He wanted to show Orr's aggressive play from the goalie's viewpoint.

• • •

The overhead lights read like celestial stars in **WALTER IOOSS JR.**'s photograph. Up rises a beatific Bill Russell, almost Christ-like, as he ascends to the heavens, leaving both his disciples and adversaries below. Many basketball photographs are constructed—consciously or unconsciously—like religious

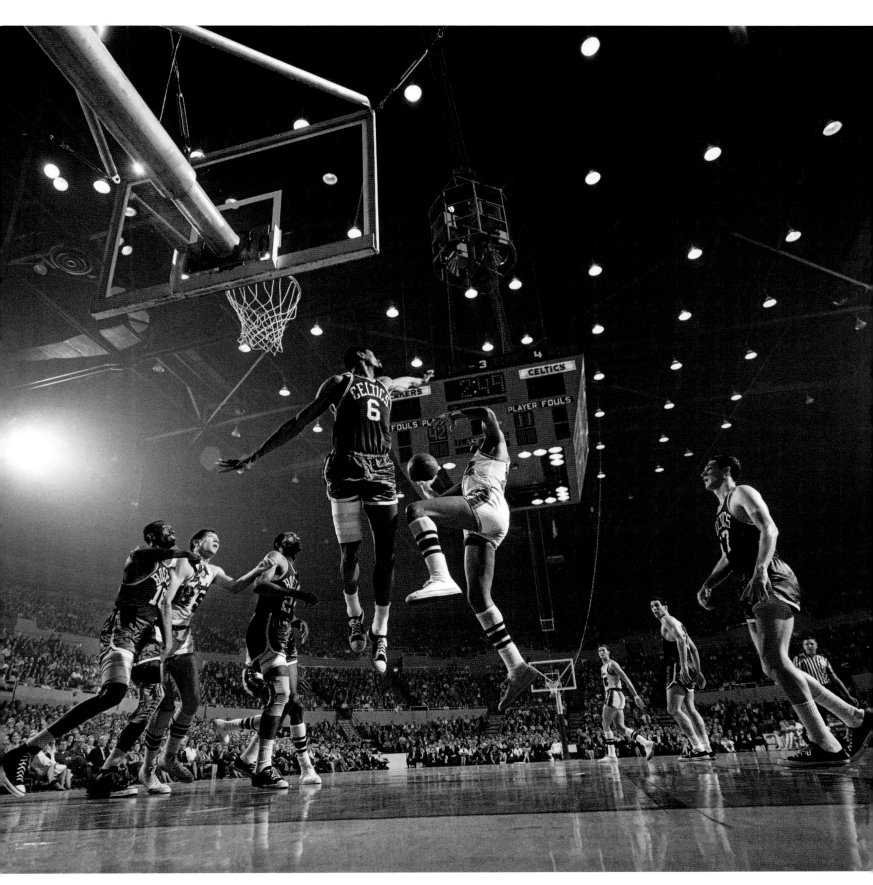

Walter Iooss Jr., *Bill Russell and Elgin Baylor,* Los Angeles, California, 1966

paintings. Only in basketball do we witness that ascension that connotes transcendence. In this image, as in many other basketball photographs, the superstar appears to rise up, not by muscular power, but by supernatural power.

. . .

BILL FRAKES woke up at 5:30 one morning in Perth, Australia, to capture the light on the water and the swimmer wearing a red, white, and blue Speedo cap. He knew, as the sun rose, that the water would turn red and blue. He loaded his camera with transparency film. Lying low, he balanced his camera with its 600mm lens on the pool deck, near the water's surface. The anonymous swimmer is monumental, a sea creature, hardly human. The photograph has the perfection of an advertising shot, but Frakes made it for himself.

. . .

JOERG MITTER, an extreme sport photographer, did, once upon a time, try to photograph a soccer game. He stood there with a 400mm lens and drank two beers and was bored.

Mitter was born in 1980 in Leoben, in the heart of Austria. Half of the town's six famous people are connected to sports, and Mitter was always climbing, skiing, and outdoors while growing up. He thought he might enjoy studying geographical information technologies (i.e., informatics, GPS) after high school. What appealed to him more was using a friend's camera, which he borrowed for one day, and the pictures he shot from that single roll of film. Two years later, at twenty-two years old, he bought his first camera. He moved from information technologies to organizing events, including some sponsored by Red Bull. From there, he found himself coordinating the photographers, including himself, at extreme sporting competitions. He now runs his own agency, Limex, specializing in extreme sports, and continues to photograph.

Mitter emphasizes that there is a lot of risk—"calculated risk"—in extreme sports. The athletes have to trust the photographers because everyone is together in challenging and dangerous situations. Unlike the photographers who hang

Bill Frakes, *All Over, Down Under,* World Swimming Championship, Perth, Australia, 1998

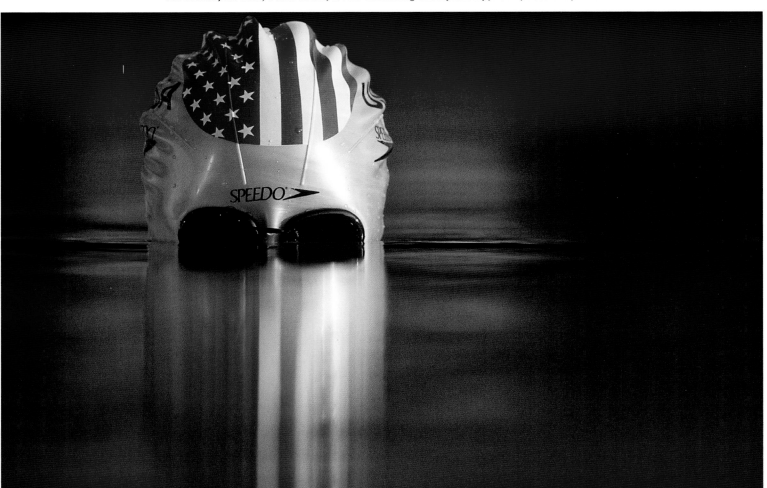

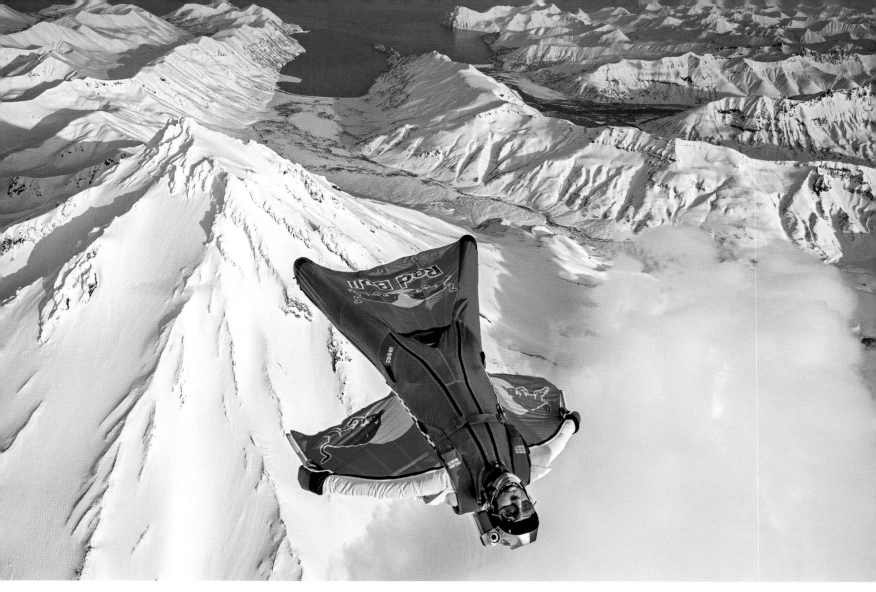

Joerg Mitter, Russian extreme sport athlete Valery Rozov flies his wingsuit after jumping out of an MI-8 helicopter over Kamchatka Peninsula, Russia, April 9, 2009. (Joerg Mitter/Limex Images)

out on the sidelines of sporting events and never really get to know the athletes on a deeply personal level, Mitter travels with, eats with, and stays at the same hotels as the daredevils he photographs. He knows which one reads a Bible before competing; which one doesn't give a damn. He knows when they are going to try a new trick—a trick that can result in injury or worse—or win a top prize.

In extreme sports photography, there are no second chances. Mitter considers everything, including the backgrounds. His photographs are startling because they are so complete—not just the moment of perfection of the trick or

flip but the backgrounds, the colors, the angle, the sharpness, the composition all come together to make for a total picture.

Jumping into active volcanoes from helicopters while wearing a wind suit (and at the photographer's request, turning over to show the logo of the sponsor) or doing flips during a freestyle motocross (FMX) event are new sports. Mitter, however, is old-school when photographing them. He measures the distance to the action and doesn't use autofocus (he says autofocus isn't quick enough anyway for the sports he photographs). He tapes down his lens so it doesn't move (he and his camera might be hanging out of a

• • •

Joerg Mitter, Freestyle motocross rider Mat Rebeaud of Switzerland jumps in front of the Blue Mosque, Istanbul, Turkey, June 13, 2012. (Joerg Mitter/Limex Images)

helicopter). After months of preparation, he may have only one chance to get his shot and must not miss. He cites a time when he had to photograph skydiver and BASE jumper Felix Baumgartner jumping off the then world's tallest building. He, and his camera, saw him pass in less than the blink of an eye. Mitter told me it would have been impossible to capture him if everything wasn't measured, organized, and pre-conceptualized.

For Mitter, keeping it real is what extreme sports photography is about. The athletes do not cheat; they put themselves on the line. The photographer must not cheat either. Even if it looks like the motorcycle has been Photoshopped into a drop-dead-gorgeous setting, it hasn't.

What you see in the photograph is what happened in time and space. Extreme sports and photography are about thinking your eyes are fooling you. Amazingly, they are not.

Sebastian Marko, Ryan Doyle performs at Machu Picchu, Peru, May 21, 2012. (Sebastian Marko/Limex Images)

. . .

SEBASTIAN MARKO is a leading extreme sports photographer. He admits to getting goose bumps when working. He gets them because he has a good sense of what is going to happen; he gets them because he doesn't know what is going to happen. He just knows that his job is more than merely capturing the action. He has to show the peak of performance, when the athletic body is at its best and perfectly balanced. Harmony is hardly the word that comes to mind when talking about extreme sports, but the best athletes and the best photographers are in harmony with their surroundings. In the case of Sebastian Marko and Ryan Doyle, a prince of parkour, they are in harmony with each other.

Marko was born in 1980 in the medieval town of Lienz, Austria. When his family moved to Innsbruck three years later, he already knew how to ski. By the age of five he and his friends were allowed to go up into the mountains on their own. Hiking in summer, skiing and snowboarding in winter, he spent most of his time in the mountains. He went to engineering school to study electronics. He qualified to be an accountant, but was bored. His skills got him a job as a timing and tracking engineer at a Red Bull air race, where he met Joerg Mitter. Although the same age, Mitter was already an extreme sports photographer. Mitter saw the passion and motivation in Marko and said, "Let's work together." He also saw someone with a good eye, who was physically fit and technically adept. Marko is a member of Limex, the Austrian photo agency that was founded by Mitter in 2012.

One of Marko's best-known photo stories is of Ryan Doyle doing jumps at all the Seven Wonders of the Modern World. Parkour, it is often cited, was founded in the Paris suburbs by young immigrant men who needed to jump over barriers to run away from the police. Many youths are drawn to parkour, as it encourages innovation and creativity in maneuvers; is graceful like ballet; does not require expensive equipment; and, some would say, is philosophical in its approach to "obstacles." Doyle says it is an art, a discipline, not a sport. What is clear, however, is that Marko is a distinguished photographer of extreme sports.

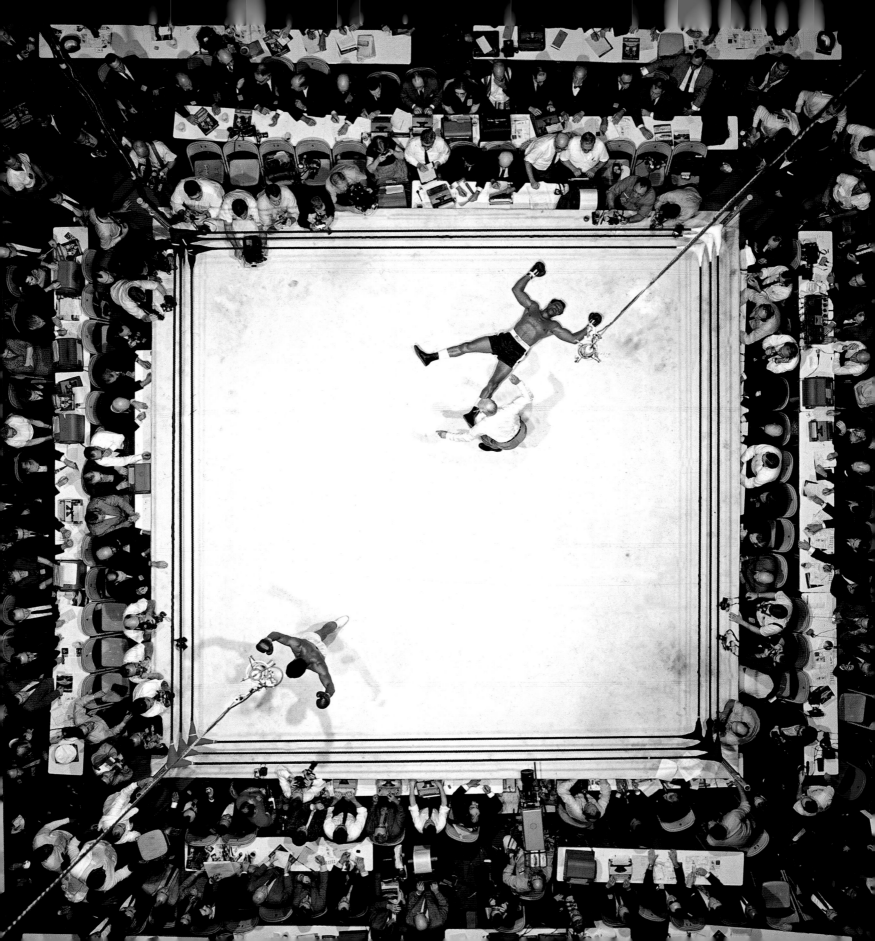

CHAPTER SIX

IN AND OUT OF THE RING

B oxing and bullfighting are to sports photography what jazz is to music photography. They, who would never photograph rock 'n' rollers or classical virtuosos, turn their cameras to jazz musicians. Art photographers who would never stand on a sideline willingly go, week after week, to the ring. Wrestling and MMA (mixed martial arts) are so universal, so basic—two bodies, no equipment—that photojournalists encounter them all over the world. There are interesting cultural variations—think Nuba wrestling in the Sudan; Bökh wrestling in Mongolia; sumo wrestling in Japan; *lucha libre* (they do wear masks) wrestling in Mexico; Shuai Jiao in China.

Naked or semi-clothed, boxers and wrestlers are fabulous subjects for the camera. With bullfighting, the color and cut of the *traje de luces* (suit of lights) are part of the aesthetic appeal. The best photographers capture the physicality and the psychology behind each of these matches. Many people uninterested in looking at photographs of team sports will admire the brilliance and artistic merit of boxing, wrestling, and bullfighting images. Perhaps they are familiar with great novels and paintings of these subjects, without realizing that the painters often were inspired by the photographs, and not the other way around.

• • •

Hard to imagine a twenty-three-year-old kid taking a "shot of the century," but that is exactly what a pugnacious, precocious **NEIL LEIFER** did. The year before, he took what might be even a more famous boxing image: Muhammad Ali standing in victory over a prostrate Sonny Liston (see page 173). Leifer was a boy wonder. In 1959 he bought himself a $5 upper grandstand ticket for the Ingemar Johansson–Floyd Patterson title fight and attempted to shoot from the heavens; a year later he had a press pass and was in the fifth-row press circle. And one year after that, the nineteen-year-old was ringside shooting for *Sports Illustrated*.

Like the legend he befriended, Muhammad Ali, who calls him "Strawberry" because of his red hair, little Leifer is a giant in his field. Football, baseball, boxing, and more—Leifer has produced defining, surprising, and enduring pictures.

In sports photography, someone has a great idea, works hard to implement it, and publishes the groundbreaking image in a magazine, and then in the following weeks, scores of photographers try to replicate the photograph. Shooting sporting events from above with remote cameras is commonplace now; Leifer's 1966 picture is still the best. Period. He wins. Leifer says the picture was a lucky accident, but it wasn't, not really. The perfect border of reporters with

Neil Leifer, "Aerial of Muhammad Ali victorious after his round three knockout of Cleveland Williams during the 1966 World Heavyweight Title fight at the Astrodome," Houston, Texas, November 14, 1966

The really great sports photographers—when they get lucky—they don't miss.

NEIL LEIFER

• • •

their portable typewriters, photographers with their big and small cameras perched on the mat, and commentators with their headphones and mikes, plus of course the two contenders—it is an image for the ages. The three figures in the ring are perfectly positioned. The remote camera might have been held aloft in a gondola fifty feet above the ring at the Houston Astrodome, but Leifer positioned it impeccably and pushed the button at the exact moment of compositional perfection.

Neil Leifer grew up in a housing project on the Lower East Side of Manhattan. He learned how to photograph at the Henry Street Settlement House at the age of ten. He was the photo editor of the Seward High School newspaper and always gave himself the sports assignments. He graduated at fifteen and didn't have the money to go to college, nor the desire. If he wasn't going to be a navy pilot, which was unlikely, he wanted to be like Ozzie Sweet, a photographer for *Sport* magazine who made the pictures of his beloved Dodgers hanging on his bedroom wall. Miraculously, but not effortlessly, he achieved his goal at a ridiculously young age. He started getting into ball games by being one of the kids who volunteered to push veterans in their wheelchairs into Yankee Stadium. The camera under his jacket soon came out and Leifer was living his two passions: sports and photography. On his sixteenth birthday, December 28, 1958, he took his first great sports photograph and started shooting for *Sports Illustrated*. Twenty years and about 160 *SI* covers later, he left the magazine for *Time* before becoming a film director and producer.

Leifer is a short man. For the longest time, he also looked like a little kid. He said, "The first time I did Ali [less than a year older than Leifer], in 1964, I was twenty-one and looked about eleven." There is a photograph of Leifer around the time he started working for *SI*. He is at Comiskey Park

standing on a box behind a 4000mm (not a typo!) lens custom-made for *LIFE* photographers. The lens appears to be twice his height. But short men (think Napoleon) are often the most determined. There is a story about Leifer, age eighteen, defying the Soviet authorities at the USA vs. USSR track meet in Moscow. The journalist Lance Morrow, who has worked with Leifer on a number of assignments, wrote, "Neil's operating theory is that charm, combined with endless, unprecedented, mind-boggling, supernatural persistence, can pick any lock, open any door, defeat any bureaucracy." He seems to have been born with determination. Leifer may like boxing the best of all sports because he, too, comes out punching. He can turn mud-caked football players into the equivalent of Impressionist paintings. Leifer is quite remarkable, too, looking into the eyes of baseball players and capturing what feels like their soul.

The story of Leifer's winning shot at the little hockey arena in Lewiston, Maine, is legendary at *Sports Illustrated*. The magazine sent two photographers, the senior, more experienced Herb Scharfman, wearing glasses and looking bewildered between Ali's spread legs, and the young upstart Leifer. They were opposite each other and it was Leifer who lucked out. Liston was knocked out in the first round and fell directly in front of Leifer. Liston's arms did not cover his face, the referee was off to the side, and as Ali lifted his arm he opened his mouth. Perfection. Leifer noted that for a sports photographer at a boxing match, it doesn't matter how many rounds there are, you need only one great photograph.

Celebrity is relative, but in the world of sports photographers, Leifer is royalty and probably the world's best known sports photographer. In 2014 he was the first photographer ever to be inducted into the International Boxing Hall of Fame.

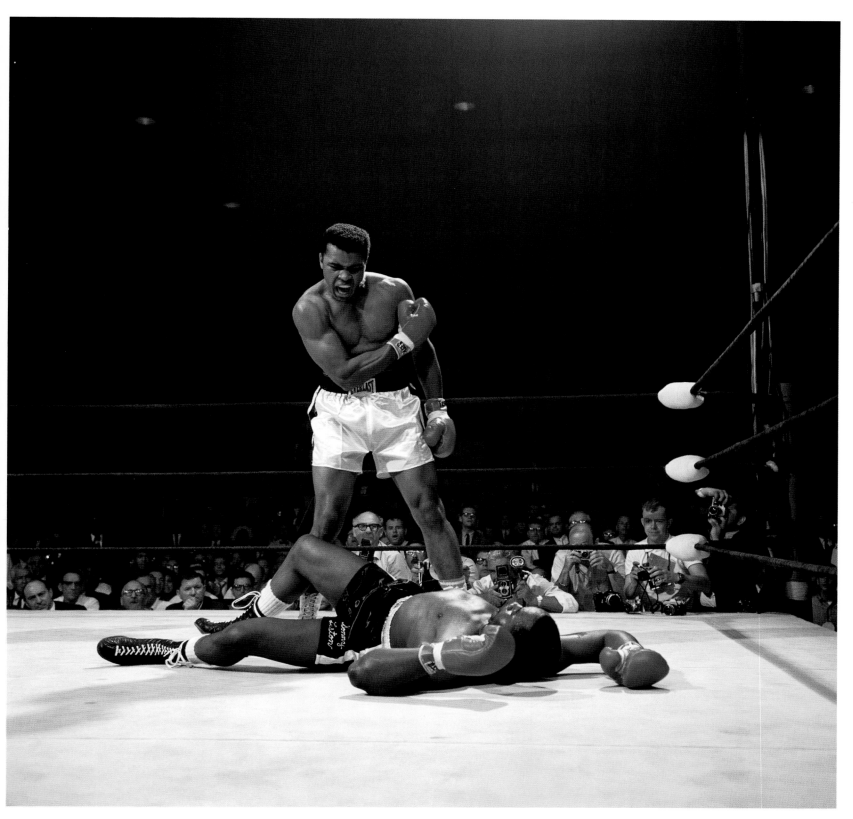

Neil Leifer, Muhammad Ali vs. Sonny Liston, St. Dominick's, Lewiston, Maine, May 25, 1965

The literature of the sports page is devoted to sizing up a man's capacity to endure pain and humiliation.

JIMMY CANNON, BOXING JOURNALIST

• • •

• • •

"Curiouser and curiouser," cried Alice, and the same can be said for the strange life of **HY PESKIN.** For a while he was a sports photographer without equal and the first to be hired by *Sports Illustrated.* Even after he changed his name to Brian Blaine Reynolds (his father, a tailor, had changed the family name from Pesachowitz) and his identity, including never revealing to the children of his second marriage that he was the famous photographer Hy Peskin, he was still "pesky"—difficult and defiant.

Hy Peskin was born in Brooklyn in 1915. According to his biographer, the sports historian John Thorn, instead of attending high school, he started selling newspapers to pay the family's rent after his father lost his job during the Depression. He met Izzy Kaplan, a *New York Daily Mirror* photographer, in 1933 and for a few years accompanied him on assignments, mostly to ball games. He didn't get paid, but he learned journalism and how to use a camera. He then married his girlfriend, Blanche, from Erasmus High School and became a full-time photographer in 1935. The Brooklyn Dodgers were a favorite subject.

He enlisted in the Marines during World War II, and when he returned in 1945 he had the idea of shooting sports in color, even though magazines were still printing almost exclusively in black and white. He purchased, at great expense, a box of Kodachrome ASA 10 for his Speed Graphic. Cautiously, so as not to waste film, he made three exposures at an important boxing match illuminated with a contraption of his own design using three flashbulbs popping simultaneously. When the three pictures came back from Kodak, they were perfect. He ran them over to *Look* magazine and never looked back. From that moment, he became a magazine photographer, making more money than he had ever made before.

Hy Peskin, "Carmen Basilio wins world welterweight title," 1955

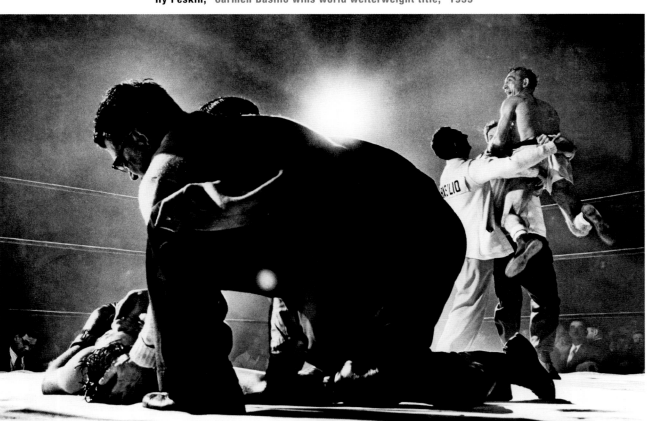

Herb Scharfman, Robin "Hurricane" Carter vs. Dick Tiger,
Madison Square Garden, New York, May 20, 1965

What makes for a great sports photographer? Peskin would answer "anticipation," sensing what will happen next. Peskin was pushy and he had chutzpah. When, at Ebbets Field, he ran from first base across the pitcher's mound to third base *during* a game, it was the end of photographers being allowed on the field during National League ball games. He was not liked by his colleagues, but he was greatly respected for the pictures he took.

Peskin wanted people to know what it was like being at a sporting event, not just see what happened. A Peskin photo has energy (the man himself was a five-foot-seven, 195-pound dynamo) and a visceral quality that makes the viewer sweat. One doesn't just look at a Hy Peskin photograph. One *experiences* it.

· · ·

It is legendary, in the history of sports photography, that **HERB SCHARFMAN** was in the "wrong seat" at the Mohammad Ali–Sonny Liston fight in 1965. The young Neil Leifer got the winning shot (see page 173) but to add insult to injury, Scharfman is seen between Ali's legs looking defeated. But a great photographer like Scharfman, shooting sports for forty-four years for International News Photos/UPI and later *Sports Illustrated* should be known for the pictures he took, not for the one that got away.

If evidence is needed of Scharfman's ability, look no further than the hundreds of brilliant boxing photographs he took, including the classic one of the 1952 title fight between Jersey Joe Walcott and Rocky Marciano. Marciano did deliver a knockout punch in the thirteenth round, but Scharfman's picture of Walcott receiving a thunderous right hook, the slammer setting up the knockout punch, and the "rubber face" image of all time. Scharfman used a Speed Graphic for much of his career in order to get absolute sharpness and detail. Sweat flies off the athlete and practically hits the viewer of a Scharfman photo in the face. Boxers' veins and muscles pulsate, their skin glistens. Scharfman illuminated his exposures just right. Even when they are brutal, they have a Renaissance glow.

· · ·

When the indomitable publisher and book packager Constance Sullivan decided to do a book, everyone in the photo world paid attention. She didn't have "good" taste; she

Charles Hoff, Walter Cartier vs. Kid Gavilan, December 14, 1951

had her own taste in photography, and it went from formal nudes to punching people's faces, and much in between. When she created a "boxing book," she hit upon the perfect balance of image and text.

The Fights: Photographs by Charles Hoff starts with the premise that **CHARLES HOFF**'s boxing photographs are brilliant. They are. Each of his pictures puts the viewer in the ring and all you see are two men doing damage to each other. But you can't take your eyes off what the human face and body look like frozen and transformed by physical abuse and exertion. Sullivan published essays on boxing by A. J. Liebling, Jimmy Cannon, William Nack, and James Baldwin, and asked Richard Ford to select the pictures by Hoff and write the introduction. But even with the book's stellar lineup of literary figures (all men—she should have invited Joyce Carol

Oates, who has written extensively on boxing), Hoff, the *Daily News* reporter, is the one to show us most persuasively what James Baldwin called the "Sweet Science or the Cruel Profession or the Poor Boy's Game."

The photography writer and critic Richard Woodward, in his essay about Hoff at the end of the book, acknowledges that "sports has never received the attention it deserves in histories of photography" and goes on to say that Hoff, who photographed from 1935 to 1966 for the New York *Daily News,* America's most widely read newspaper, was at the "right place at the right time." He covered sports before television ruled so that the picture at the back of the paper meant an incalculable amount to the sports fan. Hoff was also fortunate that he could use Dr. Harold Edgerton's stroboscopic lighting to stop motion.

Charles Hoff was born March 11, 1905, on Coney Island, the son of a first-generation German-Polish Jewish father who worked for Reuters and then opened a camera shop on the boardwalk. Hoff's interest in journalism and photography was homegrown. Hoff shot more than sports during his thirty-four years at the *Daily News,* but that is what he is best known for. And it helped that at boxing matches he had the best seat in the house, dead center at ringside. But that alone was not enough to get his incredible shots. According to Woodward:

Hoff had a costly rig of stroboscopic speedlights that weighed more than three hundred pounds and had to be pushed around on a dolly. Operating on AC house current through four power packs that fit underneath the boxing ring (with a master under the control of the photographer), they could freeze action at 1/3,000 to 1/30,000 of a second. Running between the master and a switch built into the shutter of the camera was an electric wire known as the tripper cord. It synchronized the tripping of the shutter and the explosion of light from the three flashlamps inside large reflectors over the ring.

Hoff's generation grew up assembling vacuum-tube radio kits. Being handy, being technical, was part of being a boy. Hoff loved the strobe lighting because it opened up so many new possibilities—"stop a hockey puck traveling eighty miles an hour," he said, plus he could shoot with a very small aperture and have everything sharp.

Sports photographers always have had to shoot instinctively. Timing is everything, and the more you practice, the better you become. Hoff was known as "One-Shot Charlie" because he didn't waste film. All the writers in Sullivan's book understand the boxers are fighting for more than money or fame—they are fighting for their dignity.

Photography rarely gets this raw, this visceral. A Francis Bacon painting comes closest.

* * *

GEORGE RODGER, one of the four founding members of the photographic cooperative Magnum Photos, had a hard war, as they say. Afterward, he needed to get away and he and his wife, Cicely, decided to go to Africa. He was drawn to the Nuba and their culture, and between February 21 and

March 4, 1949, after dealing with impossible bureaucracies ("No visitor is allowed to enter the Province of Kordofan without the written permission of the Sudanese government in Khartoum"), he and his wife dealt with the nearly impassable roads and other logistical problems facing two foreigners in the Africa of the 1940s. Nevertheless, his photographic essay on the tribal people of the southern Sudan is revelatory. Only years later did he regret that his pictures may have motivated the Sudanese government to impose restrictions on the traditions of the Nuba and that his published pictures opened them up to outside exploitation.

Leni Riefenstahl, "Hitler's photographer," saw Rodger's photographs in a thirty-page essay in *National Geographic* in February 1951 and wrote to him offering to pay $1,000 if

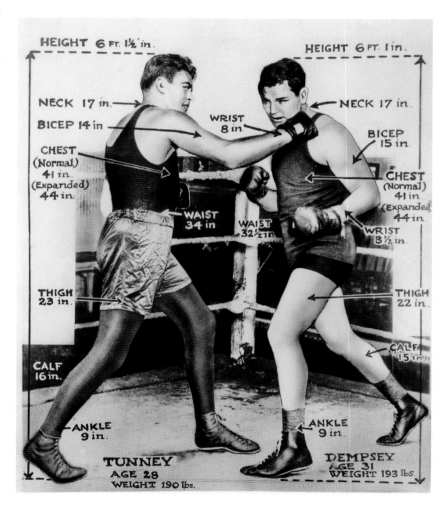

Anonymous, Retouched press photograph with measurements of Gene Tunney and Jack Dempsey, 1925 or 1926

he would introduce her to the wrestler in the photograph reproduced here. His answer was succinct: "Knowing your background and mine I don't really think we have much to communicate." She found the Nuba without his help and did two controversial but highly acclaimed books on them.

In the weeks Rodger traveled to the different villages, he witnessed a full range of activities, many of which were sporting competitions. He noted that instead of warring against each other, tribal men prefer athletic diversion . . . each tribal group specializes in a different "sport"—spear throwing, wrestling, stick fighting or, the most lethal of all, bracelet fighting—and, especially with their sticks and bracelets, they fight to within a very small margin of death.

No "quarter given," the Englishman George Rodger wrote about the ferociousness of the competitions, "and none was asked."

George Rodger, *Korongo Nuba Wrestling Champion,*
Kordofan province, Southern Sudan, 1949

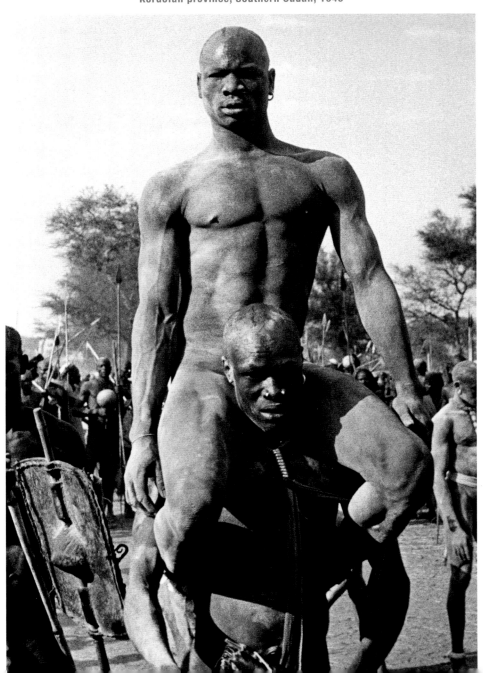

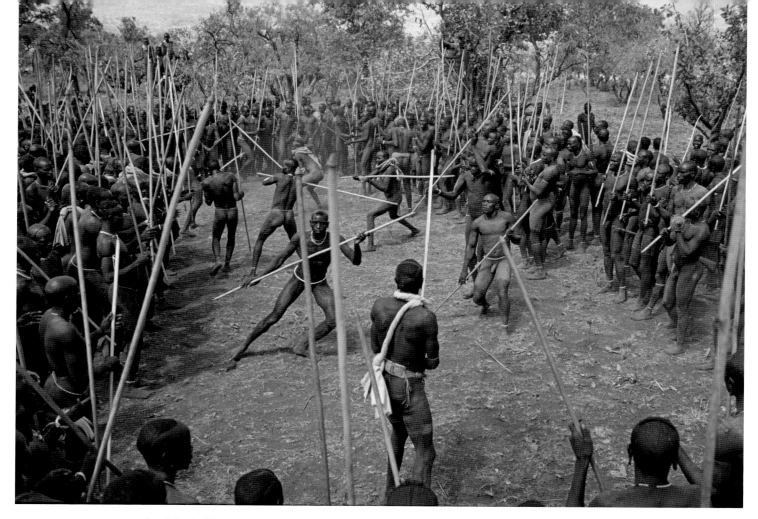

Carol Beckwith and Angela Fisher, "Surma men engaged in Donga stick fighting," Ethiopia, 1987

• • •

Traditionally, after the harvest, Surma men assembled for a form of wild stick fighting called the Donga. Now banned by the Ethiopian government, Donga stick fighting was considered one of the most vicious of all sports across the African continent. Severe injuries were common but rarely fatal. If a participant killed his opponent, he and his family were banished from the village. It was a sport proving masculinity, settling vendettas, and winning wives. Men came from many villages, often walking thirty miles, to participate in the tournament, where the prize was a pretty young girl who had chosen to be wed to the victor. The contestants fought in heats, the winners going on to the next round until the final two battled it out with their six-foot pointed wooden poles. The winner was carried nobly off on a platform of Donga sticks.

CAROL BECKWITH AND ANGELA FISHER's work recording traditional African culture and ceremonies is colossal. Their photographs and videos ensure the beauty, singularity, and traditions of Africa will be remembered for generations.

Mokao, Beckwith and Fisher's Wodaabe nomad friend and guide, who had never seen a book, tried to imagine what these two women were doing over their nearly forty years of photographing and making books and exhibitions on Africa. He concluded that they were making *maagani yegitata*— "medicine not to forget." Their pictures are revelatory, bold, and beautiful, capturing the colors of a continent once called "dark." They show African culture to be as rich as it is unfathomable for the uninitiated.

Beckwith and Fisher continue their investigation of African sports, attending the Maasai Olympics, a competition of skill

Jules Allen, *Young Man at Gleason's Gym*, New York City, ca. 1984

and aptitude. It was instituted to replace the ritual killing of a lion as initiation to manhood.

· · ·

JULES ALLEN grew up in San Francisco watching boxing on Friday nights with his father and friends. The boxers were beautiful to behold, rhythmic and powerful. Both his parents love Sugar Ray Robinson, as did he.

Decades later, as a professor of photography at the City University of New York and a photographer doing his own projects, he remembered his love of the way boxers moved, and decided to explore, in depth, the life of the boxing gym.

He wanted to know his subject intimately before he picked up his camera. For several years he trained as a boxer with the legendary Bobby McQuillen at Gleason's Gym.

The idea, common among photographers, that they have to "know their subjects" before photographing them is only half of it. The other half, which Allen found through training as an amateur boxer, was "understanding yourself, your capabilities, your fears, your strengths and weaknesses." Astutely seeing what transpired at the gym, plus understanding core elements of himself, resulted in a remarkable and original body of work. Allen has coined the

phrase "depth of field turned into depth of feeling." His work is living evidence of this postulate.

• • •

For the British sports photographer **GERRY CRANHAM,** the story of an athlete begins with his or her roots. Most people around the world will not recognize the name Howard Winstone. He was no Muhammad Ali, but he did strive for greatness and achieved the featherweight championship of the world. He never should have gone so far because his right hand had been damaged in an industrial accident in his teens. But he had a devastating left jab.

The Welsh town of Merthyr Tydfil, the backdrop of his dawn workouts, proudly produced "boxers, not brawlers." It also could be the setting of a Dylan Thomas poem. The brilliance of Cranham's photograph is its mystery and longing. Winstone will go down the hill, back into the town, breathe the sooty air, go to the factory to earn his daily bread, while keeping within him the breaths he took, the miles he ran, and his dreams of greatness while up on the Welsh hills.

• • •

In the early 1960s, the Spanish publisher Editorial Lumen, based in Barcelona, matched writers with photographers for

Gerry Cranham, Howard Winstone, first British featherweight champion of the world, training in the Welsh hills, ca. 1965

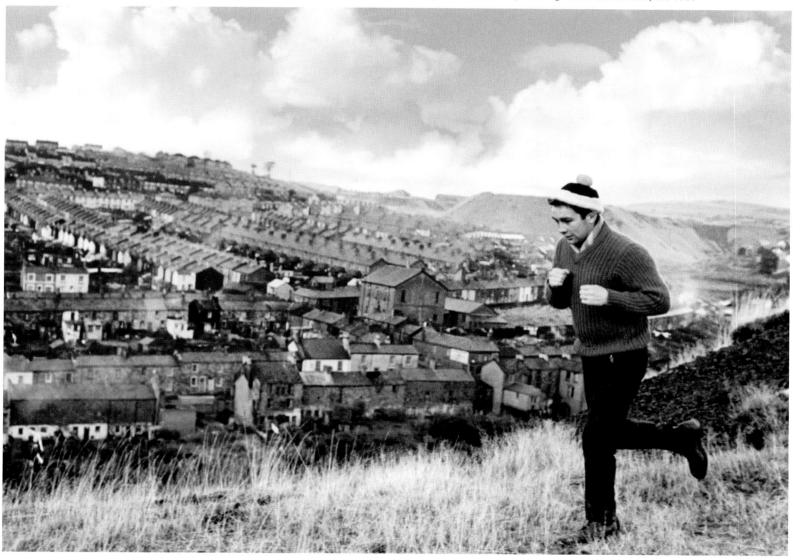

Ramón Masats, *Neutral Corner,* **Madrid, 1962**

a series of books called *Palabra e Imagen* (Words and Images). The first in the series, published in 1962, brought together photographer **RAMÓN MASATS** and writer Ignacio Aldecoa. Masats's photographs did not illustrate Aldecoa's short stories about boxing, but stood on their own, a testament to Masats's aesthetic and visual imagination. His boxer could have been cut out of a Francis Bacon painting—or be the inspiration for one.

• • •

To listen to the Danish photographer **NICOLAI HOWALT** speak about adolescent boys' first time in the boxing ring, thoughts of lost virginity come to mind. He knew, from personal experience, that it is one of the most transformative moments in a young boy's life. On the back cover of Howalt's book *78 Boxers* it reads, "The knock-out of puberty. An end to child's play. No winners or losers. No final count. The gloves are off."

Nicolai Howalt, Boxer #19 (Anders Mærkedahl), 2003

Howalt photographed adolescents between the ages of eleven to seventeen before and after their first fight. He did the series between 1988 and 2001. He photographed them, feet together so they couldn't take an attitudinal stance, in the same spot ten to twenty minutes before the fight and five minutes after. He used a Pentax camera with 120 film to get sharp detail. We only think we look different after we lose our virginity; these boys truly do look different before and after the fight. Sometimes it is obvious because of the blood, sweat, and messed-up hair; sometimes the change is subtler. Always, Howalt observes, there is something in the eyes that reveals the experience.

Howalt recalls boxing as a boy. He remembers going into the ring and coming out, but not the actual fight. He remembers the light on him and not being able to escape; having to hit but not be hit. Absolute fear. There were four

· · ·

I never forgot the moment I had to go into my first boxing fight. It was different than anything else. I was completely on my own. I forgot my first tennis game but not my first boxing match.

NICOLAI HOWALT, INTERVIEW, NOVEMBER 12, 2014

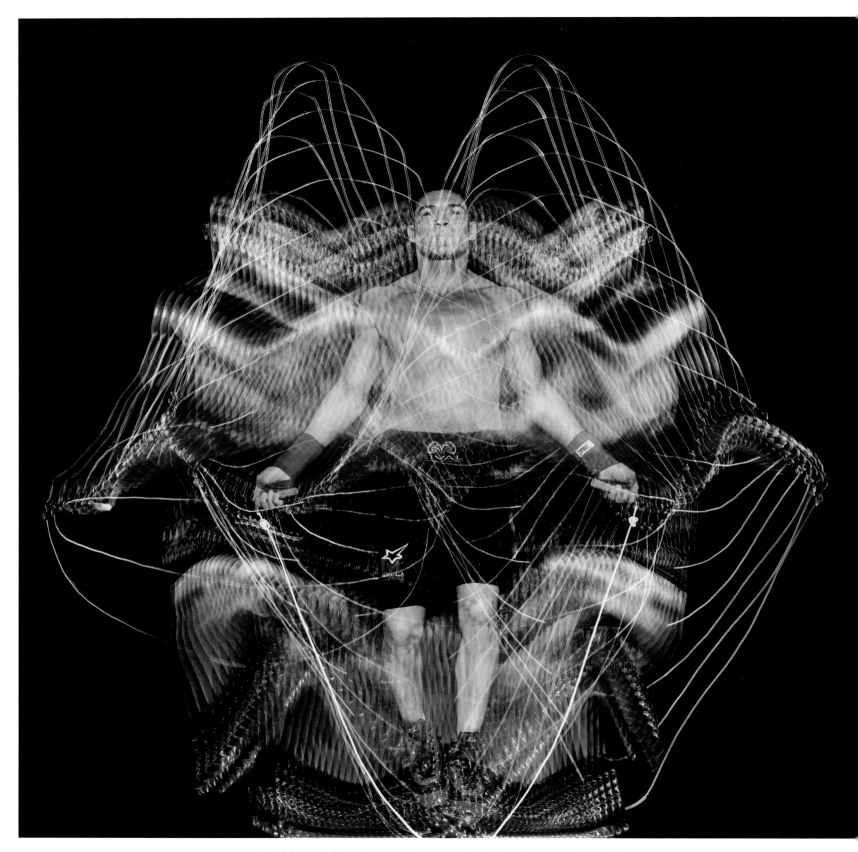

Howard Schatz, *Sergio Martínez, Middleweight Boxing Champion,* **March 2012**

I am a photographer, but this is my second profession. I was educated and worked as a physician—I was trained, even programmed, to abhor any human activity that damages the brain—so my journey in the world of professional boxing has not been an easy one. . . . I learned . . . there are no other athletes who endure and experience what fighters accept: the risk of serious physical harm caused by opponents whose careers are advanced by inducing a comatose state—often brief, sometimes irrecoverable—in their opponents.

HOWARD SCHATZ, *AT THE FIGHTS: INSIDE THE WORLD OF PROFESSIONAL BOXING*

• • •

rounds of two minutes each, with one-minute intervals. There was always a winner and a loser. Not by knockout; the winner was the one who boxed best.

Howalt boxed in his teens because he thought he would be good at it. He did it because of the training. He did it, he says, "to know myself better." He went to art college. He thought he would be good at it. He does extended photographic, mostly conceptual, projects. He is getting really good at knowing himself.

• • •

HOWARD SCHATZ did a heavyweight book on boxing based on his six years devoted to the sport. It is titled *At the Fights: Inside the World of Professional Boxing*. Unlike the tabloid photographers of yore, whose best shots always seemed to show a broken nose and a rubber face, Schatz's boxing photographs probe all aspects of the sport, from what is "ethically right" to what is physically manifest. The greatest insight into the athletes comes in the studio, where Schatz's camera serves as microscope and magnifying glass combined. Page one of the book is a list of words that summarize Schatz's investigation: **TAPE GLOVES SWEAT SACRIFICE TRAIN ROAD RUN . . . GAIN RESPECT . . . ALONE FEAR INSANE . . . CUT BLOOD PAIN . . . DEFEAT SUSTAIN COURAGE DETERMINED PASSION REIGN CHAMPIONSHIP CELEBRATE MONEY THRILL FAME LEGS HANDS BODY HEART BRAIN.** He matches each word with his brilliant visual literacy.

The photograph of the Argentine middleweight boxer Sergio Martínez was done in the studio. Multiple stroboscopic flashes capture the many phases of the jump rope in a single frame; one rear synchronized flash is directed on Martínez. Like a snake losing its skin, Martínez's hands and feet seem

to peel away. The upward glance of the eyes, body erect and centered, are reminiscent of Russian icons.

• • •

Sexy. Wild. For sure. But also a devoted family man with the same Jewish wife till the day he died. **STANLEY KUBRICK,** brilliant image maker, captured the many sides of the champ in "He's a Good Boy Now," a photo essay that ran many pages in *Look* magazine under the headline "The Day of the Fight Is a Long One." The story, part of the *Day in the Life* series, was just that: breakfast with wife and kids, interview with the press, playing cards with his brother, working out at the gym, rubdown by his trainer, biting his fingernails, in the ring. The two-year suspension from professional boxing for failing to report a $100,000 bribe, which he didn't take, had just been lifted when the article ran.

Rocky Graziano (born Thomas Rocco Barbella) was born in Brooklyn and grew up on Manhattan's Lower East Side, where, boxing historian Bert Sugar wrote, "both sides of the track were wrong." By the age of six, he was already a fighter. His dad taught him to keep throwing punches, but throughout his youth he got into trouble all on his own. The gym was the only place for Rocky to survive and thrive.

Stanley Kubrick, famed filmmaker, began photographing in high school. *His* father encouraged him to take photographs to help compensate for being a terrible student. Graziano's father always had boxing gloves in the house; Kubrick's dad built him a darkroom. Cutting school was both their MO. One day when he should have been in class, Kubrick took a great photo, printed it, and ran it over from his home in the Bronx to *Look*'s offices in Manhattan. Kubrick already knew the only thing he excelled at was

Stanley Kubrick, American boxer Rocky Graziano, from the picture story "Rocky Graziano, He's a Good Boy Now," *Look* magazine, February 14, 1950

seeing. Immediately out of high school he became a staff photographer for *Look,* and many film historians cite Kubrick's years framing still photographs as seminal to the success of his film career.

Kubrick's picture story, "Prizefighter," about the boxer Walter Cartier, ran in the January 18, 1949, issue, a year before the Graziano story. It was the basis for his first film, *Day of the Fight,* in 1951. Sixteen minutes in length, the film used many of the same camera angles, lighting techniques, and grainy black-and-white effects as in the Cartier and Graziano stories. Kubrick's high school friend Alexander Singer, who worked on the film with him, thought Kubrick's attraction to boxers

Mixed Martial Arts (MMA) is an umbrella title given to combat sports that combine fighting disciplines such as karate, boxing and traditional wrestling. It is a modern variant of Greco-Roman wrestling, which can trace its origins back to 650 Before Christ. Today, we know MMA thanks to America's Ultimate Fighting Championship (UFC), which pulls in big crowds in 175 countries although it is still illegal in France. Two fighters clash in an octagonal cage that is 32ft in diameter and 6ft high. Here, during a three-or-five-round contest, they try to knock out their opponent by, just about, any means necessary although biting, head-butting, or kicking an opponent when he is down is banned. If both are still standing at the final bell, the winner is decided by a trio of judges. Welcome to hell.

WALL LABEL, FRANCK SEGUIN EXHIBITION. FESTIVAL SPORTFOLIO, NARBONNE, FRANCE, 2013

• • •

Franck Seguin, Georges St-Pierre of Canada and Carlos Condit of the United States, from the series *Mixed Martial Arts,* Bell Centre, Montreal, Quebec, Canada, November 17, 2012

came from his fantasies about personal power and strength, but chess was the only game Kubrick could play well.

· · ·

LARRY FINK took one of the finest and most mysterious series of boxing photographs and published them in the book simply titled *Boxing*. It was originally conceived as a comparison between boxers and brokers. According to a 1989 article in the magazine *American Photographer* by Eric Levin, Larry Fink wanted to pair the opposite worlds of a seedy boxing gym in Philadelphia with the elite Wall Street brokerage firms. (He had paired extremely divergent economic classes in his previous book, *Social Graces*.) Even without seeing the photos, one can imagine where this project was headed. Fink is attracted to opposites that in reality have much in common. In the case of boxers and brokers, there is male bonding and awards for aggression. He did not do that book.

Fink's trademark look is the result of his use of electronic flash, which, unlike the manual advises, he doesn't mount on the camera but holds to one side, aiming it at odd angles "to

cast," Levin writes, "stygian shadows on itself." And because Fink often uses a wide angle lens, the edges of the pictures are dark where the flash doesn't reach. But the reason the flash is so emotionally resonant is not just because it simultaneously reveals and conceals, but because it serves, as the critic Max Kozloff noted, "to gain moral understanding and emotional knowledge." Boxing has a history of underclasses fighting their way out of discrimination and prejudice. Fink gravitates toward social issues and injustices.

Fink writes in the introduction to *Boxing,* "The excessive opposites active in and latent within the sport drew me," but it was his quoting the writer Katherine Dunn that makes us understand the profound contradiction in the sport that insists upon and permits people to beat each other up:

> A boxing gym is a place where men are allowed to be kind to one another. Anyone there will gently wipe any other man's face with a towel, fix his helmet straps, tie his shoes, massage his tense shoulders. There is no shadow of impropriety. . . . This tender, respectful nurturing is absolutely necessary because of one magical ingredient of the game: the gloves. Anyone wearing bulky, fingerless gloves is utterly unable to blow his nose or take a drink of water by himself. Those who are not gloved-up help those who are. From this central fact radiates the whole demeanor of the game [*Mother Jones,* September–October 1993].

Larry Fink sees grace in the gym, in the ring, and in the men who engage in this contradictory, lyrical, violent, tender sport.

· · ·

DANIEL OCHOA DE OLZA knows something about bulls. He was born in Pamplona, Spain, in 1978, the son of a writer and an art history teacher. But running with the bulls is very different from the rituals of bullfighting.

For the early part of his career, Ochoa de Olza was a painter. In 2001 he started studying photography in Pamplona and Barcelona and recognized that it, too, was an art. When he moved to Madrid to accept a job with the Associated Press, he realized how culturally rich and varied his country was, but he had very little awareness of many of the traditions that defined Spanish culture, including bullfighting. He doesn't like when animals get hurt, but it was an obvious place to begin his photographic explorations.

Ochoa de Olza's series of photographs of Spanish bullfighter Juan José Padilla, known as the "Cyclone of Jerez," is a poetic narrative. In October 2011, Padilla was gored by a bull. He lost sight in one eye, his face was partially paralyzed, and he needed a titanium plate and substantial reconstructive surgery.

Each photo in the essay leads to the next, engaging and instructing the viewer at the same time. Ochoa de Olza is fully aware of the debate in his country about the ethics of bullfighting. Roland Barthes in his book *What Is Sport?* discusses five different sports as representative of five countries. For Spain, he chose bullfighting. Ochoa de Olza's photo essay gives visual coherence to two of Barthes's main points: "style" and "spectacle":

> Style makes a difficult action into a graceful gesture, introduces a rhythm into a fatality. Style is to be courageous without disorder. . . . Courage, knowledge, beauty, these are what man opposes to the strength of the animal. . . .
>
> Bullfighting is hardly a sport, yet it is perhaps the model and the limit of all sports; strict rules of combat, strength of the adversary, man's knowledge and courage; all our modern sports are in this spectacle from another age, heir of ancient religious sacrifices. But this theater is a false theater; real death occurs in it. The bull entering here will die.

· · ·

To impress Pablo Picasso with a photograph was not easy. But **ERNST HAAS**'s series of bullfighters and bulls did just that. Haas blurred man and beast together, showing their battle to be more spiritual than corporal. When Picasso saw Haas's photographs published in *LIFE,* he ran over to the home of his friend Lucien Clerque and insisted on finding out more about the photographer. When Picasso had his eightieth birthday exhibition at the Museum of Modern Art in New York City in 1962,

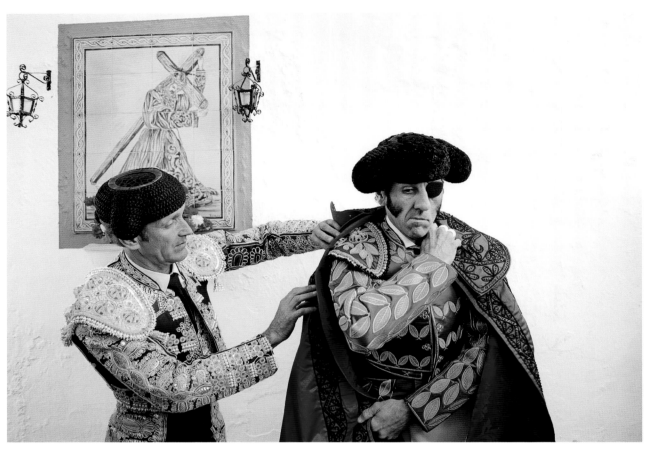

Daniel Ochoa de Olza, *Bullfighter's Comeback,* Juan José Padilla, Olivenza, Spain (disputed territory), 2012

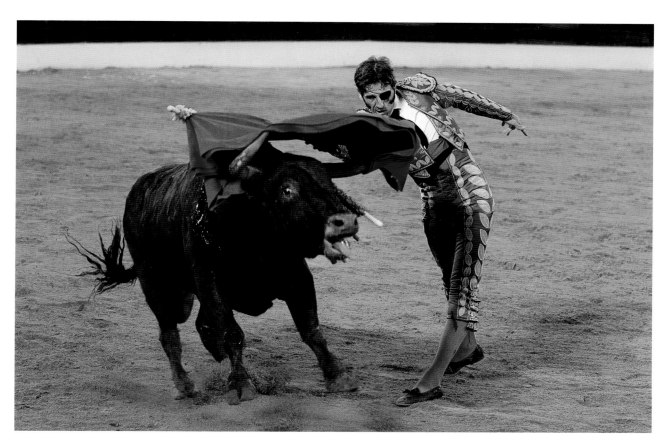

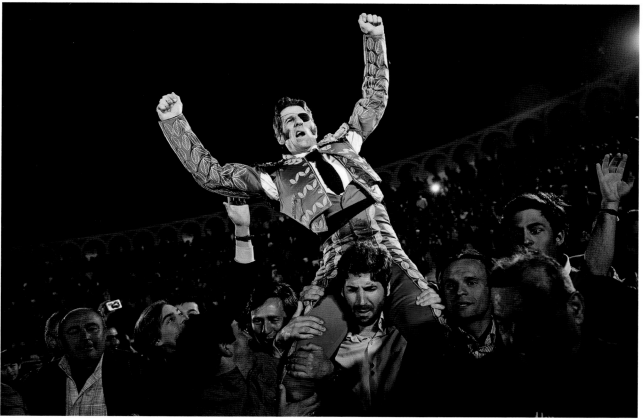

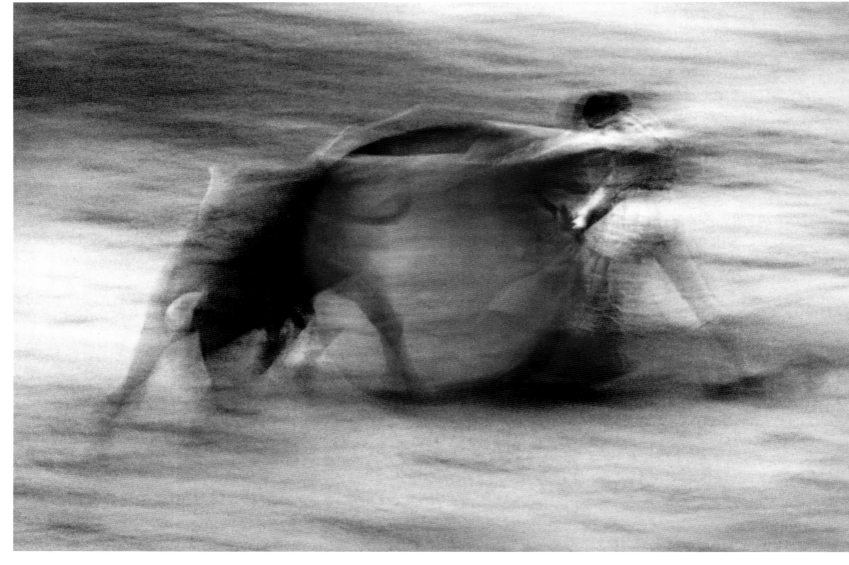

curators felt a good pairing would be to have a one-person show of the photographs of Ernst Haas. The museum recognized a shared spirit and the complementary nature of their work. That Haas exhibition was MOMA's first color photography show.

• • •

RINEKE DIJKSTRA, a contemporary Dutch portraitist, photographed matadors immediately coming out of the ring. She did her first body of work in 1994, the same year she photographed women holding their infants just after giving birth. She wanted to photograph individuals physically exhausted. She thought in that state they would be unlikely to hold an artificial pose.

She commented:

The matadors came out covered in blood and exhausted—very similar to the mother. . . . I did not intend to do the men like that, all macho and the women as mothers—it just evolved from the experience . . . women make this extreme physical effort . . . while the men search for it as a

kind of adventure. But still, both are exhausting and life-threatening.

A woman after giving birth is transformed. She has unequivocally entered womanhood. Dijkstra understands that in many cultures, the Iberian included, men need to prove their manliness, generally through acts of bravery (which can also be seen as foolhardy). The portrait of the bullfighter reproduced here is confusing, as the young man has engaged in a rite of passage but still maintains his look of innocence and vulnerability. This is Dijkstra's brilliance. She knows that, in his exhaustion, there can be no artifice. Dijkstra requests museums to hang her series of the new mothers and bullfighters together. What are we to make of the women who have brought life into the world and the men who destroy it?

Rineke Dijkstra, *Forte da Casa, Portugal, May 20, 2000*

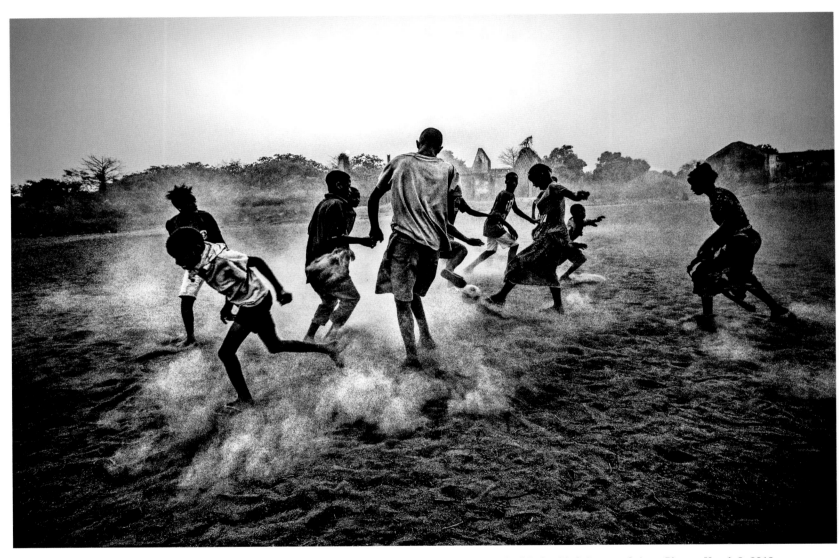

Daniel Rodrigues, "Youths play soccer on a field that was once part of a military barracks," Dulombi, Galomaro, Guinea-Bissau, March 3, 2012.

FOR THE LOVE OF SPORT

Some of the most famous sports photographers in the world will admit to "not always wanting to photograph millionaires." They started in the field because of their own passion for sports, and they like to see it and to photograph it in others. The word "amateur" comes from the root "to love." Photography has an uncanny ability to celebrate human activity—Little League in Pittsburgh, kicking a ball with friends in Yemen, a baseball game on a street in Havana. Photography is a great democratic medium: it shows there is no hierarchy in sports if the criterion is the enjoyment received by the people playing the game.

• • •

This is a true story. **DANIEL RODRIGUES** is a young photographer, a graduate of the Portuguese Institute of Photography. For two years after finishing school, he interned at a newspaper and worked for the photo agency Global Imagens. It didn't pay the bills and he was broke. He went to Africa with a humanitarian organization, Missão Dulombi, helping to reconstruct a school and a hospital.

Every day, if they can, the children and young people play soccer. Rodrigues played with them and then, one day, when the light was perfect, took this photograph.

When he returned to Portugal, he was still as impoverished as when he left. To pay his bills and those of his grandmother, with whom he lived, he sold his camera, three lenses, a tripod, flash, and backpack. "It was a last resort," he said, "the most difficult decision of my twenty-six years." When the World Press Photo awards were announced, Rodrigues had won first prize in the "daily life" category, a huge honor, recognized around the world. And then the largess began. Canon

Portugal and a Portuguese bank gave Rodrigues equipment and all the material he needed to allow him to return to photojournalism. People offered him their cameras.

Anthropologist Edward T. Hall called it "the dance of life"—how people are tied together by hidden threads of rhythm and walls of time. Rodrigues's photograph is part of the dance.

• • •

For many years, visitors to the Museum of Modern Art in New York would always see the work of one contemporary British photographer in the permanent photo galleries—**ROGER MAYNE**. His quiet, unassuming, small-scale black-and-white pictures catch the viewer off guard. One look at a Mayne photograph means being transported to postwar, working-class West London. His work is not unlike Helen Levitt's photographs of children on the Lower East Side of Manhattan. Mayne, however, focused more on children's structured play—sport—and how that gave a wholeness and meaning to their shabby environment. Addison Place and Southam Street, where many of the photographs were taken, become a self-contained world, and the children's play its lifeblood. A life of physical labor is almost always their destiny.

Every photograph by Mayne is brilliantly composed with haunting shadows and a dynamic flow of bodies interacting with the old cobblestones and crumbling buildings of London. His journey toward photographic greatness was serendipitous: first a chemistry degree from Oxford and then interest in abstract art and friendship with painters Terry Frost, Patrick Heron, and Roger Hilton.

Roger Mayne, *Addison Place, North Kensington,* London, 1956

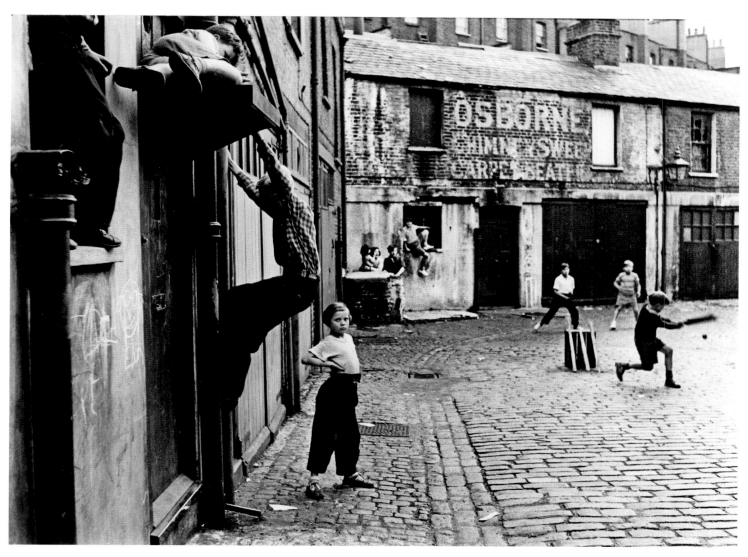

Roger Mayne, *Addison Place, North Kensington,* London, 1956

The Hill District was considered the cultural center of African American life in Pittsburgh. August Wilson set nine of his ten plays in the *Pittsburgh Cycle* in the neighborhood. And if Wilson captured the voice of these residents, **CHARLES "TEENIE" HARRIS** captured the look. Harris had formal schooling only up to eighth grade, but historians and sociologists continuously consult his body of eighty thousand prints and negatives as a penetrating and accurate portrayal of African American life in Pittsburgh from the 1930s through the 1970s.

Harris was an accomplished baseball player, a cofounder in the mid-1920s of, and shortstop for, the original Crawford Colored Giants. Thirty years later, when this photograph was taken, Major League Baseball had started to be integrated, and the excitement on this day in May was palatable. Jackie Robinson, Roy Campanella, Joe Black, and Jim (Junior) Gilliam, all members of the famed Brooklyn Dodgers, were in town to take part in the festivities surrounding the opening-day ceremonies for the Uptown Little League. How proud these boys must have felt, in their new uniforms, walking past their neighbors. They were probably thinking only as far into the future as the next six innings, but the mature Harris must have seen them walking into a new world.

Charles "Teenie" Harris, "Uptown Little League baseball opening day ceremonies," Kirkpatrick Street, Hill District, Pittsburgh, May 29, 1953

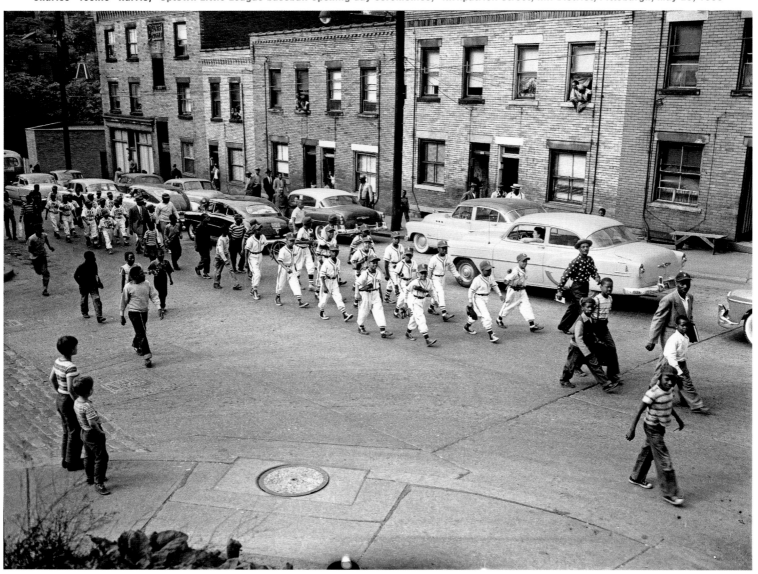

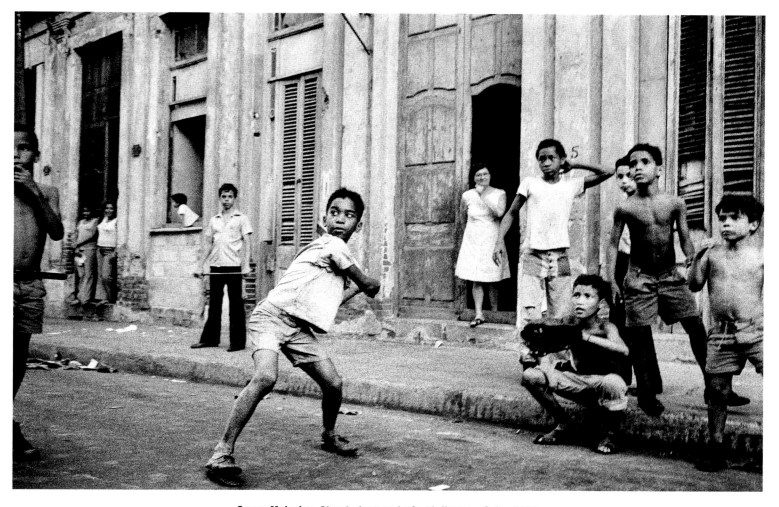

Susan Meiselas, Street along waterfront, Havana, Cuba, 1977

· · ·

"I was a real jock," **SUSAN MEISELAS** told me, "basketball, tennis." She has an affinity for women's stories, from carnival strippers to women soccer players, dominatrixes to marathon runners and girl boxers. But it has never been her whole story.

In 1977 Meiselas was one of a group of photojournalists invited to Cuba. For a brief period, there was a thaw in Cuban-American relations. For the first time since Batista was kicked out and Castro took power, U.S. citizens could see life in the nearby island nation.

The photographers were taken to many institutional facilities but were also allowed to roam. This baseball picture is a result of what photographers do best—stumble upon, pay attention, see, and shoot. The photograph is structurally complex and nuanced. From the torn sole of the batter's shoe to the fine-looking mitt on the catcher's hand, the street scene is alive but the lives are unknown. What are the homes like behind the broken shutters and worn grand doorways? No men are present, but women keep an eye on the children and socialize. The photograph is a powerful reminder that black-and-white photography focuses the eye on essentials and preserves life's never-ending mysteries.

When Tim Clayton, first, and then Steve Christo joined the photo department at the *Sydney Morning Herald* in the early 1990s, they were greeted by one of Australia's finest sports photographers, **CRAIG GOLDING,** who was the chief sports photographer at the paper. Soon, the threesome made a mark not just in local sports coverage, but also around the world. Golding, however, has particular sensitivity to those physical activities that help define Australian culture and values. His black-and-white photographs of octogenarians and nonagenarians are particularly heartfelt in a world where athleticism is associated with youth. He has fine pictures of ninety-nine-year-old Dorothy De Low playing Ping-Pong and ninety-one-year-old Jack Mathieson, proud as a peacock, after competing in the 800-meter freestyle race.

Golding captures all sports well. Being Australian, he excels when the ocean is a backdrop. His color surfing photographs are superb as is his many-years-long study of lifesaving clubs practicing technique and participating in the National Championship. There are scores of sports photographers around the world who rarely are acknowledged, even with a byline. Their reward, if not fame or fortune, is thinking they have (or had) the best job in the world.

Craig Golding, "Inoue Takashi, 80 years old, from Japan, lines up for start of the Men's 'Over 80 years old' 200 meter race during the Sydney World Masters Games," Sydney Olympic Park Athletic Centre, October 18, 2009

Lucy Nicholson, "Holocaust survivor Betty Stein, ninety-two, plays Ping-Pong at a program for people with Alzheimer's and dementia at the Arthur Gilbert Table Tennis Center in Los Angeles," California, June 15, 2011.

• • •

Reuters photographer **LUCY NICHOLSON** describes shooting a sporting event as being as competitive as the game being played. For a petite woman, pushing for position in a profession predominantly male is problematic. Some men are protective, some physically aggressive, and most just view her as a colleague doing her job. She admits, "At the end of some classics [Super Bowl, Olympics], there are some real scrums, and I am tiny so I don't do so well, but I am fast, probably faster than most of the men." Even though she may be hassled and pushed, "there is a camaraderie in sports that I really like," she says.

In the early days of photography, male sports photographers and editors would say that women couldn't carry the equipment, they weren't strong enough. Nicholson says, "There is a lot of heavy lifting. I do a lot of exercise. Keep my strength up. In some countries, you see women carrying heavy loads." A sports photographer today has lighter equipment but still a lot to carry: long lenses, tripods and unipods, more than one camera, computers.

Nicholson began her career in 1996 at *The Middlesex Times* in her native Britain as a journalist and photographer, always writing her own captions. She says the biggest difference now is "I can edit from remote locations. Edit at half time. I am very fast with shooting, editing and pre-writing captions."

Nicholson enjoys being on the front lines but also taking the time to do extended photo essays. This story is about a hundred elderly people suffering from Alzheimer's who are taught to play Ping-Pong to improve their balance, increase their heart rate, and get more blood flowing to their brains.

Ramón Masats, *Seminario*, Madrid, 1960

· · ·

The Spanish photographer **RAMÓN MASATS** worked as a still photographer and cinematographer through much of Francisco Franco's fascist regime, always photographing what he wanted but knowing that many of the pictures he was taking would never be published during the regime. Starting in the early 1980s, he began publishing books of his photographs and exhibiting his work.

Born in 1931, he discovered photographic art magazines while in the army. His first extended photographic essay, in 1953, was on Las Ramblas, Barcelona's notorious main pedestrian thoroughfare, where human activity—Masats's favorite subject—never stops. In 1957 he was living in Madrid and employed by *Gaceta Ilustrada*. An assignment to photograph Basin, an avant-garde political group of artists, led to close friendships and encounters that shaped his vision and his photography.

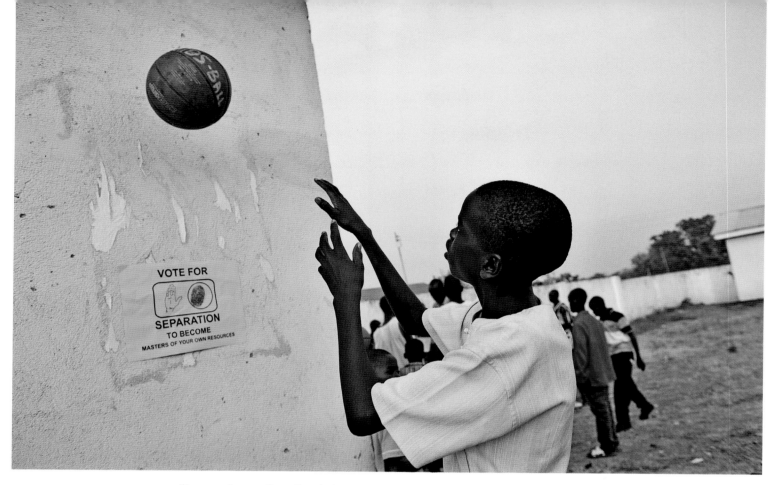

Shannon Jensen, From the photo essay *Reaching for the Rim,* southern Sudan, 2011

• • •

What does freedom look like? After the fall of the Berlin Wall, freedom in Prague was attending a Rolling Stones concert. In southern Sudan, after decades of war, freedom can be playing basketball.

New York Times writer Josh Kron, in an article published on February 19, 2011, accompanied by **SHANNON JENSEN**'s photographs, describes the basketball court as a "sanctuary" from the "unrivaled poverty, violence, instability" of life in southern Sudan. Young men who thought their only destiny was holding a gun now embrace a basketball as an almost sacred object. For these young men from the Dinka and Nuer tribes, genes and/or god gave them the gifts of height and agility. American colleges gave them scholarships and the opportunity to star—if the State Department gives them visas and their own country gives them permission to leave.

Amadou Fall, vice president of the NBA's global outreach program, Basketball Without Borders, noted that "southern Sudan does have an abundance of tall, well-talented players. We have to pay attention." Photographer Shannon Jensen is saying with her extraordinary talent that there is beauty and delicacy inherent in the people and the sport.

Shannon Jensen is an American photographer currently based in London. She won Magnum Photo's Inge Morath Award in 2014, one of the most prestigious prizes for female photographers under the age of thirty. Jensen is a 2007 graduate of the University of Pennsylvania's Wharton School with a bachelor's degree in economics, and her best-known body of work is photographs of shoes—the shoes worn, over many months in 2012 by Sudanese fleeing to South Sudan. The worn-out shoes with their individual characteristics are symbols of these strong people who have walked so many miles and been through such terror. Their plight is keenly

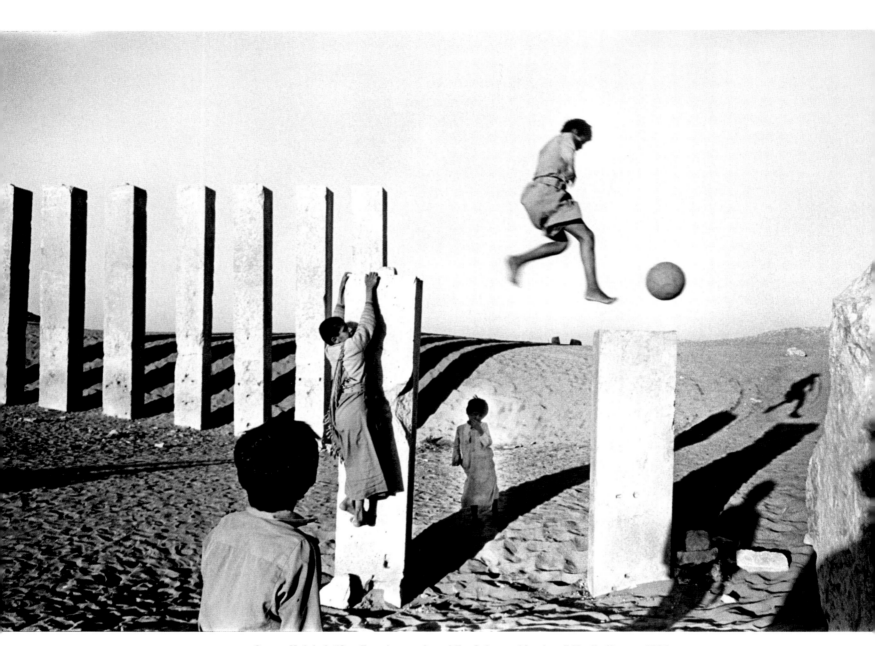

Samer Mohdad, "Sun Temple remains of the Sabaean kingdom," Marib, Yemen, 1994

felt. It was one of the most original, poignant, and important photo essays of that year.

• • •

SAMER MOHDAD is one of the most respected fine art photographers from the Middle East. He sees the Muslim world from the inside, a rare and precious gift he is able to share. His books *War Children, Return to Gaza, Mes Arabies, Assoudia, Mes Ententes,* and *Beirut Mutations* are poetic and profound.

Born in Lebanon in 1964, he was a war refugee eight years later. Educated in Belgium, he worked for the Paris-based photojournalism agency Vu before being hired as the liaison between the Musée de l'Elysée in Lausanne (one of Europe's leading photographic museums) and the Arab world. From then on, the focus of his personal photography was sharply on the region of his birth.

There is a fine line between play and sport. There would be no major league athletes had they not played as children. Play is the first rung, followed by practice, followed by ritualized and regulated sport. Competition is what often connects them: who can jump highest, run fastest, get the ball where it is supposed to go. If the game has rules, if score is kept, it starts looking like sport. It is hard, though, to mark a playing field in shifting sands. Standing ancient pillars replace goalposts and shadows speak to life's eternal mysteries.

• • •

LUCIA HERRERO, a Spanish artist, decided to investigate sports indigenous to the Basque region. Her exploration was twofold: see for herself traditional sports at risk of extinction; translate these practices into works of art that embody the land and the people.

An architect by training, a student of physical theater, and an accomplished photographer with a long résumé of exhibitions, Herrero has brought her subject alive by using a color palette slightly unreal, slightly monochromatic, and with an overall wash of brown. She explains that the sepia reflects the Basques' culture of "defending the earth, their fields, their mountains." Her unique imagery is also a result of working in daylight with a flash that darkens the background. Her subjects literally glow.

We worry about languages that are spoken by only a few elderly people in remote corners of the world. We worry—but not enough—about endangered species. Herrero directs our focus to endangered traditions, and in her competent hands we are brought back to fundamentals. Herri Kirolak, traditional Basque sports, have no sponsors, no international superstars, no athletes with sweet deals from energy drink companies—nothing, really, except the things that have been around them for generations: rocks, boulders, trees, animals, family, community.

What are these Basque sports? Lifting stones, cutting down trees with an ax, tugs-of-war with heavy ropes, tossing big chunks of wood, partnering with oxen to pull heavy (very heavy) loads. These activities have been part of the working lives of people in the region for generations. And, Herrero reminds us in an interview, these are passionate people whose folklore plays a part in how these sports are executed. There are more "virtuous" ways to lift a rock than others. The execution can be "semi-romantic [loving] as opposed to just brute force" and takes total concentration. Do it mindlessly or against tradition, and you can "break your back" because the "force" is not with you.

Herrero discovered that not only are the Basques proud of their land and culture, but they have always been competitive. While working in the quarries, for example, they made the physical labor more joyful by playing games. During work breaks, rather than relax, they would see who could toss a boulder the farthest. The lumberjacks, too, made chopping down trees more fun if there was someone nearby to compete against.

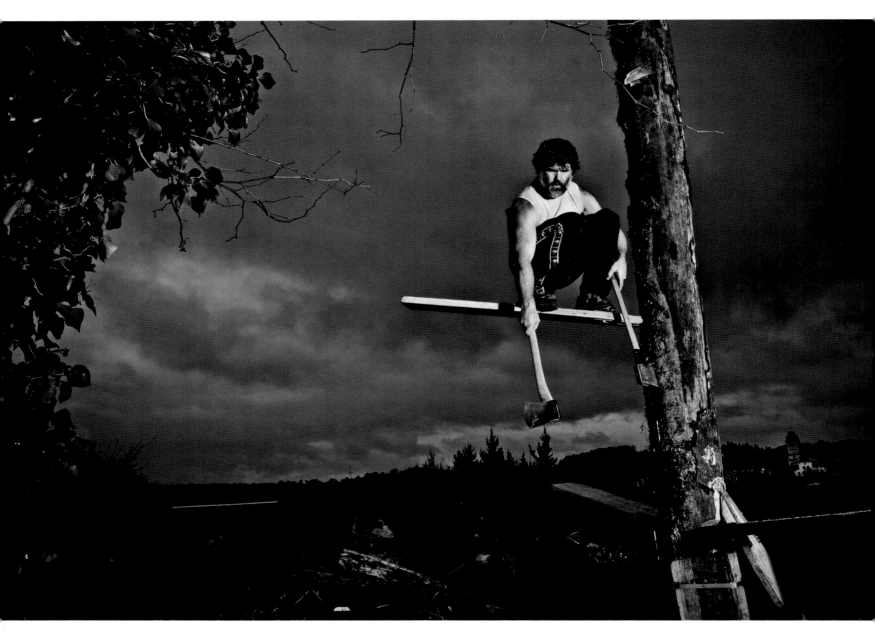

Lucia Herrero, *Herri Kirolak-Departes Vascos, Spanish and French Basque Country,* **January 2012**

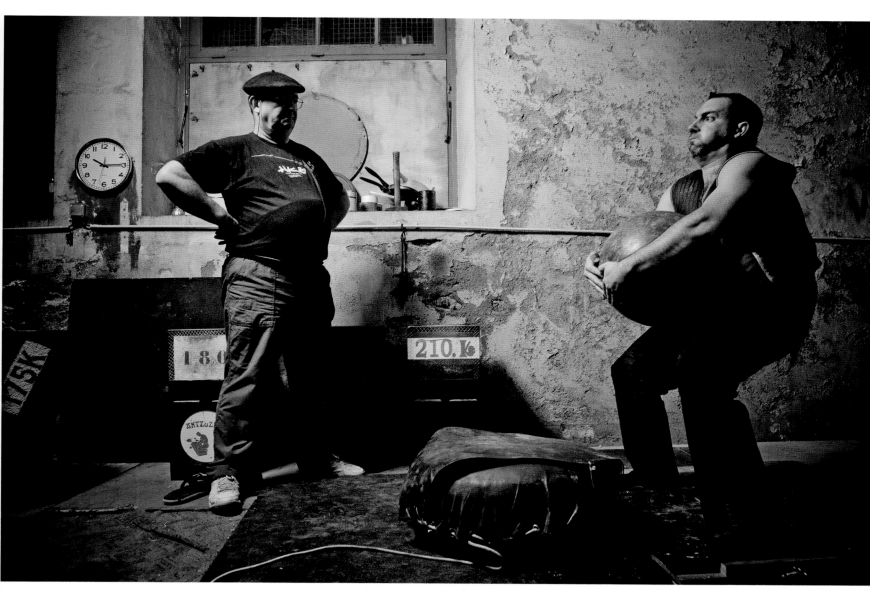

Lucia Herrero, *Herri Kirolak-Departes Vascos, Spanish and French Basque Country,* **January 2012**

Thomas Hoeffgen, Babylon, Namibia, 2007

· · ·

THOMAS HOEFFGEN was born in 1968 in Kiel, Germany, about sixty miles north of Hamburg. He is proud to say he went to the "wrong" photo school. He didn't study at Kunstakademie Düsseldorf, where Bernd and Hilla Becher taught Andreas Gursky, Thomas Ruff, Thomas Struth, Candida Höfer, and other prominent artists. He learned technique through apprenticeships, some formal training, and a lot of experimentation. He had to figure out the nature of his own

photography while recognizing that he loved the adventurous, outdoor life.

Hoeffgen spent ten years photographing African football pitches, calling them "arenas" because the original Latin *arena* means simply "sand." He traveled alone with his Novoflex for panoramas and a Contax $4\frac{1}{2} \times 6$-inch camera on a tripod. He was not interested in football (he went to a Waldorf school that didn't allow the kicking of a ball) but was fascinated by the physical spaces where the game were played. It was also

an excuse to make multiple road trips throughout Africa, photographing in twelve countries. In this diverse continent, one constant in cities, towns, villages, and hamlets was the playing field. There was ALWAYS a playing field. Finding them, however, was sometimes a challenge as they could be hidden in the strangest places.

For the series *African Arenas,* Hoeffgen employs desaturated color. The color—or lack of it—unites these photographs taken in different countries, as if the strong sun was the unifying element. In the excellent introduction to Hoeffgen's book, Nadine Barth cites Friedrich Schiller's idea of the "playing man": "Human beings, according to Schiller, could only develop their abilities to the full through play, and only through play could they experience true freedom of action." In a continent that had been invaded, brutalized, and repressed, no wonder every hamlet, village, town, and city had a place to be *free.*

In Mogadishu, women risk their lives to play basketball. Every time they show up at the bullet-riddled court situated in the ruins of the city, armed guards at the ready, they risk their lives. Basketball is the sport of the "deadly enemy America." They are on the hit lists of the killer commandos of Al Shabaab, the militant Islamist group that controls large parts of Somalia.

Al Shabaab has declared female basketball players "un-Islamic" and proposes as punishment sawing off these women's right hands or left feet—or simply killing them.

The captain of the Somali national team is a young woman named Suwey. She is constantly being threatened with death. But these young women are fearless. At the All Arab Games in Qatar they won many of their games. And, they believe, unlike the dominant male authority, sport can play a role in the struggle for peace.

JAN GRARUP is a Danish photojournalist. He has covered the Haitian and Kashmir earthquakes, genocide in Darfur and Rwanda, maternal mortality, boys from Ramallah, a garbage dump in Kabul, and the Central African crisis. His work is visceral, immediate, and crucial.

Jan Grarup, *Death or Play. Women's Basketball in Mogadishu*, Somalia, 2012

Andrew Esiebo, *Alter Gogo,* Orange Farm Township, Gauteng, South Africa, 2010

Alter Gogo is a diptych portrait series featuring a group of grandmothers who are members of the Gogo Getters Football Club in Orange Farm, South Africa. For them, playing football is more than a recreational activity; it's also had a profound social and physical impact on their lives. In a community plagued with social and physiological problems like high unemployment, crime, alcoholism, diabetes, and high blood pressure, football serves as a salve. And all too often . . . African women are located in the sphere of tradition and oppression, especially when they reach old age.

ANDREW ESIEBO

• • •

Gender issues in Africa are central in **ANDREW ESIEBO**'s work. But unlike many photographers who will choose one group to focus on, Esiebo is ecumenical. Gays and grannies face their own gender as well as generational perceptual challenges in Africa. (The LGBT community in most of Africa is clandestine because of extreme discrimination. Esiebo and Zanele Muholi's portraits are addressing and changing the dialogue.) Grandmothers are adored but relegated to caring for the young, cleaning, and other household chores. The ladies of Alter Gogo have a real kick to them and thoroughly enjoy running, competing, and falling on their faces as they battle for the ball. They break all

stereotypes when they appear in their soccer jerseys, shorts, and high socks.

Esiebo's series would be fascinating even without the other half of the diptych: grandma with grandchildren. Deciding to make diptychs is where Esiebo the artist trumps Esiebo the documentarian. On the right of each pair is the grandmother at home surrounded by her grandchildren. She is the bedrock of Africa, the strong woman who nurtures the next generations, keeping them fed, clean, and housed. On the left are the women we do not recognize. Long live the grandmas, may they continue to score points on and off the field.

Photographing soccer is a particular favorite subject for Esiebo. He doesn't have to look far to find it: Soccer is

everywhere and pitches are shared, often by farm animals. He describes the essay "For the Love of It," about soccer in Nigeria, as showing the game being played "from farm land to city roads, from beaches to markets." These pictures contrast the glut of photographs showing professional sport and its high-power and big-money stakes.

Sports have a special place in Esiebo's body of work. He followed a former soccer star who set up "a church on the field" and simultaneously coaches and preaches. He did another story on the vuvuzela, the instrument that became the symbol of African football during the South African World Cup in 2010 (when he also did his reportage on soccer grannies). He was part of the All Africa Dream Team of sixteen journalists and photographers chosen to give an alternative view of soccer during this time.

Andrew Esiebo, born in Nigeria in 1978, became a photographer only because he got fired from his job at a bookstore. He loves books. He was happy being surrounded by them. When he had to find another profession, he turned to photo books and learned from them. He had no formal photographic training, although later he took some workshops.

Without seeing what great photographers had accomplished, he would have thought the profession was just portraits and wedding photographs, which was what his uncle shot for a living. But books and the Internet and a wonderful Nigerian AP photographer, George Osodi, showed him there was a world of visual storytelling, and he recognized it as his destiny.

Esiebo is one of the most respected African photographers. He has had residences in Paris; London; and Gyeonggi Province, South Korea, and his work has been exhibited in those countries as well as in Havana, São Paolo, and Beijing, and in the Netherlands as part of the Noorderlicht Photo Festival. He is equally proud of the photographic workshops he has initiated for socially excluded children in Nigeria called "My Eye, My World."

. . .

How fortunate for everyone that **DAVID GUTTENFELDER** and his colleagues at the Associated Press were able to open a bureau in Pyongyang, North Korea, in early 2011, although Guttenfelder had been going earlier. We know North Korea to be brutal, we know it is paranoid, we know that it has a huge, mechanically orchestrated population marching to the

David Guttenfelder, "Young North Korean synchronized swimmers perform at an exhibition event in Pyongyang," February 15, 2013.

I do think that it's fair to say that synchronized swimming is a sport in North Korea, though it is as much surreal performance and propaganda.

DAVID GUTTENFELDER, EMAIL CORRESPONDENCE, FEBRUARY 18, 2015

• • •

tune whistled by all-powerful party head Kim Jong-un. Until Guttenfelder's photographs were distributed, we saw the people only as automatons marching in military parades or participating in the annual Mass Games. Guttenfelder took photographs of many orchestrated activities, but he also has shown us a subtler side of North Korea.

Guttenfelder was shadowed by a government minder wherever he went, but because he was in the country photographing in such a sustained manner, he gradually built a body of work that spoke to his personal experiences in North Korea. He describes it as "an unorthodox experiment that succeeded beyond all our expectations." It also helped that in addition to shooting with his digital single-lens reflex camera, which he used to photograph the synchronized swimmers, he took hundreds of photographs with his iPhone and posted them on Instagram and Twitter. The combination of photographing and sharing pictures opened up a new area of photojournalism for this experienced AP photographer.

A native of Iowa, Guttenfelder started exploring the world when he was an exchange student in Tanzania, where he went to learn Swahili. He spent the following twenty years working for the AP outside the United States, working in seventy-five countries and living in Kenya, Ivory Coast, India, Israel, and Japan. He covered the wars in Iraq and Afghanistan; the aftermath of the 2011 tsunami in Japan; Typhoon Haiyan in the Philippines in 2013; and the atrocities of the Rwandan genocide. He has returned to the United States to live and is one of the first five National Geographic Photographic Fellows.

• • •

It looks like torture, yet five to twenty thousand people show up to put their bodies through grueling physical challenges designed to prepare soldiers for battle, not for a cup of hot cocoa at the end. How **BOB MARTIN,** not the fittest guy around, positioned himself to get the best photographs of Tough Guy (known as Tough Mudder in the United States) is for Bob to know and us to be thankful—we get an intimate view of it without having to be tough ourselves.

Bob Martin, Competitor emerging from mud and water, Tough Guy, Endurance
Assault Course, Perton, Wolverhampton, England, January 28, 2007

Bob Martin, Competitors climbing forty-foot ladder, Tough Guy, Endurance Assault
Course, Perton, Wolverhampton, England, January 28, 2007

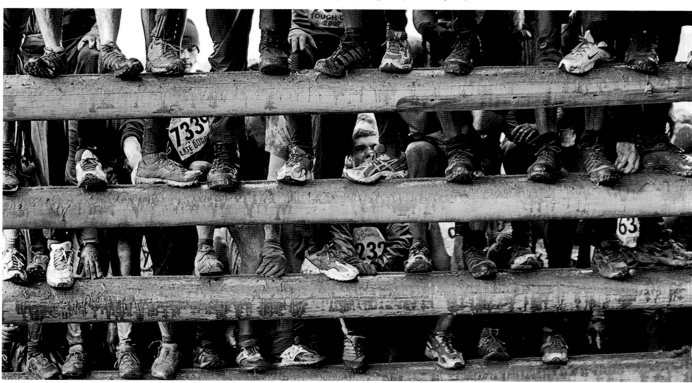

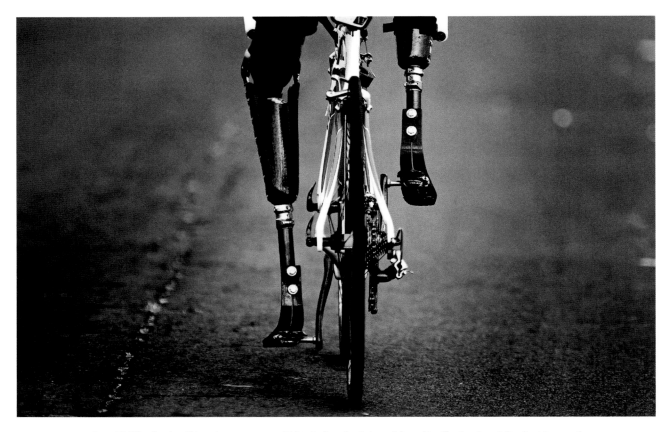

Donald Miralle Jr., "Twenty-one-year-old Rudy Garcia-Tolson bikes the final mile of the last leg and his race of the Ironman World Championship," Kailua-Kona, Hawaii, October 10, 2009.

. . .

Photographic historian Marcus Schürpf introduced me to the sports photographs of **LOTHAR JECK**. His photographs, from 1918 through the 1940s, constitute the most important body of sports photography in Switzerland during those decades.

Born in Bale, Switzerland, in 1898, Jeck started his apprenticeship in 1912 in the photographic studio of Wilhelm Dierks. By the age of twenty, he had published his first sports photographs. He continued to work for other photographers until 1924, when he won a first-place award in a photography competition and opened up his own photographic studio. From 1925 to 1945 he worked for Ringier publishing and his work was published in *L'Illustré* and the journal *Schweizer Illustrierte*.

What differentiates Jeck from other photojournalists of this period is his insistence on showing not only the dynamism of sports but also its balance, beauty, symmetry, and form. (Paul Senn, Gotthard Schuh, Emeric Feher, and Max Schirner are among the exceptions.) His compositions are unusually strong

for this early in photo reportage. He seems to have absorbed lessons in modernism and applied them to his photography. The book *Sportreporter Lothar Jeck* is one of the best overall surveys of sports in Europe in the 1920s and 1930s. He always finds an interesting angle from which to shoot gymnasts, pole vaulters, high jumpers. At the start of a race, he crouches down with the runners. The viewer of the photograph waits for the gun along with the athletes. Jeck is equally good photographing among crowds—kneeling on the street to take his photograph as a marathon runner, surrounded by young boys, walks toward him, relishing the idolization of the crowd.

Jeck was attentive to "national sports." Strange sports equipment, such as oversize paddles, gives no clue to the nature of the game. These are contrasted with the most universal of sports, wrestling. And, because he was Swiss, winter sports—bobsledding, skiing, figure skating, ice hockey, speed skating—play a big role. Jeck's action photographs of soccer matches in the late 1920s are as good as Martin Munkacsi's, but less well known. And his roller hockey, field

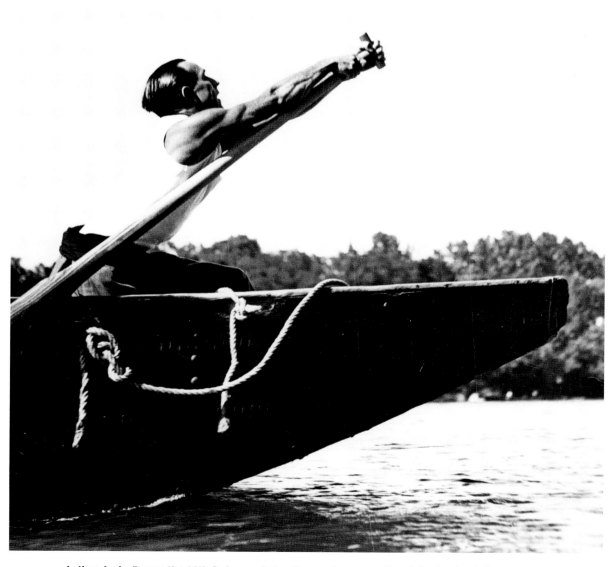

Lothar Jeck, *Rower,* the 12th Swiss confederation pontoon race, Basel, Switzerland, August 1933

hockey, and bicycle, motorcycling, and automotive racing photographs are original for the time.

The thoroughness of Jeck's documentation of sports is impressive. He took some of the earliest photographs of horseback riders being thrown from their horses during jumps, and the sad sight of a horse on its back, legs up, after a fall. In the late 1930s, sports turn into military exercises, with competitors wearing helmets and rifles slung over their shoulders. Jeck's most famous photograph is of the thousands of spectators in the stadium at the Berlin Olympics giving the Heil Hitler salute. There doesn't seem to be an arm not raised. The swirl of the arena feels like a vortex where everyone is being sucked down. It is a powerful cautionary image from 1936.

· · ·

There is a fairy tale quality to many of **RAY ATKESON**'s photographs. The hero is on a quest and must reach it on his own or is accompanied by a very few trusted friends. He or she traverses difficult terrain, faces innumerable obstacles, perseveres, and ends victorious. In Atkeson's world, that reward is skiing down the mountain.

When Ray Atkeson began skiing and taking photographs, there were no chairlifts. Until 1936, he hiked through the powder to get up the mountains. He carried a Speed Graphic camera and twenty-five pounds of gear on his back. It might have taken all day to get to the top. The run down was euphoric and a lot quicker. Sometimes, when the hike was only four hours (and five minutes down) a dedicated skier (or photographer) could get two runs in a day.

Even after the introduction of rope tows and then the first chairlifts, designed in 1936 by W. Averell Harriman's engineers for the railroad magnate's ski resort, Sun Valley, Atkeson often walked up the mountain. He was after something more sublime than a fast run down. He wanted to show the snow in its most pristine glory, the strangely shaped trees after a snowfall, and the contours of the land in this white wonderland. He liked to photograph in the predawn darkness and at twilight. Light, especially backlight, was his paintbrush. Yes, Atkeson loved skiing, but he loved photography even more. His archive in Portland, Oregon, consists of forty thousand 4 × 5 inch negatives, most of which are the result of heroic effort.

Atkeson, born in 1907, had a steady job operating an elevator at a Montgomery Ward department store in Portland. This was not the type of "up and down" that caught a young man's fancy. In the 1920s, Norwegian immigrants to the American West started to carve skis from wood and began racing down snow-covered mountains. One of the Norwegians invited his three neighbors, as Warren Miller writes in *Ski and Snow Country: The Golden Years of Skiing in the West, 1930s–1950s*, on the first "learn-to-ski weekend." One of them was Ray Atkeson, who also brought his small box camera. Snow and photography would be his joint passions for the rest of his life. He also found that it was more fun earning a living selling his photographs to companies like Jantzen and White Stag, to book and calendar publishers, and to the developing ski industry than running that elevator eight hours a day.

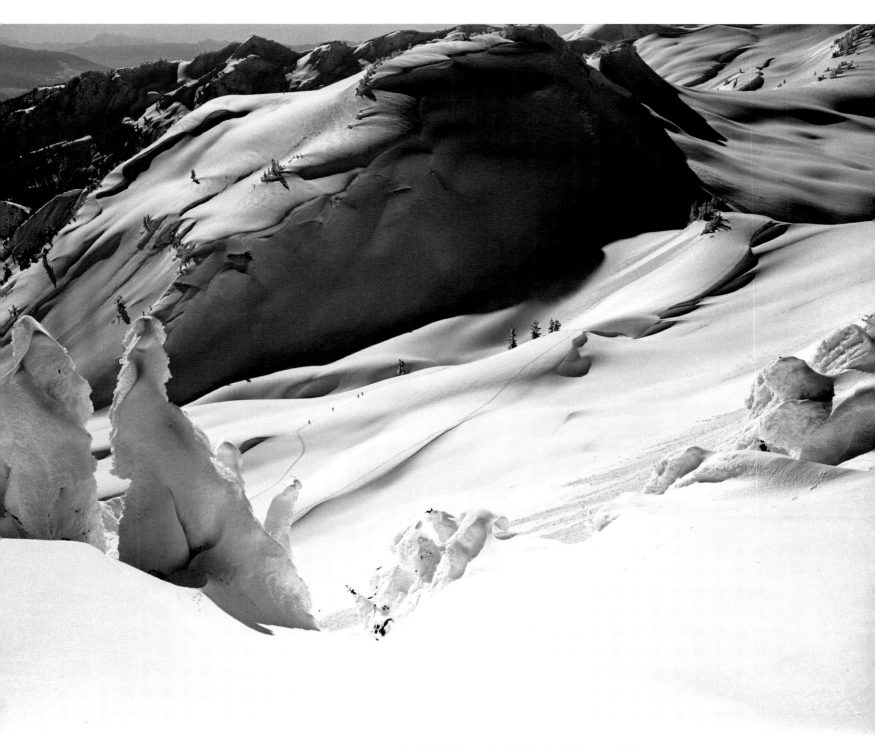

Ray Atkeson, Skiers, from the summit of Table Mountain, Washington State, ca. 1950

I have been fascinated mostly by the role that sports play in isolated, sometimes exotic cultures. What I always feared was that my photography would be perceived as "exotic," depicting "the others." My goal is totally different. I want to keep the universal aspect of a sport clearly in sight. In the 1940s, an American anthropologist listed about five dozen traits characterizing all known cultures of the world. Athletic sports were among those universal cultural peculiarities. Sport is a very powerful metaphor of human condition in all times.

TOMASZ GUDZOWATY, *GLASS MAGAZINE*

· · ·

Tomasz Gudzowaty, "Car drifting on the parking lot ramp at the Grand Sur shopping mall," Mexico City, 2010

• • •

"I find sport is a neutral key to show the differences in culture/countries today," the Polish photographer **TOMASZ GUDZOWATY** told me while visiting New York City. He travels all the time. He loves investigating the uniqueness of a place while keeping the "universal aspect" in perspective, and has found sports a clue to understanding the mind and the spirit of a people. He has photographed men and boys living in the roughest slums in India, playing golf with metal bars and cheap plastic balls, yet still insisting on keeping score according to the rulebook. These golfers may sometimes see green golf courses while caddying, but they themselves play on rooftops and alleys.

Gudzowaty has photographed wrestling in Japan and Mexico—sumo and *lucha libre,* respectively—both vital expressions of each country's culture and heritage. He has spent a long time in São Paolo, Brazil, photographing homeless and hungry youths entering Garrido's free boxing gyms, sparring, and coming out with new realizations of who they are. He has done magical photographs of horse racing in Mongolia, competitions that trace their origin to the time of Genghis Khan. He has been fascinated by the focus and physical exertion of young Chinese gymnasts who seem to have most in common with Buddhist monks in their devotional pursuit. (Anderson and Low's photographs of Chinese gymnasts are in muted colors; Gudzowaty shoots only in black and white and normally uses a large Linhof camera.)

Gudzowaty has a powerful aesthetic. His "sports" photographs are the opposite of the usual sports pictures that convey clearly what happened at a game or an event. Gudzowaty's photography is about ambiguity and mystery. His teacher was Sebastião Salgado. He even shares a printer with him. He says, and it is true, "My athletes are much closer to Sebastião Salgado's workers than to the figures portrayed in Riefenstahl's *Olympia*." For Gudzowaty, sports is physical, naturally, but also spiritual, cultural, and communal.

One of the most communal sports in Mexico is also illegal. The illicit aspect of car racing in Mexico makes it one of the most social, even addictive, group activities. The excitement comes from the speed of the souped-up cars, the girls, the music, the alcohol, the smoke, and the knowledge that the cops can throw you in jail at any moment if you don't run for your life when you hear the sirens blast. The brilliance of Gudzowaty's photographs—and much of his work is brilliant—is that it never reveals too much. He uses chiaroscuro as great painters do—to seduce the viewer into the picture and then leave dark spaces for the imagination to roam.

Bob Martin, Photographers capturing the euphoria of Team USA's Steven Holcomb, Steve Mesler, Curtis Tomasevicz, and Justin Olsen after winning the Four-Man Bobsled gold medal, Whistler Sliding Centre, Whistler, Canada, February 27, 2010

CHAPTER EIGHT
THE OLYMPICS

The international group of athletes who come together every four years train to be the best on the world stage. So do the photographers. They are every bit as competitive as the athletes. They want *their* photographs published—not someone else's. They have to be fit enough to sustain two weeks of running with heavy equipment, captioning and transmitting pictures, and little sleep. Camera companies provide them with prototypes of lenses and cameras not yet on the market. They want their products to be used by the sports photographers—and to be seen on television being used by them. The top photographers ask themselves, "How can I make my photographs better than anyone else's while still fulfilling the demands of newspapers/magazines/picture agencies and the World Wide Web?" Forced to huddle together, they find it difficult to stand out. The pros, however, find the position that will result in the most telling image; a perspective that surprises; a clean background; colors that enhance the picture. Only a tiny fraction of the pictures made will be seen and published. The Olympics is the time for photographers to achieve greatness.

THE PHOTOGRAPHERS OF THE FIRST MODERN OLYMPICS

The first modern Olympics, resurrected in Athens in 1896, was the brainchild and passion of the founder of the Olympics movement, the French nobleman Baron Pierre de Coubertin. The trials and tribulations leading up to the Games are well documented in books, scholarly articles, Hollywood movies, television documentaries, and the International Olympic Committee's detailed historical record.

Hardly known are the small band of men who came to the first Olympiad with cameras.

There were 12 (possibly 13) known photographers at the first Olympics, as compared to more than 1,450 accredited photographers at the 2012 London Olympics. But it must be noted that at the first modern Olympics there were only 14 athletes from the United States; 13 from France; 19 from Germany; and a whopping 169 from the host nation, Greece. Fourteen nations were represented with a total of 241 athletes participating.

Aliki Tsirgialou, chief curator, Photographic Archive, Benaki Museum, in Athens has uncovered the names of the Greek photographers at the 1896 Games: Ioannis Lampakis, Rhomaides Brothers, Nikolaos Pantzopoulos (photographer to the Greek king from 1882 and the one who photographed the closing ceremony), Constantinos Athanassiou, Ioannis Makropoulos, Nikolaos Birkos (who had a studio in Athens and was also in Paris for the 1900 World Exhibition and second Olympiad), and M and Mme De Boe. The German sports historian Volker Kluge adds the name Paul Melas to the list of Greeks who photographed the Games.

Hand cameras, including the Kodak, were on sale in Europe in the 1890s, so probably the number of people taking pictures was greater than the twelve known names. Three Americans, two of them Olympic athletes, took photographs at the Games. Thomas Pelham Curtis (1873–1944), winner of the 110-meter hurdles, had with him one of the first Kodak models that took the distinctive round pictures and, possibly, a second camera that took small rectangular pictures. Dr. Sumner Paine (1868–1904), who along with his brother John (1870–1951) won the shooting competitions in Athens, was also an amateur photographer.

The notable photographer and cinematographer Burton

Holmes (1870–1958), the man "who photographed the world," was also in attendance, but his pictures were lost through deterioration. His travelogue *The Olympian Games in Athens, 1896: The First Modern Olympics,* reprinted by Grove Press in 1984, is well illustrated with uncredited photographs. The Americans seemed to share their pictures, and attribution is not always easy.

• • •

IOANNIS LAMPAKIS (1848 or 1849–1916) was the most important Greek photographer at the Games. He was a skilled cameraman, originally working with the wet plate process. His involvement with the Olympics began in 1875, when he accompanied the first German archaeological team excavating at Olympia. Prior to the first modern Olympiad, Lampakis took photographs at the sports festival organized by the Panellenio Gymnastikos Syllogos in 1891 and 1893.

Lampakis, still using in 1896 a bulky large-format camera taking glass plates, made multiple albums containing approximately thirty-five albumen prints each. He photographed the opening ceremonies, gymnastic demonstrations, actual races, presentations of awards, the celebration feast for the medal winners, and the international group of athletes' excursion, with the Greek crown prince, to Daphi, where Lampakis's younger brothers, one a Byzantinist and the other a painter, were restoring the famous monastery.

Lampakis did what no other *professional* photographer attempted. He photographed the athletes competing. He photographed hurdlers and jumpers—long jump, triple jump, high jump. He caught some of the gymnasts in action, too. The pictures are taken from the bleachers and the athletes seem more like tiny blurs than Olympians. Some of the American athletes, with their snapshot cameras, also tried to capture the action, but their results were even poorer than Lampakis's. Lampakis also photographed the crowds, generally focusing on the dignitaries.

Thomas Pelham Curtis, "Olympians Arthur Blake, Thomas Pelham Curtis, William Hoyt, Ellery Clark, and Thomas Burke exercising on the tramp steamer *Fulda* en route to the Athens games," 1896

Possibly **Thomas Pelham Curtis.** Back row: standing, far left, Arthur Blake; holding flagpole, probably Thomas Burke; Thomas Pelham Curtis, whose camera may have been used to take the photograph (the camera case is sitting on the front bleacher); probably Sumner Paine; John Paine (holding pistol); Ellery Clark (holding end of flag). Front row, from left: two unidentified men; coach John Graham, holding small flag; William Welles Hoyt

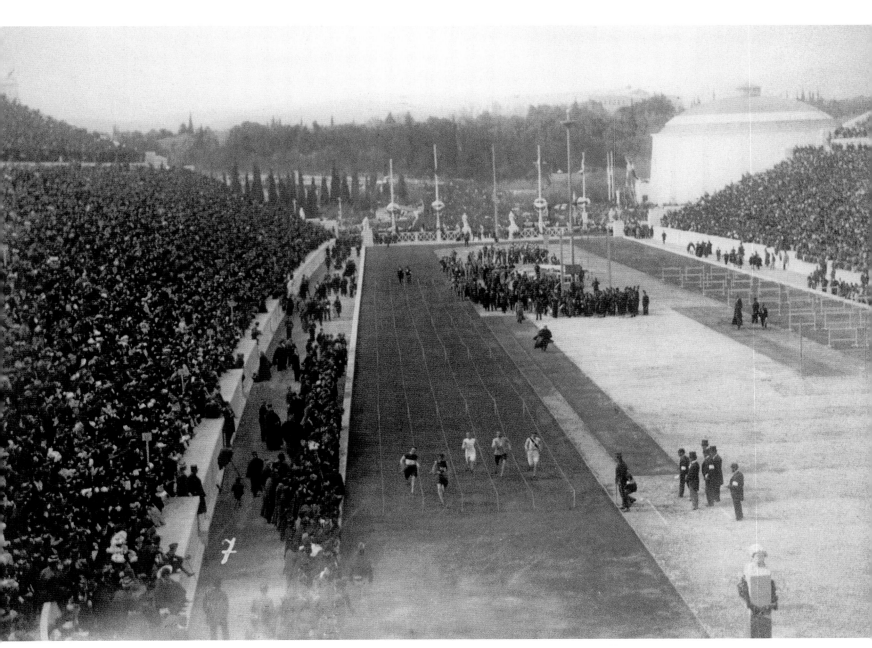

Ioannis Lampakis, "The final of the 100 meters where the American Thomas Burke came first," Athens, 1896

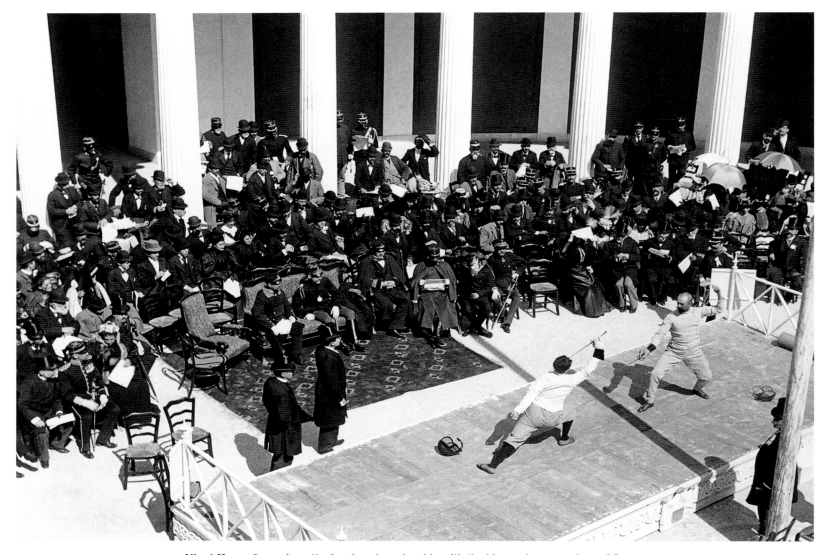

Albert Meyer, Scene from the fencing championship with the king and crown prince of Greece and Prince George III in the front row, Zappeion Building, Athens, 1896

• • •

ALBERT MEYER (1857–1924) arrived in Athens in 1896 with the German team. He was commissioned to make albums for the German royal court and Olympic Committee. He was a fine portraitist and his photographs are the only character studies of the athletes and organizing committee members. He rarely attempted to stop action, but managed to photograph the beginning of one of the running races and the twelve-hour bicycle race—before anyone moved. There are views by Meyer of the Greek discus thrower in classical pose, the shot-putter about to throw, and a German gymnast suspended on the rings and also frozen vertically on the parallel bars.

In the photograph by **NIKOLAOS PANTZOPOULOS** below, the photographer Nikolaos Birkos stands with an assistant to the right of the Hermes statue. To the left of the statue, wearing either the dark or light hat, is probably the German photographer Albert Meyer. The man in the white hat is holding what looks like a Suter Detective Magazine camera, manufactured in Basel.

Among the medal winners, facing away from the podium, is someone, possibly Thomas Pelham Curtis, holding a roll film camera, possibly a Kodak Junior No. 3 or No. 4 (just above the dark blur in the foreground).

Nikolaos Pantzopoulos, The closing of the Olympic Games, Athens, April 15, 1896. King George I is handing out the awards to the athletes. Spiridon Louis, the Greek marathon champion, in the white fustanella, is to the right of the podium.

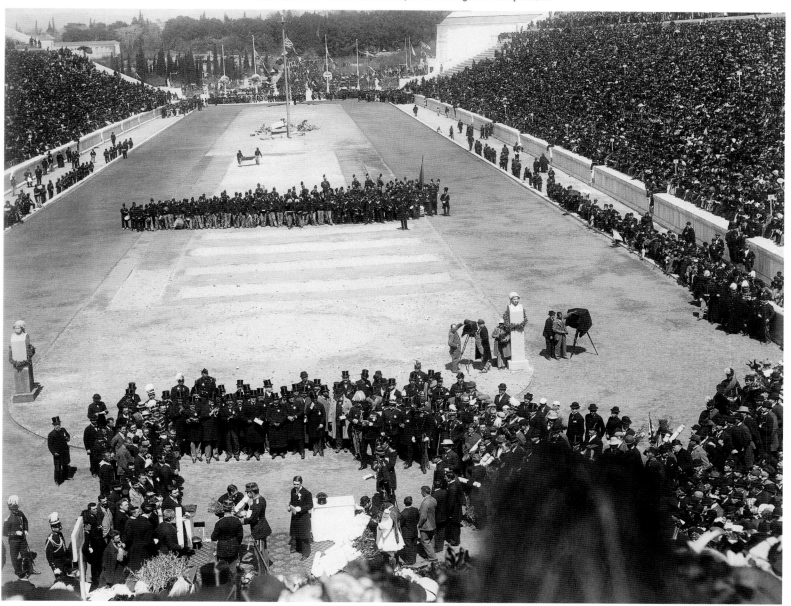

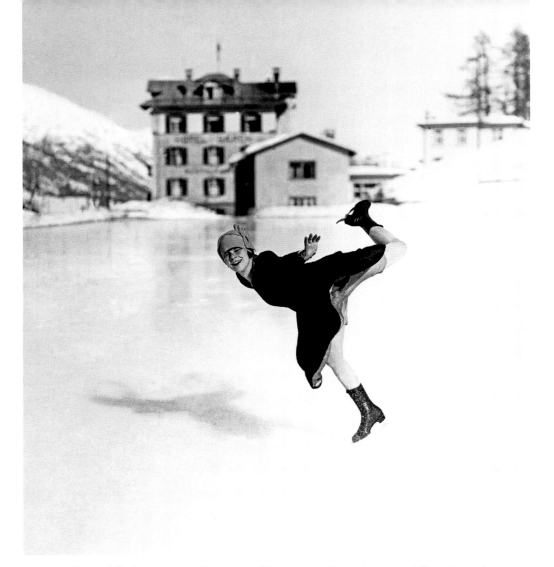

Edmund Neuhauser, Sonja Henie, age fifteen, competing in her second Olympics and the first in which she received a gold medal, St. Moritz, Switzerland, 1928

. . .

ERICH ANDRES, born in Leipzig in 1905, was active in Hamburg and died there in 1992. He became a professional newspaper photographer in 1932 using the Leica, often with great originality but also pathos. He lived through and photographed some of the twentieth century's most momentous and terrifying events.

The only persons who received accreditation to take photographs at the 1936 Olympics were those belonging to the Imperial Commission of Photojournalists in the Imperial Association of the German Media—which meant all foreign photojournalists and certainly the great Jewish sports photojournalists Herbert Sonnenfeld (1906–1972), Abraham

Pisarek (1901–1983), and Martin Dzubas (1900–1941) were excluded. Max Schirner, who in 1924 had founded his own photo agency, Sportbild Schirner, was one of the fortunate. Even the eminent Leica photographer Dr. Paul Wolff of the firm Wolff & [Alfred] Tritchler did not have a press pass and felt like "a horse with curb bits in his mouth," sitting high in the bleachers and not being able to photograph the events close-up. The spectators sitting around Wolff in the stands were annoyed when he pulled out his unfamiliar Leica and starting seriously shooting. Many people brought their cameras to the Games, but the Nazi propaganda machine was invincible and the dissemination of images was controlled with their usual iron fist. (Emanuel Huebner spent decades

tracking down home movie footage from the 1936 Olympics. His documentary, *Olympia 1936—Die Olympischen Spiele 1936 in privaten Filmaufnahmen,* was released in 2011. It presents the Olympics as people experienced it, as opposed to Leni Riefenstahl's brilliant but propagandist, pro-Nazi classic film *Olympia,* which has shaped public perception of the event since its release in 1938.)

The archives of the International Olympic Committee hold strong bodies of work by three men who photographed the 1936 Games: Lothar Rübelt, the most prolific; Gerhard Riebicke, one of the first Germans to specialize in sports photography; and Erich Andres, the most original. While Riefenstahl was celebrating the glorious Aryan athlete, Andres was looking at the shoes and boots worn by *Fräulein* and *Mann* from behind and beneath the bleachers. We see in his quirky photographs a panoply of German citizenry: the schoolboy with knee socks, the military man with scary leather boots (better to kick you with), damsels with practical low-heel shoes and stocking seams running up their shapely legs, and Dapper Dans in white trousers and white buck shoes. The irony is that while his graphic photographic essay at the Olympics was about individuality and vagaries, very soon the majority of Germans would be wearing these same shoes to goose-step behind Hitler.

When Andres was not under the bleachers, he was photographing from above, looking down at the patterns of people walking into the stadium. He took magnificent overhead shots of hockey players through the net, resulting in wonderful action photographs with abstract patterns. These pictures fit well into the Bauhaus aesthetic, but the right-leaning Andres would not himself fit into the left-leaning school. In 1937, one year after he photographed both Hitler and Jesse Owens in Berlin, Andres was photographing on behalf of the fascists during the Spanish Civil War.

From 1939 to 1945, Andres was a member of Propaganda Kompanie (PK), a German army unit supplying photographs and films for distribution by Joseph Goebbels's Nazi Ministry of Propaganda. In the aftermath of the Allied air raids on Hamburg, especially the RAF firestorm attack in July 1943, Andres defied regulations and made images that were strictly forbidden by the Nazis: "The grilled babies, dead nude bodies whose clothing had been burnt off, a city in total ruin," wrote the photographic historian Dr. Hans Christian Adam in an email correspondence to me. Because of Andres's official PK status, he had ample film and cameras, even during the latter part of the war. After 1945 he continued his photojournalistic career and later became a staff member of Hamburg-based news magazine *Der Spiegel.*

Erich Andres, "Garmisch-Partenkirchen, Olympic Winter Games," 1936

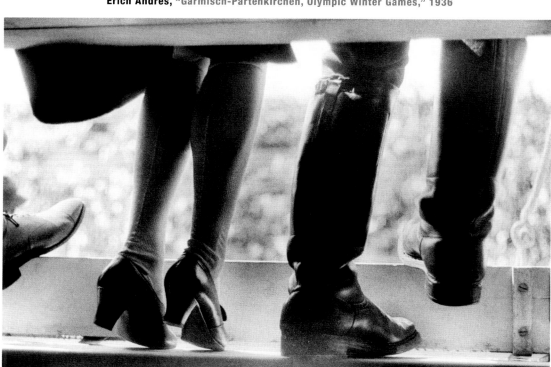

[handwritten dedication in German]

Meinem Führer in unauslöschlicher Treue und tiefempfundener Dankbarkeit zur Erinnerung an die olympischen Spiele in Berlin gewidmet.

Weihnachten 1936 Leni Riefenstahl

Leni Riefenstahl (compiler), Dedication to Adolf Hitler, handwritten by Leni Riefenstahl, at the beginning of the album *XI Olympiade, Berlin,* 1936

. . .

The dedication in German, written in ink by **LENI RIEFENSTAHL** at the beginning of this handsome album, translates, "My Führer in inextinguishable loyalty and deeply felt gratitude as a remembrance of the Olympic games in Berlin." It contains sixty-eight gelatin silver developed-out prints pasted onto gray secondary mounts on thick cream deckle-edge pages. The presentation is exemplary; the photographs exquisite; the recipient, a monster. Riefenstahl gave it to "her Führer" as a Christmas present while she was working on her masterpiece, the film *Olympia,* which premiered on Hitler's birthday in 1938. There is no question of Riefenstahl's complicity with the Nazis, and her later denials were baseless. Her ambition and her talent, however, were prodigious.

The reason the Hitler album is in the Library of Congress is simple. The Allies won the war. When the American military entered Berlin, they confiscated materials from Hitler's library and sent them to the Library of Congress to be archived. To the victor go some of the spoils.

The relationship of the Nazis to physical culture, their ideas of the superiority of the Aryan race, the complexity of the legacy of Friedrich Ludwig "Father" Jahn (1778–1852), who established the first centers for gymnastics and made them into a patriotic centers—all are part of the story leading to the 1936 "Nazi" Olympics. According to sports historian John M. Hoberman, "[Jahn] hated French and Jews. He combined the ideas of racial purity with physical purity. . . . It required little originality on the part of the Nazis to put this style in the service of the Third Reich." Boxing was, according to Hoberman, "Hitler's idea of a politically wholesome sport—an antidote to 'peaceable aesthetes and bodily

degenerates'—and it was accorded pride of place within Nazi physical culture."

The 1936 Olympics was a great success for Hitler and the Third Reich. Stupidly, the International Olympic Committee (composed, some would argue, of a number of anti-Semites) trusted and even respected Hitler and awarded him the Games he desperately wanted as a vehicle to show off German superiority. Not enough of the world's nations boycotted the Games, and they were considered a great success.

To the great credit of the Catalonians, they organized the People's Olympiad (Catalan: *Olimpíada Popular;* Spanish: *Olimpiada Popular*) to be held in Barcelona from July 19 to 26, ending six days before the Olympics began in Berlin. Six thousand anti-fascist athletes registered for the games in Barcelona, which in addition to the regular Olympic events included chess, folk dancing, music, and theater. Political exiles from Germany and Italy planned to attend, as well as Jewish athletes. Just prior to the start of the Olympiad, the Spanish Civil War broke out. The borders were closed and some athletes never arrived, while others made a hasty retreat, but two hundred stayed to fight with the Republican forces.

Verna Posever Curtis, in her book *Photographic Memory: The Album in the Age of Photography,* writes about the Riefenstahl "Hitler" album as being designed to reflect the

Leni Riefenstahl, *Dicatholon,* Berlin 1936.
Album presented by Leni Riefenstahl to Adolf Hitler, opened to page showing Riefenstahl's photograph of American Glenn Morris posed as *Discobolus,* 1936

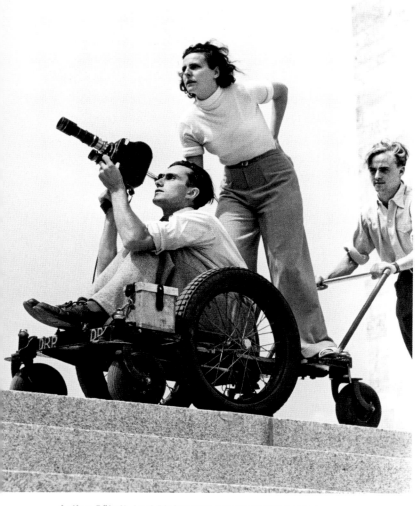

The album is a prime example of 1930s sports photography, not balanced reportage of the Games. It is powerful, graphic, imaginative, and assembled in a manner to please Hitler. There are Japanese athletes but no African Americans, not even the great gold medalist Jesse Owens (he did appear in the film).

Riefenstahl and her male crew came up with many breakthroughs in still photography and cinematography, especially underwater techniques and artificial lighting. Stop-action photography was still difficult in 1936, but they arrived at technological solutions allowing for a wide variety of images: close-up portraiture, graceful action, and panoramas. Riefenstahl consistently looked for the dramatic angle, reflecting lessons absorbed from the banned Bauhaus and the communist Constructivists.

Riefenstahl did not take most of the photographs in the album. Her photographers were Hans Ertl, Walter Frentz, Willy Zielke, Arthur Grimm, Rolf Lantin, and Gustav Lantschner. Hans Scheib used the enormous Big Bertha super-long lens. Ertl did much of the underwater photography. The album ends, as Curtis says, "with a nostalgic look at the Olympic flame at midnight."

Lothar Rübelt, Leni Riefenstahl and Hans Ertl behind movie camera, Berlin Olympics, 1936

Leni Riefenstahl, *Dicatholon*, Berlin, 1936

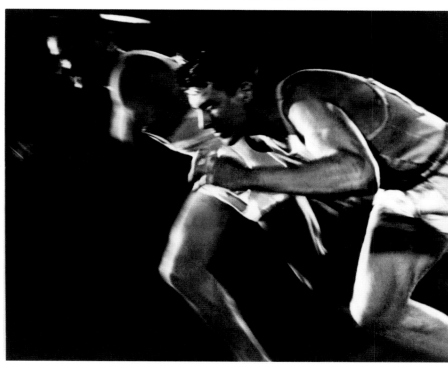

neoclassical style favored by the Nazis. They enjoyed drawing a line from the Third Reich straight back to the Greeks of antiquity. Curtis writes: "The carefully chosen images in the album are a combination of stills and freeze frames from footage shot before, during, and after the games. They coincide with many aspects of the finalized film [*Olympia*], even though the album was constructed while Riefenstahl was still organizing her raw footage and working out her ideas." The album opens with the Olympic flame, which Hitler introduced into the modern Olympics, and continues with Greek runners carrying the torch and the American Glenn Morris posed as the classical *Discobolus*. In the film he was replaced by a German, Erwin Huber.

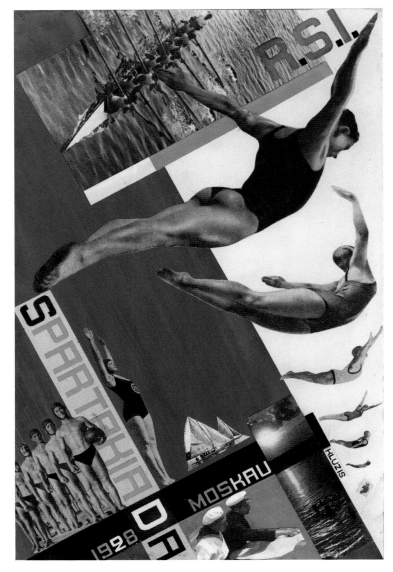

Gustav Klucis, Poster advertising the Spartakiada, 1928

* * *

The Latvian **GUSTAV KLUCIS,** a student of Kazimir Malevich and Antoine Pevsner, was the most prominent and finest avant-garde photomontagist making the posters and postcards for Spartakiadas, the Soviet Union's answer to the "capitalist and bourgeois" international Olympics. His postcards, commissioned by the government, were printed in the tens of thousands. Between 1922 and 1952, the Soviet Union did not participate in the Olympic Games.

Spartakiadas served ideology as much as sports. They brought together trade unions, the Red Army, and children in highly regulated demonstrations of group prowess. The individual was not to be celebrated. The sports were regimented but the art depicting them, before the Stalinist purges and mass murders of the 1930s, was original and superb. Gustav Klucis, a teacher in Moscow's Vkhutemas, the "Russian Bauhaus," was a committed communist whose agitprop posters served the Soviet regime. Whether due to political naïveté or unbounded creativity that knew no limits, Klucis paid the highest price. He was killed in 1938 during Stalin's purge ("elimination") of intellectuals and artists, along with thousands of his fellow Latvians living in Russia at the time.

* * *

Czech military officers were rehearsing their routine in an unwelcome shallow pool of black mud. Teams from different parts of what was then Czechoslovakia entered local competitions to determine who would go to the nationwide Spartakiada, a gathering of up to 750,000 bodies moving in unison, organized by the communist government. The day this award-winning picture was taken was so rainy, all the professional photographers at the event stayed dry undercover. **ZDENEK LHOTAK,** a student in art photography in Prague, working as a freelance sports photographer, saw in front of him images he had imagined in his mind's eye. There was immediate recognition that these were the photographs he had to take. For the artist Lhotak, it was one of the most welcome fifteen minutes of his life. That day he gave form, he said, to his "dream pictures."

Lhotak's dream was not purely pictorial, although he is an excellent and dedicated artist. The deeper dream was of freedom, breaking free of the ironclad communist control of all aspects of life. The Spartakiada represented this control of the state over the individual. Lhotak wrote:

With goose bumps on my body from the maximum excitement, I took in the amazing images unfolding in front of me and subconsciously chose from among them those that expressed my feelings towards the Spartakiada.

Zdenek Lhotak, *Spartakiáda, Prague,* 1985

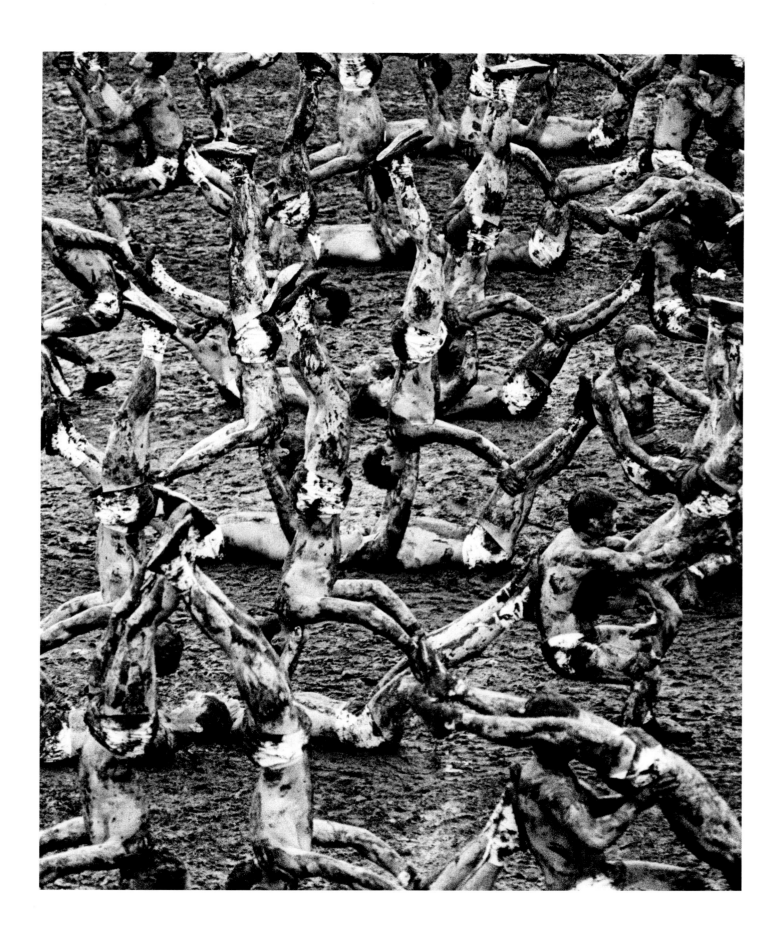

Like most people, I was not fond of it, but certain visual aspects enthralled me. I managed to do only two 135 films (2 × 36 images) on [special film] smuggled in from Russia that was easy to overdevelop.

Bodies as engines of the state. Bodies as graphic design gone amok. The soldiers, whose participation in the Spartakiada was mandatory, arrived for practice in clean white shorts. They soon turned into animal-like creatures, and the entire scene is more redolent of an abattoir than a playing field. The picture plane is flattened with brilliant skill, the composition is tight, and the bodies abstracted. The order imposed by the communist regime has become unhinged in Lhotak's series of pictures, and in four years so will the entire Eastern Bloc.

<center>. . .</center>

GEORGE SILK was an innovator—a visual innovator.

The frozen moment in sports photography is not always the truest. Silk adapted the photo-finish camera to communicate kinetic energy, to demonstrate movement. "I wasn't producing a *record* of [the 1960 Olympic] trials; I was providing an engaging illustration. . . . Any competent photographer can find a nice piece of reality and take a picture of it."

No history of sports photography would be complete without a mention of the camera magician Marty Forscher, who helped scores of professional cameramen and -women tweak or totally redesign their cameras so that they could realize an *idea* they had for a certain type of picture. Among sports photographers there was a variation on "If you build it, they will come." It went "If Marty can build it, we will make pictures never before seen."

George Silk got the idea of playing around with the photo-finish camera while covering the Kentucky Derby. The only problem was that it weighed three hundred pounds. Nevertheless, with the clout of *LIFE* behind him, he had it delivered to his home in Westport, Connecticut, and photographed his children and their friends in their

George Silk, "Hurdlers at the Olympic Trials," Palo Alto, California, 1960

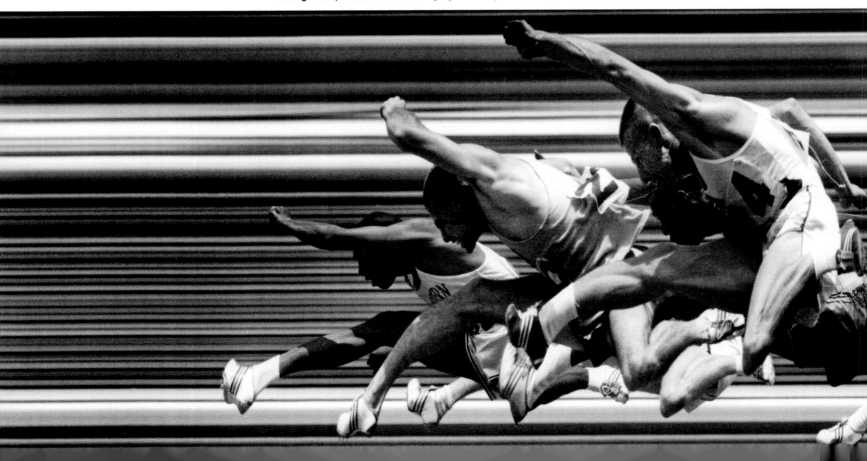

Halloween costumes. The resulting images were uncanny, distorted, greatly amusing, and hugely successful when they ran in *LIFE*. He decided to use the camera at the 1960 Olympic trials in California—if he and Marty could reduce the weight by about 270 pounds and get it to work. The portable version they designed was powered by a spring-wound gramophone motor and took 100-foot rolls of 35mm film. The film went past a very narrow slit, eliminating the need for a shutter. Silk's boss at *LIFE* told him NOT to use the funny camera at the Olympic trials, but he didn't listen. He worked around the clock and came back to New York with six-foot negatives showing stretched and foreshortened athletes. He thought he was going to get fired but instead achieved a photographic coup. The pictures were the main story in the issue and ran on eight pages. Silk wanted photography to be fun and exciting—just like sports. He achieved his goal.

. . .

Neil Armstrong famously said, "That's one small step for a man, one giant leap for mankind." **TONY DUFFY**'s shot of the jump of 8.90 meters (29 feet, 2½ inches) was one long leap for sports photography. After the success of this photograph, Duffy launched the most admired sports photographic agency of all time, Allsport. Steve Fine, another "most admired" in the sports photo world, had this to say of Allsport's philosophy and methodology:

> Don't follow the pack; don't try to make the safe picture (leave that to the wire services); don't settle for the ordinary. Make the reader feel as if he were there. Give a sense of place. Find the right light and wait for the picture to develop. . . . It's always been more than just coverage. It's about creating spectacular images, capturing key moments in sport that will be remembered for all time.

Tony Duffy was a thirty-one-year-old chartered accountant in London when he found the money for a plane ticket to the Mexico City Olympics. Photography was his hobby, but he had never taken a class in it or read a how-to book. The camera he took to Mexico "no self-respecting professional photographer would be seen dead with," and he had no credentials to be a photographer at the Olympics. But he was lucky that day in October 1968 when Beamon flew through thin air.

Although Duffy's ticket for the long jump event was high up in the stands, there were empty seats near the front and Mexican student security guards—not the most bureaucratic people on earth—let him sit in the front row. No professional photographers were blocking his view, as they were all at the finish line for another event. In the very first round Bob Beamon broke the world record, by so much that the competition was effectively over. His competitors realized they could never equal that distance. The long jump is a sport where progress is measured in half inches. Beamon broke the record by nearly two feet.

There were only three other photos taken of Beamon's record jump, described in the press as the "greatest single athletics feat of all time," and Tony Duffy's was the best. Innocently, Duffy kept the roll of film in his pocket for two

days before taking it to a Mexican one-hour photo kiosk used by tourists. Fortunately for him they didn't lose, scratch, or incorrectly develop the film.

The two seconds that Beamon was airborne literally changed Duffy's life. The photograph was so successful that he started photographing as many sporting events on weekends and evenings as possible, while still doing his day job. He was, he told me in an interview in May 2013 at his home overlooking the Pacific Ocean in Southern California, "the world's worst accountant—not prudent, not restrained, not willing to sit at a desk all day." Yikes. He was desperate for another career.

"I had been to Manchester University, studied law and graduated in 1959. My tutor had said unless I did a further course I'd be drafted into the armed forces, so I did accounting even though I was mathematically challenged. I was told law and accountancy were a great combination. More than anything, I did it to get a deferment until they discontinued the draft." Duffy found his work as an articled clerk in a tax department "excruciatingly boring." The only thing, he said, that kept him sane was sports. Soccer was his sport, but all his life he had worn glasses, and soccer is not forgiving to the individual with bad eyesight. Neither is photography, but by wearing eyeglasses, he got around that obstacle and found himself a new profession.

Tony Duffy, The original negative, enlarged, of American Bob Beamon breaking the long jump record on October 18, 1968, at the Mexico Olympics

Prudent, no, but pertinacious, yes. Duffy realized he did not want to work for someone else and that he needed others to help him build a business. Allsport, known in London as "Duffy's agency," originally had its "archive" in a shoebox under Duffy's bed. It was not the first sports photo agency in the United Kingdom. That honor goes to Colorsport, started by Stewart Fraser and Colin Elsey in the late 1960s. Duffy just had that competitive edge and wanted his agency to be the best.

John Starr, an advertising photographer friend with all the technical expertise Duffy lacked, was the first to join him in his new business endeavor. Then Steve Powell, fifteen years younger, joined as a "junior partner," working in the darkroom, shooting events, and doing marketing. He is, according to Duffy, "a natural-born leader." Duffy also hired talented individuals, such as Lee Martin, in editorial and managerial positions.

"Running a sports photo agency is like coaching a sports team," Duffy said. "You have to identify areas that need strengthening. You have to decide which positions make optimum use of each player's talents." Before long, David Cannon was specializing in golf; Adrian Murrell, cricket; Steve Powell, tennis and athletics; Don Morley, motor sports; John Gichigi (John Gee) in the darkroom and photographing boxing; Bob Martin, a technical whiz, also in the darkroom and then specializing in tennis and athletics; Gerard Vandystadt, in France, ice skating; Simon Bruty, soccer and other team sports.

In 1983, Allsport, having just got the contract to cover the Los Angeles Olympics, opened up an L.A. office. Duffy headed the L.A. office and was joined by nineteen-year-old Mike Powell, who came over from England. Later, Al Bello joined the agency as a boxing specialist but soon was photographing all sports. Meanwhile, Steve Powell took over the London office and oversaw the company's global development and introduction to the digital age, right up to the company's acquisition by Getty in 1998.

Duffy is one of the heroes of sports photography. He did more than start an agency and champion women's sports; he created an environment of excellence, and his legacy is reflected in the work of many of the photographers in this book.

* * *

The Ethiopian Abebe Bikila, a bodyguard to Emperor Haile Selassie, running in only his third marathon, was given little chance of winning a gold medal in Rome. His victory makes the photograph historic, but it is **JOHN G. ZIMMERMAN**'s brilliance that makes it memorable. The triumphal Arch of Constantine, the journalists in their suits and hats, the crowd bending forward, and the cinematic lighting conspire to make this a Felliniesque moment. Roman grandeur surrounds a simple man running barefoot for 26 miles and 385 yards in record time.

When John Zimmerman started in photography in the early 1950s, there was hardly any television competition. For Zimmerman, however, there was no tougher competition than his own drive to make photographs that had never been made before. Karen Carpenter, the executive director of Multimedia Licensing and Swimsuit Operations, who does more than anyone at *Sports Illustrated* to support photographers—past and present—says simply, "John Zimmerman did everything first."

Zimmerman's "big idea" was new perspectives using new camera techniques. When you look at sports photography today, his legacy is apparent. He was always experimenting and he was a technical genius who was happy to share his knowledge with his younger colleagues. Zimmerman set the bar high for his profession. He put *Sports Illustrated* readers "inside NHL hockey nets, on giant slalom slopes, or behind the backboard when Wilt Chamberlain stuffed one," wrote Gerald Astor, former picture editor of *SI*, referring to when, in 1961, Zimmerman placed a camera above the rim of a basketball net. It is common now; it wasn't then. Walter Iooss Jr. was only a teenager when the great man allowed him to look over his shoulder as he edited these pictures. "It was like looking at something from another planet," Iooss remembers. "It had never been done before, no one had seen the game from there."

It was a joke among journalists that even if they had never met Zimmerman, they could spot him at a sporting event as the guy taking a camera apart and putting it back together. When motor drives on cameras could take a maximum of five frames a second, Zimmerman rigged his Canon to take fifteen frames per second. Former *Sports Illustrated*

John G. Zimmerman, Abebe Bikila, Marathon, Rome, 1960

photographer Robert Beck said, "I don't know everything that John invented or developed or dreamed up in his career. . . . He was a genius. He designed cameras. He designed strobe systems and figured out to use them to help him make better images." Zimmerman invented a double shutter so that a subject, such as a baseball pitcher, could be shown simultaneously frozen and blurred. He used a Panon slit camera on its side to create wild zigzag and serpentine effects. He mastered multiple exposures with complex multicolored results. Sometimes he didn't want the film to advance, so he had to disconnect the mechanism so all the exposures would be on one frame. If he was photographing underwater, he would forgo the scuba equipment and just hold his breath because he didn't want bubbles in his pictures. He made a split diopter dome port for an underwater camera housing that allowed him to correct for the refractive index difference between air and water.

Aesthetes go bleary-eyed when listening to these types of innovations, but technology combined with imagination gives us images never before seen. John Szarkowski, former director of photography at the Museum of Modern Art in New York, quotes Auguste Renoir as saying in his old age, "Paint in tubes, being easy to carry, allowed us to work from nature . . . without paints in tubes there would be no Cézanne, no Monet, no Sisley or Pissarro." Szarkowski knew that in photography—a mechanical-, optical-, and chemical- (previously) based art—technical breakthroughs resulted in visual breakthroughs. And no one group of photographers pushed the medium forward technologically as much as sports photographers. Zimmerman was the leader of the pack.

John Zimmerman studied photography at John C. Fremont High School with legendary teacher Clarence A. Bach, whose students went on to *LIFE* and other publications. He was a *Time* staffer in 1950 and from 1953 to 1955 worked for *Ebony* on stories dealing with African Americans in the Midwest and Jim Crow in the South. He also worked for *LIFE*. When *Sports Illustrated* was launched in 1954, he was among the first staff photographers. He stayed at the magazine, shooting as well as instructing younger photographers, until 1963.

Max Rossi, "Janeth Jepkosgei Busienei of Kenya falls during women's 800-meter first heat," World Championships, Berlin, August 16, 2009.

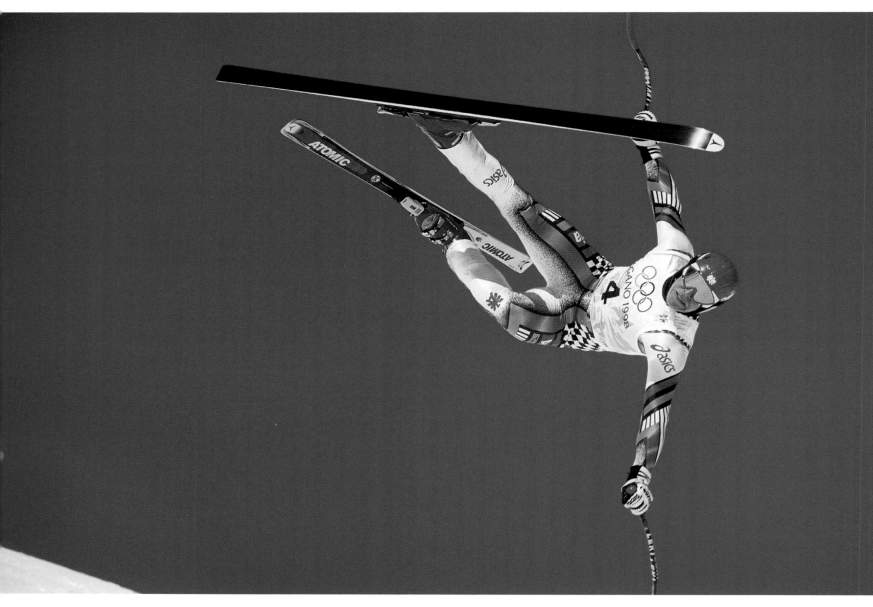

Carl Yarbrough, "Hermann Maier crashing, men's Olympic downhill race," Nagano, Japan, February 13, 1988

Janeth Jepkosgei Busienei collided with Caster Semenya of South Africa in the 2009 World Championships. Mary Decker's similar misfortune at the Los Angeles Olympics in 1984 resulted in a classic photograph by David Burnett conveying Decker's unbearable emotional pain as well as disappointment and anger. **MAX ROSSI**'s photograph shows more horror than anything else. Both photographs give a dramatically powerful perspective on sports.

Max Rossi is an Italian photographer with Reuters. He was self-taught, turning to Ansel Adams's series of technical books for hard information. He learned well. His pictures stand out from the pack, just like a winning athlete.

February 13, 1988, fell on a Saturday, but for Hemann "Herminator" Maier, it felt more like Friday the thirteenth, but only to begin with. In his Olympic downhill race, he catapulted thirty feet into the air, landed on his helmet, rammed through two safety fences at an estimated speed of eighty miles per hour, and walked away. Now it felt more

like Christmas. A few days later, he won gold medals in the giant slalom and super-G. This photograph, taken by star skiing photographer **CARL YARBROUGH,** of Maier's spectacular fall, sometimes referred to as the most spectacular in skiing history, was the cover of *Sports Illustrated,* not surprisingly.

Maier again astonished the world after his near-fatal motorcycle accident in August 2001. Told his leg might have to be amputated, he chose reconstructive surgery and a long rehabilitation. In January 2003, he won a major super-G race and the following year began taking first place in international skiing competitions. Laureus World Sports gave him the Comeback of the Year award. He is the "Herminator"!

Carl Yarbrough lives his dream. He graduated from Southern Methodist University in Dallas, Texas, and went to the famed Art Center College of Design in Pasadena, California. After seven summers as a mountain guide, he became a professional photographer in 1979, shooting World Cup and Olympic skiing. He is a biathlon competitor, Nordic skier, sea kayaker, sailing enthusiast, and long distance adventure cyclist, so his photography is an extension of his life.

Simon Bruty, Matthias Steiner, representing Germany, drops a 432-pound barbell on his neck, Olympics, London, 2012. Ouch! (Steiner was not seriously hurt.)

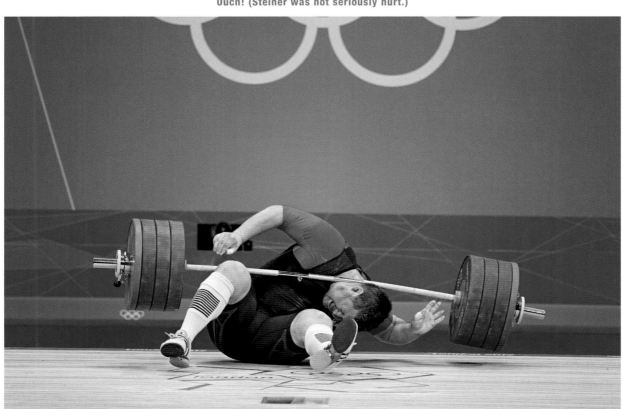

This is the moment people remember. Diving great Greg Louganis hits his head on the springboard at the 1988 Olympics, resulting in a concussion. **RICH CLARKSON** captured this split-second action, which reverberates still. "Every time he dived," stated Clarkson, "I would start with a thirty-six-exposure roll of film and hold down the button to get the entire dive. I wanted to show his form. In this instance, I caught the entire sequence—including him hitting his head."

The photograph is visually challenging because of its dichotomy: from the torso down we have Louganis's perfect body, legs elongated with toes pointing along the diagonal of the picture plane. But this perfection, which is Louganis's hallmark, is punctuated by the shock of the head hitting the diving board.

Clarkson's sequence of thirteen pictures of Louganis diving is riveting. He shot it to get the best frame, not to reveal the lead-up to and aftermath of an accident. For the first nine photographs, Louganis is extraordinary. At number ten, he hits his head and is suspended between life and death; in number eleven his form starts to melt as his hands hold his injured head; in number twelve he ignobly enters the water; and in number thirteen, he disappears with the diving board in the top left corner reminding the viewer of its role in the saga just witnessed.

This iconic Olympic photograph ended up having social ramifications well beyond its documentary status and incredible power as an image. At the time of the accident, Louganis had not disclosed he was HIV-positive, a diagnosis he had received six months previously. No one was put at risk, but controversy stirred and then subsided.

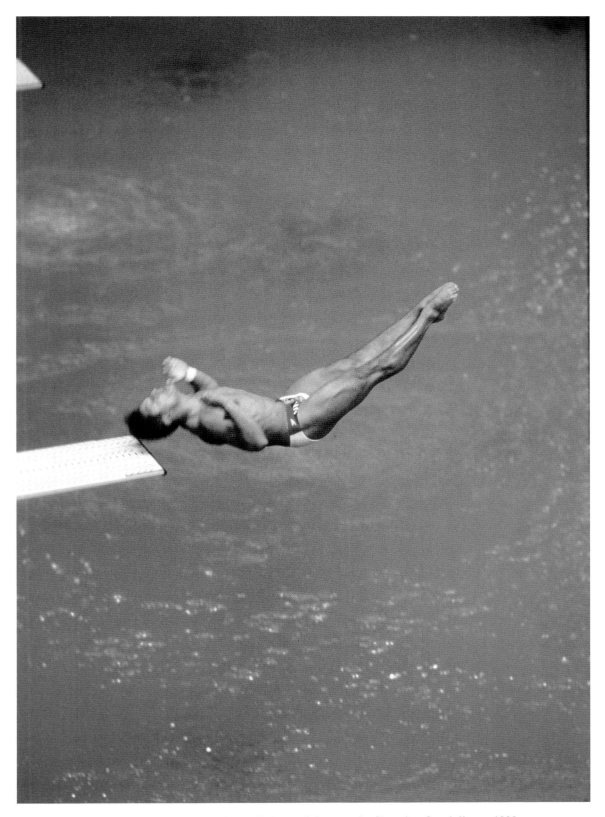

Rich Clarkson, Greg Louganis, preliminary diving rounds, Olympics, Seoul, Korea, 1988

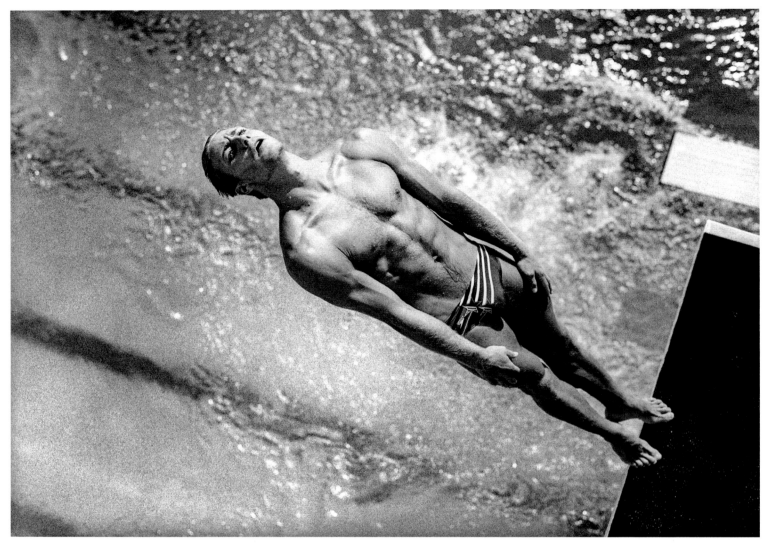

David Burnett, "Dean Panaros, platform diving, Olympic previews," Fort Lauderdale, Florida, May 1996

• • •

There is only one incomparable **DAVID BURNETT,** but he wears many photographic hats. He was a war photographer in Vietnam and is a Washington, D.C., regular who has photographed every president from John F. Kennedy to Barack Obama. He is known for his tender pictures of Bob Marley as well as the surprising ones of Supreme Leader Ayatollah Khomeini taken during forty-four difficult days in 1979 in Iran. He winked at Mikhail Gorbachev to get a reaction and has gone to more than ten Olympics.

Burnett does not do much sports photography outside the Olympics. He is one of only four photographers given a coveted pass by the IOC that permits him to shoot what he wants, how he wants to. His pictures may be quirky, experimental, or astute. He reports to no master but himself and subsequently many of his Olympic photographs are masterful, artistic, and memorable. The Olympic Museum in Lausanne recognizes his unique vision and exhibits his work.

"I've always liked new kinds of hardware," admits Burnett, "because they give me another way to look at something.

They help me see something in a little different way." Burnett takes an assortment of cameras to the Games, including an inexpensive Holga, which gives him vignetting, blur, light leaks, and distortions; a big old-time Speed Graphic, like the press photographers of yore used; and his 35mm cameras with wide angle to 400mm lenses. The athletes face the stiffest competition at the Olympics, but so do the photographers. "I always remind people that every four years it's the photographers' Olympics, too. You have the best photographers in the world," says Burnett, "all in one place, shooting the same thing." Well, not quite. Burnett's talent is to find exactly what the others are not photographing.

David Burnett, "Michael Uhrmann prepares for the K120 ski jumping event," Winter Olympics, Salt Lake City, Utah, 2002

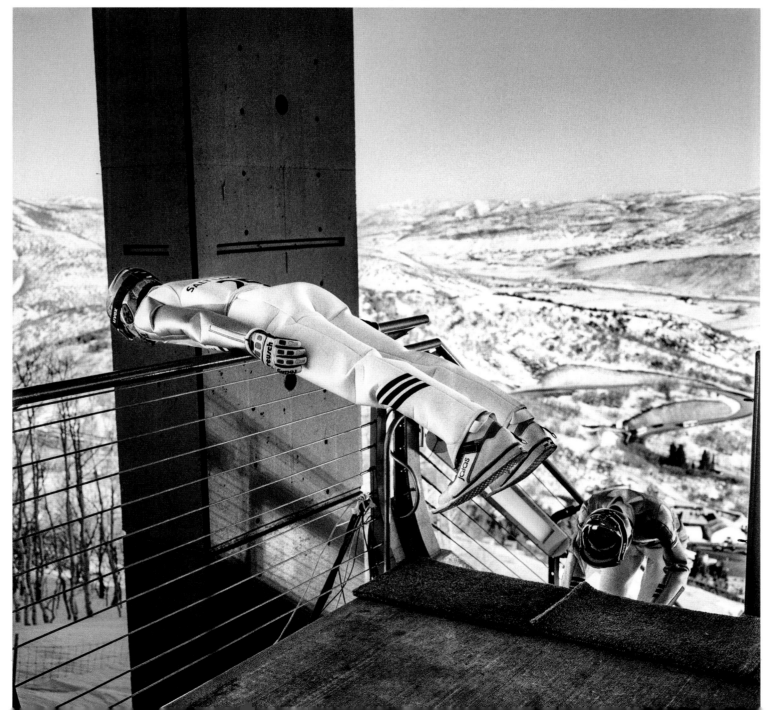

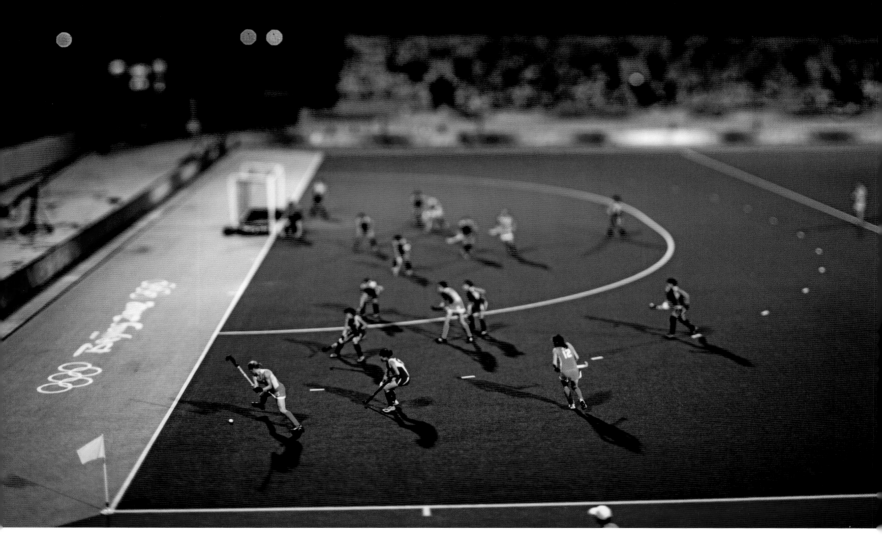

David Burnett, "Korea vs. the Netherlands, women's field hockey preliminary matches," Olympics, Beijing, China, 2008

Burnett has been taken into custody by corrupt governments, photographed in war zones, and stuck his neck out for forty years. He also is fun-loving, and his playful side comes across with his tilt-shift photographs. He won't claim to be the first to use it—Olivo Barbieri and Vincent Laforet both have made fine photographs early on with this technique—but as the hockey photograph reproduced here shows, he has mastered this technique of shallow depth of field and selective focus to present enchanting miniature worlds. He does not generally care who is in his sports photographs, a radical departure from the concerns of the hordes of cameramen and -women at the Olympics. His platform diver and ski jumper illustrate magnificently his credo when shooting sports: "The challenge and our strong point is trying to get those other little moments that may be more telling about sport or maybe more delivering a sense of the elegance and the power of these really great athletes, than it is strictly about who won."

Enter the world of robotic photography. It doesn't hearken the end of flesh-and-blood photographers. It means robotic cameras are camping out where humans are not allowed or fear to tread. In the 2012 London Olympics, new health and safety regulations did not permit photographers to sit or stand under the roof or on the catwalks of the sports arenas. They could, if they had the technology, as did **CHRIS MCGRATH** and his Getty team, place specially rigged cameras in those off-limits vantage points high above the courts, the boxing and wrestling rings, and the swimming pools. Everything had to be in place three weeks before the Games began.

In London, Chris McGrath positioned himself in the darkness at the very top of the grandstands, just where photographers used to *not* want to sit. A 100-meter-long cable tethered him to his camera rig up in the roof. He could, at his laptop, do everything he would normally do holding his camera—zoom, focus, and change the camera's position. The laptop received the camera's "Live View" output via Ethernet as the action happened. McGrath noted how quick his learning curve was: "We were firing and just trying to get used to it, but then we started going 'Okay, this isn't making a picture,' so we started thinking about photography again. The novelty of the [robotic] camera started to wear off after about day two. We started going back to what we know as photographers . . . so we'd actually set the camera up somewhere and wait for the picture." And everything had to work smoothly for two months; once the camera was in place, there was no way of getting to it.

McGrath, not his mechanical helper, has the creative eye for design and pattern. He can't leave the camera alone and tell it to "keep shooting while I go for coffee." It is not a surveillance camera.

"It was all very different from a typical job," says the Australian McGrath, who began his career on the *Sunshine Coast Daily,* Queensland, before joining Getty. "I spent the whole [London] Olympics waiting for people to lie on the floor and look up." While other photographers were shooting thousands of pictures daily, McGrath was content if he got four he thought were good—and different. When the best photographers in the world are gathered together at the most photographed sporting event on the planet, "How do you find an original angle?" McGrath asked himself. That is the name of the game.

• • •

BOB MARTIN's photograph is so beautifully composed, so structured, that it is only afterward the details come into focus. This is the Paralympics. The rules of swimming are almost identical to the regular Olympics but no prostheses are permitted. Torres has left his legs behind.

A similar analogy may be made watching athletes with disabilities compete. They run so magnificently, they ski with such speed, they play team sports with such skill that the viewer may only afterward notice the physical obstacles each athlete overcomes.

Sport at its highest is about fair play and the pursuit of excellence. Creating platforms for everyone to have equal opportunity is of much greater significance than money, fame, or gold medals. After World War II, the importance of sport in the rehabilitation of spinal injuries was recognized, and soon competitions came into being to help repair the mind as well as the body. In 1960, the first Paralympic Games were held in Rome. Four hundred athletes from twenty-three countries competed in the five-day event. Today the Paralympics is one of the largest international sporting events in the world.

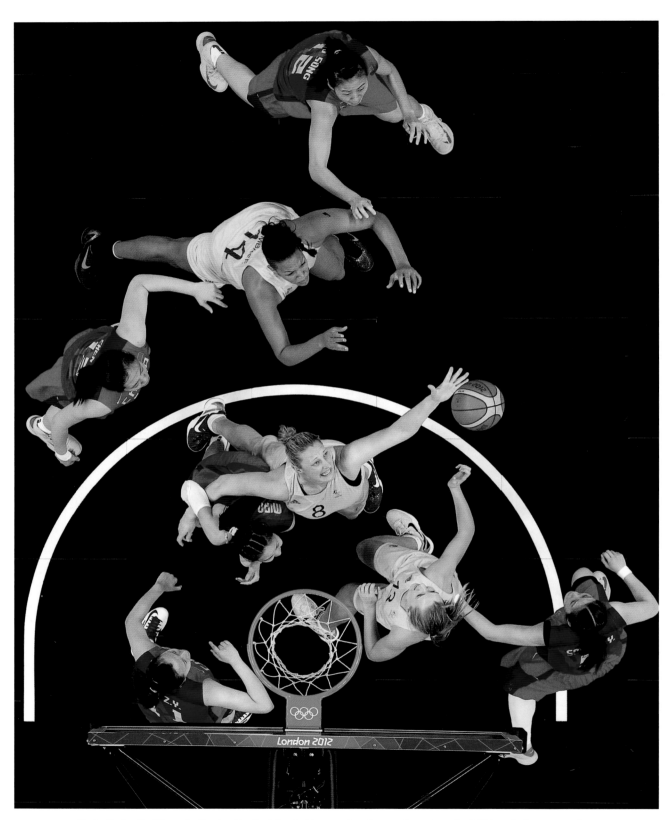

Chris McGrath, "Suzy Batkovic, No. 8 of Australia, reaches for a rebound against China during women's basketball quarterfinal on day 11 of the 2012 London Olympic Games at the Basketball Arena, London."

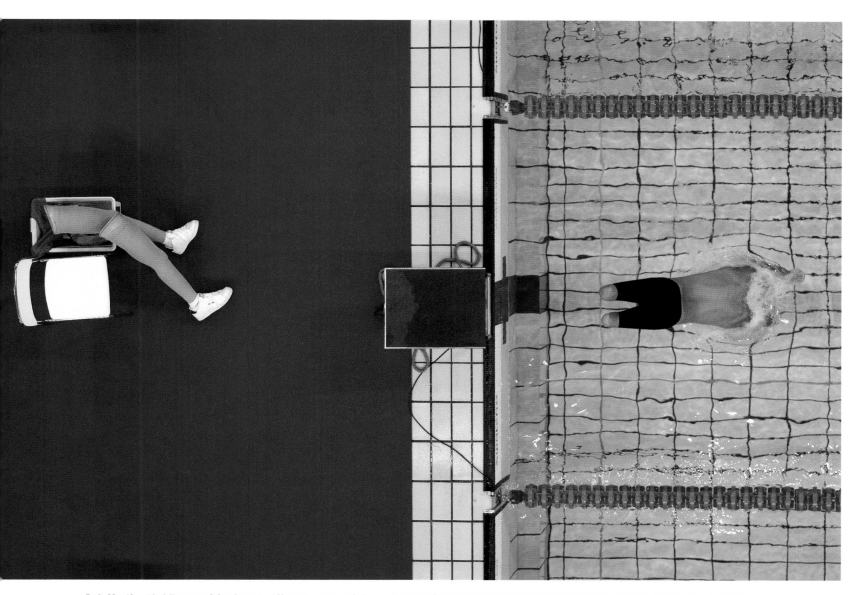

Bob Martin, "Avi Torres of Spain sets off at the start of the 200-meter freestyle heats," Paralympic Games, Athens, September 1, 2004.

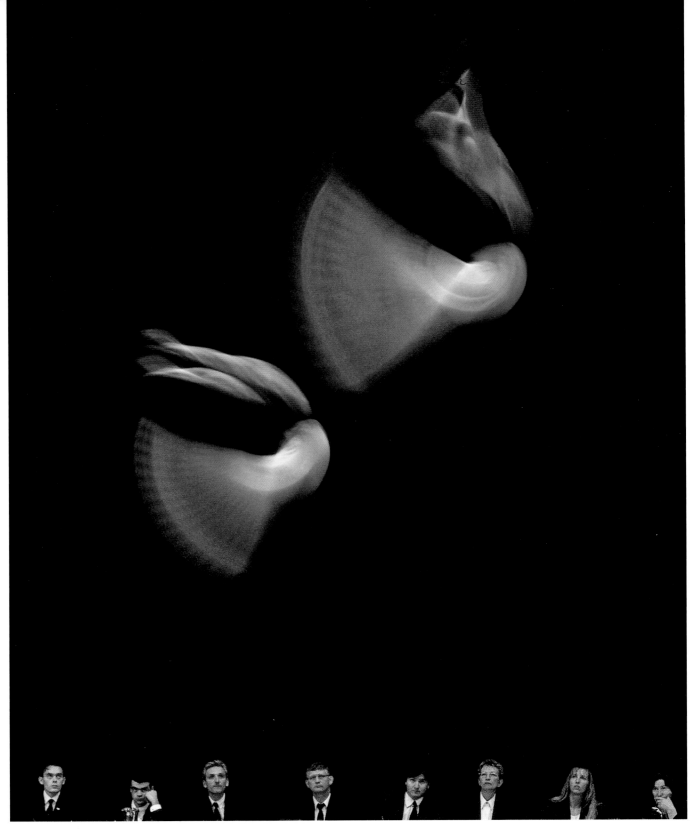

Adam Pretty, "Judges watching gymnasts compete on the trampoline, Australian Gymnastics Championships," State Sports Centre, Homebush, Sydney, 1999

Adam Pretty, Junior World Wrestling Championships, Sydney, State Sports Centre, Homebush, Sydney, 1999

* * *

ADAM PRETTY wins awards. The judges look at his pictures and say Wow, or rather, First prize, hands down. As a high school student apprenticing at his hometown newspaper, the *Sydney Morning Herald,* with the powerhouse photographic triumvirate of Tim Clayton, Craig Golding, and Steve Christo, he discovered his calling. He also recognized the challenge: how to be as good as or better than his teachers.

Pretty's work does stand out. He goes for strong composition, precise detailing, and dramatic use of color. A hundred photographers will shoot the same sporting event, but only Pretty's pictures feel like totally resolved works of art. He knows how to use differential focus, varying shutter speeds, and many lenses, as do all good sports photographers. The difference is, one suspects, that his inspiration comes from painters such as Josef Albers, Mark Rothko, Frank Stella, and Ellsworth Kelly. These photographs are not from the Olympics, but have that "Olympic" feel.

JOHN HUET grew up ten miles from where the movie *The Deer Hunter* was filmed. His neighbors were the extras. He had little direction as to a future career. The local photographer in his town in western Pennsylvania drove a Corvette. It was as good a reason as any to pick up a camera and try his luck.

John Huet does his own creative photography while running a successful commercial studio. His clients include adidas, BMW, Bose, the Boston Red Sox, the Boston Ballet, and Nike. Not much is demanded of him for the big bucks of advertising, he told me, "just one photograph that will sell a million pairs of shoes." He has shot Nike campaigns for the past twenty-nine years. The "Trash Talk" Nike campaign was his baby. He has won many awards, including the 2015 International Photography Awards Sports Photographer of the Year.

How Huet arrived at his enviable position in both the commercial and art photography worlds reveals a singular journey. High school photography classes and two years of college technical training weren't going to give him the edge. Six months photographing on his own in Florence, Italy, filled him with passion for photography, but when no one back home in Pennsylvania was interested in his pictures, he didn't touch a camera for two years.

Huet had just turned twenty-two when he was hired for a job in Boston shooting photographs for catalogues. It was boring, but he did learn how to photograph a sneaker. He was fortunate to assist Al Fisher, the "best photographer in Boston. . . . The eighteen months together taught me how to be a professional." Fisher also introduced Huet to excellence in black-and-white photography; he made his own platinum prints and showed Huet three other platinum prints by Irving Penn.

As huge as sports advertising is today, it did not exist when Huet began. Reebok, bigger than Nike at the time, had hired Herb Ritts to shoot a campaign. Ritts brought in professional dancers to pretend to play basketball or run. Huet immediately saw the opportunity to replace the dancers with real athletes whose bodies were equally beautiful but were sculpted differently. (He had to convince the advertising gurus that taller, more muscular, solid bodies were okay.) It was the first time athletes were cast to sell the products they themselves used.

One of Huet's most successful personal bodies of work, *Soul of the Game: Images and Voices of Street Basketball,* was an exhibition at the International Center for Photography in New York City and a bestselling book. In Pee Wee Kirkland's introduction to Huet's book, he explains concisely why Huet did a book about street basketball: "All the best things you see in pro basketball today were invented 25 years ago in the schoolyards of Harlem." Huet, himself six foot three, went to New York City basketball courts where the kids play all day, rolled out white paper to give a clean background, and shot them from above with a 4 × 5-inch camera. An organizer of the Salt Lake Olympics saw his photographs and asked him to work on a book of the 2002 Games.

John Huet is a member of one of the smallest and most elite groups of photographers in the world. He, David Burnett, and Jason Evans have been invited by the International Olympic Committee to photograph the Games without restrictions. They leave the usual documentation to the ubiquitous press corps and turn their cameras on what interests them the most—and what feels like the true essence of the Games. They all agree it is the small details, the quiet moments contrasted with the frenzy of the biggest show on earth, that interests them. Like Burnett, Huet comes with a variety of cameras—Graflex, Linhof, digital. Sharp and soft focus, black and white and color, blurred and stop action, Huet masters them all to produce very personal pictures. His imagery often harks back to another time.

John Huet speaks about the mental side of sports, the passion. "Athletes spend four years preparing for something that might last ten seconds—if they don't qualify. Maybe last four hours if they do. Anguish is as important as joy." He then adds, "I train for the Olympics. Combination of getting physically and mentally fit. Physically, it is the most demanding thing I do."

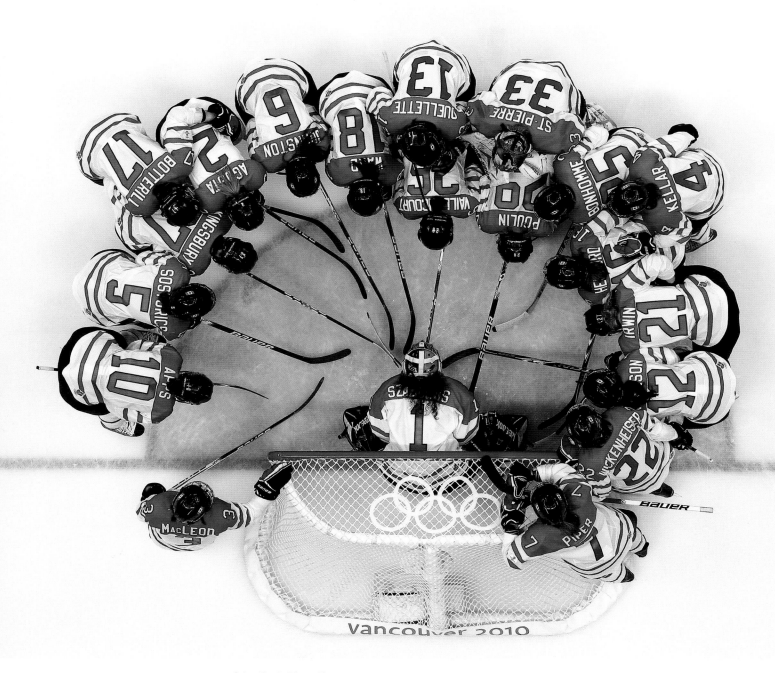

John Huet, "Canadian women's hockey team, Vancouver Olympics," 2010

Peter Read Miller, "Gabby Douglas on the balance beam," Olympic Trials, San Jose, California, June 2012

* * *

Gabby Douglas, on the balance beam, is on her way to an Olympic gold medal. **PETER READ MILLER**'s camera is balanced on a beam high above the beam. Miller's camera is controlled by radio remote. Douglas is in control by training, commitment, and over-the-top aptitude. Sports photographers, obviously, need the athletes. The athletes need images that not only preserve moments of brilliance and grace, victory and defeat, but also embody the totality of their effort and striving. Sports mean more than just winning or losing; sports photography, at its best, translates why sports mean so much to so many.

Peter Read Miller has been in the game for a long time. He photographed sports at Phillips Exeter, where he went on a scholarship. His grandmother gave him a camera "like the rich kids had." Then he went to Pasadena High School, which he loved because there were girls in class and cars on the roads. He was only sixteen when he enrolled at the University of Southern California, as a socially awkward economics major. It helped that he was good at photographing sports. He could earn some money and overcome his shyness. He did a master's degree in public administration and was accepted in the PhD program at the Wharton School of the University of Pennsylvania. Stop. He saw the film *Blow-Up,* which made, he said, "photography cool." He dropped out of school.

Miller jump-started his career by first buying *PRO! Magazine,* the publication of the National Football League. He looked at the masthead and called the editor, John Wiebusch. Wiebusch and the publisher, David Boss, were, Miller said, "the two men who did more for my career than anyone else." By the time Miller was twenty-five, he was shooting the National Football League and living in Southern California. Life was good and would soon get better. In 1977 he was given a yearly contract with *Sports Illustrated,* which continued until 1995, when he was put on staff. He worked with all the early greats in sports photography—Marvin E.

Newman, Jerry Cooke, John Zimmerman, John Dominis, Mark Kauffman, Robert Riger, and then the generations that came after them.

His book, *Peter Read Miller on Sports Photography: A Sports Illustrated Photographer's Tips, Tricks, and Tales on Shooting Football, the Olympics, and Portraits of Athletes,* was published in 2013.

. . .

If there is one photograph that encapsulates the joy of winning, it is **KEN GEIGER**'s photograph of the Nigerian women's relay team at the 1992 Barcelona Olympics. And here, too, is the power of photography. We share these women's achievement; we sense that it was arrived at through a combination of training, camaraderie, willpower, and bodies that can fly.

The photograph is significant for another reason. In the history of art, women are madonnas and domestics; royalty and bent-over reapers and gleaners; wives and mothers; fashion plates and streetwalkers—but rarely great athletes. These four women are twentieth-century Muses. They are total women, alive and joyous in sisterhood. They should serve as banner women of our age.

In the 1920s, the "new" woman had a sleek, fashionable look and a cigarette in her hand. She didn't move much, although she was racing toward independence from male dominance (a lot farther away than 4 × 100 meters). Geiger's photograph of the Nigerian relay team, unlike one of a single winner in a race, shouts out that women can do it together—and be beautiful and strong and successful. And their euphoria isn't because they won the gold. They got the bronze and could not be happier.

Ken Geiger, now deputy director of photography for *National Geographic,* made this photograph while at *The Dallas Morning News.* He has covered four Olympics as well as worked as a photojournalist in China, Mexico, Burma, Bosnia, and post-Sandinista Nicaragua. He received his formal photographic education at the Rochester Institute of Technology. For anyone in the know, that translates into rigorous training. Graduates come out with the technical tools they need to work in any area of photography.

Ken Geiger, "Nigerian relay team," Olympics, Barcelona, 1992

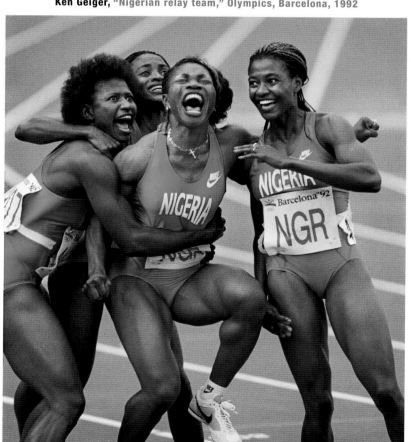

DONALD MIRALLE, who studied art with John Baldessari and Sharon Lockhart at UCLA, worked as a sports photographer for the Allsport and Getty picture agencies for twenty years before going freelance. "My most successful photographs are pre-conceptualized," he told me. "Frame the scene. Start composing like a painting rather than chasing things and just capturing action." Look closely and there is an artist at his easel on the building exactly across from where Don Miralle set up this shot.

Michael Kimmelman, architectural critic for *The New York Times,* says ghosts link the photographs in **GARY HUSTWIT** and **JON PACK**'s *The Olympic City.* On the cover of their book these words are embossed: London Berlin Helsinki Moscow Sarajevo Barcelona Rome Athens Beijing. The back has: Los Angeles Mexico City Montreal Lake Placid.

Thousands of photographers travel to the cities hosting the Olympic Games. Pack and Hustwit go later to see what remains. Every city tries to present its best face to the millions whose eyes, for two weeks or more, are glued on it. Then, when the journalists, athletes, and tourists depart, each faces the challenge of what to do with the newly built infrastructure. And each city comes up with answers based on its traditions, resources, respect for its population, political will, and financial situation after its hemorrhaging of funds for an average of seven years.

Hustwit and Pack let time pass. Then they arrive at a former Olympic city to photograph the ghosts. In their skillful hands and intellectual approach, ghosts make a powerful subject. Inviting Kimmelman to introduce the book made good sense. The ghosts reside in the built environment. What remains of the Olympic City is concrete, steel, glass. Barcelona's famed swimming pool, with its backdrop of Antoni Gaudí's Basilica de la Sagrada Família and the city of Barcelona, maintains its integrity. Sarajevo's luge track is a blight on the surrounding forest. The photograph of its ski

Donald Miralle, Ricardo Santos of Brazil jumps to serve the ball as teammate Pedro Cunha watches and Martin Reader and Joshua Binstock of Canada prepare to receive it, Men's Beach Volleyball, London Olympics, the Horse Guards Parade Ground, August 1, 2012.

jump, reproduced here, echoes the ruins of a Mayan ball court.

Poets sing the praises of ancient ruins, but present-day populations don't see the poetry in decay. Hustwit and Pack's photographs say with great force, "Be responsible. A few weeks in the spotlight are not reason enough to violate neighborhoods."

Pack, who studied religion and philosophy at college, had the idea for the project after watching the Beijing Olympics on television. He told me he wasn't a "big fan" of the Olympics. He found the focus in the media about "money or Michael Phelps or the infrastructure" lacking depth.

A photographer who has always been drawn to the inter-connection between nature and city, he asked himself two questions: What happens to these cities after the party is over? How does it affect the people in the host city?

Hustwit is a distinguished filmmaker, best known for his three documentaries, *Helvetica, Objectified,* and *Urbanized.* Resident in New York and London, he knew Pack for fifteen years before beginning to collaborate in 2010. There were thirteen cities to cover; it was and is a productive ongoing partnership. Pack shoots film and digital with his 35mm Mamiya; Hustwit uses a digital Leica. They are working on the next five Olympic cities.

Jon Pack, *Football at the Base of Olympic Ski Jumps, Igman Mountains, Sarejevo, Bosnia,* July 2012

THE BEGINNINGS OF SPORTS PHOTOGRAPHY

Sports photography is built on a brilliant foundation. The earliest known "sports" photograph was taken by David Octavius Hill and Robert Adamson in 1843 of a handsome young real tennis (also known as court tennis) player wearing white pants and a striped jersey and holding a racket. Our Mr. Laing or Laine may not be in action, but he has attitude to spare. He focuses his gaze on an imaginary ball and, in doing so, looks out into the future. Robert Adamson focused his lens on our young athlete, counted one or two minutes and Mr. Laing or Laine is preserved for eternity. Sports photography, since its earliest days, communicates to generation after generation something about human vitality, determination, skill, beauty, and grace.

• • •

HILL AND ADAMSON were the greatest of the earliest portraitists using the calotype (a paper negative that was "developed" after a short exposure) process invented by William Henry Fox Talbot in 1840. Talbot and Louis Jacques Mandé Daguerre had announced their first, separate inventions of photographic processes in January 1839. Neither Talbot's nor Daguerre's exposure times could stop action, but immediately inventors and tinkerers and all sorts of artists and craftsmen were lining up at the gate attempting to develop faster lenses and cameras and to find more light-sensitive chemicals so that this new invention of photography could be employed to photograph people and stop action.

To capture movement is at the heart of the history of sports photography.

The Scottish National Library has nine photographs of the young Laing or Laine. He is graced with good looks and youth, so all the photographs have charm and attraction. The other photographs show our hero seated pensively holding a book or resting against a pedestal adorned with putti. They all have a nineteenth-century generic feel. Only when he is dressed for badminton does he become wholly present and alive and engage the viewer. Sports photography is a celebration of physical as

Hill and Adamson, Mr. Laing or Laine, 1843

André-Adolphe-Eugène Disdéri, Schoolboys wrestling, France, 1853

well as mental energy. The portrait of Mr. Laing or Laine as a badminton player is a wonderful beginning to the story of sports photography.

Above, on the left, are two debonair schoolboys standing with their arms around each other, content to have their physical contact be affable, whereas the two on the right are already rolling up their shirtsleeves, waiting their turn to get down and dirty. The teacher watches intently to be sure that the boys follow the rules of engagement on their road to manhood. The two boys in the center of the picture are as intertwined as conjoined twins. Although later the camera will stop motion and we will see the body in ways never before imagined, even with a posed photograph and a long exposure, sports photography *still* has the ability to present configurations startling and strange. Sports photography opens up the imagination in many ways, and it is not surprising that artists, from the great Impressionists to figurative painters, turn to photographs over and over again for inspiration.

· · ·

LEWIS CARROLL (Charles Dodgson) was an amateur camera enthusiast who adored depicting children playacting and dressing up. His favorite young model was Xie Kitchin (he photographed her fifty times), whose father, the Reverend George William Kitchin, was a colleague at Oxford University. Kitchin became headmaster at Twyford Preparatory School in 1854. Dodgson had multiple reasons to visit the school in 1858 and 1859. The Kitchin family was there, as was his youngest brother, Edwin Heron Dodgson.

It is always painful to see boys eager to play ball having to stand still. But patience on the parts of those in front of and behind the camera was a requisite of nineteenth-century photography. Not only were the exposures long, the photographic plates had to be prepared and sensitized just prior to exposure, a difficult and time-consuming process. But in this early history of sports photography, a nod must be given to the "amateurs." It is an honor to have Lewis Carroll carry the banner for all of those who photograph for the sheer "love of it." In 1859 Carroll made a team portrait of the Twyford School Eleven and a very stilted photograph of them on the school's cricket field.

Contrast the awkward schoolboys with England's twelve

Lewis Carroll, "Cricket team, Twyford Boys Preparatory School," Winchester, England, 1859

Baron Wilhelm von Gloeden, *Two Wrestlers,* Taormina, Sicily, ca. 1890

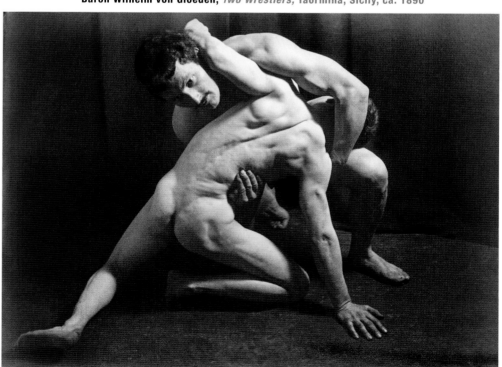

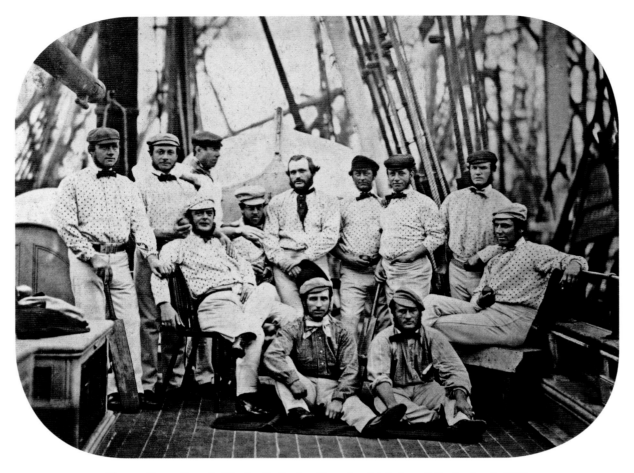

Thomas Henry Hennah, "England's Twelve Champion Cricketeers," September 1, 1859

champion cricketers aboard ship in Liverpool harbor in September 1859, about to depart for their first tour of North America. Here are Robert Carpenter, William Caffyn, Tom Lockyer standing on left; John Wisden, H. H. Stephenson, George Parr, James Grundy, Julius Caesar (yes, for real), Thomas Hayward, John Jackson in the middle; Alfred Diver and John Lillywhite seated in front—some of the most famous names in cricket history.

It was the first overseas cricket tour by an English team. And this picture by **THOMAS HENRY HENNAH** is one of the first true sports celebrity photographs. These men project their individuality and star power as they convey the spirit and conviviality of team sport. No wonder there was an early market for this picture. Many copies of the photograph were made from the original glass negative and it was also turned into an

engraving. It was published by W. H. Mason and J. Wisden, of *Cricketer's Almanack* fame, on October 2, 1859, a month after the picture was taken. That is speedy, nineteenth-century time.

James Buchanan was president of the United States when the British ship arrived, the Civil War was around the corner, and baseball was not fully ascendant over cricket in the New World. (Historians wonder whether, if the war hadn't interrupted these international matches, cricket, and not baseball, would be the national pastime.) Because the English players were so superior to any United States or Canadian team, and betting on the outcome was part of the fun, the Brits divided up and played three exhibition games with teammates from North America. When these dashing, confident men played together, they were invincible.

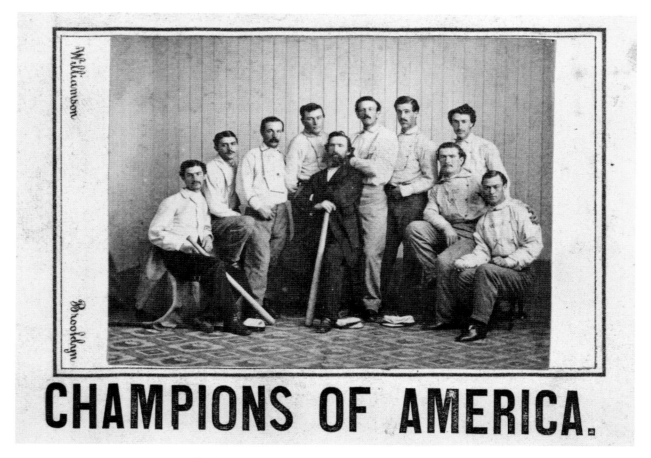

Charles H. Williamson, "Champions of America," 1865

. . .

Compared to the dashing cricketers, the American baseball champions pictured above, the Brooklyn Atlantics of 1865, look downright apprehensive.

They were known for their bravado on the field, but here, in what is considered perhaps the earliest extant collectible baseball "card," they are devoid of personality. Posing for photographs was new, and it is possible this was the first time many of them even stood before a camera. It comes, too, as a shock to see young men in this period not as Civil War soldiers in the gray or the blue, but in baseball garb. The Brooklyn Atlantics won championships in New York City in 1861, 1864, and 1865. Sports has always been a reprieve from the trauma of war, everywhere in the world.

This early team baseball photograph was taken by Scottish-born **CHARLES H. WILLIAMSON**, who opened his first daguerreotype studio in Brooklyn in 1851 and continued to work

as a photographer until his death in 1874. The baseball card was an actual albumen print glued on a stiff paper support and given by the Brooklyn club as a souvenir to people as they came into the ballpark.

Baseball cards began in 1887 with pictures of players on one side and some form of writing on the back. They were used as marketing tools by rival tobacco companies before many small tobacco companies were consolidated into the American Tobacco Company. The granddaddy of the early sets is the Old Judge series of photographic cards issued by Goodwin & Co. between 1887 and 1890. Taken in the studio, they have surprising variety, showing players in sliding positions, batters in mid-swing pretending to hit a ball suspended on a string, and catchers crouching. Actual photographic prints, mounted on boards a little larger than $4\frac{1}{2} \times 6\frac{1}{2}$ inches, were given in return for several dozen tobacco coupons.

**These are the saddest of possible words:
"Tinker to Evers to Chance."
. . . Words that are heavy with nothing but trouble:
"Tinker to Evers to Chance."**

Franklin Pierce Adams, "Baseball's Sad Lexicon"

Truly great photographic portraiture by the studio of Paul Thompson resulted in the mundane early baseball cards issued by the American Tobacco Company. Joseph Tinker, shortstop; Johnny Evers, second baseman; and Frank Chance, first baseman, were part of the Cubs' invincible infield. Each look directly at the camera, knowing the purpose was to be colorized and miniaturized to about 2⅝ x 1½ inches by chromolithography and then be stuffed into a pack of tobacco. That is what makes the photographic portraits so compelling. They sit for their portraits trying to figure out what is expected of them. Tinker, doe-eyed, communicates longing and sensitivity; Evers refuses to reveal too much; Chance is quizzical and bewildered. Harry Katz, former head curator in the Library of Congress's Prints and Photographs Division and the principal author of *Baseball Americana: Treasures from the Library of Congress,* wrote about the baseball cards produced from these and thousands of other photographs, noting that they "created heroes of banker's and paperhanger's sons alike, filling ballparks and selling cigarettes." The photographs are infinitely more interesting than the reproductions, but it was the cards that were cherished, as the owner could look at them over and over again—or trade them. The trajectory of baseball cards went from tobacco packs to Cracker Jack boxes to chewing gum packets.

It is impossible to know if Paul Thompson himself took these powerful photographs or if someone else in his studio did. There are about two dozen in the series, and each is excellent. The portraits are complex, mysterious, and in-depth character studies. In the 1910s and 1920s Thompson employed a team of photographers to provide pictures to newspapers and magazines—and tobacco companies.

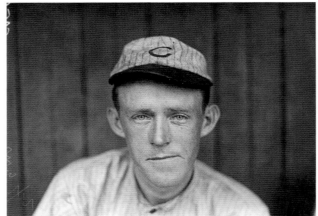

Studio of Paul Thompson, Joseph Tinker, Johnny Evers, and Frank Chance, photographs and chromolithographs, ca. 1910

In North America in the nineteenth century, photography was not an art but a commercial enterprise. The most successful chain of photographic studios in this period in Canada and New England were the twenty-four branch establishments named Notman. William Notman, another Scotsman, founded his first photographic studio in Montreal in 1856, and over the next two decades created a thriving empire.

Mia Fineman, the curator of photography at the Metropolitan Museum of Art, introduces Notman's importance in the history of sports photography when she writes in *Faking It: Manipulated Photography Before Photoshop* that, "as a photographer, Notman was a master of illusion. His outdoor scenes of hunting, skating, and tobogganing—created entirely inside the studio, using sheep's fleece or salt to simulate snow and a sheet of polished zinc as an ersatz skating pond—were praised for their persuasive artifice: as one critic put it, the pictures were 'true to nature, without being wholly nature itself.'"

Notman, as an émigré, understood that Canadian identity was tied to the great outdoors, including the many sports they devised to keep themselves active during the long winters. Roland Barthes wrote about the Canadian love of ice hockey, "It is a sport that rises out of the substance of a nation, out of its soil and climate. To play hockey is constantly to repeat that men have transformed motionless winter, the hard earth, and suspended life, and that precisely out of all this they have made a swift, vigorous, passionate sport."

Notman, with skill and ingenuity, could create the illusion of action. He set up sporting scenes in the studio and made composite pictures from many individual negatives, each printed to scale. As original as these pictures were, his business was best known for its first-rate portraiture. He and his associates were frequently called upon to make team portraits, including many Native American lacrosse teams. Lacrosse was originated by Native Americans.

. . .

In Europe, mountain climbing as a recreational sport was popular for men and women, but the big mountains, such as Mont Blanc, were perilous. Marta Caraion, a professor at the University of Lausanne, writes, "A trip to Mont-Blanc had all the characteristics of an adventure beyond the realms of ordinary mortals: the ways of losing one's life were numerous." Painters generally chose not to carry their easels and paints into these magnificent landscapes. Cameramen in this period were notably adventurous, enterprising, and industrious. They had more

Anonymous, Kahnawake lacrosse team about to meet their European opponents, Belfast, Ireland, 1876

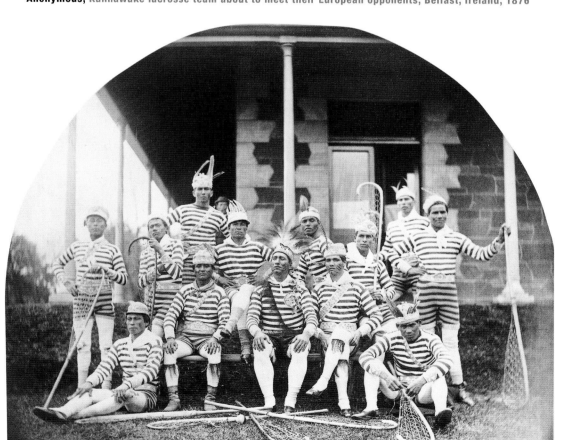

equipment to carry than painters, but were willing to make the effort.

Two of the finest photographers working in the field of alpine photography from the late 1850s were the Bisson Frères. Auguste-Rosalie Bisson, the younger brother, on his third attempt, reached the summit of Mont Blanc in 1859 and claimed the laurels of first photographer to scale the mountain and its glaciers and bring back a record of the ascent and descent. Twenty-five porters were employed to carry the fragile glass plates, chemicals (but no distilled water—snow was used instead), dark tent, cameras, and varnish needed to make a photograph, plus all the gear and provisions needed to stay alive during the expedition.

Flash forward 150 years and the Italian Olivo Barbieri shows mountaineers proportionally the same size as the Bisson Frères' in vast mountain landscapes, and although he hikes the trails, his color photographs are conceptual, computer-generated images.

There were no shortcuts in nineteenth-century mountain climbing photography. It was a form of "extreme photography."

• • •

It is a well-known story that Leland Stanford, the phenomenally wealthy railroad magnate and former governor of California, raised Thoroughbred horses and wagered that one of his prize racehorses, at full gallop, would have all four feet off the ground. To win his bet, he hired landscape photographer Eadweard Muybridge, "Helios, the Flying Camera," in 1872 to prove his thesis.

These were still wet collodion days, but Muybridge claimed to achieve exposures as short as ¼,₀₀₀ of a second. As Hans Christian Adam, author of *Eadweard Muybridge: The Human and Animal Locomotion Photographs,* wrote in an email, "To the best of my knowledge there were no means to measure such short periods of time then, so Muybridge just guessed. His self-made (or made with the help of Stanford's railroad/telegraph

Auguste-Rosalie Bisson, "Ascension of Mont-Blanc," from the album *Haute-Savoie, Le Mont Blanc et Ses Glaciers: Souvenir du Voyage de M.M. L'Imperatrice,* 1860

engineers), electrically triggered, spring-operated guillotine shutters delivered very short exposure times, though. I guess them to be somewhere around ½₅₀ to ½₀₀ of a second. Which is pretty fast for his times!" Muybridge kept many aspects of his work secret, but was forthcoming in showing journalists his bank of cameras, lenses, and shutters and how the horses triggered the cameras as they ran by. Phillip Prodger, another one of Muybridge's biographers, notes something about Muybridge's earliest work that has been generally overlooked: "He

[Muybridge] appears to have been one of the first photographers to use panning to capture motion, following the subject with his camera to reduce its movement relative to the plane of the negative. . . . It enabled him to produce pictures in which his moving horses were relatively sharp." Until the introduction of autofocus, being able to follow focus was one of the key skills necessary to be a successful sports photographer. Prodger adds, and sports photographers will commiserate, "Even using a series of cameras, as he [Muybridge] did in his later work, it was tricky

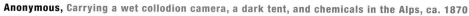

Anonymous, Carrying a wet collodion camera, a dark tent, and chemicals in the Alps, ca. 1870

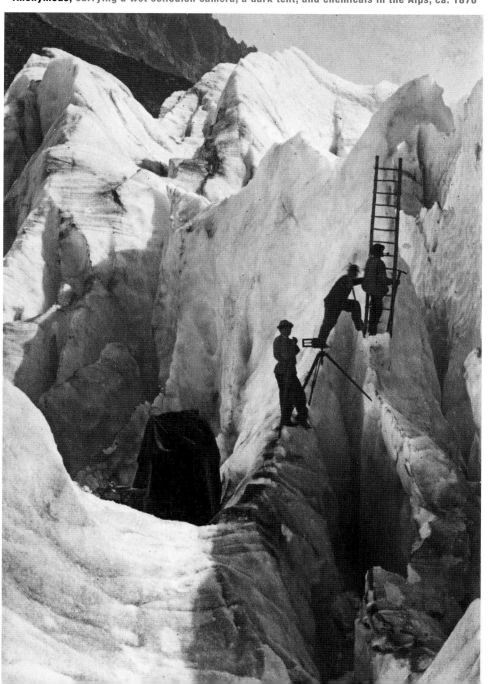

Eadweard Muybridge, *Man Performing Standing High Jump,* #161 in *Animal Locomotion:*
An Electro-Photographic Investigation of Consecutive Phases of Animal Movements, 1887

to gauge the velocity of a subject, and determine where to place the cameras to obtain the best results."

Muybridge was not the first to design a shutter, as is often reported, but he did come up with important innovations. He worked at Stanford's Palo Alto stables until 1877, achieving success and notoriety. His work drew the attention and admiration of scientists (including Étienne-Jules Marey), artists (including Thomas Eakins and, much later, Francis Bacon), and the general public.

Among Muybridge's best-known pictures are those of athletes running, jumping, fencing, boxing, wrestling, playing tennis and cricket, throwing the discus and the javelin, batting

a baseball, and kicking a football. These were made while he was resident at the University of Pennsylvania between 1884 and 1886. The results were published as *Animal Locomotion.* They are wonderful to behold but cannot always be trusted to show what they purport. Marey's biographer Marta Braun says that 40 percent of the 781 plates Muybridge published are not sequential but arranged to fool the eye. "When a phase of the movement was missing—perhaps a camera failed or a negative broke or was fogged—Muybridge assembled the negatives that remained, gave them internal consistency, and renumbered them to appear consecutively in the print. At times he even went so far as to compile sequences whose individual elements came

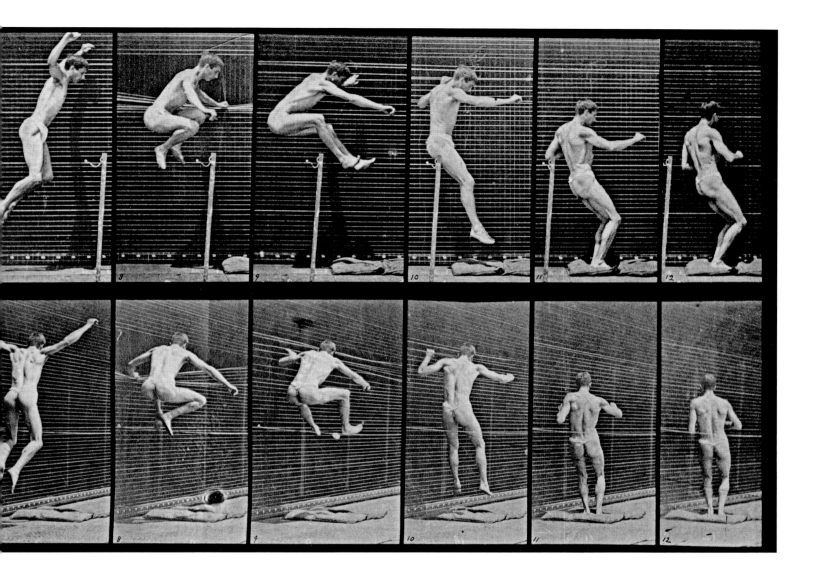

from separate picture taking sessions." Muybridge had failings, for sure, but he was also one of the most original, important, influential, and endearing photographers of the nineteenth century. As Prodger observes, "Muybridge was the first person to make convincing photographs of small fractions of time," and as such has earned his place in the history of sports photography.

The sequence reproduced here, *Man Performing Standing High Jump,* shows that Muybridge did not always have his subjects perform in front of his usual painted grid. Here, our jumper accidentally touches the strings in the background, which are arranged an inch apart.

In the 1880s and 1890s, a handful of men from different disciplines and countries were inspired by Muybridge's earliest published work from the 1870s and began to study movement through sequential photography. The availability of dry plates sold in shops for the first time facilitated their photographic experiments. In addition to the two best known, Muybridge and Étienne-Jules Marey, Georges Demeny, Ottomar Anschütz, Ernst Kohlrausch, and Albert Londe were brilliant innovators.

Ottomar Anschütz, a Prussian, invented a camera with a focal plane shutter that had exposure times as fast as $\frac{1}{1,000}$ and $\frac{1}{2,000}$ of a second, faster than any previous device in the 1880s and giving more precise detail of moving objects. His work was groundbreaking. He has been called "the father of sports

Ottomar Anschütz, "Horse and rider jumping over ditch and fence," 1886

photography," but sports photography had many forebears. Anschütz's best-known photographs are of horses jumping and exercising and a stork landing on her nest. In 1886 he published *Snap Shots of the Motion in Running, Jumping, Javelin and Discus Throwing.*

Albert Londe, a Frenchman, did a unique sequence of photographs, around 1891, of Jean-Baptiste Charcot, a noted sportsman, skillfully kicking a soccer ball. Charcot was the son of Londe's famous colleague, Professor Jean-Martin Charcot. Action pictures like these were not seen at this time. Londe used a single camera with twelve lenses. Carte de visite portrait photographers used cameras with multiple lenses, but their sitters had to stay very still. Paul Richer, an anatomy teacher who was also a colleague of Londe's, did a drawing in 1895 of Londe's photograph of a nude man descending a staircase. According to the French photo historian Michel Frizot, it could have inspired Marcel Duchamp's painting of 1911–12. It is very similar.

To achieve their goals of stopping the body in motion, Muybridge, Marey, Demeny, Anschütz, Kohlrausch, and Londe had to design cameras and shutters, have lenses specially ground, experiment with emulsions, build outdoor studios, and find men, women, and animals willing to be part of their experiments.

The history of sports photography must be viewed through the prism of technological innovation, begun in the nineteenth century and continued to the present.

The greatest scientist of all these experimenters was Étienne-Jules Marey, a professor at the Collège de France. Four days after Muybridge's horse studies were published in France in *La Nature* in December 1878, Marey wrote to the publisher, Gaston Tissandier, that "he was filled with admiration for Mr. Muybridge's instantaneous photographs."

In 1874, the French astronomer Pierre Jules César Janssen used a gun-shaped camera to photograph the transit of Venus. Marey knew of this work and decided to build his first camera based on Janssen's gun design. In 1882 Marey took pictures with it on round and octagonal disks with exposure speeds of less than $\frac{1}{500}$ of a second. "It resolved the problems of inaccuracy inherent in Muybridge's system . . . it was measurably precise; it worked with unprecedented speed and produced the number of images needed for synthesis," writes Marta Braun, author of *Picturing Time,* a brilliantly researched biography of Marey. She adds, "He wanted nothing less than a scientific interpretation" of the "range, velocity and sequence of the various phases of movement, not only in walking, but also in running and jumping."

Marey had met Muybridge when the latter was in Paris in 1881. For Marey, Muybridge's photographs were an inspiration but did not provide the scientific data he required for his research. In May–June 1883, Marey finished building his fixed-plate chronophotograph camera and, Michel Frizot writes, "fulfilled the physiologist's requirement by bringing together on the same plate a series of sequential images, representing the different positions that a living being, traveling at a particular pace, occupies in space at a series of given moments."

In 1880 a new law was passed in France making physical education obligatory in all French lycées. The following year, Georges Demeny became Marey's assistant, hired in part because of his background and commitment to physical education, an involvement that would continue his entire life, in addition to his facility with sophisticated instruments.

Between 1883 and 1887, Marey and Demeny used chronophotography to analyze in scientific detail how people walk, run, and jump, and birds fly (these photographs were known by the Wright brothers and influenced their experiments); animal locomotion; ballistics; and the kinetics of falling objects. Marey, over a long and distinguished career, made major contributions in physiognomy, prosthetics, ergonomics, medical instrumentation, cinema, and aviation.

Georges Demeny took hundreds of photographs while working for Marey, often in collaboration with his mentor,

A photograph of C.B. Fry executing a broad jump at an inter-varsity meet in 1892 is perhaps the first or certainly one of the earliest action photographs taken at an actual sporting event. It comes as a huge surprise. At this time, "action" photographs were posed, simulated, taken at a far distance, or the result of controlled and careful experimentation by scientists and technical innovators. Nigel Russell, a camera expert, explains that it is easier to capture motion (you can get away with a slower shutter speed) when the motion is coming toward the camera than when it is moving across the field of view. Front view or side view, this photograph by Stearn of Cambridge is remarkable for its time.

Stearn of Cambridge, C.B. Fry competing for Oxford University in the broad jump event during the inter-varsity athletics meet between Oxford and Cambridge at Queen's Club in London on April 8, 1892. The photograph was used for an engraving in the *Illustrated London News.*

but also on his own, especially during the six months each year when Marey was at his home in Naples, Italy. Braun writes, "The experiments he [Demeny] did under Marey's direction would ultimately become the foundation for a method of physical education based on physiology that would be diffused throughout the army and the schools."

The 1900 Olympics (technically, the International Competition of Physical Exercises and Sports) was held in Paris. Demeny chaired the Congress on Physical Education. At the time, it was thought that English "greatness" was based on a culture that valued physical fitness. The Americans, however, had surprised the world when they swept the 1896 Olympics, taking home an overwhelming majority of the medals. Marey

and Demeny were thrilled in 1900 to have the opportunity of studying champions and to investigate through scientific measurement, graphing, and chronophotography their physical attributes.

In 1902 Demeny took up a position at l'École de Joinville, a college for training athletes and soldiers in physical fitness. It was established by Napoleon III in 1852 to ensure that his army would be composed of physically competent soldiers. (The tumultuous revolutionary year of 1848 was still in everyone's memory.) Demeny was hired to head a scientific photographic laboratory, the first of its kind in the world in a sports college, and to work on "biomechanicals and physiology." He was charged with helping to develop the training of French

Étienne-Jules Marey studio, "Untitled," n.d., from a negative slide in the collection of Cinémathèque française, Paris, ca. 1890

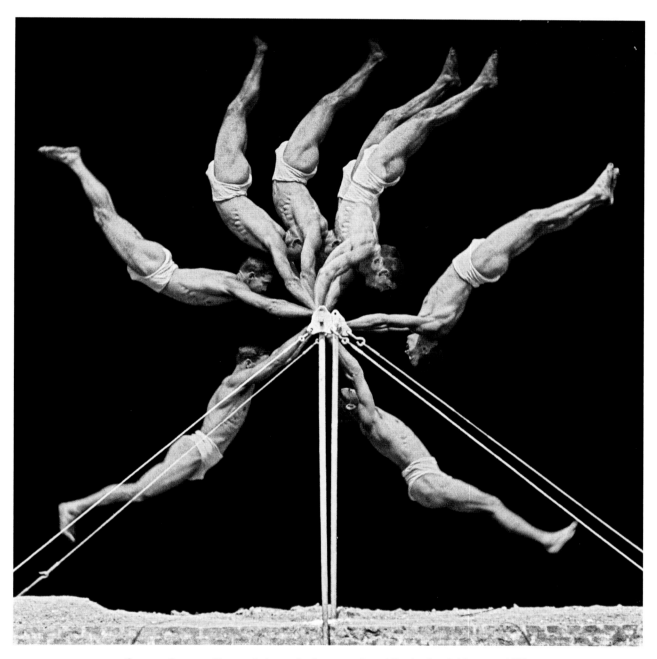

Georges Demeny, Chronophotograph of an exercise at the horizontal bar, ca. 1906

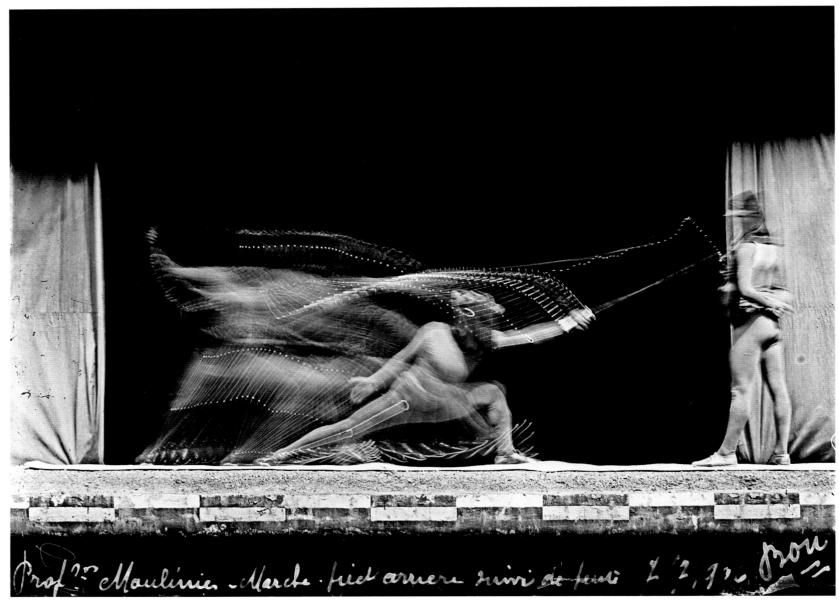

Georges Demeny, Fencing, showing a left-hand lunge by Master Moulinier to his instructor, Master Bazin, ca. 1906

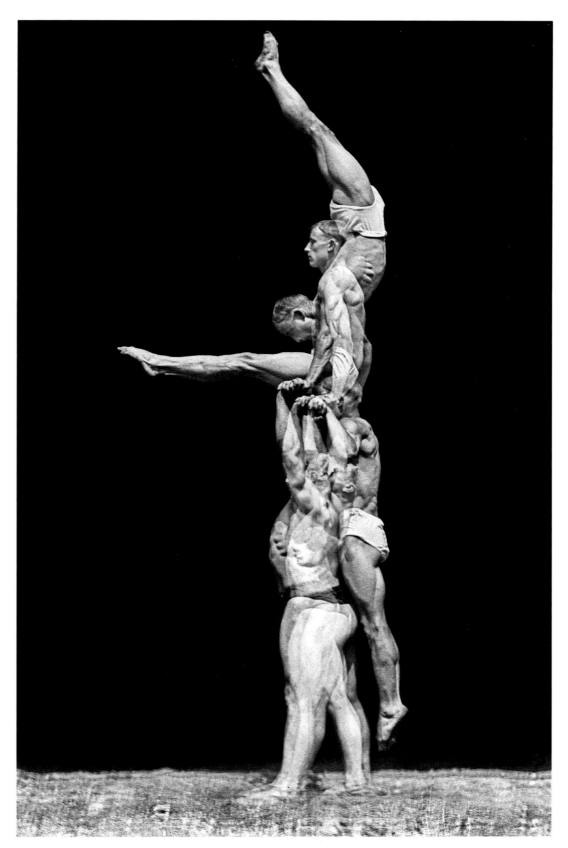

Georges Demeny, Acrobatic gymnastics in a hand-to-hand lift exercise, ca. 1906

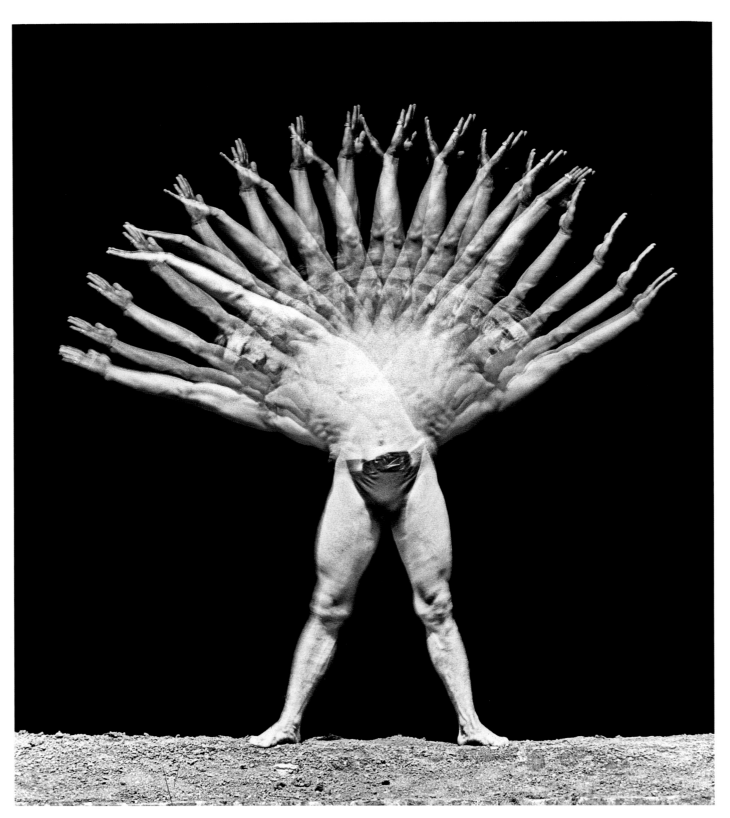

Georges Demeny, A limbering-up exercise of the torso by lateral tilting of torso, arms stretched and legs apart, ca. 1906

Studio images of baseball players were commonplace during the 1870s and 1880s— the first photographic baseball card set, consisting of thousands of portraits, was introduced shortly after this image was taken—but from the moment this one, larger at 6 x 4½ inches, was discovered it was recognized as special: among other reasons, its subject is black. Only a handful of similar images survive. Identified on the negative only as "Van Emery," the subject's true identity remained hidden until recently. Its owner, a photography collector named Paul Reiferson, was driven to discover the photograph's story by a simple question: Why was this black man presented with such dignity at a time when the most popular depictions of blacks playing baseball were stereotypically racist?

The answer, which Reiferson explored in an essay, "He Wears the Mask," published in *Southwest Review*, July 1, 2015 (pages 413–22), is that the subject, Javan "Van" Emory, was a celebrated catcher at a time when catching was dangerous and required real courage. A contemporary legend maintained that Emory had actually played in an exhibition game for the National League—some sixty years before Jackie Robinson— and proved so threatening that Major League Baseball drew the color line in direct response. Whether or not that legend is factual is incidental. People believed it at the time, and it reflected the real regard fans— black and, for a time, white—had for Emory.

That regard was clearly shared by this anonymous photographer and is evident in his dramatic use of light (Emory is half in shadow, which also enhances an illusion of three-dimensionality) as well as his sensitivity to the different techniques required for lighting black skin, which is modeled by highlight rather than shadow. It is also seen in the photographer's decision to pose his subject in a forceful posture with direct eye contact. Though it was probably not the photographer's intention, the mask adds both metaphor and mystery and creates a desire to see the man behind it.

The image was once one of a pair; the other image, surviving only as a glass negative, showed Emory in the same pose without his mask. Lent to a publishing company, it was dropped and irreparably damaged.

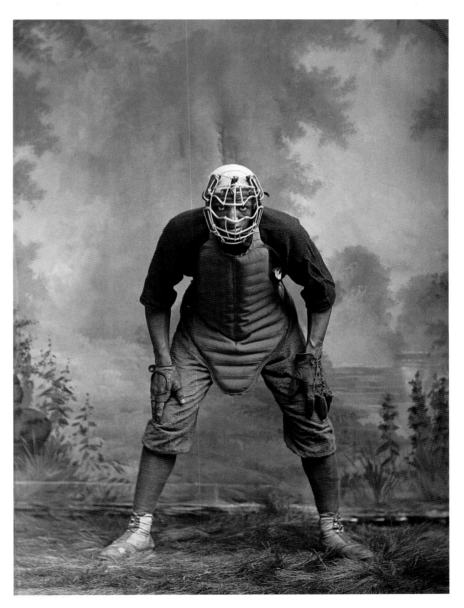

Anonymous, Javan Emory, African American baseball catcher, ca. 1885

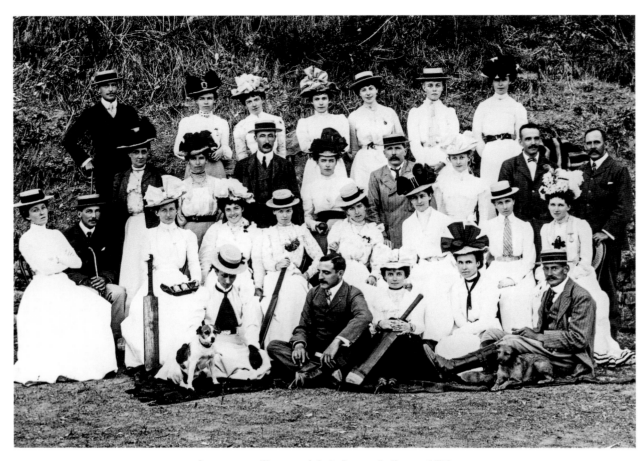

Anonymous, Women cricket players, India, ca. 1901

competitive athletes. He did this by trying to understand how the body could be used more efficiently and effectively. Photography was central to his research on stress, fatigue, muscular movements, and efficiency in physical activity. He also revised and compiled manuals for training gym teachers and coaches.

There are two to three hundred glass-plate negatives by Demeny at the Institut National du Sport et de l'Éducation Physique (INSEP), the successor to Joinville. His original prints were burned by the Nazis during World War II when they occupied the campus, it being a French military training school.

Muybridge used female models, but not as sports figures, and Marey and Demeny ignored them completely as athletes. Baron Pierre de Coubertin, the founder of the Olympic movement, vowed that women would never participate in the Olympiad (he had to rescind this promise), and doctors advised girls and women not to exert themselves. A famous doctor, Maurice Boigey, wrote in 1922:

Girls are handicapped from the point of muscular development; they must not seek out exercises that require a certain deployment of strength. . . . Intense effort is not good for them. It tires them . . . damaging their health. The special functions that a woman must undergo and perform are incompatible with intensive muscular work. . . . Women are not made to struggle, but to procreate.

No wonder the women cricket players look so proud in the anonymous photograph taken in India around 1901. If they were able to get their bats near the famous Dr. Boigey's butt, they would probably have given it a good slap. There are late-nineteenth-century, early-twentieth-century photographs of women with croquet sticks and archery bows; playing basketball immediately after its invention in 1891 and friendly family games of softball in fields near their homes; hiking in the mountains—but photographs of athletic women in this period are few.

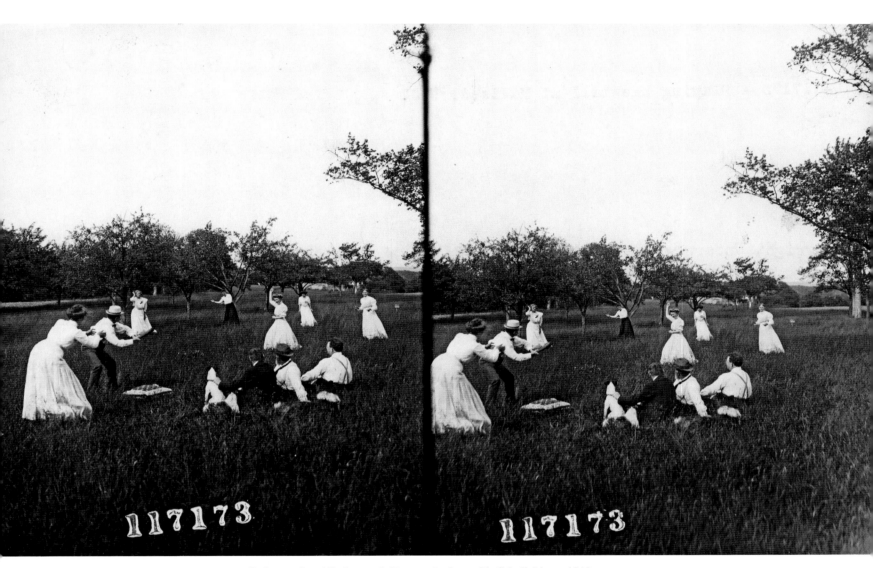

Underwood and Underwood, Women playing softball in field, ca. 1910

Early in the twentieth century, women were fencing and rowing, playing golf and tennis, excelling in archery. Bicycling was a new craze that women enjoyed as much as men. It gave them freedom to get out of town and go places. There is the occasional news photograph of young women playing soccer with captions such as "Sargent girls playing soccer. This is the first girls school to take up such a strenuous sport."

Women swimmers led the fight for recognition as serious athletes. They also wanted to get themselves out of the ridiculous costumes that weighed them down once wet. The Library of Congress has, in the important Bain Collection, a wonderful photograph of Annette Kellerman in 1907, the year she was arrested in Massachusetts for indecency. Yes, she was wearing her

George Bain News Service, Annette Kellerman in locker room, May 4, 1907

one-piece that she designed to allow her to swim properly. Yes, it showed off her curves and muscles, but her legs were completely covered and she was a world champion swimmer and the first woman to publicly attempt to swim the English Channel. If the law was against her, the press photographers who flanked her loved her attire, and editors reproduced the "shocking" pictures of her in her revealing bathing suit.

A more liberal take on women's sports can be seen in the 1904 photograph of women's handball, taken by the New York photographic firm of Byron. Whew. The young women are wearing clothes they can actually move in, even though, because of Byron's long exposure time, they have to stay absolutely still. Beautifully arranged and lit, these students, bare hands outstretched, are looking at the spot where Byron imagined the ball, later to be drawn in on the negative, would be in a real game.

• • •

The **BYRON COMPANY,** a leading New York commercial photography firm from 1890 to 1942, had the commission to photograph Teachers College's new physical education facilities at 525 West 120th Street. These included the handball court, swimming pool, fencing rooms, bowling alleys, a gymnasium, rowing machines, and even a "hair-drying room," appreciated by the young women, especially in winter. From the beginning, these facilities were coeducational. Teachers College was started in the 1880s to train young men and women to enter education. It is the college where John Dewey taught, and many of the young graduates went to poorer communities to educate immigrant and working-class children. Teaching them to play sports and get fresh air was part of their training.

The Byron Company was best known for its work in the theater, but it had many varied commissions over the years and also worked on speculation. Curling; biking; horse and car racing; rowing and sailing; track and field (surprisingly good action as early as 1896); and baseball at the original Polo Grounds were among the sports they photographed. They also photographed the Columbia University football players, Columbia being the first university with an organized football team.

The most interesting historical anecdote connected to Byron's sports photography is undoubtedly their coverage of the 1895 America's Cup. The British *Valkyrie III* challenged the New York Yacht Club's *Defender*. The *New York World* had its own tugboat, and Byron photographed the race from it and then made salted-paper prints on board. An artist traced the light-sensitive

Byron Company, Women's handball at Teachers College, New York, 1904

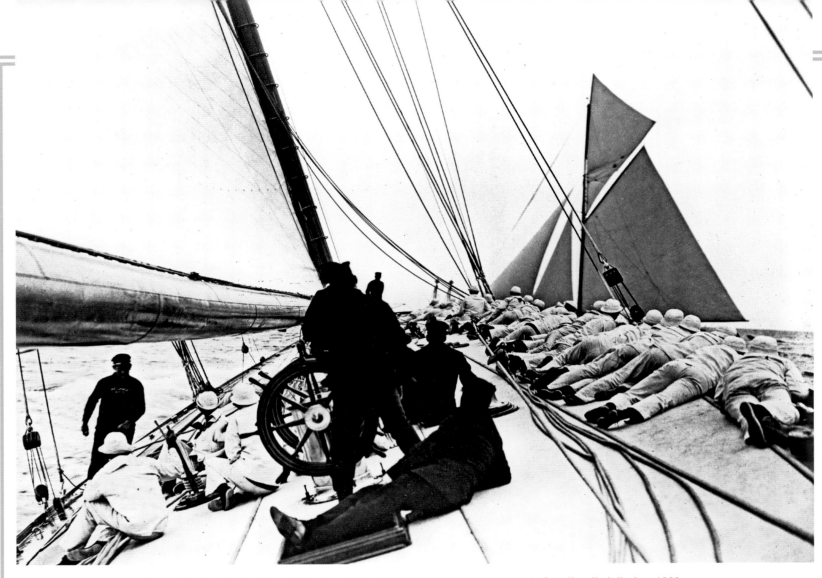

James Burton, *On the Wind, Reliance,* **moving toward the start of the America's Cup, New York Harbor, 1903**

ere we have one of the earliest and greatest sailing action photographs, taken from the stern of the ninety-foot *Reliance* by yachting photographer James Burton of New York. Captain Charlie Barr is at the helm, and all eyes are fixed on the challenger, probably *Shamrock III,* about to cross in front. Nautical painting has a long and distinguished history; many great artists were attracted to the powerful energy and colors of the sea, sky, and shapely ships. Painters did not generally place the viewer on board but rather as an onlooker from the safe and distant shore.

Burton does something radically new. He steadies his large camera behind the captain while we imagine him trying to steady himself, too. The angles, the sails, the prostrate bodies stretch out in a long line, the dark shapes of the captain and his mates, the lines of the mast and ropes—all contribute to a dynamic composition and convey the excitement of the moment.

Ed Holm in his definitive book *Yachting's Golden Age: 1880– 1905* mentions a half-dozen pioneering maritime photographers active in the Boston, New York, and San Francisco Bay areas. Among the most important are James Burton, Charles E. Bolles, and Edwin Levick in New York; Nathaniel L. Stebbins and Henry G. Peabody in the Boston area; Willard B. Jackson of Marblehead; and two amateurs who took pictures of ships in San Francisco Bay, William Letts Oliver and William H. Lowden.

Levick's assistant, Morris Rosenfeld, became the pater familias of the next generation of leading yachting photographers. He established his own studio in 1910 and his three sons continued photographing yachting races and boating until the business was closed in 1981. Their counterpart in the United Kingdom is Beken of Cowes, begun on the Isle of Wight by Alfred Beken in 1888, passed down to his sons, and continuing to the present.

photographs in pen and ink, rolled them up, and sent them, via carrier pigeon, to the newspaper's Park Row headquarters. You don't get an image to press any quicker than by carrier pigeon in the 1890s.

Frenchman **JULES BEAU** (1864–1932) was the first person to specialize as a general sports photographer. The leisure class, as the name implies, was formerly the only class to engage in recreational sports. By the late nineteenth century, sports were a popular pastime in Europe. Beau, the son of a successful Parisian baker and the brother of a priest and an architect, opened up his first photographic studio at 19 avenue de Ternes before moving to 51 rue de la Passy in 1892. His second studio was near the Bois de Boulogne, where people rode horses, exercised, and engaged in the new Parisian craze of "velocipede." But unlike Louis-Jean Delton (1807–1891), a member of the aristocratic Jockey Club, who established an early photographic studio in 1861 in the Bois de Boulogne to take only equestrian portraits of a wealthy clientele, Beau was a photographer of "the people's sports."

(Delton's two sons joined him in the family business and one, Georges, also worked for the French sports journal *La Vie au Grand Air*.)

Jules Beau was particularly attracted to bicycling, which soon became a competitive sport. His albums are filled with men and women posed on their bicycles. There is a stark contrast in class between the Deltons' equestrians and Beau's working-class bike riders, who could never imagine owning a horse.

Major Taylor has a remarkable place in sports history. He won the one-mile track cycling *world championship* in 1899, one of his many great racing achievements. Another "race" achievement was successfully managing his career as a black man at a time when being a superbly talented athlete made many whites in America determined to ban him from competitions. Racists don't like to compete fairly.

The newly introduced faster gelatin silver plates in the 1890s allowed Beau to leave the studio with his camera and begin to photograph athletes in action. Beau's other early photographic

Jules Beau, *Major Taylor,* cyclist, Paris, 1906 or 1907

MAJOR TAYLOR

Jules Decrauzat (1879–1960) has only just been resurrected to his rightful place in the history of Swiss photojournalism. He is now considered to be Switzerland's first photo reporter, and sports has a major place in his oeuvre. His shift from his initial career as a sculptor in Paris to film and photography was prompted by the excitement for these two new mediums of expression and communication. He studied at the Ecole Pathé in Paris at the end of the nineteenth century, a time when photographs printed in halftone were beginning to appear in the popular press and cinematography was redolent of images with a new kind of visual energy.

His first photographic coup was an instantaneous shot in 1899 of a man attacking Alfred Dreyfus's lawyer during the famous trial in Rennes. The twenty-year-old was paid a hefty sum for this photograph, which launched his career. He did general (and very early) photo reportage before being offered in 1910 a job with the illustrated magazine *La Suisse Sportive*, where he worked as a photographer until 1925. This was his most concentrated and prolific period of sports photography.

Most of Decrauzat's glass negatives, estimated to have numbered around eighty thousand, have been lost. The Swiss photo agency Keystone has identified 1,250 as taken by him between 1910 and 1925, and, not surprisingly, they are heavily focused on sports, aeronautics, and automobiles.

"Movement" can be ambiguous when discussing photography. There is the obvious movement of a body in motion— Decrauzat took splendid pictures of tennis players jumping, hurdlers leaping, cars and motorcycles racing. But movement can also be internal—bursting with excitement, satisfaction, and anticipation, as in some of his group portraits.

Jules Decrauzat, Start of "Group 3" motorcycle race, Lausanne, 1919

Horace W. Nicholls, *A Scene at the Course, Derby Day,* Epsom, England, 1914

interest was track and field competitions, and eventually he added ballooning, automobile racing, rugby, football, hockey, polo, and covering the activities of the growing number of French sports clubs. Thirty-six densely packed albums of his almost exclusively sports photographs from 1895 to 1913 are housed at the Bibliothèque Nationale in Paris.

In the late 1890s, halftone and letterpress printing processes allowed for illustrated weeklies to publish photographs with text. In France, *La Vie au grand air,* started in 1898, specialized in sports reporting, and it was here, from its inception, that Jules Beau's photographs of sporting events and athletes appeared. As historian Thierry Gervais writes, "Only *La Vie au grand air* published nothing else, from 1898 to 1922 under 'art director' Lucien Faure. It pioneered a graphic style that ushered in the age of the modern magazine."

George Grantham Bain is sometimes called the "Father of News Photography," but he neither invented photojournalism

nor was a professional photographer, although in his early journalistic career he carried a Kodak camera to interviews. He received this title because in 1898 he established the first commercial organization to collect and distribute photographs. The first two decades of the twentieth century were a time of explosive growth in newspapers and magazines. After working as a journalist, Bain moved to syndication, working for the newly organized United Press Association, the up-and-coming rival to the older Associated Press. What he learned syndicating news stories he applied to the distribution of photographs. Presciently, he included photographs with the stories he syndicated. Often the pictures were more interesting than the stories. In 1898 he set up **GEORGE BAIN NEWS SERVICE,** located at 15 Park Row in the heart of New York's newspaper district. Frances Benjamin Johnston was one of the many freelance photographers who worked for him. The business proved successful because, although editors wanted to run

pictures, they were unwilling to pay photographers to be on staff.

In 1911, Bain announced to his newspaper customers that he was starting a "special sport service" that provided three sports photographs a day for only five dollars a week. The photographs are all anonymous but they tend to be of beautiful quality, having been shot on 5 × 7- or 8 × 10-inch dry glass plates. Among the best athlete portraits are those of Jack Dempsey training; Johnny Weissmuller by the side of the pool; heavyweight world champion Jess Willard, who knocked out Jack Johnson in Havana; Jim Thorpe, voted the greatest athlete of the first half of the twentieth century; the controversial but brilliant baseball player Ty Cobb; Connie Mack, the manager of the Philadelphia Athletics for their first fifty seasons; and Jack Johnson, the first African American to become heavyweight champion of the world.

Bain understood that sports had a big draw, so he built a huge inventory of photographs of famous athletes and he sent his photographers to sporting events regularly (see page 294).

In England, **HORACE W. NICHOLLS,** a contemporary of Bain, took some of the most imaginative sporting photographs before the First World War. He specialized in "the Season"—Royal Ascot, Derby Day, Cowes Week, Henley Regatta, Goodwood. Cecil Beaton was shown contact prints in black and white of Nicholls's Ascot photographs and based his costumes and sets for *My Fair Lady* on them. (Only in the early 1970s did Beaton learn who the actual photographer was—when I revealed to him the name.) Nicholls worked for himself, developed and printed his own pictures, and jumped on his bicycle to peddle his prints to the Fleet Street picture editors. Nicholls was an odd news photographer, as he frequently made photomontages, enlarging the crowds, increasing the number of umbrellas on a rainy Derby

Ewing Galloway, *Boy's Ball Game,* n.d.

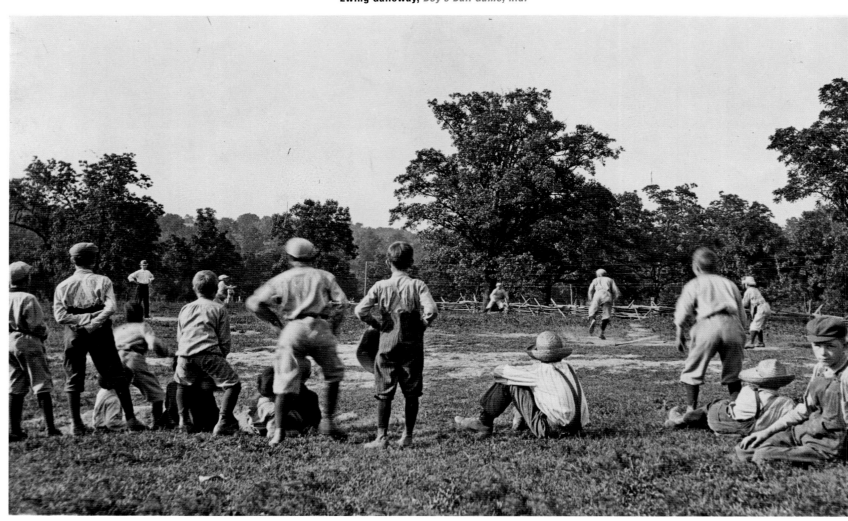

Charles Conlon, *Knuckleball,* Eddie Cicotte, Chicago White Sox, 1913

Day, moving the Gypsies' caravan to a more aesthetic location, adding or removing clouds from the sky, cutting and pasting elegantly dressed ladies at Ascot onto more properly manicured lawns. He felt his montages conveyed his experience of these events more accurately, but they certainly fooled the viewer into thinking they were real. Most of his photographs, however, were straight and he had a wonderful ability to capture the decisive moment.

Newspapers and journals started to reproduce photographs at the end of the nineteenth century and picked up speed going into the twentieth. Most press photographers worked for agencies and never received a byline.

Roger Angell, staff writer for *The New Yorker,* called *Baseball's Golden Age: The Photographs of Charles M. Conlon* by Neal McCabe and Constance McCabe "the best book of baseball photographs ever published." The "golden age of baseball" is a moving target. For some, it was the 1940s and 1950s. Others reflect nostalgically on an earlier period when some of the greatest names in baseball history got their start in the great cities of the United States. What isn't debated is who the greatest baseball photographer was for the first three decades of the twentieth century: **CHARLES CONLON.**

Conlon was born in 1868 and died in 1945. An amateur

photographer, he started going to ball games with his Graflex camera at the urging of an editor at the *New York Telegram.* He was known for producing "intimate" portraits that ran in his own paper, the *Telegram,* where he was a proofreader, and also the *Sporting News* and *Spalding Guide.* His cameras were cumbersome: from 1904 until 1915, he used a 5 × 7-inch format camera; from 1916 to 1934 a 4 × 5-inch format; and in the last years of his career he was able to dispense with glass negatives, switching to 4 × 5-inch sheet film.

One photographer comes to mind when thinking about Conlon's gift to the history of baseball in America. We would not know what the greatest of the French intellectuals, artists, and writers of the Second French Empire looked like without the penetrating portraits of the great Nadar. We would not have such an emotional, visual connection with the baseball players of the first three decades of the twentieth century without Conlon's probing and perceptive portraiture.

Nadar explained the essence of portrait photography during a court case involving his nom du plume:

What can [not] be learned . . . is the moral intelligence of your subject; it's the swift tact that puts you in communion with the model, makes you size him up, grasp his habits

Charles Conlon, Lou Gehrig, 1927

32422 Bobby Jones at the Top of the Backswing—Mashie Pitch.

Keystone View Company, Sets of stereoscopic slides produced to teach the correct way to play golf. Here, Bobby Jones teaches his famous winning golf swing, ca. 1929.

and ideas in accordance with his character, and allows you to render, not an indifferent plastic reproduction that could be made by the lowliest laboratory worker, commonplace and accidental, but the resemblance that is most familiar and most favorable, the intimate resemblance. It's the psychological side of photography—the word doesn't seem overly ambitious to me.

One could not find two more different men than Nadar, the extrovert, radical, bohemian, caricaturist, and aeronaut, and Charles Conlon, who had a desk job and no artistic pretensions. Nadar was professional in all he did; Conlon saw photography as a hobby that gradually evolved into something much more. But each man, in his own style, sought a true likeness of the

psychologically complex characters in front of their cameras. Whereas for Nadar, the three-quarter profile gave the best intimation of the man, for Conlon it was the full face, the hand gripping the bat, a close-up of the eyes, or the pitcher's grip on the ball for a spitball, curveball, knuckleball, or fastball.

If Nadar saw individuality and character in intellect, Conlon looked for them in physical attributes. He photographed fingers and palms, putting measurements and notations on the backs of the prints (on the verso of the photograph opposite it reads: "Lou Gehrig's home run batting eyes"); he did careful studies of the hands of all the players, providing evidence of how hands become misshapen according to the position played. He looked deeply into players' eyes to see if they revealed something superhuman that allowed them to slam a ball most people could not even see.

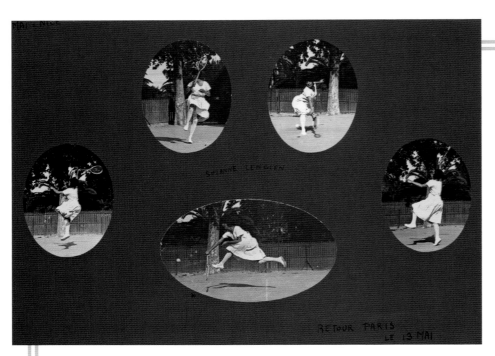

Jacques Henri Lartigue, Suzanne Lenglen, "Retour Paris le 13 Mai," Nice, 1921

the dust flying on the dirt road and the excitement of lift-off. If his cousin Bichonnade was riding her bicycle, he would capture her ignobly crashing and landing facedown in a bush. If he wasn't allowed to play with his older brother and cousins because he was too little, he could at least observe their daring activities and have fun making snapshots. Lartigue ignored every rule on how to make "good" photographs (except how to develop and print them—although getting consistent results was problematic) and ended up making great ones.

As he grew older, he never lost his childlike wonder. He photographed exuberantly through the 1910s, 1920s, 1930s, and 1940s. He was a sportsman himself, exercised daily, and focused his camera on those activities he enjoyed—either as participant or spectator—swimming, tennis, bodybuilding, gymnastics, the shot put, the

Jacques Henri Lartigue, "My cousin Simone and Charles Sabouret," Saint-Moritz, February 7, 1913

The name Jacques Henri Lartigue is synonymous with joie de vivre. From practically when he first opened his eyes in 1894 to when they closed forever ninety-two years later, Lartigue saw magic where others saw the commonplace. From his earliest pictures at the age of six, he framed his universe with an uncanny ability to see and to compose. How fortunate that he came from a happy, eccentric, playful, sports-loving, fabulously wealthy family with a father already enamored with photography. How fortunate that he never lost his inner child. There is purity to a child's relationship to the world, a sense of wonderment and a lack of guile. To view his earliest images, in particular, is to regain that sense of sheer pleasure in life's bounty. The marvels the child Lartigue witnessed and recorded could be as prosaic as his nanny throwing a ball up in the air in 1904 to the serious attempts by his elder brother to fly at a time when only a very few soared into the skies.

Like all children, action was infinitely more exciting than inaction, and happiness was when something—anything—was happening. Whereas most amateur photographers with their Brownies were dutifully telling their subjects to "stand still," one little French boy was asking his subjects to run, jump, to fly down a flight of stairs, and to do backbends. If his brother was going to race go-carts or fly airplanes, Lartigue was going to photograph

Jacques Henri Lartigue, The great champion Géo André training for the Olympics, Colombes Stadium, June 26, 1924

Jacques Henri Lartigue, World ski jumping championships,
Juan-les-Pins, Côte d'Azur, September 1938

high jump, boxing, automobile racing, air glider and airplane competitions, bicycle and motorcycle racing, track and field, boating, sailing and waterskiing, and horse races. Winter sports, too, had become popular and alpine resorts were de rigueur for his social class. Lartigue and his coterie skied, tobogganed, ice skated, and watched curling and ice hockey. We know this because his photograph albums show exactly how he and his friends spent their time. Lartigue, too, enthusiastically followed the great athletes of his day, photographing the best woman tennis player, Suzanne Lenglen, and also French Olympians training for the Games in the 1920s.

Lartigue accomplished the miracle of enjoying life to the fullest and his photographs prove it. Sport was integral to his happiness and well-being. His pictures are a living testament to Carl Jung's stated requirement for adult fulfillment—maintain childlike (not childish) wonder. We all need a little Lartigue.

The New York Renaissance, the "Rens," was also known as the Renaissance Big Five. They were the quintessential basketball team of the 1920s and 1930s. They got their name from their first sponsor, the Renaissance Casino on 138th Street and Seventh Avenue. Nearby, at 109 West 135th Street, was the Guarantee Photo Studio, owned by the Harlem photographer James Van Der Zee. He chronicled the people of Harlem from 1917, when he opened the Guarantee Photo Studio (later GGG) with his wife, Gaynella, through 1945. His biographer, Deborah Willis, writes that Van Der Zee defined "a people in the process of transformation and a culture in transition. . . . Van Der Zee presented in visual terms the growing sense of personal and national identify of his sitters." Willis observes that between the wars, images of African Americans were almost always "crude, degrading racial caricatures." Van Der Zee's portraiture is critically important, Willis continues, because "his subjects could expand spiritually, emotionally, and symbolically." Images of African American athletes were integral to this emerging new identify.

James Van Der Zee immortalized many of Harlem's athletic clubs and teams: the Pledges of the Unity Athletic and Social Club (1923); an unidentified basketball team whose name probably started with a "C," that being the letter on their jerseys; a panorama of the more than sixty-eight children of the Harlem Swimming Team (1925); the basketball team of the first intercollegiate Greek-letter fraternity, Alpha Phi Alpha (1926); the New York Black Yankees, part of the Negro National League from 1936 to 1948; and the Monte Carlo Sporting Club (1934) with its male and female members. Van Der Zee did not specialize in any one area of portraiture. Showing the people of his community with dignity and respect was his great and lasting objective.

James Van Der Zee, *Renaissance Big Five Basketball Team,* **1925**

TECHNOLOGY TIMELINE BY NIGEL RUSSELL

1830s

1839 William Henry Fox Talbot and Louis Jacques Mandé Daguerre both announce photographic processes in January. Talbot's Photogenic Drawing produced negatives and positives on paper with exposure times of 30 to 60 minutes. The daguerreotype process produced a positive image on a sheet of silver-plated copper and had exposure times of 15 to 30 minutes on a bright day.

1839 Giroux starts sales of the first camera available to the public.

1840s

1841 William Henry Fox Talbot patents and introduces the calotype process for paper negatives. This was a positive/negative process, so multiple copies could be made from the negative, and it became the method used for photography until digital photography. Exposure times were now down to 1 to 2 minutes.

1842 Improvements in the daguerreotype process bring exposure times down to 10 to 60 seconds.

1849 First experiments with stereoscopic (3-D) images, taking two photographs from the perspective of the left and right eyes.

1850s–1860s

1851 Introduction of the wet-plate glass negative and, a few years later, the albumen print, together the most popular form of photography until the late 1890s. Exposure times were 30 to 120 seconds for a large landscape camera and ½ to 5 seconds for a small stereoscopic camera.

1851 William Henry Fox Talbot demonstrates the principle of high-speed flash photography using a spark from Leyden jar batteries. The spark was about ½,000 of a second and froze the image. It was not until the 1930s, however, that high-speed flash was made practical.

1859 Thomas Skaife introduces his Pistolgraph camera, which uses a rubber-band-operated shutter and a large lens of f/2.2. A moving object is captured on a 1⅛-inch negative.

1870s

1872 Former California governor Leland Stanford hires photographer Eadweard Muybridge to take photographs of a galloping horse to settle an argument. Muybridge develops a system using a bank of 12 cameras with trip threads attached to the camera shutters and takes a series of photographs of a white horse running against a black background. By 1878 his technique has improved and his exposure times have been reduced to, he claimed, ½,000 of a second, but possibly ½50 or ½00 of a second. Still very fast for the time.

1873 Gelatin dry plates come on the market, with exposure times of ½5 to 4 seconds by the end of the decade. This process is much easier to use than the older wet-plate process and more amateurs take up photography as a hobby.

1880s

1880s Gelatin silver prints are introduced and gradually replace the albumen print.

1882–1883 Étienne Jules Marey takes chronophotographs of athletes.

1884 Prussian photographer Ottomar Anschütz invents a small handheld

camera using a focal plane shutter to provide exposures as short as $\frac{1}{1,000}$ of a second. In 1886 he designs an automatic shutter mechanism that takes twenty-four photographs at $\frac{3}{4}$ of a second. He photographs a horse jumping.

1888 Kodak introduces the Kodak camera, and a year later transparent roll film for it. The age of the amateur photographer begins.

1890s

1893 In France, Louis Boutan becomes the first underwater photographer. This requires wearing a heavy diving helmet and suit supplied with air pumped from the surface. Boutan develops an early form of flashbulb that will burn magnesium flash power in a glass jar underwater for illumination.

1898 The Folmer & Schwing Manufacturing Co. of New York City

1900s

produces the first Graflex camera. This becomes a popular line of large-format single lens reflex cameras fitted with focal plane shutters. The last Graflex is made in 1963.

1900 Gelatin dry plates and film improve with exposures in the range of $\frac{1}{250}$ to 1 second. At $\frac{1}{250}$ of a second, stopping motion becomes possible and the average user is able to take photographs of sports events.

1900 The Sigriste focal plane shutter hand camera is marketed. Using the dial on the camera, a total of 240 shutter speeds could be set up to $\frac{1}{5,000}$ of a second. Fitted with a Krauss-Zeiss Planar 160mm f3.8 lens, this camera is designed for stop-action photography.

1912 The Folmer & Schwing Division of the Eastman Kodak Co., in

Bain News Service, News photographers at the opening game of the World Series between the New York Giants and Philadelphia Athletics, Polo Grounds, New York City, 1913. We don't know who the press photographers are, but Todd Gustavson, curator, Technology Collection at the George Eastman House, identifies the cameras. Left to right: 4 × 5 Auto Graflex, reflex camera; 4 × 5 reflex camera; 5 × 7 Press Graflex; 5 × 7 Press Graflex reflex camera; 4 × 5 reflex camera; 5 × 7 Press Graflex; 4 × 5 Auto Graflex. They may look big and boxy, but they were state-of-the-art press cameras and could be handheld. And why would anyone need more than 10–12 pictures from a World Series game? Interestingly, American press photographers, often at the insistence of picture editors who wanted to have sharp prints from large negatives they could then crop, continued to use the bulky Speed Graphic for decades after European photojournalists switched in the 1920s to the much smaller Ermanox and the 35mm Leica and then, in the early 1930s, the Contax.

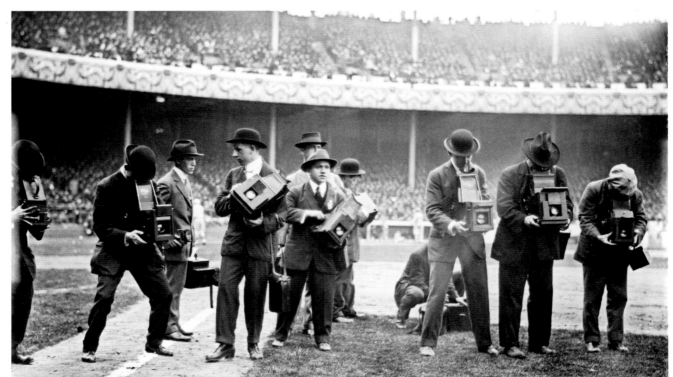

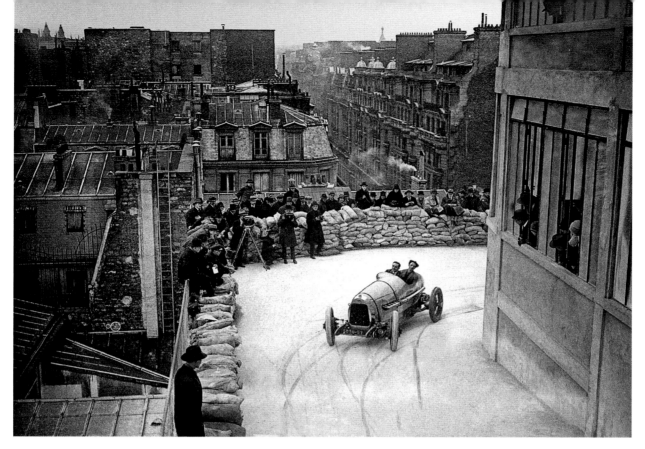

Anonymous, The newly built Banville Garage, the world's first multistory parking garage, in the 17th arrondissement of Paris, serves as the hill climb for a car race. World champion Robert Benoist in his six-cylinder, 5.1 liter Delage passes photographers at the ready, February 25, 1927.

Rochester, New York, introduces the Speed Graphic, the most famous press camera in the United States for many decades. This press camera is a large-format camera (up to 5 × 7 inches) that can be handheld and focused with a built-in rangefinder. The focal plane shutter allows the use of a wide range of lenses and had a top speed of ¹⁄₁,₀₀₀ of a second. Manufacturing of the camera, with improvements, especially in the 1940s, continues until 1973.

1912 The first use of a photo finish camera in the Olympic Games is at the Stockholm Olympics. The camera is used once to decide the second- and third-place finishers of the 1,500-meter running final.

1920s

1925 Leica introduces the 35mm focal plane miniature camera, the first commercially successful 35mm camera. With the combination of mechanical precision and a high-quality lens, the photographer is now able to shoot with what is now called a "miniature" camera and make enlarged photographs from the negatives instead of carrying the bulky equipment of the day.

1928 The Ermanox 4.5 × 6-cm focal plane plate camera of 1928 becomes a favorite of photojournalists. It is well suited for sports photography, with its very fast f/1.8 lens, allowing the use of very high shutter speeds to capture fast-moving action. This model is discontinued in 1931, made obsolete by the Leica and the soon-to-be released Contax.

1928 The Rolleiflex twin lens reflex camera is introduced and becomes popular with photojournalists, since it produces high-quality images from a relatively compact camera.

1930s

1931 Dr. Harold Edgerton produces the first electronic flash tube and during the 1930s perfects high-speed flash photography and the multi-flash technique, which records multiple images in rapid succession on one sheet of film.

1932 The Bush Vario-Glaukar is considered the first true zoom lens. Designed for 16mm movie cameras like the Bolex, it allows cinematographers, for the first time, to zoom in on the action while filming.

1932 The "Kirby Two-Eyed" photo finish camera was used at the 1932 Los Angeles Olympics for timing the decathlon. Developed jointly by Gustavus T. Kirby, president of the U.S. Olympic Committee, and C. H. Fetter, a Western Electric engineer, it photographs the finish through one lens and a clock through the other lens. It is accurate to $\frac{1}{100}$ of a second.

1934 William A. Kuenzel, a Detroit news photographer, is credited with building the first Big Bertha camera. These are never mass-produced but usually are made from a Graflex 5 × 7-inch body with a 28-inch Zeiss Triplet or a 40-inch Dallmeyer f/8 telephoto lens. In 1937 a fast-focusing "gear-shift" model is developed by George

Anonymous, Ernie Sisto, foreground, with the Graflex "Big Bertha." Behind him is Frank Hurley, with probably an early Hulcher. The Big Bertha was usually a 5 x 7 Graflex with a 40-inch lens. They were never mass-produced, so the configuration varied. A smaller Speed Graphic press camera is between the two big ones. Taken at the old Yankee Stadium, Bronx, New York, late 1950s or early 1960s

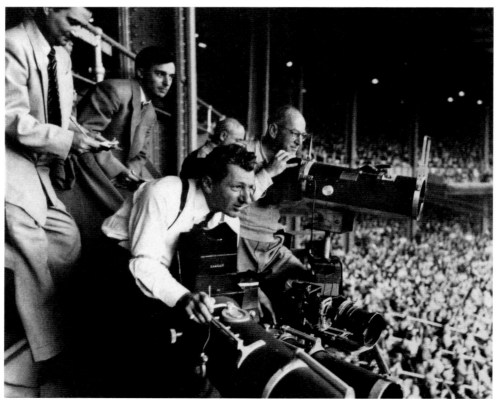

Schmidt of the New York *Daily News.* Around 1940 the 60-inch Dallmeyer f/8 is introduced, which is too long for baseball but used for other sporting events.

1936 Kodachrome 35mm film is introduced with an ISO speed of 8, too slow to capture motion. This is the first high-quality multilayered color film.

1936 Zeiss Ikon develops two accessories for the Contax 35mm rangefinder camera to help photograph the Berlin Olympic Games. The Zeiss Ikon rifle stock that the Contax camera is mounted on is developed by the famous sports photographer Lothar Rübelt. The other accessory is a chest tripod, which was designed to steady the camera when using the heavy f/2.8 18cm Zeiss Sonnar lens.

1937 The first photo finish camera using strip photography, invented by Lorenzo del Riccio of Paramount Studios, is installed at Bing Crosby's Hollywood racetrack, the Del Mar Turf Club.

1938 Leica introduces the motor drive for the Leica 35mm rangefinder cameras. This spring-wound motor drive is the first such attachment for 35mm cameras. Motors are introduced for cameras because they can wind the film for the next exposure faster than by hand. This is of great importance to sports photographers, who are trying to capture the action. This clockwork motor takes shots at 2 frames per second and can take 12 photographs in quick succession with a single winding.

1940s

1946 Kodak introduces Ektachrome color transparency film with an ISO speed of 8. The processing of Ektachrome is much simpler than Kodachrome and could be done by the user.

1948 The Hasselblad 1600F is introduced. This medium-format single lens reflex camera becomes popular with fashion and wildlife photographers. It is sometimes used in sports photography, where the utmost quality is needed.

1948

Polaroid Land Model 95 Instant Folding Camera, the first of Edwin Land's instant picture cameras, is introduced. The Polaroid produces "instant" photographs in minutes instead of the days previously required to get film developed and printed. Polaroid cameras become popular for decades with amateur photographers.

1950s

1952 The Hulcher 70 camera is introduced. It can shoot 50 frames a second on 70mm film. The Hulcher camera is well suited for sports photography. It is considerably faster than the 2 or 3 frames per second of 35mm camera motor drives at this time, but slower than the 1,000 frames per second high-speed cameras used for scientific research.

1959 High-speed Ektachrome film is introduced with an ISO of 160, and by 1968 Kodak is offering push processing to bring the speed up to ISO 400.

1960s

1960 Goodyear installs a camera in one of its blimps and uses it to cover a sporting event at the Orange Bowl, the first time shots from a blimp are broadcast on national television.

George Silk photographs the athletes for the 1960 USA Olympic tryouts with a strip camera for the July 18, 1960, issue of *LIFE* magazine (see page 234).

This photo was taken with what is variously called a strip camera, a slit camera, a streak camera, or a linescan camera. A film camera records a very narrow slit of just the finish line and the film is moving continuously at a set rate past the slit. With digital cameras this is just 1 pixel wide and usually 1,000 to 2,000 times a second. So anything that is stationary appears blurred and anything moving is captured. If you know the exact rate of the film or the frequency of the digital capture you can measure, on the

photograph, the precise time between runners, horses, etc.

1960 The Calypso 35mm film camera is introduced. The invention of the world-famous oceanographer Jacques Cousteau, it is designed by Jean de Wouters and made in France. Instead of taking a camera and putting it in a cumbersome waterproof underwater housing, the Calypso is a small camera designed to work without a housing down to 200 feet. This makes underwater photography practical even for the novice scuba diver.

1960 Canon introduces the Canonflex R 2000 35mm SLR with a top shutter speed of ½,₀₀₀ of a second, only months after the Konica F, the first 35mm SLR with that top speed, was introduced.

1960 The Nikon F 35mm single lens reflex camera is introduced shortly before the 1960 Olympics. The Nikon F quickly becomes the camera of choice for sports photographers. By the Tokyo Olympic Games in 1964, the Nikon F, with its line of telephoto lenses, has almost completely replaced the large folding press cameras of earlier years.

1961 The Reflex-Nikkor 1,000mm f/6.3 lens for the Nikon rangefinder mount is introduced. It has three elements in two

Robert Riger, "Laffey falls at Becher's Brook," Grand National, Aintree Racecourse, Merseyside, England, April 1964. Some photographers have doubled-up press cameras to allow them to shoot in rapid succession. A 35mm camera has been placed underneath the fence by one of the photographers, who triggers it with a long cable release.

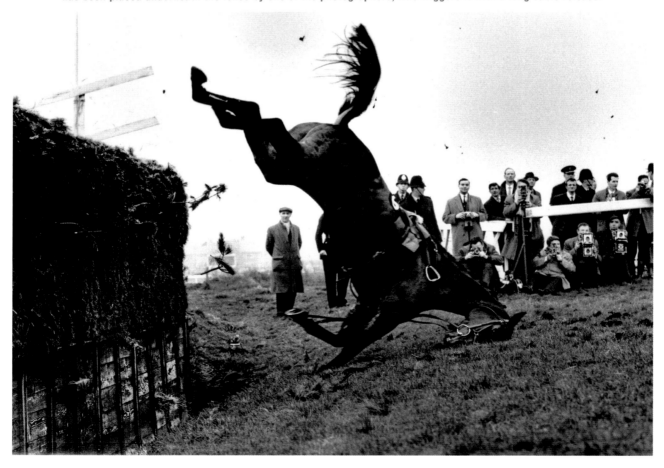

groups in a 470mm long × 232mm diameter lens, and weighs almost 22 pounds. It is reintroduced in 1963 in Nikon F mount for Nikon SLR cameras. It is used extensively in the 1964 Tokyo Olympics.

1963 The Graph-Check sequence camera is introduced. It has eight lenses and ¹⁄₁,₀₀₀-second shutters that fire in rapid succession to give a series of eight small photographs on one sheet of Polaroid film. It is advertised as a way to analyze one's golf swing and is used as a training aid in other sports.

1963 Nikon takes over production of the Calypso 35mm underwater film camera and renames it the Nikonos. Nikon introduces several improved models until manufacturing stops in 2001 due to slowing sales and the increase of digital imaging.

1964 The Nikon S3 Olympic 35mm rangefinder camera is introduced. Although the Nikon S3 rangefinder camera is discontinued in 1961, a batch of 2,000 black cameras is sold in 1964 to commemorate the XVIII Tokyo Summer Olympic Games.

1970s **1972** To top Nikon, Canon develops the fastest motor-drive camera up to that time, the High Speed F-1 for the 1972 Olympics. Its fixed pellicle mirror allowed continuous viewing at 9 frames per second. It was available only to news and sports photographers by special order.

1972 The Nikon F high-speed 35mm single lens reflex camera is introduced. Fitted with a more powerful motor drive, this camera is capable of speeds of up to 7 frames per second with the mirror locked up. It is used at the Winter Olympics in February 1972 in Sapporo, Japan.

1976 For the Olympic Games in Montreal, Nikon catches up to Canon in the motor-drive speed race with a Nikon F High Speed incorporating a pellicle mirror and capable of 9 frames per second.

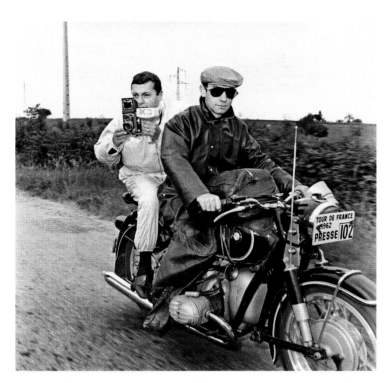

André Lecoq, photographer for *L'Équipe,* on back of a motorcycle shooting the Tour de France, Stage 5 (race against time) with a Rolleiflex with an electronic flash unit, July 6, 1962

1978 Konica C35 AF is the first point-and-shoot autofocus camera.

1978 Ektachrome 400 is introduced. With an ISO of 400, it is the fastest transparency film of its day.

1981 The Pentax ME F is the first 35mm autofocus SLR but it works only with the SMC Pentax AF 35 mm–70 mm f/2.8 zoom lens.

1980s **1983** Nikon makes the Nikkor 300mm f/2 ED IF lens in Nikon Ai-S mount, comprising 11 elements in 8 groups. It is 330mm long × 183mm diameter and weighs 17 pounds. This lens is developed to cover indoor sporting events at the 1984 Winter Olympics in February at Sarajevo. It is the fastest production 300mm lens ever made for 35mm SLRs.

1984 In July 1984, Canon conducted a trial of a professional color still video

camera (the prototype for the RC-701) and an analog transmitter at the Los Angeles Olympics. During the broadcasting of the men's marathon, the automobile telephone attached to the electronic transmitter failed to work, and the information had to be transmitted over a public telephone. The images were transmitted back to Japan in less than 30 minutes. They were then printed in the Yomiuri newspaper.

1984 Kodak introduces Ektachrome P800/1600 35mm color transparency film for the Winter Olympics at Sarajevo. This film has an ISO of 800 and can be push processed to an equivalent of ISO 1600.

1984 Canon develops the new F-1 high-speed 35mm single lens reflex camera. This is a special version of the F-1 for high-speed sequence photography at up to 14 frames per second. The camera is designed for press photographers at the 1984 Los Angeles Olympic Games. Only about 100 cameras are produced.

1984 Fuji introduces Fujichrome 1600 35mm film for the summer Los Angeles Olympic Games. With an ISO speed of 1600, it can easily be used with shutter speeds of over $\frac{1}{1,000}$ of a second.

1984 The Skycam is first publicly used at an NFL preseason game in San Diego between the Chargers and the 49ers, televised by CBS. It uses a system of computer-operated wires and pulleys to move the camera above the field.

1984 The blimp's usefulness as a broadcast tool drastically increases in 1984, when the airships begin to be outfitted with a gyro-stabilized camera mount that can carry the largest broadcast lens, a Canon 40X telephoto. The mount is introduced by Winged Vision, Bob Mikkelson's company. Cameras stationed in blimps can now pick up the numbers on a player's jersey or a golf ball in the grass.

1986 The Canon model RC-701 SLR-type still-video camera is introduced. It

Reuters-Seiko, Official photograph taken with a streak camera showing Kerron Clement of the United States crossing the finish line to win the men's 400-meter hurdles during the 12th IAAF World Championships in Athletics, Olympic Stadium, Berlin, August 18, 2009

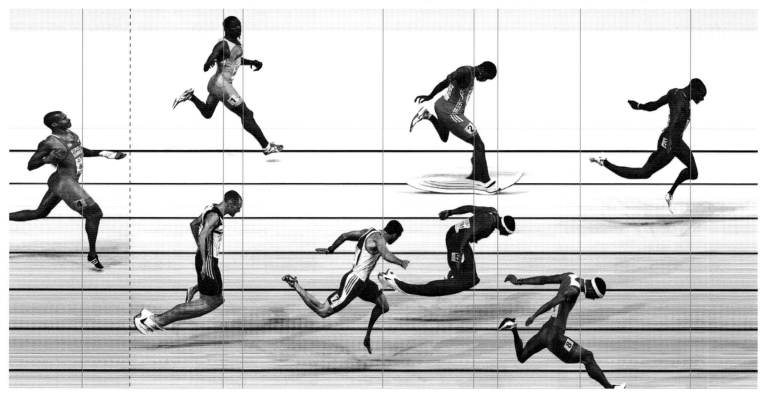

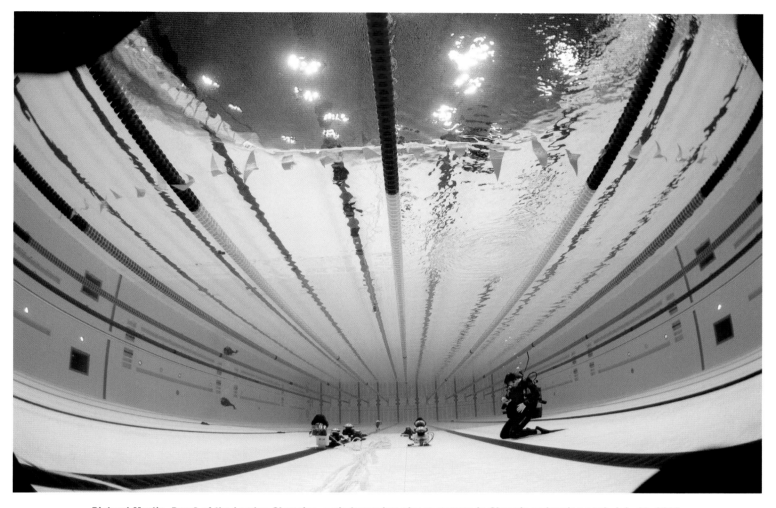

Richard Martin, Day 2 of the London Olympics, a photographer places camera in Olympic swimming pool, July 29, 2012.

produces 50 still-video frames on a 2½-inch floppy disk. For a brief period in the late 1980s, before the introduction of digital cameras, still-video cameras are sold by several manufacturers.

1987 The world's fastest color negative film, Konica SR-V3200, is introduced, with a speed of ISO 3200.

1989 The FUJI DS-X, the first consumer handheld digital camera, is sold to the public. It stores digital images on a flash card and has a 15mm f/3.5 lens with shutter speed of ⅓₀ to ⅕₀₀ of a second, and has a built-in flash. The price is $20,000 for the complete system.

1990s

1990 The Nikon Zoom lens 1200–1700mm f/5.6–f/8.0, Nikon Ai-S mount is introduced. It features 18 elements in 13 groups, is 237mm in diameter × 880mm long, and weighs 35 pounds. This special-order lens is the longest focal length zoom ever made. It is specifically designed to capture a pitcher, catcher, and batter in one frame while shooting from a press box.

1994 The Olympus Deltis VC-1100, the first digital camera capable of transmitting images over phone lines without a computer or other device, is introduced.

1995 Canon introduces the first optically stabilized interchangeable lens, the EF 75-300mm F4-5.6 IS USM. This reduces the appearance of camera shake, allowing photographers to use slower shutter speeds or long focal length lenses handheld and get sharper images.

1998 The Nikon F3 high-speed 35mm single lens reflex camera is introduced. It has a top speed of 13.5 fps (frames per second)—the fastest Nikon film camera ever made and faster than the Canon EOS 1n RS at 10 fps.

2000s

2001 Canon launches the EOS-1D, a 4-megapixel professional digital single-lens reflex camera capable of shooting at eight frames per second with a top shutter speed of 1/16,000 of a second.

2004 Nikon introduces a prototype underwater housing for their digital SLRs that, when placed on the bottom of a pool looking skyward, will focus on the swimmers on the surface. These cameras are operated by remote control from the sidelines. This system is first used by Agence France-Presse at the 2004 summer Olympics in Athens. At the Beijing Olympics, in 2008, the cameras are fitted with zoom lenses that can be controlled at a distance and remote monitors to see through the camera lenses.

2004 GoPro launches its first camera, the 35mm Hero.

2005 Kodak EasyShare One is the first camera with built-in Wi-Fi connectivity. It allowed for emailing photos, uploading them to the Web, and printing wirelessly.

2006 The GoPro Digital Hero hits the market, with 10-second bursts of VGA quality video but no audio.

2007 Nikon introduces the D3, a 12-megapixel professional SLR with a top ISO setting of 25,600. It is able to

Anonymous, FIFA World Cup 2006. Remote cameras set up behind net, December 6, 2006

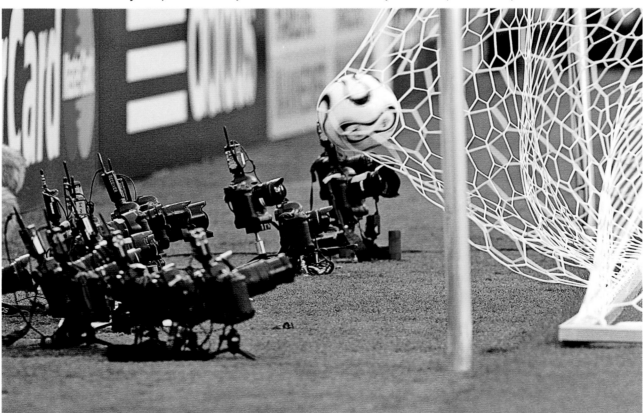

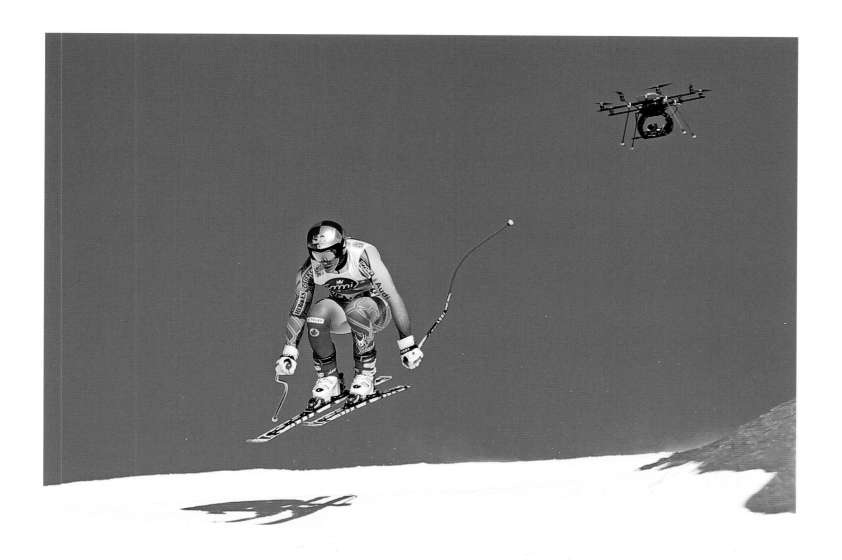

Arnd Wiegmann, Wiegmann photographs Canada's Erik Guay during the second practice of the men's alpine skiing World Cup downhill race and a TV drone (not a quadricopter but an eight-rotor robocopter, or "octocopter") flies behind him. Lauberhorn in Wengen, Switzerland, January 12, 2012

stop action or take photographs by candlelight.

2008 Nikon introduces the D90, the first digital SLR camera with video capabilities.

2009 Kodachrome film is discontinued.

2009 At the Rome World Aquatics Championships, Nikon and Extrem' Vision demonstrate a remote-controlled underwater robot camera that moves along the bottom of the pool following the swimmers.

2009 Robotic remote-controlled cameras are tested by Reuters at the World Championships in Athletics in Berlin. The cameras are able to be placed where a photographer cannot go, such as on a ceiling looking down on the athletes. Partially for security reasons, this

technology was used widely in the 2012 London Summer Olympics (see page 248).

2010s

2010 GoPro introduces the Hero HD, with 1080 video and a 127-degree wide-angle lens.

2013 Sports photographer Brad Mangin shoots professional baseball with his iPhone and publishes *Instant Baseball: The Baseball Instagrams of Brad Mangin.*

2013 Kodak discontinues Ektachrome color transparency film.

2014 Drones are used in the 2014 Winter Olympics in Sochi for filming skiing and snowboarding events. Some advantages of using unmanned aerial vehicles in sports are that they allow video to get closer to the athletes, and they are more flexible than cable-suspended camera systems. Drones are also used for still photography, but the lines between still and video are becoming blurred. A Nikon or Canon DSLR can take bursts of video, so a photographer will take a few seconds of video and then choose the perfect still frame. The video mode is being used like a 30fps motor drive.

2014 The Nikon D4s and Sony α ILCE-7S cameras are introduced, with a maximum ISO speed of 409,600.

2015 Fox uses drones to cover the U.S. Open Golf championship at Chambers Bay, Washington.

BIBLIOGRAPHY

Abaza, Alexander. *Alexander Abaza*. Moscow: Moscow House of
Photography, 2005.

Adam, Hans Christian. *Eadweard Muybridge: The Human and
Animal Locomotion Photographs*. Cologne: Taschen, 2014.

Adelman, Bob, and Susan Hall. *Out of Left Field: Willie Stargell
and the Pittsburgh Pirates*. New York: The Two Continents
Publishing Group, 1976.

Alexander, Jesse. *Looking Back with Jesse Alexander*. Santa
Barbara, California: At Speed Press, 1982.

Anderson & Low. *Athlete/Warrior*. London: Merrell Publishers,
2005.

———. *Black Sand: Surfers in Taiwan*. U.K.: Lucky Panda Press,
2013.

———. *Endure: An Intimate Journey with the Chinese Gymnasts*.
Chicago: Serindia Contemporary, 2012.

Andre, Dena, and Jane Livingston, editors. *Visions of Victory: A
Century of Sports Photography*. New York: Pindar Press, 1996.

Arnell, Peter. *O Wonderful, Wonderful and Most Wonderful,
Wonderful! And Yet Again Wonderful . . .* New York: Sidney
Press, 1991.

Arte Fotográfico Futbolístico Mexicano, Febrero/Marzo, 1983.
Mexico City: Museo Rufino Tamayo, 1985.

Atkeson, Ray, and Warren Miller. *Ski and Snow Country:
The Golden Years of Skiing in the West, 1930s–1950s*. Big Sky,
Montana: Warren Miller, 2004.

Barbieri, Olivo. *Alps: Geographies and People*. Ravenna: Danilo
Montanari Editore, 2012.

Barnes, Simon. *Eamonn McCabe Photographer*. London:
Kingswood Press, 1987.

Barrat, Martine. *Do or Die*. New York: Penguin, 1991.

Barthes, Roland. *What Is Sport?* Translated by Richard Howard.
New Haven: Yale University Press, 2007.

Baumann, Erich. *Sport-impressionen: Ein Bildband mit 120 der
schonsten Farbfotos von Eric, Eieter un Hannelore Baumann*.
Künzlsau and Salzberg: Sigloch Service Edition, 1977.

Benetti, Paolo, and Ermenegildo Anoja. *Ruggers*. Padova, Italy:
Biblos Edizioni, 1990.

Bernstein, Andrew D. *NBA Hoop Shots: Classic Moments from a
Super Era*. San Francisco: Woodford Press, 1996.

Best Shots: The Greatest NFL Photography of the Century. New
York: DK Publishing, 1999.

Biever, Vernon, and Peter Strupp, editor. *The Glory of Titletown:
The Classic Green Bay Packers Photography of Vernon J. Biever*.
Dallas, Tex.: Taylor Publishing, 1997.

Braun, Marta. *Picturing Time: The Work of Étienne-Jules Marey
(1830–1904)*. Chicago: University of Chicago Press, 1992.

Burnett, David. *Emotion: L'anima dello Sport*. Grazia Neri
Edizioni, 1996.

Burnett, David, Jason Evans, Christopher Furlong, and John
Huet. *The Art of Motion: A Photographic Expression of the 2012
London Games*. Lausanne, Switzerland: International Olympic
Committee, 2012.

Cahan, Richard, and Mark Jacob. *The Game That Was:
The George Brace Baseball Photo Collection*. Chicago:
Contemporary Books, 1996.

Callahan, Sean, and Gerald Astor, with the editors of Alskog,
Inc. *Masters of Contemporary Photography Photographing
Sports: John Zimmerman, Mark Kauffman and Neil Leifer*. Los
Angeles: Alskog, 1975.

Callanan, Fionnbar. *A Sporting Eye*. Dublin: Liberties, 2005.

Cannon, David, and Nick Edmund, editor. *Visions of Golf*.
Hexham, U.K.: Kensington West Productions, 1994.

Cariou, Patrick. *Surfers*. New York: powerHouse Books,
1997.

Clark, Robert. *First Down Houston: The Birth of an NFL
Franchise*. Houston: Museum of Fine Arts, 2003.

Clarkson, Rich. *Notre Dame Football Today*. New York: Pindar
Press, 1993.

———. *Texas Longhorn Football Today*. New York: Pindar Press,
1993.

Close-Up, vol. 15, no. 1, Winter 1985, "Spirit of Sport."
Cambridge, Mass.: Corporate Communications Group of
Polaroid Corporation, 1985.

Constable, George. *The XI, XII, & XIII Olympiads: Berlin 1936–*

St. Moritz 1948 (Olympic Century series). Los Angeles: World Sport Research & Publications, 1996.

Çorman, Richard. *Prep: The Spirit of a High School Football Team*. Brooklyn: powerHouse, 2008.

Cranham, Gerry, Richard Pittman, and John Oaksey. *The Guinness Guide to Steeplechasing*. Enfield, Middlesex: Guinness Superlatives, 1979.

Cranham, Gerry, and Christopher Poole. *The Guiness Book of Flat Racing*. Enfield, Middlesex: Guinness Superlatives, 1990.

Curtis, Verna Posever. *Photographic Memory: The Album in the Age of Photography*. New York: Aperture, 2011.

Dafoe, Frances. *Figure Skating and the Arts: Eight Centuries of Sport and Inspiration*. Atglen: Schiffer Publishing, 2011.

Davis, David. *Play by Play: Los Angeles Sports Photography, 1889–1989*. From the Photography Collection of the Los Angeles Public Library. Santa Monica: Angel City Press, 2004.

Demos, John. *1896–1906 Greece: Images from Stereoscopic Photographs*. Athens: Aperion Photos, 2004.

Duffy, Tony, and Paul Wade. *Winning Women: The Changing Image of Women in Sports*. New York: Times Books, 1983.

Edgerton, Harold E., and James R. Killian Jr. *Moments of Vision: The Stroboscopic Revolution in Photography*. Cambridge: MIT Press, 1985.

Fabianis, Valeria Manfrerto de. *Sport*. Vercelli, Italy: Cubebook, 2010.

Fafalios, Stamos, and Alkiki Tsirgialou. *The First Modern Olympics—Athens 1896*. London: Hellenic Centre and Benaki Museum, 2012.

Finke, Brian. *2-4-6-8: American Cheerleaders and Football Players*. Interview with Kathy Ryan. New York: Umbrage, 2003.

Fleder, Rob, editor. *Sports Illustrated 50th Anniversary Book*. Introduction by Frank Deford. New York: Sports Illustrated Books, 2004.

Frey, Theo. *Theo Frey Fotografien*. Zurich: Limmat Verlag/ Fotostifung Schweiz, 2008.

Friedrich, Thomas, editor. *In Bewegung/In Motion: Leichtathletik un Fotografie 1884–2009/Athletics and Photography*. Berlin: Berlin Organizing Committee, 2009.

Frissell, Toni. *Toni Frissell: Photographs, 1933–1967*. New York: Doubleday, 1994.

Frizot, Michel. *Le Passe Compose: Les 6x13 de Jacques-Henri Lartigue*. Paris: Centre National de la Photographie et l'Association des Amis de Jacques-Henri Lartigue, 1987.

Fry, C. B., editor. *The Book of Cricket: A Gallery of Famous Players*. London: George Newnes, 1899.

Gaines, Charles. *Pumping Iron: The Art and Sport of Bodybuilding*. New York: Simon & Schuster, 1974.

Garner, Joe, and Bob Costas. *100 Yards of Glory: The Greatest Moments in NFL History*. New York: Houghton Mifflin Harcourt, 2011.

Gautrand, Jean-Claude. *Visions du Sport: Photographies 1860–1960*. Aix-en-Provence, France: Admira, 1989.

Getty Images. *Visions of Sport: The World's Greatest Sports Photography*. Kingston upon Thames, U.K.: Vision Sports Publishing, 2011.

Gottesman, Jane. *Game Face: What Does a Female Athlete Look Like?* New York: Random House, 2001.

Greene, Vivien, editor. *Italian Futurism, 1909–1944*. New York: Guggenheim, 2014.

Grobet, Lourdes. *Lucha Libre: The Family Portraits*. Mexico City: Editorial RM, 2009.

Hall, Roger, Gordon Dodds, and Stanley Triggs. *The World of William Notman: The Nineteenth Century Through a Master Lens*. Boston: David R. Godine, 1993.

Hammel, Bob, and Rich Clarkson. *Silver Knight: 25 Remarkable Years of Championship Indiana Basketball*. Bloomington: Herald-Times/A Rich Clarkson Book, 1997.

Heimann, Jim, editor. *LeRoy Grannis: Surf Photography of the 1960s and 1970s*. Cologne: Taschen, 2010.

Herschdorfer, Nathalie, editor. *High Altitude: Photography in the Mountains*. Milan: 5 Continents Editions, 2011.

Hoeffgen, Thomas. *African Arenas*. Ostfildern, Germany: Hatje Cantz, 2010.

Hoff, Charles. *The Fights: Photographs by Charles Hoff*. Selected and with an introduction by Richard Ford. San Francisco: Chronicle Books, 1996.

Holm, Ed. *Yachting's Golden Age, 1880–1905*. New York: Alfred A. Knopf, 1999.

Holmes, Burton. *The Olympian Games in Athens, 1896: The First Modern Olympics*. New York: Grove Press, 1984.

Hoon, Will. *Football Days: Classic Football Photographs by Peter Robinson*. Foreword by Michael Palin. London: Michael Beazley, 2003.

Hoone, Jeffrey. *Contact Sheet: Toby Old*. Syracuse: Light Work, 2005.

Howalt, Nicolai. *78 Boxers*. Copenhagen: Hjørring, 2011.

Huet, John. *Soul of the Game: Images and Voices of Street Basketball*. New York: Melcher Media/Workman Publishing, 1997.

The IOC Best of Sport Photographic Contest. Numbers 2–10. Lausanne, Switzerland: IMS/Studio, 1990–98.

Iooss, Walter Jr. *Athlete*. New York: Sports Illustrated Books, 2008.

Jackson, Phil, and Andrew D. Bernstein. *Journey to the Ring: Behind the Scenes with the 2010 NBA Champion Lakers*. San Leandro, California: Time Capsule Press, 2010.

Jackson, Phil. Introduction to *50 Amazing Years in the City of Angels: Los Angeles Lakers*. San Leandro, Calif.: Time Capsule Press, 2009.

Jeck, Rolf, and Max Pusterla. *Sportreporter Lothar Jeck: Fotografien, 1918–1948*. Basel: Christoph Merian Verlag, 1997.

Jones, Roxanne, and Jessie Paolucci. *Say It Loud: An Illustrated History of the Black Athlete*. New York: Ballantine/ESPN Books, 2010.

Jordan, Michael. *Rare Air: Michael on Michael*. Photographs by Walter Iooss Jr., edited by Mark Vancil. San Francisco: Collins, 1993.

Joukowsky, Artemis A. W., and Larry Rothstein. *Raising the Bar: New Horizons in Disability Sport*. New York: U.S. Paralympics/Umbrage, 2002.

Kaenel, Philippe, Markus Schurpf, and François Vallotton. *Hans Steiner: Chronique de La Vie Moderne: Alles Wird Besser*. Lausanne: Musée de l'Élysée, 2011.

Kalinsky, George. *Garden of Dreams: Madison Square Garden: 125 Years*. New York: Stewart, Tabori & Chang, 2004.

———. *New York Knicks: World Champions*. New York: Madison Square Garden, 1974.

———. *Shooting Stars*. New York City: Simon & Schuster, 1992.

Kalisher, Simpson. *The Alienated Photographer*. New York: Two Penny Press, 2011.

Katz, Harry. *Baseball Americana: Treasures from the Library of Congress*. New York: Smithsonian Books, 2009.

Kidney, Christine. *Muhammad Ali: The Illustrated Biography*. New York: Welcome Rain Publishers, 2009.

Krout, John Allen. *The Pageant of America: Annals of American Sport*. New Haven: Yale University Press, 1929.

Kuper, Simon. *Magnum Soccer*. London: Phaidon Press, 2002.

La mesure du corps sportif 1904–1924. Exhibition Galerie Saint-Germain, November 4–18, 2011. Paris: Iconothèque de l'INSEP, 2011.

Langeland, Henrik H. *Oslo 2012*. Photographs by Tom Sandberg. Oslo: Forlagetpress, 2011.

Leifer, Neil. *The Best of Leifer*. New York: Abbeville, 2001.

———. *Guts and Glory: The Golden Age of American Football*. Cologne: Taschen, 2011.

Lemmon, David. *Cricket Reflections: Five Decades of Cricket Photographs*. Newton Abbott, Devon: David & Charles, 1985.

Levinthal, David. *Baseball*. New York: Empire Editions, 2006.

Lewis, David Levering, and Deborah Willis. *A Small Nation of People: W. E. B. Du Bois and African American Portraits of Progess*. New York: Amistad, 2003.

LIFE: The Olympics. From Athens to Athens. An Illustrated History of the Summer Games. Commemorative Edition, 2004.

Little, David E. *The Sports Show: Athletics as Image and Spectacle*. Minneapolis: University of Minnesota Press, 2012.

Loengard, John. *LIFE Photographers: What They Saw*. Boston: A Bulfinch Press Book, 1998.

Maddow, Ben. *Faces: A Narrative History of the Portrait in Photography*. Boston: New York Graphic Society, 1977.

Mangin, Brad. *Instant Baseball: The Baseball Instagrams of Brad Mangin*. Petaluma, Calif.: Cameron & Company, 2013.

Mangin, Brad, and Brian Murphy. *Championship Blood: The San Francisco Giants— 2014 World Series Champions*. Petaluma, Calif.: Cameron & Company, 2015.

———. *Never. Say. Die. The San Francisco Giants: 2012 World Series Champions*. Petaluma, California: Cameron & Company, 2013.

Mather, Philippe D. *Stanley Kubrick at Look Magazine: Authorship and Genre in Photojournalism and Film*. Bristol, U.K.: Intellect, 2013.

Mattura, Franco, editor. *The Art of Donald Miralle*. Rome, 2012.

Maube, Gregory. *Surfing Photographs by Sylvan Cazenave*. Paris: Fitway Publishing, 2004.

McCabe, Neal, and Constance McCabe. *Baseball's Golden Age: The Photographs of Charles M. Conlon*. New York: Abradale Press, Harrry N. Abrams, 1993.

———. *The Big Show: Charles M. Conlon's Golden Age Baseball Photographs*. New York: Abrams, 2011.

Modica, Andrea. *Minor League*. Washington, D.C.: Smithsonian Institution Press, 1993.

Morgan, Susan. *Martin Munkacsi*. Aperture 128, 1992.

Murphy, Brian, and Brad Mangin. *Worth the Wait*. San Diego: Skybox Press, 2013.

Murrell, Adrian. *Cricket Impressions*. London: Kingswood Press, 1987.

Nicholson, Geoffrey. *Eamonn McCabe: Sports Photographer*. London: Aurum Press, 1982.

Old, Toby. *Times Squared*. Chesterfield, Mass.: Chameleon Books, 2002.

Pack, Jon, and Gary Hustwit. *The Olympic City*. Self-published, 2013.

Paish, Wilf, and Tony Duffy. *Athletics in Focus*. London: Lepus Books, 1976.

Palley, Reese, and Anthony Dalton. *The Best of Nautical Quarterly,* Volume 1: *The Lure of Sail*. St. Paul: MBI Publishing, 2004.

Papanicolaou-Christensen, Aristea. *The Panathenaic Stadium: Its History over the Centuries*. Athens: Historical and Ethnological Society of Greece, 2013.

Parkes, Marty. *Classic Shots: The Greatest Images from the United States Golf Association*. Washington, D.C.: National Geographic Society, 2007.

Payson, Eric. *Bobcats*. New York: powerHouse, 2002.

Pfrunder, Peter, editor. *Jules Decrauzat: Der erste Fotoreporter der Schweiz, 1879–1960*. Basel: Echtzeit Verlag, 2015.

Pol, Andri, and David Signer. *Gruezi: Strange Things in Heidiland*. Zurich: KONTRAST Verlag, 2007.

Pratt, John Lowell, and Jim Benagh. *The Official Encyclopedia of Sports*. New York: Franklin Watts, 1964.

Reed, Billy. *The Final Four: Photographs by Rich Clarkson*. Lexington, Kentucky: Host Communications, 1988.

Regan, Ken. *Knockout: The Art of Boxing*. San Rafael, California: Insight Editions, 2007.

Reiferson, Paul. "He Wears the Mask," *Southwest Review,* vol. 100, no. 3, 2015.

Reuters Sports in the 21st Century. London: Thames & Hudson, 2007.

Reyburn, Susan. *Football Nation: Four Hundred Years of America's Game from the Library of Congress*. New York: Abrams, 2013.

Riger, Robert. *The Athlete: An Original Collection of 25 Years of Work*. New York: Simon & Schuster, 1980.

———. *Man in Sport: An International Exhibition of Photography*. Baltimore: Baltimore Museum of Art, 1967.

———. *The Pros: A Documentary of Professional Football in America*. Commentary by Tex Maule. New York: Simon & Schuster, 1960.

———. *The Sports Photography of Robert Riger*. New York: Random House, 1995.

Riger, Robert, and Branch Rickey. *The American Diamond: A Documentary of the Game of Baseball*. New York: Simon & Schuster, 1965.

Rodger, George. *Village of the Nubas*. New York: Phaidon Press, 1999.

Rosenfeld, Stanley. *A Century Under Sail*. Reading, Massachusetts: Addison-Wesley, 1984.

Rübelt, Lothar. *SPORT Die wichtigste Nebensache der Welt*. Vienna: Fritz Molden, 1980.

Schaap, Dick. *The Illustrated History of the Olympics*. New York: Alfred A. Knopf, 1975.

Schatz, Howard. *At the Fights: Inside the World of Professional Boxing*. New York: Sports Illustrated Books, 2012.

———. *Athlete*. New York: HarperCollins, 2002.

Schlegelmilch, Rainer W. *Formula 1: Portraits of the 60s*. Cologne: Könemann, 2004.

Schulke, Flip, with Matt Schudel. *Muhammad Ali: The Birth of a Legend, Miami, 1961–1964*. New York: St. Martin's Griffin, 1999.

Scott, Brough, and Gerry Cranham. John Livesey, editor. *The World of Flat Racing*. London: Peerage Books, 1983.

Sheed, Wilfred. *Muhammad Ali: A Portrait in Words and Photographs*. New York: Alskog, 1974.

Shelton, Ann. *Metadata*. Auckland, New Zealand: self-published, 2011.

Silverman, Barton. *Capturing the Moment*. New York: Penguin, 1996.

Silverman, Ruth. *Athletes: Photographs, 1860–1986*. New York: Alfred A. Knopf, 1987.

Sites et Jeux: XVI Jeux Olympiques d'Hiver Albertville, Savoie, 1992. Photographies de Raymond Depardon. Lyon: Fondation Nationale de La Photographe, 1992.

Smith, Chris. *Sport in Focus*. Haywards Heath, England: Partridge Press, 1987.

Smith, Ron. *Baseball: 25 Greatest Moments; Milestones and Memories of Our National Pastime*. St. Louis: The Sporting News, 2002.

Sports Illustrated: Greatest Pictures; Memorable Images from Sports History. New York: Time Inc. Home Entertainment, 1998.

Spotlighting the Sporting Body. Musée Olympique. Exhibition, October 10, 2002–February 23, 2003.

Stechyk, C.R. III, and Glen E. Friedman. *DogTown: The Legend of the Z-Boys*. New York: Burning Flags Press, 2000.

Steer, Duncan. *Cricket: The Golden Age; Extraordinary Images from 1859 to 1999*. London: Cassell Illustrated, 2003.

Subway Series. New York: Bronx Museum of the Arts, Queens Museum of Art, zingmagazine, 2004.

Szarkowski, John. *The Photographer's Eye.* New York: Museum of Modern Art, 1966.

Tennant, John. *Rugby: The Golden Age.* London: Cassell Illustrated, 2005.

Terret, Thierry. *Jacques Henri Lartigue: A Sporting Life.* Paris: Actes Sud/Hermès, 2013.

Toschi, Livio. *Art of Wrestling/Wrestling in Art: Antiquity.* Rome: Fila, 2010.

Trifari, Elio. *Cube Book: Sport.* Edizioni White Star, 2010.

Uzzle, Burk, and Martha Chahroudi. *All-American.* St. David's, Pennsylvania: St. David's Books, 1984.

Vandystadt, Gérard. *Le Regard du Sport.* Ville du Havre: Gérard Vandystadt, 1977.

———. *Sports: Passion Photos.* Halifax: Gérard Vandystadt, 1990.

Vandystadt, Gérard, editor. *Sportives.* Suresnes, France, 1990.

Vennum, Thomas Jr. *American Indian Lacrosse: Little Brother of War.* Washington, D.C.: Smithsonian Institution Press, 1994.

VICTORY. Victoryjournal.com.

Villegas, José Luis, and Marcos Bretón. *Home Is Everything: The Latino Baseball Story.* El Paso: Cinco Puntos Press, 2002.

Visions of Sport: Celebrating Twenty Years of Allsport. New York: Pelham Books, 1988.

Visser, Dirk-Jan, and Arthur Huizinga. *Offside: Football in Exile.* Edam, Holland: Paradox, 2012.

Walter, Jean-Denis, ed. *Hobo by L'Équipe.* Paris: Editions L'Équipe, 2012.

Wancke, Henry. *Visions of Tennis: A Celebration of the Work of the Allsport Photographic Agency.* London: Quiller Press, 1996.

Ward, Geoffrey, and Ken Burns. *Baseball: An Illustrated History.* New York: Alfred A. Knopf, 1994.

Williams, Richard, editor. *In the Moment: The Sports Photography of Tom Jenkins.* London: Guardian Books, 2012.

Wombell, Paul. *Sportscape: The Evolution of Sports Photography.* London: Phaidon Press, 2000.

Wood, Norton, editor. *The Spectacle of Sport from Sports Illustrated.* Englewood Cliffs: Prentice Hall, 1957.

Wright, Graeme. *Test Decade: 1972/1982.* Kingswood, Surrey: World's World, 1982.

XII Salón Internacional de Fotogranfia Esportiva: Children's Sport. Reus, Catalunya: Organització Club Natació Reus "Ploms," 1992.

XVI Bienal Internacional de Fotografia de l'Esport. Reus, Catalunya: Organització Club Natació Reus "Ploms," 2000.

Yalouris, Nicolaos, editor. *The Eternal Olympics: The Art and History of Sport.* New Rochelle: Caratzas Brothers, 1979.

Ziegel, Vic. *Summer in the City: New York Baseball, 1947–1957.* New York: Harry N. Abrams, 2004.

Toni Frissell, Dawn on the Oklahoma Track, Saratoga, New York, 1963

ACKNOWLEDGMENTS

Sarah Frank and Jonathan Marder are my collaborators on *Who Shot Sports*. Their encouragement, enthusiasm, efforts, insights, and professionalism have been a source of constant support. Jessica White is much more than my assistant. She is my backup and memory—better than any external hard drive and more fun. Her dedication, organizational skills, and experience working with photographs have been invaluable.

Luke Janklow, my literary agent, has always steered me in the right direction and away from pitfalls. He brought me to Knopf, one of the world's most distinguished publishers, and to my editor, Victoria Wilson, one of the best in the field. Wilson has been editing and championing photography books (and much more) for as long as I have been writing them. I am deeply honored to have her as my editor, backed by her colleagues: Audrey Silverman and Ryan Smernoff, editorial assistants; Iris Weinstein, book designer; Carol Carson, jacket designer; Rita Madrigal, production editor; and Roméo Enriquez, production manager.

Dr. Arnold Lehman, former director of the Brooklyn Museum, enthusiastically embraced my proposal to have a major museum exhibition on the history of sports photography. Simultaneously, while researching and writing this book, I developed, with the staff of the Brooklyn Museum, an exhibition on this subject. My appreciation goes out to Anne Pasternak, Shelby White and Leon Levy Director of the Brooklyn Museum; Sharon Matt Atkins, vice director, Exhibitions and Collections Management; Matthew Yokobosky, chief designer; Lisa Small, curator of exhibitions; Emily Annis, curatorial assistant; and Dolores Farrell, exhibitions manager.

Steve Fine, former director of photography at *Sports Illustrated*, gave invaluable advice and guidance. He introduced me to the greatest sports photographers and editors, and prepared lists of contact information for the people he believed should be included in the history. The selection of people and pictures is my own; Steve is not responsible for omissions, additions, and my final decisions. His book would be quite different.

Nigel Russell, a world expert on cameras and photographic technology, kindly agreed to do the Technology Timeline of equipment and materials used in sports photography. His contribution is a wonderful addition to the book and something I could not have done myself.

Hundreds of people assisted my research, but the following were especially generous with their knowledge: Dr. Hans Christian Adam, Kevin Baker, Larry Canale, Noel Chanan, Tim Clayton, David Davis, Tony Duffy, Jean-Claude Gautrand, Darrell Ingham, Mark Leech, Brad Mangin, Anne Morin, Renee Pappas, Paul Reiferson, Marcus Schürpf, Bob Thomas, and Anne Wilkes Tucker.

Caretaking of a collection often falls to family members. I have been welcomed into many photographic archives by loving custodians and spoke or corresponded at length with others about the photographers in their family. I would like to thank the following relatives: Ariel Aberg-Riger, Dawn Aberg, Victoria Riger Phillips, Robert Paris Riger, Adrienne Auricho, Dieter Baumann, Damon Bingham, Mary Delaney Cooke, Thomas Pelham Curtis II, Mary Engel, Elena Prohaska Glinn, Victoria and Alex Haas, Rolf Jeck, Jesse Kalisher, Ioannis Lampakis, David Mallinson, Lauren Field McGrath, Beverly Ornstein, Tom Paine, Preston Reynolds, Georgina Silk, Ernie Sisto Jr., and Greg and Linda Zimmerman. David Nieves, executor of Nat Fein's estate, was like a son to Fein.

Karen Carpenter, the executive director of Multimedia Licensing, Rights Management and Swimsuit Operations for *Sports Illustrated*, has a special place in sports photography. It is through her that I was introduced to many of the family members and photographers. She champions and protects her photographers—past and present—as does no one else in the field. She is generous with her knowledge and her guidance was instrumental to the successful completion of this book.

Not family, but right hands to the photographers and very helpful to me were Marilyn Cadenbach, Chris Steppig, Caroline Gaudriault, and Tomasz Lewandowski.

Who Shot Sports is a wide-ranging survey and I turned to experts in many areas of photography for help. I would like to thank Stuart Alexander, Professor Marta Braun, Marcelo Brodsky, Bobbi Baker Burrows and Russell Burrows, Genoa Caldwell, Tony Decaneas, Sir Harold Evans, James Fox, Jim Gaines, Andres Gunthert, Nathalie Herschdorfer, Gary Hershorn, Dr. Emanuel Hübner, William Hunt, David Lansley, Bronwen Latimer, Ken Lieberman, Patrick Montgomery, Alison Nordström, Shawn O'Sullivan, Julia Scully, Lefteris Skiadas, Katherine Slusher, Helena Srakocic-Kovac, Sara Stevenson, Joe Struble, Rick Swig, Enrica Viganò, Bodo von Dewitz, Edward Wakeling, Stephen White, Deborah Willis, and Steve Yates.

Colleagues at museums, libraries, and archives were generous with their knowledge, advice, and access to their collections. I would like to thank Jenny Ambrose, assistant photographic archivist, and John Horne, photographic archivist, National Baseball Hall of Fame; Julia Andrews, director, Fine Arts Program, National Geographic Creative; Marion Beckers, chief curator, and Elisabeth Moortgat, independent curator, Das Verborgene Museum, Berlin; Linda Benedict-Jones, former curator of photography, Carnegie Museum of Art, Pittsburgh; Rebekah Burgess, former archivist, *LIFE* Picture Collection; Thomas Cazentre, curator of photography, Département des Estampes et de la Photographie, Bibliothèque Nationale de France; Phyllis Collazo, photo rights and permissions editor, *New York Times;* Sean Corcoran, curator of photography, Museum of the City of New York; Julian Cox, founding curator of photography and chief curator, de Young Museum, San Francisco; Malcolm Daniel, curator, Department of Photography, Museum of Fine Arts, Houston; Julia Danly, curator, Portland Museum, Oregon; Martine D'Astier, director, Donation Jacques-Henri Lartigue; Iveta Derkusova, deputy director for collections, Latvian National Museum of Art; Natasha Derrickson, collection manager, Art Institute of Chicago; Dr. Deborah G. Douglas, director of collections and curator of science and technology, MIT Museum; Jay Fisher, deputy director for curatorial affairs and senior curator of prints, drawings and photographs, Baltimore Museum of Fine Arts; Roy Flukinger, senior research curator, Harry Ransom Center, University of Texas, Austin; Todd Gustavson, curator, Technology Collection, George Eastman House; Claire Guttinger, service des archives, Collège de France, Paris; Casey Harden, Muhammad Ali Center, Louisville, Kentucky; Vivi Hatzigeorgiou, head, and Mathilde Pyrli, archivist, Photographic Archive, Hellenic Literary and Historical Archive-National Bank Cultural Foundation (ELIA-MIET), Athens; Karen Hellman, assistant curator, Department of Photography, J. Paul Getty Museum; Ekaterina Inozemtseva, Multimedia Art Museum, Moscow; Anna Jedrzejowski, collections coordinator, Ryerson Image Centre; Allison N. Kemmerer, Mead Curator of Photography and Curator of Art after 1950, Addison Gallery of American Art; Nora Kennedy, Sherman Fairchild Conservator of Photographs, and Meredith Friedman, collections manager, Department of Photographs, Metropolitan Museum of Art; Brian Liddy, associate curator, National Media Museum, Bradford; Tasha Lutek, senior cataloguer, Department of Photography, Museum of Modern Art; Sofia Maduro, curator and director, Fundación Alberto Vollmer, Venezuela; Laurent Mannoni, Directeur scientifique du Patrimoine et du Conservatoire des techniques, and Laure Parchomenk, Chargée des collections d'appareils, Cinémathèque Française; Niki Markasioti, curator of photography, National Historic Museum, Athens; Elizabeth Meissner, director of the Volkerding Center for Research and Academic Programs, Center for Creative Photography, Tucson; Joerg Mitter, head of photography, Limex Image Production GmbH; Leigh Montville, associate director, Condé Nast Licensing; Alison Morrison-Low, principal curator, Historic Scientific Instruments and Photography, National Museums Scotland, Edinburgh; Linda Brscoe Myers, associate curator of photography, Harry Ransom Center, University of Texas, Austin; Gael Newton, formerly senior curator of photography, National Gallery of Australia; Dominik Petermann, coordinator, data and document management communications and public affairs division, FIFA; Denis Paquin, deputy director of photography, AP; Peter Pfrunder, director, Fotostiftung Schweiz, Winterthur; Michaela Pfunder, curator of photography, National Library, Vienna; Christopher Phillips, curator, International Museum of Photography; Stephen Pinson, curator of photography, Metropolitan Museum of Art; Roger Porteous, archivist, Twyford School; Françoise Reynaud, senior curator, Museé Carnavalet; Hilary Roberts, research curator of photography, Imperial War Museum; Neil Robinson, research officer, Marylebone Cricket Club; Jeff Roth, manager, *New York Times* Archives; Michel Scotto, director of photo business development, and Anne Lorre, Responsable corporate Edition à la Photographie, Agence France-Presse (AFP); Kerin Shellenbarger, archivist for the Teenie Harris Collection, and Akemi May, curatorial assistant, Carnegie Museum of Art; Agnès Sire, director, and Aude Raimbault, collections, Fondation Henri Cartier-Bresson; Leslie Squyres, director of the

Volkerding Center for Research and Academic Programs, Center for Creative Photography, University of Arizona; Dr. Terry Todd and Dr. Jan Todd, directors, and Cindy Slater, assistant director, Library Services, H. J. Lutcher Stark Center for Physical Culture and Sports, University of Texas, Austin; Angela Troisi, former head of photo sales, *Daily News;* Aliki Tsirgialou, head of department, Photographic Archives, Benaki Museum; Shawn Waldron, senior director, archive and records, Condé Nast; Dr. Stephan Wassong, director, Olympic Studies Centre, German Sport University; Louisa Watrous, intellectual property manager, Mystic Seaport; William Williams, curator of photography, Haverford College; Kate Worm, collections curator, Hickory Museum of Art; Charles Zoeller, special projects manager, Associated Press; Del Zogg, former manager, Collections and Study Center, Museum of Fine Arts, Houston.

I acknowledge the help provided by gallery owners and their dedicated staffs: Nailya Alexander; James Danziger; Keith deLellis; David Fahey; Peter Fetterman; Tom Gitterman; Howard Greenberg and Karen Marks; Hans P. Kraus Jr.; Sid and Michelle Monroe; Daniel Miller; Bruce Silverstein, Meredith Rockwell, Natalie Cothren; and, in Paris, Jean-Denis Walter.

The Library of Congress is one of my favorite places to research because of the wealth of material and the dedicated staff. I would like to thank Helena Zinkham, chief, Prints and Photographs Division and curators Beverly Brannan, Verna Posner Curtis, and Sara Duke.

Getty Images, which includes the Hulton Archive, has the largest repository of sports photography. I am appreciative of the access and assistance provided to me by Lee Martin, senior vice president, Sports; Matthew Butson, vice president, Hulton Archive; Darrell Ingham, consultant archive editor; Sarah McDonald, former curator of the Hulton Archive; and Janey Marks, senior director, Strategic Alliances.

INSEP in Paris has a wonderful archive, especially rich in nineteenth- and early-twentieth-century photographs related to the study and training of athletes. The director and curators of the photographic and film archives were extremely generous with their time—and their collection. I would like to thank Patrick Diquet, Julien Faraut, and Christophe Meunier for their assistance.

Also in Paris, I worked with François Gille, chef de service desk photos at *L'Équipe.* Olivier Michon, responsable Agence Presse Sports, kindly facilitated my research in this important sports archive.

Although I was not able to visit the Archive of Modern Conflict in person, the staff in Toronto scoured their collection for sports-related materials. I would like to thank Neil MacDonald, Jill Offenbeck, Lizzie Powell, and Amanda Shear.

Including photographers from many countries necessitated my dependence on a team of translators and interpreters. A special thank-you goes to Delphine Dautremont-Smith, who assisted me on my research trips in France. Others who helped with interviews and translations are Adia Adamopoulou, Kevin Buckland, Alessandra Capodacqua, Charleyne Dautremont-Smith, Amaranta Herrero, and Tasja Keetman.

The International Olympic Committee seeks to unite nations and people through sport. I have been very fortunate to have members of this "family" be supportive of my vision and my work. I would especially like to thank Frédérique Jamolli, head of international cultural development; David Parietti, international program project manager; and Fernando Scippa, archivist.

Many of my friends know a great deal about sports and were helpful in answering my questions. Thank you, Jack Cox, Bill Dautremont-Smith, Andrew Taylor, Andy Olesker, Elizabeth Olesker, and Mervyn Turner.

No one helped me navigate pitfalls and faux pas more than my son-in-law, Stephen Jackson Taylor. I showed him the text and he corrected wrong terminology and unschooled observations. He was wonderful, knowledgeable, and supportive, but all mistakes are mine alone.

My daughter Alaina Juliet Taylor was keenly organized and effective when I needed help. Everett Winthrop Cox III suggested my doing a book and exhibition on sports photography after he witnessed the success of *Who Shot Rock and Roll.* I am still talking to him. My granddaughter, Ivy Dorset Taylor, provided my greatest recreation during the writing of this book.

Finally, but foremost, I thank the photographers. This book is a tribute to them.

Martha Holmes, Exuberant Brooklyn Dodgers fans on Flatbush Avenue celebrating the
Dodgers winning the 1955 World Series over the New York Yankees

INDEX

Page numbers in *italics* refer to illustrations.

Aaron, Hank, 25
Abaza, Alexander, 131
ABC, 25, 28
Abdul-Jabbar, Kareem, 93
Academy of Arts (San Francisco), 59
Acme, 117
Action Photography exhibition, 84
Adam, Hans Christian, 229, 266–7
Adams, Ansel, 57, 136, 241
Adams, Franklin Pierce, 264
Adams, Russ, 68–9, *69*
Adamson, Robert, 259–60, *259*
Afghanistan, *57*, 58, 214
Afghanistan: Sport Under Fire (Seguin), *57*, 58
Africa, 177–80, 195, 208–9, 210, 212–13
African Arenas series (Hoeffgen), 209
Agence France-Presse (AFP), 37, 136, 141, 162, 302
AIC Bulletin, 24
Aintree Racecourse, *298*
Alaska, 48, *134*, 136
Aldecoa, Ignacio, 182
Alexander, Jesse, 113–14, *113*, 154
Alexander, Nailya, 131
Ali, Lonnie, 62
Ali, Muhammad (Cassius Clay), xi, 62, *72*, 95, *95*, *96*, 98, 107, 171, *171*, 172, *173*, 175, 181
All Africa Dream Team, 213
All Arab Games, 210
Allen, Forrest "Phog," 117
Allen, Jules, 180–1, *180*
Allsport, ix, 9, 16, 48, 112, 113, 120, 128, 133–4, 139, 142–3, 235, 237, 257
All-Star Game (1960), *23*
Alpha Phi Alpha, 292
Al Shabaab, 210

Alter Gogo (Esiebo), 212, *212*
Ameche, Alan, 79
American Athlete (Anderson and Low), 122
American Diamond, The (Riger and Rickey), 28
American Photo, xi
American Photographer, 40, 188
American Sports, 1970, or How We Spent the War in Vietnam (Papageorge), 119
American Tobacco Company, 263, 264
America's Cup, *32*, 41, 280, *282*, 283
Anderson, Jonathan, 122
see also Anderson and Low
Anderson, Sherwood, xii
Anderson and Low, 90, *90*, 121–3, *121*, 221
André, Géo, *291*
Andres, Erich, 228–9, *228*
André the Giant, 60, *61*
Andretti, Mario, 98
Angell, Roger, 287
Animal Locomotion (Muybridge), 268–9, *268*
Anschütz, Ottomar, 269–70, *270*, 293–4
Apeiron Workshops, 43
Aperture, 119
Arizona State University, 18–19
Arledge, Roone, 28
Armstrong, Lance, 65
Armstrong, Neil, 235
Art Center College of Design, 108, 241
Arthur Gilbert Table Tennis Center, *201*
Arthur Griffin Center for Photographic Art, Boston, Mass., 74

Art Institute of Chicago, ix, 24, 28, 79
Ashe, Arthur, 69
Associated Press (AP), x, 10, 51, 117, 145, 151, 189, 213, 214, 285
Astor, Gerald, 38, 237
Astrodome, *47*, *171*, 172
AT&T Park, *48*, *143*
Atget, Eugène, 50, 139
Athens, Greece, 223, 226
 1896 Olympics in, 223–7, *224*, *225*, *226*, *227*, 272
 2004 Olympics in, 89, 302
 2004 Paralympics in, *249*
Athlete, The: The Influence of the Athlete on Modern Life exhibition, 24
Athletes: Photographs, 1860–1986 (Silverman), ix
Atkeson, Ray, 218, *219*
Atlanta Committee for the Olympic Games (1996), 88
Atlanta Falcons, *58*
Atlanta Olympics (1996), xi, 88
At the Fights (Schatz), 185
Augusta National Golf Club, 68
Australia, 48, *112*, 200, *248*
Australian, 129
Australian Gymnastics Championships, *250*
Austria, 5
Auto Graflex cameras, *294*
Avedon, Richard, 145, 160
Az Est, 14

Babe Bows Out, The (Fein), 75, *75*
Bach, Clarence A., 38, 239
Bacon, Francis, 177, 182, 268
Bain, George Grantham, 285–6
Baker, Kevin, 37
Baker Field, *122*
Baldessari, John, 133, 257

Baldwin, James, 176
Bale, Switzerland, 216
Ball, Doc, 31
Baltermants, Dmitri, 131
Baltimore Colts, 24, *26*, 110, *110*
Baltimore Museum of Art, 28, 64
Baltimore Orioles, *144*
Banks, Ernie, 53, *116*
Bannister, Roger, 39
Banville Garage, *295*
Barbaro, *151*
Barbieri, Olivo, 246, 266
Barcelona, Spain, 181, 189, 202, 230
 1992 Olympics in, 151, 255, *255*
 Olympic City in, 257–8
Barnack, Oskar, 149
Barnes, Simon, ix
Barr, Charlie, *282*
Barth, Nadine, 209
Barthes, Roland, x, xi, xii, 61, 65, 189, 265
Baseball Americana (Katz), 264
Baseball's Golden Age (McCabe and McCabe), 287
"Baseball's Sad Lexicon" (Adams), 264
Basel, Switzerland, *217*, 227
Basilio, Carmen, *ii*, *174*
Basin (political artist group), 202
Basque region, 205, *206*, *207*
Batista, Fulgencio, 199
Batkovic, Suzy, *248*
Battle, Ashley, *18*
Baugh, Sammy, *146*, 147
Baumann, Erich, 56, 149–50, *150*
Baumgartner, Felix, 168
Bavarian Track and Field Championships, *153*
Baylor, Elgin, *165*
Bazin, Master, *274*
Beamon, Bob, 235, 236, *236*

Beaton, Cecil, 14, 286
Beau, Jules, 283, *283*, 285
Beck, Robert, 148, *148*, 239
Beckham, Odell, Jr., *17*
Beckwith, Carol, 179–80, *179*
Bednarik, Chuck, xi, 17
Beijing, China, 213
 2008 Olympics in, 151, *246*,
 258, 302
Beken, Alfred, 282
Beken of Cowes, 282
Belgium, 205
Belgium Grand Prix, 114
Bell & Howell cameras, 38
Bell Centre, *187*
Bello, Al, 9, *10*, 17, *17*, 48, 57, 134,
 162–3, 237
Belmont Stakes, xi
Benaki Museum, 223
Benepe, Alex, 152
Benoist, Robert, *295*
Berlin, Germany, 14, 51, 131, 230,
 239, 303
 1936 Olympics in, 5, 7, 218,
 228, 229–31, *230*, *231*, 297
Berliner Illustrirte Zeitung, 7, 14
Berman, Morris, 17
Bernstein, Andrew D., *106*, 107–9
Berra, Yogi, xi, *22*, 53, 127, *160*, 161
Best of Sports Illustrated, The, 109
Betsen, Serge, 104, *105*
Bianchi, Lucien, *155*
Bibliothèque Nationale, 285
Biever, Jim, 78, 79, 162
Biever, John, 78, *161*, 162
Biever, Vernon, 78–9, *78*, *99*, 162
Big Bertha cameras, 23, 24, 145,
 231, 296, *296*
Big Shot cameras, 93
Bikila, Abebe, 237, *238*
Bingham, Howard, 62–3, 107
Binstock, Joshua, *257*
Birkos, Nikolaos, 227
Bishop Auckland soccer team,
 147, *147*
Bisson, Auguste-Rosalie, 266, *266*
Black Panthers, 63
Black Power movement, xi, 63
Blackrock College, 20
Blake, Arthur, *224*
Blake, Tom, 30
Blessing, Jennifer, 75
Blow-Up (film), 254
Blue Dunk (Iooss Jr.), 125–7, *126*

Blue Horizon venue, *188*
Blue Mosque (Istanbul), *168*
Boigey, Maurice, 278
Bolex cameras, 296
Bolt, Usain, *36*, 37
Bolton Wanderers, *54*
Bonds, Barry, 59
Borodulin, Lev, 131, *131*, *132*
Bosnia, 255, 257–8, *258*
Boss, David, 254
Bost, Pierre, ix
Boston, Mass., 45, 74, 252, 282
Boston Bruins, *164*
*Boston Globe Rotogravure
 Magazine,* 74
Boston Herald, 69
Boston Herald-Traveler, 4
Boston Public Library, 4
Boston Red Sox, *3*, 23–4, *53*, 74,
 252
Boswell, Thomas, 74
Botham, Ian, 112, *112*
Botswana, 89
Bourke-White, Margaret, 57, 88,
 109
Boutan, Louis, 294
Boxing (Fink), 188, 189
Boy in the Bubble (Clayton), 129,
 129
Brace, George, 53
Bradshaw, Ian, 60, *60*
Brady, Tom, 109
Brandt, Bill, 56
Braun, Marta, x, 268, 270, 272
Brazil, *2*, *56*, 57, *257*
Brescia, Matty, *116*
Britannia (yacht), *32*
British Aerospace, 37
British Journal of Photography, 16
Brodovitch, Alexey, 14
Brooklyn, N.Y., 9, 89, 108, 174,
 185, 263, *314*
Brooklyn Athletics, 263
Brooklyn College, 145
Brooklyn Dodgers, 38, 100, *160*,
 161, 172, 174, 198, *314*
Brown, Jim, 25, 162
Brown, Roosevelt, 25
Bruegel, Pieter, 42
Bruno, Luca, 10–11
Brunskill, Clive, 69
Bruty, Simon, 134, 142–3, *142*,
 237, *241*, *322*
Bryant, Kobe, *106*, 107, 108

Buchanan, James, 262
Burke, George, 53
Burke, Thomas, *224*, *225*
Burnett, David, xi, 241, 244–6,
 244, *245*, *246*, 252
Burton, James, 282, *282*
Bush Vario-Glaukar lens, 296
Busienei, Janeth Jepkosgei, *239*,
 241
By Motorcycle Through the Clouds
 (film), 5
Byron Company, 280–3, *281*

Caesar, Julius (cricketeer), 262
Caffyn, William, 262
Cahier, Bernard, 113
California, 23, 31, 38, 81, 93, 120,
 236, 254, 266
 1960 Olympic trials in, 234,
 234, 235
California, University of
 at Los Angeles (UCLA), 133,
 257
 at Santa Barbara, *18*
California, University of Southern
 (USC), 148, 254
Callahan, Sean, 38
Calypso cameras, 31, 298, 299
Canada, 45, *253*, *257*, 265, *303*
Canadian Broadcasting
 Company, 65
Candlestick Park, *111*
Cannon, David, 139, *139*, 143, 237
Cannon, Jimmy, 174, 176
Canon, 31, 237, 298, 299–301, 302,
 304
Canon Portugal, 195
Capa, Cornell, 161
Capa, Robert, 65–6, *65*, 81, 89
Capodacqua, Alessandra, 10
Caraion, Marta, 265
Carbro process, 81
Carpenter, Karen, 237
Carpenter, Robert, 262
Carroll, Lewis, 260–2, *261*
Carter, Robin "Hurricane," *175*
Cartier, Walter, *176*, 186
Cartier-Bresson, Henri, 3, 7–9, *8*,
 14, 38, 56, 57, 127
Cascade National Park, *34*
Castelton Tower, *35*
Castro, Fidel, 44, 52, 53, 199
Cathedral of Learning, *39*
Cattabriga-Alosa, Sage, *134*

Cavic, Milorad, 151
CBS, 300
Central Park, N.Y., *118*, 119, *156*
Chamberlain, Wilt, 40, 98, 237
Chance, Frank, 264, *264*
Chandler, Don, 25
Charcot, Jean-Baptiste, 270
Charcot, Jean-Martin, 270
Chastain, Brandi, xi
Chattanooga Choo-Choos, 116
Cheevers, Gerry, *164*
Chevalier des Arts et des Lettres,
 104
Chicago, Ill., *vi*, *40*
Chicago Cubs, 53, 264
Chicago Outlaw Motorcycle
 Club, 114
Chicago White Sox, 53, *287*
China, 171, 221, *248*, 255
Chochola, Václav, 77, *77*
Christo, Steve, 31, 129, 200, 251
Cicotte, Eddie, *287*
Cinémathèque française, Paris,
 272
City Ground, Nottingham, En-
 gland, *54*
Clark, Dwight, xi, 17, *111*
Clark, Ellery, *224*
Clark, Jim, 114
Clarkson, Rich, 19, 117–18, *117*,
 242, *243*
Clay, Cassius, *see* Ali, Muhammad
Clayton, Tim, 31, 127–9, *128*, *129*,
 200, 251
Clement, Kerron, *300*
Clerque, Lucien, 189
Cloarec, Pierre, 66
Close-Up, 71
Cobb, Ty, xi, 286
College World Series (2006), *4*
Colombes Stadium, *291*
Colombia, 114, 115
Colorsport, 237
Colton, Jim, 117
Columbia University, 122, 133, 280
Comiskey Park, 172
Committee of Photojournalists
 (Third Reich), 7
Condit, Carlos, *187*
Congress on Physical Education,
 272
Conlon, Charles, 53, 287–9, *287*,
 288
Conn, Didi, 108

Connecticut, University of, *18*
Connors, Jimmy, *69*
Contact Press Images, xi
Contax cameras, 161, 208, *294*, 295, 297
Cooke, Jerry, 51–2, *51*, 64, 255
Cooper Maserati, *155*
Coover, Robert, 71
Córdoba, Iván Ramiro, 10, *11*
Cornell, Katharine, 147
Cosindas, Marie, 156
Cotton Bowl, 45, *45*
Coubertin, Pierre de, 223, 278
Cousteau, Jacques, 31, 121, 298
Craig, Roger, *111*
Cranham, Gerry, 5, 53–6, *54*, 181, *181*
Crawford Colored Giants, 198
Cream of Wheat, 82
Creation, The (Haas), 156
Cricketeer's Almanack (Wisden), 262
Crosby, Bing, 297
Crowley, Conor, 20
Cuba, 44, 52, 199, *199*
Cunha, Pedro, *257*
Curtis, Thomas Pelham, 82, 223, *224*, 227
Curtis, Verna Posever, 230–1
Czechoslovakia, 232

Daguerre, Louis Jacques Mandé, 259, 293
Dallas Cowboys, *17*, 79, *111*
Dallmeyer telephoto lens, 296, 297
Daniel, Leon, 51
Davis, David, ix, 60–1, 119
Day in the Life, A series, 185
Day of Light and Shadows, A (Schwartz), 37
Day of the Fight (film), 186, 188
Daytona Beach, Fla., *43*, 49
Day to Night series (Wilkes), *40*, 41
Dean, Fred, *111*
Death or Play (Grarup), *211*
De Boe, M and Mme, 223
Decker, Mary, 241
Deconstruction Derby, 45
Decrauzat, Jules, 284, *284*
Deer Hunter, The (film), 252
Defender (yacht), 280
Deford, Frank, 127

Degas, Edgar, ix, 24, *111*
Del Mar Turf Club, 297
De Low, Dorothy, 200
del Riccio, Lorenzo, 297
Delton, Georges, 283
Delton, Louis-Jean, 283
Demeny, Georges, x, 104, 123, 269, 270, 272, *273*, *274*, *275*, *276*, 278
Dempsey, Jack, 23, *108*, 109, *177*, 286
Deng Xiaofeng, *121*
Dennis, Adrian, 36, 37, 57, 141, *141*
Densmore Shute, 120–1, *120*
Derby Day, 286–7
de Waal, Roald, *32*
Dewey, John, 280
de Wouters, Jean, 298
Dicatholon (Riefenstahl), *230*, 231
Didrikson, Mildred Ella "Babe," 84
Dierks, Wilhelm, 216
Dijkstra, Rineke, 73, 192–3, *193*
Dillon Gym Pool, *134*
DiMaggio, Joe, 24
Dinka people, 203
Discobolus (Riefenstahl), *230*, 231
Disdéri, André-Adolphe-Eugène, *260*
Dive, The series (Silk), 134, *134*
Diver, Alfred, 262
Doby, Larry, 116, *116*
Dodgson, Edwin Heron, 260
Dominis, John, 38, 145, 255
Donga stick fighting, 179, *179*
Douglas, Deborah, 121
Douglas, Gabby, 254, *254*
Dow, Jim, 45, 46, *47*
Dowling, Bob, 112
Doyle, Ryan, 169, *169*
Drawn to Water series (Osinski), 79
Dress series (Evans), *158*
Dreyfus, Alfred, 284
Dublin Horse Show, *51*
Duchamp, Marcel, 270
Duffy, Tony, 9, 60, 120, 143, 235–7, *236*
Dugan, Ellen, ix
Dulombi, Galomaro, Guinea-Bissau, *194*
Dundee, Angelo, 62
Dunn, Katherine, 189
Dunn, Matt, 129, *129*

Durham, England, 147
Dzubas, Martin, 7, 228

Eadweard Muybridge (Adam), 266
Eakins, Thomas, 24, 268
Ebbets Field, 25, 175
École de Joinville, L', 272, 278
Ecole Pathé, 284
Edgerton, Harold, *15*, 84, 120–1, *120*, 176, 296
Editorial Lumen, 181–2
Edwards, Hugh, ix, 24
Ehret, Theo, 60–2, *61*
Eisenstaedt, Alfred, 51
Ektachrome film, 297, 299, 300, 304
Elbert, Joe, 19
XI Olympiade, Berlin album (Riefenstahl), 230–1, *230*
El Santo, 100
Elsey, Colin, 237
Emory, Javan "Van," 277, *277*
Endeavor (yacht), *32*
Endurance Assault Course, *215*
England, 45, 60, 70, 142, 286
 cricket team of, 112, *112*
Équipe, L', ix, 57, 59, 104, 162, *299*
Équipe SNC, L', 57
Ermanox cameras, 5, *294*, 295
Ertl, Hans, 231, *231*
Esiebo, Andrew, 212–13, *212*
ESPN, 59, 97
Ethiopia, 179, *179*
European Cup, 70
Evans, Jason, 252
Evans, Walker, 45, 57, 90, 158–60, *158*
Evers, Johnny, 264, *264*
Evert, Chris, 93, *93*
Exquisite Mayhem (Ehret), 62
Extrem' Vision, 303

Faces (Maddow), 73
Faking It (Fineman), 265
Fall, Amadou, 203
Family of Man (Steichen), 28
Farrell, Dan, 23, 145
Faure, Lucien, 285
Federer, Roger, 123, *123*
"Federer as Religious Experience" (Wallace), x
Fein, Nat, xi, 75, *75*
Fenway Park, *3*
Ferrari Turbo, *154*, 155

Festival Sportfolio, 187
Fetter, C. H., 296
Fielder, Prince, *161*
FIFA World Cup (2006), *302*
Fights, The (Sullivan), 176, 177
Filipski, Gene, 25
FINA World Championship (2009), *162*
Fine, Steve, 89, 104, 110, 111, 162, 235
Fineman, Mia, 265
Fink, Larry, 188–9, *188*
Finke, Brian, 48–50, *49*
Firestone Country Club, *97*
Fisher, Al, 252
Fisher, Angela, 179–80, *179*
Fisher, Mark, *134*, 136
Fitzmaurice, Deanne, *58*, 59
Flash (Edgerton), 121
Flessel, Laura, *103*
Flicker, Kathy, *134*
Florence, Italy, 252
Florida Derby, *151*
Folmer & Schwing Manufacturing Co., 294–5
Forscher, Marty, 38, 234
Forte de Casa, Portugal, *193*
Foton camera, 38
Frakes, Bill, 18–20, *18*, 118, 166, *166*
France, ix, 7, 9, *57*, 58, 59, *65*, 149, 223, 237, *260*, 270, 285, 294, 298
 Tour de France in, 7, 65–6, *65*, 66, 67, *299*, 304
Franco, Francisco, 202
Fraser, Stewart, 237
Freedman, Jill, 90
French Open (2004), *16*
Frey, Thomas, 50, *50*
Friday Night in the Coliseum (Winningham), 45
Frissell, Toni, 64, *64*, *310*
Frizot, Michel, 270
Fry, C. B., 271, *271*
Fuji, 300, 301
Fulda (steam ship), *224*
Furillo, Carl, *22*

Gaceta Ilustrada, 202
Gallico, Paul, 82, 84
Galloway, Ewing, *286*
Garmisch-Partenkirchen Olympics (1936), 228–9, *228*
Garo, John, 74

Gaudí, Antoni, 257
Gaudriault, Caroline, 104
Gautrand, Jean-Claude, ix
Gavilan, Kid, *176*
Gehrig, Lou, xi, 81, 97, *288*, 289
Geiger, Ken, 255, *255*
George Bain News Service, 280,
 280, 285–6, *294*
George I, King of Greece, *226*,
 227
George III, Prince, *226*
Géricault, Théodore, ix, 24, 104
German Grand Prix (1994), 28, *29*
Germany, 65, 81, 147, 153, 230
Germany, Nazi, 7, 9, 14, 65, 84,
 228, 229, 230, 231, 278
Germany, Olympic athletes of,
 84, 223, 226, *241*
Germeshausen, Kenneth, 121
Gerulaitis, Vitas, *93*
Gervais, Thierry, 285
Getty Images, 9, 109, 112, 162,
 237, 247, 257
Getty Museum, 149
Gichigi, John, 237
Gifford, Frank, xi, 17, 25
Gillette Stadium, *10*, *12*
Gilmore, Gary, 42
Ginella, Matt, 68
Giroux cameras, 293
Glass Magazine, 220
Gleason's Gym, 180, *180*
Glinn, Burt, 44, *44*
Global Imagens, 195
Gloeden, Wilhelm von, *261*
Goebbels, Joseph, 229
Gogo Getters Football Club, 212
Going Texan (Winningham), 45
Goldberg, Vicki, xi
Golden Arm, The (Riger), 25, *26*
Golding, Craig, 31, 128, 200, *200*,
 251
Golf Courses: Fairways of the World
 (Cannon), 139
*Golf Courses: Great Britain and
 Ireland* (Cannon), 139
Golf Magazine, 68
Goodwin & Co., 263
Goodwood Racecourse, *52*, 286
Goodyear, 297
GoPro cameras, 136, 302, 304
Gorbachev, Mikhail, 244
Gorman, Tom, *23*, 24
Gostkowski, Stephen, *10*

Goude, Jean-Paul, 104
Graflex cameras, 252, 287, 294,
 294, 296, *296*
Graham, John, *224*
Graham, Tyler, *4*
Grand National, *298*
Grand Olympic Auditorium, 60,
 61, *61*, 62
Grand Sur shopping mall, *220*
Grannis, LeRoy, *30*, 31
Graph-Check cameras, 299
Grarup, Jan, 210, *211*
Graziano, Rocky, 185, 186, *186*
Great Intimidator, The (Riger), 25
Greece, x, *19*, 120, 223
Green, Todd, *161*
Green Bay, Wis., 79, 162
Green Bay Packers, xi, 78, 79, *99*
Gregg, Forrest, 25, *78*
Gretzky, Wayne, *93*
Grier, Herbert E., 121
Griffin, Arthur, 74, *74*
Griffiths, Philip Jones, 89
Grobet, Lourdes, 100, *101*
Grüezi (Pol and Signer), 139
Grundy, James, 262
Gspon, Switzerland, *138*
Guarantee Photo Studio (later
 GGG), 292
Guay, Erik, *303*
Gudzowaty, Tomasz, 220, *220*, 221
Guildford College of Art and
 Design, 112
Gulfstream Park, *151*
Gursky, Andreas, 67, 208
Gustavson, Todd, *294*
Guttenfelder, David, 213–14, *213*
Gutteridge, Reg, 62
Guy, Buzz, *110*

Haas, Ernst, 156–8, *156*, *157*, 160,
 189, 192, *192*
Hakoah (Jewish sports club), *6*, 7
Halberstam, David, 111, 160
Hall, Edward T., 195
Hamburg, Germany, 228, 229
Hamill, Dorothy, *93*
Harlem, N.Y., 252, 292
Harlem Swimming Team, 292
Harper's Bazaar, 14
Harriman, W. Averell, 218
Harris, Charles "Teenie," 198, *198*
Harris, David, *12*
Harris, Harry, 145

Harvard Crimson, 44
Harvard University, 44, 45
Hasselblad cameras, 23, 297
*Haute-Savoie, Le Mont Blanc et
 Ses Glaciers* album (Bisson),
 266
Havana, Cuba, 44, 195, 199, *199*,
 213, 286
Hayward, Thomas, 262
Henie, Sonja, *229*
Henley, Russell, *139*
Hennah, Thomas Henry, 262, *262*
Hennessey, Brad, 161–2
Henry Street Settlement House,
 172
Hernandez, Aaron, 11, *12*
Herrero, Lucia, 205, *206*, 207
*Herri Kirolak-Departes Vascos,
 Spanish and French Basque
 Country* (Herrero), *206*, 207
"He's a Good Boy Now" photo
 essay (Kubrick), 185, *186*
"He Wears the Mask" (Reiferson),
 277
Hewitt, Charles "Slim," 147–8,
 147
Heysel Stadium disaster,
 69–70, *70*
Hicks, Wilson, 51
High Tops (San Francisco bar), *58*
Hill, David Octavius, 259–60, *259*
Hill, Graham, 113, 156
Hill District (Pittsburgh), 198,
 198
Hitler, Adolf, 51, 84, 177, 218, 228,
 229, 230, *230*, 231
Hoberman, John M., 230
Hoeffgen, Thomas, 208–9, *208*
Hoff, Charles, 22–3, 145, 176–7,
 176
Holcomb, Steven, 222
Holga cameras, 245
Holland, 130
Holm, Ed, 282
Holmes, Burton, 223–4
Holmes, Martha, *314*
Homer, Winslow, 24, 111
Homestead-Miami Speedway, *322*
Hopkinson, Tom, 147
Horse Guards Parade Ground, *257*
Hotel Ansonia, 108, *108*
Hotel Mirabeau, *155*
Houston Astros, *143*
Houston Oilers, *111*

Houston Rockets, 45
Howalt, Nicolai, 73, 182–5, *183*
*Howard L. Bingham's Black
 Panthers 1968* (Bingham), 63
How Life Imitates the World Series
 (Boswell), 74
Hoyt, William, *224*
Huber, Erwin, 231
Huebner, Emanuel, 228
Huet, John, 252, *253*
Hulcher cameras, 23, 129, 145,
 296, 297
Hulton/Archive, ix
Hungary, 14, 80–1
Hunt, George, 160
Hurley, Frank, 17, 23, 145, *296*
Hustwit, Gary, 257–8

IAAF World Championships in
 Athletics, *300*
Iditarod dogsled race, 48
Igman Mountains, *258*
Ignatovich, Boris, 131
Ikoflex II cameras, 147
Illinois Benedictine College, *126*
Illustrated London News, 271
Illustré, L', 216
Imperial Association of the
 German Media, 228
Imperial Commission of
 Photojournalists, 228
India, 49, 112, 214, 221, 278, *278*
Indianapolis 500, 67, 114
Inge Morath Award, 203
Ingham, Darrell, 9, 48, 134
Innsbruck, Austria, 169
Instagram, 214, 304
Instant Baseball (Mangin), 145, 304
Institut National du Sport ed
 de l'Éducation Physique
 (INSEP), 278
Inter Milan, *11*
International Boxing Hall of
 Fame, 172
International Center of
 Photography, 252
International Competition of
 Physical Exercises and
 Sports, 272
International News Photos, 24,
 175
International Olympic
 Committee (IOC), 7, 223,
 226, 228, 230, 244, 252

International Security Assistance Force, *57*, 58

International Tennis Hall of Fame, 69

Iooss, Walter, Jr., 17, 97, *97*, 107, 109–11, *109*, 125–7, *126*, 162, 164–6, *165*, 237

iPhones, 145, 214, 304

Ireland, *19*, 20, *20*, 22, 51, *265*

Ironman World Championship, *216*

Israel, 131, 214

Italy, 61, 65, 133, 230

Jackson, John, 262

Jackson, Phil, 107

Jackson, William B., 282

Jagschitz, Gerhard, 5

Jahn, Friedrich Ludwig "Father," 230

Jakob, Leroy, *22*, 23

Janssen, Pierre Jules César, 270

Jantzen, 218

Japan, 147, 171, *200*, 214, 221, 300

Jarecke, Kenneth, xi

Jeck, Lothar, 6, 216–18, *217*

Jensen, Shannon, 203, *203*, 205

Jeter, Derek, *144*

Jockey Club, 283

Johansson, Ingemar, 171

Johansson, Stefan, *154*

John C. Fremont High School, 38, 239

Johnson, Allen, *122*

Johnson, Benji, *4*

Johnson, Jack, 286

Johnson, Jimmie, *322*

Johnson, Lynn, 88–9, *88*

Johnson, Magic, *87*, 88

Johnston, Frances Benjamin, 285

Jones, Bobby, *289*

Jones, Leslie, *3*, 4

Jones Beach, N.Y., 161

Jordan, Michael, *vi*, 107, 125–7, *126*, 162

Journey to the Ring (Bernstein and Jackson), 107

Joyner-Kersee, Jackie, *91*, 93

Juan-les-Pins, Côte d'Azur, *291*

Jung, Carl, 291

Junior World Wrestling Championships, *251*

Juventus, 69, 70

Kabul International Airport Base, *57*

Kahn, Roger, 75

Kahnawake lacrosse team, *265*

Kamchatka Peninsula, *167*

Kansas, University of, 18, 19, 40, 117

Kansas City Royals, *159*

Kansas City Star, 117, 118

Kaplan, Izzy, 174

Karsh, Yousuf, 56, 74

Katz, Harry, 264

Kauffman, Mark, 31, *32*, 37–9, 56, 145, 255

Kayafas, Gus, 121

Kellerman, Annette, 280, *280*

Kennedy, Jacqueline Bouvier, 64

Kennedy, John F., 23, 42, 64, 244

Kennedy, John F., Jr., 23

Kentucky, University of, *117*

Kentucky Derby, 51, 234

Kenya, 214, *239*

Keyes, Cornelius M., 18–19

Keystone View Company, 284, *289*

Khartoum, 177

Khomeini, Ayatollah, 244

Kiel, Germany, 208

Killian, James R., Jr., 120

Kim Jong-un, 214

Kimmelman, Michael, 257

King Ranch, Texas, 64

Kipling, Rudyard, 123

Kirby, Gustavus T., 296

"Kirby Two-Eyed" cameras, 296

Kirkland, Pee Wee, 252

Kitchin, George William, 260

Kitchin, Xie, 260

Klucis, Gustav, 232, *232*

Kluetmeier, Heinz, 11–12, *12*, 18, 127, 150–1, *151*, 162

Kluge, Volker, 223

Knockout (Regan), 98

Kodachrome film, 50, 174, 297, 303

Kodachrome USA, 112

Kodak, 112, 145, 174, 223, 227, 285, 294–5, 297, 300, 302, 304

Kohlrausch, Ernst, 269, 270

Konica, 298, 299, 301

Kordofan Province, 177, *178*

Korongo Nuba Wrestling Champion (Rodger), 177–8, *178*

Koskie, Corey, 161–2

Kotasin, Montenegro, *163*

Kozloff, Max, 189

Krauss-Zeizz Planar lens, 294

Kron, Josh, 203

Kubrick, Stanley, 185–6, *186*, 188

Kuenzel, William A., 296

Kunstakademie Düsseldorf, 208

Kutschuk, Cecile, 51

Ladies' Home Journal, 81

Lafayette High School, 145

Laforet, Vincent, 246

La Grande Odyssée-Savoie-Mont Blanc sledding race, 136, *137*

Laing or Laine (with racket), 259–60, *259*

Lake Constance, *150*

Lake Placid Olympics (1980), xi

Lampakis, Ioannis, 223, 224, *225*

Land, Edwin, 297

Landy, John, 39

Lange, Dorothea, 88, 109

Larsen, Don, xi

Lartigue, Jacques Henri, 290–1, *290*, *291*

Las Ramblas, Barcelona, 202

Lauberhorn, *303*

Laughead, Jim, 99, *99*

Laureus World Sports, 241

L.A. Weekly, 62

Lebanon, 205

Lecoq, André, *299*

Leech, Mark, 2, 4–5

Leibovitz, Annie, *87*, 88, 93, 127

Leica cameras, 6, 14, 50, 149, 153, 228, 258, *294*, 295, 297

Leicester News Agency, 139

Leifer, Neil, xi, 41, 51, 107, 110, 171–2, *171*, *173*, 175

Lenglen, Suzanne, *290*, 291

Leoben, Austria, 166

Levick, Edwin, 282

Levin, Eric, 188–9

Levitt, Helen, 195

Lewis, Carl, *119*, 120

Lewiston, Maine, 172, *173*

Lhotak, Zdenek, 232–4, *232*

Liberia, 14

Library of Congress, 230, 264, 280

Lienz, Austria, 169

LIFE, 37, 38, 39, 40–1, 48, 51, 63, 64, 84, 95, 129, 147, 151, 160,

164, *164*, 172, 189, 234, 235, 239, 297

Lillywhite, John, 262

Lima, Mauricio, 56–7, *56*

Limex agency, 166, 169

Linhof cameras, 136, 221, 252

Lissywollen Stadium, *19*, 22

Liston, Sonny, xi, 171, 172, *173*, 175

Little, David E., ix

Little League baseball, 80, 195, 198, *198*

Little World Series (1940), 147

Liverpool soccer team, 70, 71

Livingstone, Jane, ix

Lochte, Ryan, *162*

Lockhart, Sharon, 133, 257

Lockyer, Tom, 262

Loengard, John, 38, 39–40

Lombardi, Vince, xi, 24, 25, 78, 79

Londe, Albert, 269, 270

London, England, 9, 48, 112, 120, 122, 139, 143, 195, *196*, *197*, 203, 213, 235, 237, *271*

1948 Olympics in, 38, 56

Twickenham streaker in, 60, *60*

2012 Olympics in, 9, 16–17, *36*, 37, 122, 163, 223, *241*, 247, *248*, 257, *301*, 304

London *Sunday Times,* 71

London *Sunday Times Magazine,* 104

Look, 174, 185, 186, *186*

Los Angeles, Calif., 9, 38, 42, 61, 62, 108, 115, 120, 133, 143, *201*, 237

1932 Olympics in, 296

1984 Olympics in, 19, 88, 237, 241, 300

Los Angeles Dodgers, 25, 107

Los Angeles Kings, 107

Los Angeles Lakers, 107, 108

Los Angeles Memorial Coliseum, 148, *148*

Los Angeles Sentinel, 62

Los Angeles Times, 18, 133

Louganis, Greg, 127, 242, *243*

Louis, Joe, 62, 64, 74, 82, 83, *84*

Louis, Spiridon, *227*

Low, Edwin, 122

see also Anderson and Low

Lowden, William H., 282

Lucerne, Switzerland, 139

Lucha Libre (Grobet), 100

Lucie Award, 12, 100
Luxembourg, 28, 79
Lynch, Dick, *110*
Lyon, Danny, 114, *114*
"Lyric Documentary" (Evans lecture), 158

Maasai Olympics, 179–80
Machu Picchu, Peru, *169*
Mack, Connie, 286
Maddow, Ben, 73
Madison Square Garden, 23, 52, *106*, 164, *175*
Madrid, Spain, 189, 202, *202*
Mærkedahl, Anders, *183*
Magnum Photos, 44, 129, 177, 203
Maier, Hermann, *240*, 241
Maisel, Jay, 42, 127
Major League Baseball, 116, 198, 277
Major Taylor (Beau), 283, *283*
Malzone, Frank, 23–4, *23*
Mamiya, 67, 258
Mangin, Brad, ix, 143–5, *143*, 304
Man in Sport exhibition, 28, 64
Man o' War, 97
Manshel, Xander, 152
Mantle, Mickey, 24, 25
Marciano, Rocky, 175
Marey, Étienne-Jules, x, 104, 123, 268, 269, 270, 272, *272*, 278, 293
Marib, Yemen, *204*
Marko, Sebastian, 169, *169*
Martin, Billy, 25
Martin, Bob, 14, 16–17, *16*, 32, 48, 123, *123*, 124, 125, 143, 214, *215*, 222, 237, 247, *249*
Martin, Lee, 143, 237
Martin, Richard, *301*
Martínez, Sergio, *184*, 185
Martini, Rainer, 153–4, *153*
Martin's Stadium, *116*
Masats, Ramón, 182, *182*, 202, *202*
Mason, W. H., 262
Massachusetts, 280
Massachusetts Institute of Technology (MIT), 84, 120
Mass Games, 214
Masters Golf Tournament, xi, *68*, *139*
Mathieson, Jack, 200
Mauskopf, Norman, 52, *52*

Mayne, Roger, 195, *196*, *197*
Mays, Willie, xi, 17, 23, *23*, 25, 53, 116
McCabe, Constance, 287
McCabe, Eamonn, 69–71, *70*
McCabe, Neal, 287
McDivitt, April, *18*
McEnroe, John, *93*
McGrath, Chris, 247, *248*
McKay, Jim, 25
McLuhan, Marshall, 95
McManus, Ray, 20–2, *20*
McQuillen, Bobby, 180
Megève, France, *137*
Meiselas, Susan, 199, *199*
Melas, Paul, 223
Meltzer, Richard, 62
Merthyr Tydfil, Wales, 181
Mesler, Steve, *222*
Metropolitan Museum of Art, 42, 265
Mexico, 45, 115, 171, 221, 235, 255
 in World Cup, *56*, 57
Mexico City, Mexico, *220*
 1968 Olympics in, xi, 235–6, *236*
Meyer, Albert, 226, *226*, 227
Miami, Fla., 95, *95*, *96*
Miami Dolphins, *10*
Michels, Will, 152, *152*
Mickey Muñoz (Grannis), *30*
Microsoft Theater, 107
Middle East, 205
Middlesex Times, 201
Mikkelson, Bob, 300
Mili, Gjon, 83, *86*
Miller, Peter Read, 254–5, *254*
Miller, Warren, 218
Miller Park, *161*
Milwaukee Brewers, 161, *161*
Minnesota Institute of Arts, 43
Miñoso, Minnie, 53
Miracle on Ice, xi
Miralle, Donald, Jr., 133–4, *133*, *216*, 257, *257*
Missão Dulombi, 195
MIT Museum, 121
Mitter, Joerg, 166–8, *167*, *168*, 169
Mixed Martial Arts series, *187*
Model, Lisette, 160
Modzelewski, Dick, *110*
Mogadishu, Somalia, 210, *211*
Mohan, Paul, *19*, 22
Mohdad, Samer, *204*, 205
Mokao (African guide), 179

Moments of Vision (Edgerton and Killian, Jr.), 120
Monaco Grand Prix, *154*, *155*
Mongolia, 171, 221
Montana, Joe, xi, 17, *111*
Mont Blanc, 265, 266, *266*
Monte Carlo, Monaco, 156
Monte Carlo Sporting Club, 292
Montreal, Quebec, 265, 299
Montreal Canadiens, 164
Morgan, Susan, 13
Morley, Don, 237
Morris, Glenn, *230*, 231
Morris, John, 145
Morrow, Lance, 172
Morse, Ralph, 160–1, *160*
Moscow, Russia, 131, 172, 232
Moses, Edwin, 88
Moss, Stirling, *113*
Mother Jones, 189
Moulinier, Master, *274*
Mudhead, The (Riger), 25
Muhammad Ali: A Thirty-Year Journey (Bingham), 62
Muholi, Zanele, 212
Mullins, Amy, 89
Munich, Germany, 154
 1972 Olympics in, 129, *130*, 131, 299
Munich Olympic Photographic Exhibition, 131
Munkacsi, Joan, 13
Munkacsi, Martin, 6, 13, *13*, 14, 81, 216
Muñoz, Mickey, *30*
Muray, Nikolas, 80–1, 82
Murray, Jim, 62
Murrell, Adrian, 112–13, *112*, 142–3, 237
Musée de l'Elysée (Lausanne), 205
Museum of Fine Arts (Houston), 152
Museum of Modern Art (MoMA), 5, 24, 28, 84, 121, 125, 189, 192, 195, 239
Muybridge, Eadweard, x, 266–9, *268*, 270, 278, 293
"My Eye, My World" workshops, 213
Mythologies (Barthes), 61

Nabokov, Vladimir, 14
Nadal, Rafael, 123, *123*
Nadar, 287, 289

Nagano Olympics (1998), *240*, 241
Namath, Joe, 107, 109–11, *109*, 145
Napoleon III, Emperor of France, 272
National Art Gallery of Malaysia, 122
National Basketball Association (NBA), 107, 108, 109, 203
National Championship (surfing), 200
National Cheerleaders Convention (Old), *43*
National Collegiate Athletic Association (NCAA), 117
National Football League (NFL), 99, 254, 300
 1958 championship game of, *26*, *110*
National Geographic, 51, 88, 118, 163, 177, 255
National Geographic Photographic Fellows, 214
National League, 116, 175, 277
 Championship Series of, 25, *48*
National Library (Vienna), 5
National Portrait Gallery (London), 122
Nature, La, 270
Nazi Ministry of Propaganda, 229
NBC, 28
Neacola Mountains, *134*
Nefertiti (yacht), 41
Negro League baseball, 116, 292
Negro League Baseball (Withers), 116
Neiman, LeRoy, 145
Nelson, Lusha, 83, *84*, *85*
Netherlands, 2, 28, 32, 213, *246*
Neuhauser, Edmund, *229*
Neutral Corner (Masats), 182
New England Patriots, *10*, 12
Newhall, Beaumont, 84
Newhall, Nancy, 84
Newman, Marvin E., *72*, 254–5
New York, N.Y., 9, 14, 28, 43, 51, 52, *63*, 81, 90, 114, *118*, *158*, 172, *180*, 185, 195, 221, 252, 263, *281*, 282, 285
New York Black Yankees, 292
New York Daily Mirror, 174
New York *Daily News*, 22–3, 145, 176, 177, 297
New York Giants (baseball), 53, *294*

New York Giants (football), xi, *17*, 25, *26*, *110*, 147

New York Highlanders, xi

New York Jets, *12*, 109, 110, 111, 145

New York Knicks, 107

New York Mets, 108

New York Rangers, 108, 145, 164

New York Renaissance (Rens), 292, *292*

New York Telegram, 287

New York Times, xi, 23, *23*, 24, 56, *56*, 57, 79, 145, 146, 163, 203, 257

New York Times Magazine, x, 50

New York World, 280

New York Yacht Club, 280

New York Yankees, xi, *3*, *38*, 53, 81, *159*, *160*, 161, *314*

New Zealand, 39, 40, 41, *57*, *128*

NFC Championship (1982), xi, 17

NFL Films, 79

Nicholls, Horace W., *285*, 286–7

Nicholson, Lucy, 201, *201*

Nicklaus, Jack, xi, *93*

Nigeria, 213, 255, *255*
 soccer team of, 147, *147*

Nike, 252

Nikon, 31, 78, 108, 298–9, 301, 302–3, 304

Noblex cameras, 66–7

Noorderlicht Photo Festival, 213

North Carolina, University of, *4*

North Korea, 213–14, *213*

Notman, William, 265

Notre Dame University, 148, *148*

Nottingham Forest, *54*

Nova Belo Horizonte, Brazil, *56*

Novoflex cameras, 208

Nuba people, 177–8, *178*

Nuer people, 203

Nurnberg, Walter, 112

Oakland Athletics, *115*

Oakland Coliseum, *59*

Oates, Joyce Carol, 176

O'Brien, Michael, 60

Observer, 56, 69, 71

Ochoa de Olza, Daniel, 189, *190*

Oerter, Al, 52

Offside Sports, 5

Ogonyok, 131

Ohio State University, *142*

Oklahoma, University of, 45, *45*

Oklahoma Track, *310*

Okrent, Daniel, x, xi

Old, Toby, 43, *43*

Olen, Hank, 23

Olivenza, Spain, *190*

Oliver, William Letts, 282

Olsen, Justin, *222*

Olszewski, John, 25

Olympia (film), 221, 228, 230, 231

Olympian Games in Athens, 1896, The (Holmes), 224

Olympia 1936—Die Olympischen Spiele 1936 in privaten Filmaufnahmen (documentary), 228

Olympic City, The (Hustwit and Pack), 257–8

Olympic Games, 7, 16, 28, 51, 52, 67, 82, *103*, 104, 122, 145, 148, 154, 201, 223–58, *229*, *244*, *258*, 278, 291, *291*
 of 1896 (Athens), 223–7, *224*, *225*, *226*, *227*, 272
 of 1900 (Paris), 272
 of 1912 (Stockholm), 295
 of 1932 (Los Angeles), 296
 of 1936 (Berlin), 5, 7, 218, 228, 229–31, *230*, *231*, 297
 of 1936 (Garmisch-Partenkirchen), 228–9, *228*
 of 1948 (London), 38, 56
 of 1960 (Rome), 52, 62, 130, 237, *238*, 297, 298
 of 1964 (Tokyo), 7, 82, 298, 299
 of 1968 (Mexico City), xi, 235–6, *236*
 of 1972 (Munich), 129, *130*, 131, 299
 of 1972 (Sapporo), 299
 of 1976 (Montreal), 299
 of 1980 (Lake Placid), xi
 of 1984 (Los Angeles), 19, 88, 237, 241, 300
 of 1984 (Sarajevo), 299, 300
 of 1988 (Seoul), 242, *243*
 of 1992 (Barcelona), 151, 255, *255*
 of 1996 (Atlanta), xi, 88
 of 1998 (Nagano), *240*, 241
 of 2002 (Salt Lake City), *245*, 252
 of 2004 (Athens), 89, 302
 of 2008 (Beijing), 151, *246*, 258, 302
 of 2010 (Vancouver), *222*, 253

of 2012 (London), 9, 16–17, *36*, 37, 122, 163, 223, *241*, 247, *248*, *257*, 301, 304
 of 2014 (Sochi), 304
 trials for, 234, *234*, 235, *254*

Olympic Museum (Lausanne), 244

Olympic Portraits (Leibovitz), 88

Olympic Stadium (Berlin), *300*

Olympus Deltis VC-1100 camera, 301

O'Neal, Tatum, *93*

O'Neil, Buck, 64

On the Wind, Reliance (Burton), *282*

Opie, Catherine, 73, 75–6, *76*

Orange Bowl, 297

Orange Farm, South Africa, 212, *212*

Oregon State University, *4*, 142

Orlando, Fla., 49, *49*

Orr, Bobby, 164, *164*

Osinski, Christine, 79–80, *80*

Osodi, George, 213

Outerbridge, Paul, 156

Over the Top (Riger), 25

Owens, Jesse, 83, *85*, 229, 231

Oxford University, 195, 260, *271*

"Ozzie Sweet directing Jackie Robinson for the cover of *Sport*" (Scutti), 100, *100*

Pachoud, Jeff, 136, *137*

Pacific Magazine, 133

Pack, Jon, 257–8, *258*

Padilla, Juan José, 189, *190*

Paige, Satchel, *63*, 64

Paine, John, 223, *224*

Paine, Sumner, 223, *224*

Palabra e Imagen (Words and Images) series, 181–2

Palmer, Mickey, 162

Pamplona, Spain, 189, *192*

Panaros, Dean, *244*

Panellenio Gymnastikos Syllogos, 224

Panon slit cameras, 239

Pantzopoulos, Nikolaos, 223, *227*

Papageorge, Tod, 118–19, *118*

Paralympic Games, 247, *249*

Paris, France, ix, *8*, 41, 50, *64*, 169, 205, 213, 223, 270, 272, 283, 284, 285, *295*, 304

Paris Match, 51, 104

Parke, Trent, 129

Parks, Gordon, 62, 89

Parr, George, 262

Pasadena High School, 254

Passing Through Eden (Papageorge), *118*, 119

Patterson, Floyd, 171

Peabody, Henry G., 282

Pelé, 93, *93*

Pellizzari, Paolo, 66–7, *66*

Pencil of Nature, The (Talbot), 41

Penn, Irving, 130, 145, 156, 252

Pennsylvania, University of, 268
 Wharton School of, 203, 254

Penson, Max, 131

Pentax cameras, 183, 299

People's Olympiad (1936), 230

Pepperdine College, 42, *42*

Perth, Australia, 166, *166*

Peskin, Blanche, 174

Peskin, Hy, *ii*, 174–5, *174*

Peter Read Miller on Sports Photography (Miller), 255

Petrusov, Georgi, 131

Pfahl, John, 88

Pfrunder, Peter, 50, 51

Pfundner, Michaela, 5, 6, 7

PGA Championship (1966), *97*

Phelps, Michael, 151, 258

Philadelphia, Pa., 45, 188, *188*

Philadelphia Athletics, 286, *294*

Philadelphia Eagles, xi, 17

Philadelphia 76ers, 59

Phillips Exeter, 254

Photographer's Eye, The (Szarkowski), 5, 125

Photographic Memory (Curtis), 230–1

"Photographs and Memory" (Goldberg), xi

Picasso, Pablo, 11, 189, 192

Picture Post, 147

Picturing Time (Braun), x, 270

Pisarek, Abraham, 7, 228

Pistolgraph cameras, 293

Pittsburgh, Pa., *39*, 198, *198*

Pittsburgh, University of, 39, *39*

Pittsburgh Cycle, The (Wilson), 198

Pittsburgh Pirates, *39*

Pittsburgh Press, 89

Pix agency, 51, 161

Pleasure and Terrors of Levitation series, 153

Plimpton, George, 64
Pol, Andri, 138, *138*, 139
Polaroid, 134, 156, 297, 299
 Warhol's portraits using, 93–5, *93*
Polo Grounds, 25, 280, *294*
Porter, Eliot, 156
Portland, Oreg., 218
Portugal, 45, *193*, 195
Portuguese Institute of Photography, 195
Port Washington, Wis., 79, 162
Powell, Mike, 9, 119–20, *119*, 134, 143, 237
Powell, Steve, 9, 113, 119–20, 142, 143, 237
Prado, Edgar, *151*
Prague, 77, 203, 232
Press Graflex cameras, *294*
Pretty, Adam, 129, *250*, *251*
Princeton University, 45, *134*
"Prizefighter" (Kubrick), 186
Prodger, Phillip, 267–8, 269
PRO! Magazine, 254
Propaganda Kompanie (PK), 229
Pros, The exhibition, 24
Pulitzer Prize, xi, 19, 59, 75
Pyongyang, North Korea, 213, *213*

Queen's Club, London, *271*
Queensland College of Art, 31

Raft of the Medusa (Géricault), 104
Ramsey, Ocean, *133*
Rancinan, Gérard, *103*, 104, *105*
Rapho picture agency, 56
Rapid, Kaindl von, *6*
Reaching for the Rim photo essay (Jensen), *203*
Reader, Martin, *257*
Rebeaud, Mat, *168*
Red Bull, 31, 166, 169
Reebok, 252
Reed, Willis, 127
Reflex-Nikkor lens, 298–9
Regan, Ken, 98, *98*
Reiferson, Paul, 277
Rejlander, Oscar G., 140
Reliance (yacht), 282, *282*
Remarkables Ski Fields, *128*
Renaissance Big Five, 292, *292*
Renaissance Casino, 292
Renoir, Auguste, 239

Rentmeester, Co, 82, 129–30, *130*
Return, The (film), 7
Reuters, 162, 177, 201, 241, 303
Reuters-Seiko, *300*
Reynolds, William, 90, *90*
Rhomaides Brothers, 223
Rice Quidditch, *152*
Richards, Keith, 98
Richer, Paul, 270
Rickey, Branch, 25, 28
Riebicke, Gerhard, 7, 228
Riefenstahl, Leni, 177–8, 221, 228, 230–1, *230*, *231*
Riger, Robert, ix, xii, 24–8, *26*, 64, *110*, 111, 127, 255, *298*
Ring, 9
Ringier publishing, 216
Rites of Fall (Winningham), 45
Ritts, Herb, *91*, 93, 252
Rizzuto, Phil, 24
Roberts, Greg, *111*
Robinson, Jackie, xi, 25, 62, 100, *100*, 116, *116*, *160*, 161, 198, 277
Robinson, Sugar Ray, *ii*, 180
Rochester Institute of Technology, 88, 255
"Rocky Graziano, He's a Good Boy Now" photo essay (Kubrick), 185, *186*
Rodchenko, Aleksander, 131, 148–9, *149*
Rodger, Cicely, 177
Rodger, George, 177–8, *178*
Rodrigues, Daniel, *194*, 195
Rodriguez, Ivan, *143*
Rogan, Markus, *162*
Rolleiflex cameras, 61, 145, 153, 296, *299*
Roma soccer team, 71, *71*
Rome, Italy
 first Paralympic Games in, 247
 1960 Olympics in, 52, 62, 130, 237, *238*, 297, 298
Rome World Championships (2009), 303
Roosevelt, Franklin D., 63
Rosenblatt Stadium, 5
Rosenfeld, Morris, 282
Rossi, Max, *239*, 241
Rote, Kyle, 25
Royal Ascot, 286–7
Rozov, Valery, *167*
Rübelt, Ekkehard, 5–6

Rübelt, Lothar, 5–7, *6*, 228, *231*, 297
Rugby Union, 20
Rugby World Cup, *57*
"Rules of the Game, The: An Essay on Photography, Sports, and a Thing Called Magic" (Okrent), x
Rupp, Adolph, *117*
Russell, Bill, 164–6, *165*
Russell, Nigel, 271
Russia, xi, *167*, 234
 see also Soviet Union
Ruth, Babe, xi, 75, *75*, 81, *108*, 109
Ryan, Kathy, 50

Sabol, Steve, 79
Sabouret, Charles, *290*
Sachert, Berman, *6*
Sacks, Oliver, 99
St. Louis Cardinals, *48*
St.-Pierre, Georges, *187*
Salas, Osvaldo, 52–3, *53*
Salgado, Sebastião, 221
Salt Lake City Olympics (2002), *245*, 252
Sam Houston State University, *152*
San Diego Chargers, 300
San Francisco, Calif., *58*, 59, *59*, *111*, 180, 282
San Francisco 49ers, xi, 17, *58*, 59, *111*, *111*, 300
San Francisco Giants, 25, *48*, 115, 143, *143*, 144, *161*
Sanger, Eleanor, 28
San Marino Gran Prix, 28
Santa Monica Track Club, *119*
Santos, Ricardo, *257*
São Paulo, Brazil, 57, 213, 221
Sapporo Olympics (1972), 299
Sarajevo, Bosnia, 257–8, *258*
 1984 Olympics in, 299, 300
Saturday Evening Post, 42, 64
Schabazz, Jamel, 89–90, *89*
Scharfman, Herb, 172, 175, *175*
Schatz, Howard, *viii*, 122, 123, *184*, 185
Schiller, Friedrich, 209
Schiller, Lawrence, 42, *42*
Schirner, Max, 7, 216, 228
Schlegelmilch, Rainer W., 154–6, *154*, *155*
Schmeling, Max, 84

Schmidt, George, 296–7
Schulke, Flip, 95, *95*, *96*
Schürpf, Marcus, 216
Schwartz, Jonathan, 37
Schweizer Illustrierte, 216
Scott, Bryan, *viii*
Scottish National Library, 259
Scutti, Nick, 100, *100*
Seattle, Wash., *44*, 51
Seaver, Tom, *93*
Secretariat, xi, 97, 98, *98*
Seguin, Franck, 57–9, *57*, 187, *187*
Seguin, Nathalie Franck, 57
Semenya, Caster, 241
Semon, Nick, *152*
Sengstacke, Robert, 90
Senna, Ayrton, 28, 82, *82*, 155
Seoul Olympics (1988), 242, *243*
Serbia, 164
78 Boxers (Howalt), 182
Seward High School, 172
Shafrazi, Tony, 93
Shaikhet, Arkady, 131
Shamrock III (yacht), 282
Shamrock V (yacht), 32
Shaw, Ezra, 48, *48*
Shea Stadium, 46
Shoemaker, Willie, *93*
Shrake, Edwin, 99
Shute, Densmore, 120, *120*, 121
Signer, David, 139
Sigriste cameras, *294*
Silk, George, 39–41, *39*, 134, *134*, 145, 234–5, *234*, 297
Silverman, Barton, 107, *144*, 145–6
Silverman, Ruth, ix
Simpson, O. J., 93, *93*
Simpson Desert, Australia, 48
Singer, Alexander, 186, 188
Sir John Hotel (Miami), 95, *96*
Siskind, Aaron, 153
Sisto, Ernie, 23–4, *23*, 145, *296*
"Six day and night bicycle race" (Cartier-Bresson), *8*
Skaife, Thomas, 293
Ski and Snow Country (Miller), 218
Skycams, 300
SLR cameras, 139
Smith, Chris, 70–1, *71*
Smith, W. Eugene, 109, *146*, 147
Snap Shots of the Motion in Running, Jumping, Javelin

and Discus Throwing
 (Anschütz), 270
Snead, Sam, 97, *97*
Snow, Carmel, 14
Soar, Hank, 25
"Soccer as an Existential
 Sacrament" (Coover), 71
Sochi Olympics (2014), 304
Social Graces (Fink), 188
Solitude track, 150
Solomon, Freddie, *111*
Somalia, 210, *211*
Sonnenfeld, Herbert, 7, 228
Sony cameras, 304
Soul of the Game (Huet), 252
South Africa, 212, *212*, 213, 241
South Korea, 213, *246*
South Shore High School,
 Brooklyn, 9
South Sudan, *178*, 203
Southwest Review, 277
Soviet Union, 131, 172, 232
Spain, 65, 189, *249*
Spalding Guide, 287
Spanish Civil War, 229, 230
Spartakiada, 232–4, *232*
Speed Graphic cameras, 23, 28,
 38, 78, 145, 174, 175, 218, 245,
 294, 295, *296*
Spiegel, Der, 229
Spitz, Mark, 129–30, *130*
Sport, 100, *100*, 172
Sportbild Schirner, 228
Sporting News, 287
Sportsfile agency, 20, 22
Sports Illustrated, ix, xi, 16, 18, 20,
 25, 28, 37, 40, 41, 51, 59, 64,
 68, 76, 88, 89, 95, 99, 104,
 110, 115, 118, 127, 128, 143,
 148, 151, 162, 164, 171, 172,
 174, 175, 237, 239, 241, 254
Sports Show, The (Little), ix
Springer, Axel, Jr., 154
Sprint Cup Series championship
 (2013), *322*
Squires, LaVannes C., 117
Stacey, Alan, 114
Stadio del Nuoto, *162*
Stalin, Joseph, 232
Stanford, Leland, 266, 268, 293
Stanislavski, Constantin, 112
Staples Center, 107, 108
Starr, Bart, 162
Starr, John, 237

Staten Island Synchrolites, 79, 80
State Sports Centre, *250*, *251*
Stearn of Cambridge, 271, *271*
Stebbins, Nathaniel L., 282
Steichen, Edward, 28, 121
Stein, Betty, *201*
Steinbrenner, George, 160
Steiner, Matthias, *241*
Stengel, Casey, 53
Stephenson, H. H., 262
Stewart, Lane, 108
Stieglitz, Alfred, xii
Stockholm Olympics (1912), 295
Stoppard, Tom, 99
Stroboscopic Light Laboratory,
 121
Strock, George, 38, 63–4, *63*
Strohmeyer, Damien, *4*, 5, 118
Strug, Kerri, xi
Stubbs, George, 24
Stuttgart, Germany, 149, 150
Subway Series (Dow), 46
Sudan, 171, 177, *178*, 203, *203*
Suerte de Capa, La, *192*
Sugar, Bert, 185
Suisse Sportive, La, 284
Sullivan, Constance, 175–6, 177
Sullivan, Louis, 142
Sun Valley ski resort, 41
Super Bowl, xi, 59, 145–6, 162, 201
 III, 109, *109*, 110
Suter Detective Magazine
 cameras, 227
Sutton, Keith, 82, *82*
Suwey (Somali basketball player),
 210
Sven Simon Picture Agency, 154
Sweet, Ozzie, 100, *100*, 172
Swing, The (Griffin), *74*
Switzerland, 139, 216, *217*, 284, *303*
Sydney, Australia, 128–9, *250*, *251*
Sydney Morning Herald, 31, 128–9,
 200, 251
Sydney Olympic Park Athletic
 Centre, *200*
Szarkowski, John, 5, 24, 125, 239

Table Mountain, *219*
Takashi, Inoue, *200*
Talbot, William Henry Fox, 41,
 259, 293
Tara River, *163*
Taschen, 62
Tauber, Arthur, 83, *86*

Taylor, Major, 283, *283*
Taylor, Stephen, 17
Teachers College, 280, *281*
Team USA, 222
Technology Review, 121
Tejada, Miguel, 114, 115, *115*
Test Match, *112*
Texas, 49, 115
Texas, University of, 45
Texas Dozen, A portfolio, 45
Texas Western University, *117*
Thill, Arthur, 28, *29*
This Sporting Life: 1878–1991
 (Dugan), ix
Thompson, Paul, 264, *264*
Thorn, John, 174
Thorpe, Jim, 286
Three Village Herald, 9
Tiger, Dick, *175*
Time, 51, 98, *98*, 172
Time, Inc., 151
Tinker, Joseph, 264, *264*
Tissandier, Gaston, 270
Tittle, Y. A., xi, 17, 25, 79
Today show, 28
Tokyo Olympics (1964), 7, 82,
 298, 299
Tomasevicz, Curtis, *222*
Tomchek, Michael, *35*
Tomsic, Tony, 162
Topeka Capital-Journal, 19, 118
Torres, Avil, 247, *249*
"To Snatch the Moment's Secrets"
 (Pfundner), 7
Tottenham Hotspurs, *141*
Tough Guy competitions, 214, *215*
Tour de France, 7, 65–6, *65*, *66*,
 67, 136, *299*, *304*
Track, The exhibition, 24
Trent Polytechnic, 142
Trilogy of Moderns, The
 (Rancinan), 104
Tsirgialou, Aliki, 223
Tucker, Anne, 152
Tunney, Gene, *177*
Twickenham Stadium, 60, *60*
Twyford Preparatory School, 260,
 261
Tyson, Mike, *92*, 93, 98

Uhrmann, Michael, *245*
Ullstein Verlag, 14
Ultimate Fighting Championship
 (UFC), 187

Understanding Media (McLuhan),
 95
Underwood and Underwood, *279*
Unitas, Johnny, 24, *26*
United Press Association, 285
United States Olympic Museum,
 122
Unity Athletic and Social Club,
 292
UPI, 117, 175
Uptown Little League, 198, *198*
Uruguay, 45, 89
U.S. Olympic Committee, 296
U.S. Open (tennis), 68–9, *69*
U.S. Open Golf championship
 (2015), 304

Valdez, Nelson Haedo, 10, *11*
Valkyrie III (yacht), 280
Vancouver Olympics (2010), *222*,
 253
Van der Zee, Gaynella, 292
Van Der Zee, James, 292, *292*
Vandystadt, Gerard, 143, 237
Vanity Fair, 82, *83*, 84, *85*
Vecsey, George, 79
Vel' d'Hive Round-up, 9
Vélodrome d'Hiver, Paris, 7, *8*, 9
Velsheda, The (yacht), *32*
Verstappen, Jos, 28, *29*
Veterans Stadium, 45
Victoria and Albert Museum, 56
Vie au Grand Air, La, 283, 285
Vienna, 5, *6*, 7
Vietnam War, 43, 119
Vilas, Guillermo, 68, 69, *69*
Villegas, José Miguel, 59, *59*,
 115–16, *115*
Visions du Sport (Gautrand), ix
Visions of Victory exhibition
 (1996), ix
Vlahovic, Slobodan, *163*
Vogue, 64
Voigtlander cameras, 77
Vu agency, 205
Vuckovic, Predrag, 163–4, *163*
Vuich, Fred, 67–8, *68*

Wagner, Honus, 97
Walcott, Jersey Joe, 175
Wallace, David Foster, x
Walling, Denny, *115*
Walsh, Christy, 109
Walter, Jean-Denis, ix

Warhol, Andy, 93–5
WAR/PHOTOGRAPHY
 exhibition, 152
Washburn, Bradford, 136
Washington Redskins, 25, *146*, 147
Watson, Albert, *92*, 93
Weil, Danielle, *159*, 160
Weisman, Richard, 93
Weissmuller, Johnny, 286
Werder Bremen, *11*
Westinghouse Electric
 Company, 84
West Point, U.S. Military
 Academy at, *90*
West Side Story (film), 158
What Is Sport? (Barthes), x, 65, 189
Wheaties, 73, 81–2
Whistler Sliding Centre, *222*
White Stag, 218
Wide World of Sports, 25, 28
Wiebusch, John, 254
Wiegmann, Arnd, *303*
Wilkes, Stephen, *vi, 40*, 41–2
Willard, Jess, 286
Williams, Cleveland, *171*
Williams, Serena, 14, *16*
Williams, Ted, 74, *74*

Williamson, Charles H., 263, *263*
Willie Mays Steals Third (Sisto),
 23–4, *23*
Willis, Deborah, 292
Wilson, August, 198
Wimbledon, 16, 123, *123*
Winged Vision, 300
Winningham, Geoff, 45, *45*
Winogrand, Garry, 140, *140*
Winstone, Howard, 181, *181*
Wisden, John, 262
Withers, Ernest C., 116, *116*
Wolff, Paul, 7, 228
Wolff & Tritchler, 228
Wolverhamton Wanders, *141*
Wombell, Paul, ix
Women's National Collegiate
 Athletic Association, *18*
Woods, Tiger, 68, *68*
Woodward, Richard, 176, 177
World Championships (track and
 field; 2009), *239*, 241
World Championships in
 Athletics (Berlin; 2009), *303*
World Cup (skiing), of 2012, *303*
World Cup (soccer), xi, 153–4,
 241, *302*

of 2010, *2*, 213
of 2014, 56–7, *56*
World Exhibition (Paris; 1900),
 223
World Heavyweight Title fight
 (1966), *171*
World Masters Games (2009), *200*
World Press Photo awards, 22, 70,
 104, 128, 129, 195
World Series, xi, 25, 144
 of 1903, *53*
 of 1913, *294*
 of 1953, 22, *38*, 53
 of 1954, xi, 17, 23
 of 1955, xi, *160*, 161, *314*
 of 1960, *39*
World Swimming Championship
 (1998), *166*
World War II, 5, 7, 23, 25, 44, 61,
 63–4, 65, 131, 147, 174, 229,
 278
Wright, Krystle, 31, 34, *34, 35*
Wright brothers, 270
Wrigley Field (Wilkes), *40*

Yachting's Golden Age, 1880–1905
 (Holm), 282

Yale University, 79, 118, 158
Yankee Stadium, *ii*, xi, *22, 23, 26,
 37, 38, 39*, 46, *75, 110, 144,
 146, 159*, 160, *160, 172, 296*
Yarbrough, Carl, *240*, 241
Yemen, 195, *204*
Ylla, 64
Yorkshire Post, 128
Young, Cy, *53*

Zagaris, Michael, *111*–12, *111*,
 144
Zappeion Building, *226*
Zeiss Ikon cameras, 77, 297
Zeiss Sonnar lens, 297
Zeiss Triplet, 296
Zenith B cameras, 5
Zhang Leyang, *121*
Zimmerman, John G., 17, 38, 127,
 145, 164, *164*, 237–9, *238*,
 255
Zimmerman & Kaufman
 (Callahan and Astor), 38
Zito, Ambert, *48*
Zito, Barry, *48*
Zuccotti Park, 114
Zurich, 50

Anonymous, Tour de France, the pack crossing Honfleur, stage Paris-Le Havre, June 27, 1920

ILLUSTRATION CREDITS

All photographs are copyright of the photographer unless otherwise noted.

ii Courtesy of the Hy Peskin Collection

v Courtesy of Alaina Juliet Taylor

viii Photograph by Howard Schatz from *Schatz Images: 25 Years,* © Howard Schatz and Beverly Ornstein 2015

2 Mark Leech © Offside Sports Photography Ltd.

3 Courtesy of the Boston Public Library, Leslie Jones Collection

4 Photograph by Damian Strohmeyer/*Sports Illustrated*/Getty Images

6 Courtesy of Österreichische Nationalbibliothek, Vienna

8 © Henri Cartier-Bresson/Magnum Photos

10 Photograph by Al Bello/Getty Images

11 AP Photo/Luca Bruno

12 Photograph by Heinz Kluetmeier/*Sports Illustrated*/Getty Images

13 © Estate of Martin Munkacsi, courtesy of Howard Greenberg Gallery, New York

15 © 2010 MIT, courtesy of MIT Museum

16 Photograph by Bob Martin/*Sports Illustrated*/Getty Images

17 Photograph by Al Bello/Getty Images

18 Photograph by Bill Frakes/*Sports Illustrated*/Getty Images

19 Photograph by Paul Mohan/Sportsfile

20–21 Photograph by Ray McManus/Sportsfile

22 Leroy Jacob/*New York Daily News* Archive/Getty Images

23 Ernie Sisto/*The New York Times*/Redux

26–27 Photograph by Robert Riger/Getty Images

29 ATP Munich/Thill Arthur

30 Courtesy of LeRoy Grannis Estate and M&B Gallery, Los Angeles

32–33 Bob Martin/*Sports Illustrated*/Getty Images

36 Photograph by Adrian Dennis/AFP

38 Photograph by Mark Kauffman/*Sports Illustrated*/Getty Images

39 Photograph by George Silk/The *LIFE* Picture Collection/Getty Images

44 Burt Glinn/Magnum Photos

45 Geoff Winningham, courtesy of the Museum of Fine Arts, Houston, the Anthony G. Cronin Memorial Collection, gift of the Cronin Gallery

46 Jim Dow/courtesy of Janet Borden, Inc., New York

48 Photograph by Ezra Shaw/Getty Images

50 © Theo Frey/Fotostiftung Schweiz

51 © The Jerry Cooke Archives, Inc.

52 Osvaldo Salas, National Baseball Hall of Fame Library, Cooperstown, New York

54–55 Gerry Cranham © Offside Sports Photography Ltd.

56 Mauricio Lima/*The New York Times*/Redux

57 Franck Seguin/*L'Équipe*

61 Theo Ehret (private collection)

63 Photograph by George Strock/The *LIFE* Picture Collection/Getty Images

64 Library of Congress, Prints and Photographs Division, Toni Frissell Collection (LC-F9-02-4712-72-10)

65 Robert Capa/Magnum Photos

66–67 Paolo Pellizzari, Courtesy of Anastasia Photo

68 Photograph by Fred Vuich/*Sports Illustrated*/Getty Images

72 Marvin E. Newman © 1963

74 © Arthur Griffin, courtesy of the Griffin Museum of Photography

75 Nat Fein Estate and *The New York Times*

76 © Catherine Opie, courtesy of Regen Projects, Los Angeles, and Lehmann Maupin, New York and Hong Kong

77 Václav Chochola/© Archiv B&M Chochola

78 © Vernon J. Biever Photography, LLC

81 Courtesy of George Eastman Museum © Nickolas Muray Photo Archives

82 Sutton Images (www.sutton-images.com)

84 Lusha Nelson/*Vanity Fair* © Condé Nast

85 Lusha Nelson/*Vanity Fair* © Condé Nast

86 Photograph by Gjon Mili/The *LIFE* Picture Collection/Getty Images

87 © Annie Leibovitz

88 Lynn Johnson Collection, Mahn Center for Archives and Special Collections, Ohio University Libraries

90 *William Reynolds, Gymnast,* United States Military Academy © Anderson & Low. All Rights Reserved.

91 Herb Ritts/Trunk Archive

93–94 (all) © 2016 The Andy Warhol Foundation for the Visual Arts, Inc./Artists Rights Society (ARS), New York

95–96 © Flip Schulke

97 Photograph by Walter Iooss Jr./*Sports Illustrated*/Getty Images

98 Ken Regan/Camera 5

99 © Vernon J. Biever Photography, LLC

100 © Nick Scutti; *Sport* magazine, courtesy of Larry Canale

106 Andrew D. Bernstein/NBAE/Getty Images

108 Courtesy of LA84 Foundation

253 © 2010 IOC/John Huet. All rights reserved.

254 Photograph by Peter Read Miller/*Sports Illustrated*/Getty Images

255 Ken Geiger/*The Dallas Morning News*

258 Jon Pack, *The Olympic City*, by Jon Pack and Gary Hustwit, 2013

259 Scottish National Portrait Gallery, National Galleries Scotland

260 Bibliothèque Nationale, Paris

261 (top) Popperfoto/Getty Images; (bottom) Baron Wilhelm Von Gloeden/National Geographic Creative

262 Rischgitz Collection/Getty Images

263, 264 Library of Congress, Prints and Photographs Division

265 © McCord Museum

266 George Eastman Museum, Rochester, New York

267 Hulton Archive/Getty Images

268–269 Courtesy of Laurence Miller Gallery

270 Albertina, Vienna, work on permanent loan from Höhere Graphische Bundeslehr-und Versuchsanstalt, Vienna

271 Popperfoto/Getty Images

272 Cinémathèque française, Paris

273–276 © Georges Demenÿ, INSEP iconothèque

277 RS Family LLC

278 Hulton Archive/Getty Images

279–280 Library of Congress, Prints and Photographs Division

281 Museum of the City of New York, gift of Mrs. George Blumenthal, 1938

282 Library of Congress, Prints and Photographs Division

283 Bibliothèque Nationale, Paris

284 Photograph © KEYSTONE/Photopress-Archive/Jules Decrauzat

285 National Media Museum, Bradford, England

286 Photography Collection, Miriam and Ira D. Wallach Division of Art, Prints and Photographs, The New York Public Library, Astor, Lenox and Tilden Foundations

287 RS Family LLC

288 RS Family LLC

289 Library of Congress, Prints of Photographs Division

290–291 Photograph by Jacques Henri Lartigue, © Ministère de la Culture—France/AAJHL

292 © Donna Mussenden Van Der Zee

294 Library of Congress, Prints and Photographs Division

295 *L'Équipe*

296 Anonymous/*The New York Times*/Redux

298 © Estate of Robert Riger

299 *L'Équipe*

300 Reuters/Seiko/Handout

301 Richard Martin/*L'Équipe*

302 Team 2/Ullstein Bild/Alinari Archives

303 Reuters/Arnd Wiegmann

304 *L'Équipe*

310 Library of Congress, Prints and Photographs Division, Toni Frissell Collection

314 Photograph by Martha Holmes/The *LIFE* Picture Collection/Getty Images

330 Simon Bruty/*Sports Illustrated*/Getty Images

A NOTE ON THE TYPE

This book was set in Adobe Garamond. Designed for the Adobe Corporation by Robert Slimbach, the fonts are based on types first cut by Claude Garamond (c. 1480–1561). Garamond was a pupil of Geoffroy Tory and is believed to have followed the Venetian models, although he introduced a number of important differences, and it is to him that we owe the letter we now know as "old style." He gave to his letters a certain elegance and feeling of movement that won their creator an immediate reputation and the patronage of Francis I of France.

COMPOSED BY *North Market Street Graphics, Lancaster, Pennsylvania*

PRINTED AND BOUND BY *Mohn Media, Gütersloh, Germany*

DESIGNED BY *Iris Weinstein*

Simon Bruty, "Jimmie Johnson victorious during Victory Lane celebration after winning Sprint Cup Series championship at Homestead-Miami Speedway," November 17, 2013